DATE DUE

SE 26 '03		
AP 16 '07		
MY 7 '07		

DEMCO 38-296

Pictures of the Body

JAMES ELKINS Pictures of the Body

Pain and Metamorphosis

STANFORD UNIVERSITY PRESS

STANFORD, CALIFORNIA

1999

Stanford University Press
Stanford, California

© 1999 by the Board of Trustees of the
Leland Stanford Junior University

In Chapter 5, the section on microscopy is a revised version
of "On Visual Desperation and the Bodies of Protozoa,"
Representations 40 (1992): 33–56. The section on cubism
draws on a larger argument set forth in "Piero, Picasso:
The Aesthetics of Discontinuity," in *Streams into Sand:
Links Between Renaissance and Modern Painting* (New York:
Gordon and Breach, forthcoming). Scattered paragraphs
revisit themes in Chapter 4, "Seeing Bodies," in
The Object Stares Back: On the Nature of Seeing
(New York: Harcourt Brace, 1997).

Printed in the United States of America
CIP data appear at the end of the book

For Barbara Stafford

Man playing bagpipes.

Photo by George Kosmopoulos, © Olympia Press.

Preface

The past few decades have witnessed a renascence of writing on the depicted body. Loosely following phenomenological accounts by Jean-Paul Sartre and Maurice Merleau-Ponty, and taking up threads from Robert Vischer's theory of empathy and Jacques Lacan's descriptions of the web of vision, writers have begun to weave a more reflective understanding of what happens when a viewer encounters a represented body.[1] The pictured body is no longer imagined as an immobile shape on paper or canvas, but as a counterpart and figure for the observer. As my body moves, or as I think of moving, the body I behold also shifts, and as I look, I see myself being seen, and I return the painted gaze. My thoughts are entangled in what I imagine as the painted figure's thoughts, and my image of myself is mingled with the way I respond to the pictured body. Because the body intromits thought, important aspects of my responses to a picture of a body might not even be cognized: I may feel taller looking at an attenuated figure or be thrown into a frustrated mood upon seeing a figure that is twisted or cramped. The nature of my thought, my very capacity to form judgments, is in question: as Elaine Scarry has emphasized, the act of beholding a body affects my ability to form propositions and to use language, blurring the capacity to judge and finally erasing it when I am in the presence of excessive pain.[2] Mark Johnson has suggested that thinking about the body is also thinking *by means* of the body, because the very structure of propositional logic follows in part from the experience of the body.[3] In light of these conceptual traps, it can be difficult to maintain the traditional distinctions between viewer and viewed, and depicted bodies

may be understood as opportunities for a peculiar kind of response that can be difficult to name—although it might be called "visceral seeing," or "thoughtful embodiedness."

A large number of disciplines and methods have been converging on these ideas: at the least art history, feminism, gender studies, varieties of psychoanalysis, phenomenology, studies of popular culture, the histories of science and medicine, anthropology, contemporary scientific imaging, advertising, and contemporary art from neoexpressionism to experimental film, fiber art, and comics.[4] Given this emerging awareness, it is worth bearing in mind that questions of visceral seeing are not an innovation of the late twentieth century and that corporeal responses to pictures of the body go back to the origins of Western art criticism. Philostratus's *Imagines*, written around A.D. 220, is a ready example. It presents itself as the record of a lecture tour of the paintings in a house outside Naples. As Philostratus describes each painting for the benefit of his admirers, he addresses himself to a ten-year-old boy, the son of his host. Stopping in front of a painting depicting the death of Menoeceus outside the walls of Thebes, Philostratus praises the wonderful way the painter has shown Menoeceus pulling the sword from his body. Philostratus would have been standing to one side of the painting, with the boy next to him and the spectators ringed around. "Let us catch the blood, my boy," Philostratus says, "holding it under a fold of our garments; for it is flowing out, and the soul is already about to take its leave, and in a moment you will hear its gibbering cry."[5] To Philostratus, the *Menoeceus* is a painting that speaks, that bleeds, that is about to give up a soul. I imagine Philostratus making a gesture, as if to receive the blood, and if his rhetoric was strong enough his audience would have felt the boundary between painting and public begin to weaken.[6]

Strains of this kind of bodily response echo throughout the history of art and art criticism, and so does interest in what we now call "constructions of gender." (Philostratus's choice of a ten-year-old boy is not chance, and it has its effect on his monologue as well.) Yet it could be argued that the contemporary mixture of ideas has produced a new configuration of problems. The sometimes narcissistic "infatuation with different modes of body consciousness" is beginning to coalesce into a field of extraordinary conceptual complexity, and on some occasions the new amalgam of interests has almost become a discipline in its own right.[7] For its first retrospective collection, the journal *October* created a heading for "The Body"

alongside more conventional topics. Rosalind Krauss, Leo Steinberg, Barbara Stafford, Georges Didi-Huberman, and Michael Fried are among the writers who have begun to theorize and practice the new concerns.[8]

But the principal trait of this new set of interests is still its incoherence. Michael Feher's edited, three-volume collection of essays on the body, entitled *Fragments for a History of the Human Body*, is interesting among other reasons for its near-absolute lack of order. Contributors represent many disciplines and deploy incommensurate interpretive methods (Feher himself favors a Plotinian approach), and they make use of contradictory notions of such key terms as "body" and "representation."[9] The resulting disarray suggests that the body cannot be directly addressed because it is both more and less than a philosophic or physical object. The exhilaration of the better essays in *Fragments for a History of the Human Body* comes in part from their utter newness: there is a certain joy in seeing Tibetan medical manuals or African images of the afterlife, or in contemplating medieval notions of the wandering womb. But even when the novelty has begun to fade, the essays remain memorable as examples of radical conceptual disorder.

It might be that as the represented body becomes something art historians can talk about alongside the other subjects of the discipline, it also becomes less coherent as a concept—it turns into an amorphous repository for whatever escapes our current methods and systems. That which is unassimilable, vague, without category or quality is now diverted into the realm of the somatic. The represented body becomes the one place where no order is possible. It takes on the interconceptual function of the region where, as Freud said, the demands of the body become ideas in the mind: the very spot where flesh becomes intelligible, where mute drives become signs. It appears that the represented body exists in a contaminated zone between the two, so it cannot properly be in full possession of its meaning. That, at least, is my understanding of the literature that has so far been produced on the subject of pictured bodies and viewers' bodily reactions. Writers are drawn to the subject in part as the remaining refuge of deep irrationality, unbridgeable interdisciplinarity, and inexpressible subjectivity in a discipline that seems constricted by the harsh demands of philosophic methodologies.

One purpose of this book is to resist that dispersion of ideas. I am interested in the conditions of representation of bodies in general—the ways bodies have been given pictorial form, and their varying relations to viewers—and I believe it is possible to find some order in the welter of

images. This book is an aerial view of the subject, a first attempt to gather works, terms, and theories and to give some clarity to a field that is nearly incoherent. My grounding thesis is that pictured bodies are expressive in two largely opposite modes: some act principally on the beholder's body, forcing thoughts about sensation, pain, and ultimately death; and others act more on the beholder's mind, conjuring thoughts of painless projection, transformation, and ultimately metamorphosis. Although I mention competing binarisms and other theories that can vie with this one, I propose this framework as a way of bringing provisional order to a literature that grows less manageable with each passing year.

Another thesis of this book runs counter to the opposition of "pain" and "metamorphosis," undercutting it at every point: the conviction—and perhaps the structural necessity—that the depicted body must be intractable, that it must escape all categories, all systems, all imposed orders. I would hope the general accounts of depicted bodies I develop in these pages might find uses in the production, history, theory, and criticism of bodily images of all kinds—even while the particular explanations labor and finally break under the pressure of the conviction that the body is the most powerfully unsystematic object we can know. The sense that I am wrong, and that the body is unencompassably strange and irretrievably unruly, will be a constant accompaniment to my ordered exposition: it could not be otherwise.

J.E.
Chicago, 1989–1999

Contents

List of Illustrations xiii

List of Tables xvii

Introduction 1

PART ONE Pain

1. Membranes 35

2. Psychomachia 71

3. Cut Flesh 109

PART TWO Metamorphosis

4. By Looking Alone 153

5. Analogic Seeing 205

6. Dry Schemata 245

Notes 287

Index 339

Illustrations

1. *Portrait of Isaku Yanaihara* (Alberto Giacometti) 3
2. *Still Life* (Balthus) 9
3. *The Cherry-Picker* (Balthus) 11
4. *Larchant* (Balthus) 12
5. *Grayed Rainbow* (Jackson Pollock) 14
6. Elasticity of skin contrasted in a man of sixty-eight years and a man of twenty-six years (Robert Douglas Lockhart) 21
7. *Lying Woman and Guitarist* (Pablo Picasso) 25
8. Emblem of the skin, vessels, and membranes (Jan Van Rymsdyk) 37
9. *Portrait of George Dyer Staring at a Blind Cord* (Francis Bacon) 40
10. Clay model of a sheep liver, marked for divination 48
11. Lucina, the goddess of childbirth 57
12. *Leigh in Stripes* (Lucian Freud) 58
13. The patient Catherine C., a "monstrously fat" woman 60
14. *Doni tondo* (Michelangelo), detail 63
15. *A Lady with a Dog* (Bronzino), detail 64
16. *Study for the Last Judgment or the Resurrection of the Flesh* (Jacopo da Pontormo) 66
17. *Study for the Arm of St. Sebastian* (Matthias Grünewald) 68
18. Expressions in fish and in a hippopotamus 77
19. "The Psychological Railway" 77
20. Nostrils, indicating degrees of sensuality 80
21. "Faces Incapable of Greatness" 82
22. "Composed Emotions" 83
23. Involuntary expression in response to a note from a tuning fork 84
24. Competition reliefs of the Sacrifice of Isaac (Lorenzo Ghiberti, Filippo Brunelleschi) 86, 87

25. *The Night* (Max Beckmann) 92

26. *Christ on the Cross Between Mary and John* (Michelangelo), detail 94

27. *Crucifixion* (Villard de Honnecourt) 96

28. "Anatomical Crucifixion," a cast of the flayed, crucified corpse of James Legge (Thomas Banks) 97

29. *Crucified Christ* (Michelangelo) 99

30. Astral faces impressed in plaster (Eusapia Palladino) 102

31. Abnormal positions of calves in utero 103

32. Mr. Fantastic, battling his dark side 105

33. Terra-cotta figure of Humbaba 110

34. Monster from John Carpenter's *The Thing* 111

35. Eighteenth-century sutures 113

36. *Mes Voeux* (Annette Messager) 114

37. *Boy with a Raised Hand (Hans Reichel)* (Oskar Kokoschka), detail 117

38. Figures looking at *opus incertum* (Giambattista Piranesi), detail of "Rovine delle antiche fortificazioni del monte e della città di Cora," *Antichità di Cora* 119

39. *The Mocking of Ceres* (Adam Elsheimer) 120

40. *Michel Leiris* (Francis Bacon) 122

41. *Saint Sebastian* (Titian), detail 123

42. *Los geoglíficos de las Postrimenás* (*Hieroglyph of our last days*) (Valdés Leal), detail 125

43. Male skeleton (Andreas Vesalius) 130

44. Male skeleton (Jan de Wandelaer) 131

45. "Wound-Man" demonstrating his own intestines 133

46. Life-size wax model of a pregnant woman (Clemente Susini and Giuseppe Ferrini) 135

47. *Trichophytie* afflicting the upper chest 136

48. Superficial muscles of the back 138

49. The uterus and vagina of a young woman 140

50. Stereoscopic photographs of a female pelvis 141

51. Skeleton (Jan de Wandelaer), detail of schematic key 142

52. *Écorché* and young rhinoceros (Jan de Wandelaer), detail 143

53. Cross section of the eye (Samuel Thomas von Sömmerring), detail 144

54. Cross section of a mummy's head (Karl-Heinz Hoehne) 146

55. The right platysma muscle and pectoral fascia (Erich Lepier) 147

56. *Resistances* (Joan Livingstone), studio view 148

57. *The Birth of Venus* (Sandro Botticelli), detail 154

58. Gottlieb M., a "wandering Jew" 158

59. *Gilles*, or *Pierrot* (Antoine Watteau) 159

60. Apollonia Schreyer 163

61. Somatotyping triangles 166, 167

62. Two men of the same somatotype 168

63. Palau nipples and small penises 171

64. Forms of breasts 173

65. Rear view of woman and chimpanzee 174

66. Dr. Mary Walker, a *Mannweib* type 175

67. A "typical Negress" 176

68. An orangutan and a Japanese priest; the "Negro position" in a Fajelu man and woman and in a chimpanzee 178

69. A pubic hair denoting homosexuality 181

70. A Niam-niam 183

71. Profiles, from tailed ape to Apollo 185

72. Leibniz's skull, and Leibniz's skull and wig superimposed 187

73. Australian woman 190

74. Bavarian man 191

75. Daughter and father afflicted with chronic trophoedema 192

76. "Sexual position number 7" (Giulio Romano, possibly after a design by Raphael) 196

77. Drawing for Jean de la Fontaine, *Contes* (Jean-Honoré Fragonard) 199

78. *Nude* (Francis Bacon) 200

79. *Temptation of St. Anthony* (Martin Schongauer), detail of a demon (inverted) 206

80. *Girl with a Mandolin* (Pablo Picasso) 208

81. *Portrait of Daniel-Henry Kahnweiler* (Pablo Picasso) 210

82. The Ravenna monster 213

83. The Scythian lamb, or *borometz* 214

84. *Celebes* (Max Ernst) 216

85. A miraculous branch, prefiguring war. Found on a tree near Frankenthal, Germany, 1625 217

86. Woodcut (anonymous), after Hieronymus Bosch, *Temptation of St. Anthony*, detail of lower-left corner 218

87. The harlequin worm (Martin Frobenius Ledermüller) 221

88. Two *Zee-diertjes*: the *Zee-scherminkel* (*Physica marina*) and the *Zee-duizendbeen* (*Scolpendra marina*) (Martinus Slabber) 224

89. *Der kleine Proteus* (the Amoeba), with *Volvox* sp. at the top (August Johann Rösel von Rosenhof) 225

90. Leeuwenhoek's *vaten* 227

91. Milt vessels of the calamary 229

92. The freshwater hydra (August Johann Rösel von Rosenhof) 232

93. Infusoria (Heinrich August Wrisberg) 233

94. *Leucophrys patula* (Christian Gottfried Ehrenberg) 236

95. *Arachnosphaera oligocantha, Aulosphaera elegantissima* (Ernst Haeckel) 239

96. *Kakabekia*-like forms grown on agar in an atmosphere of ammonia and air 241
97. Photographs of living forms developed from sterilized matter (Wilhelm Reich) 242
98. The humoral body (Robert Fludd) 246
99. Tip the Saw-Horse and Jack Pumpkinhead (John R. Neill), two figures from *The Land of Oz* 249
100. The "zodiac man," an astrological bloodletting diagram (Johannes de Ketham) 253
101. Coordinate transformations of four Acanthopterygian fishes (D'Arcy Wentworth Thomson) 255
102. Right lateral views of the newborn infant and the adult 256
103. A demonstration of the elasticity of skin, with the trunk marked in three-inch squares (Robert Douglas Lockhart) 257
104. Harmonic analysis of the face of Miss Helen Wills 260, 261
105. Analysis of the harmonies of a relief of Heziré (Else Christie Kielland) 262
106. Comparison of 18- and 21-square Egyptian figures 264, 265
107. Egyptian figures in an 18-square grid (Amenhophis III) 267
108. Egyptian figure in a 21-square grid (Edfu, Temple of Horus; Ptolemy XIII Neos Dionysos) 269
109. *Christ the Redeemer*, with inset of Byzantine three-circle face 275
110. African magical amulet 280
111. King Solomon spearing a devil 281
112. The letter "I" (Geoffrey Tory) 284

Tables

1. Positions in front of a picture of a body 16
2. Six categories of pictured bodies 28
3. Systems of medical semiology 72
4. Poses of the crucified Christ 98
5. Crookshank's racial homologies 177
6. Camper's facial angles 184
7. The Lee-Pearson formula for cranial capacity, in cubic centimeters 186
8. Cranial capacity ranges, in cubic centimeters 188
9. Stratz's schema of the races 189
10. The 18-square canon of proportions in Egyptian art 266
11. The 21-square canon of proportions in Egyptian art 268
12. Alberti's canon of *Exempeda* 271
13. Dürer's canon of rules 271
14. Measurements proposed in Alberti's *De statua* 272
15. The Vitruvian canon of proportions 273
16. The Byzantine nine-part canon 273
17. The Byzantine canon of proportions for the face 274

But how it abuses our senses and their "dictionary,"

this pain that turns their pages!

—Rilke's last words[1]

Introduction

Every picture is a picture of the body.

Every work of visual art is a representation of the body.

To say this is to say that we see bodies, even where there are none, and that the creation of a form is to some degree also the creation of a body. And if a splash of paint or a ruled grid can be a picture of the body—or the denial of a body—then there must be a desire at work, perhaps among the most primal desires of all: we prefer to have bodies in front of us, or in our hands, and if we cannot have them, we continue to see them, as after-images or ghosts. This is a beautiful and complicated subject, the way our eyes continue to look out at the most diverse kinds of things and bring back echoes of bodies.[2]

According to Stoic philosophy as it is given voice by Lucretius and Epi-curus, we see objects because they shed "films" or "membranes" (*membranae*) that come floating continuously toward us through the ether.[3] The skin is not the abstract marker of a body's limits, as in Leon Battista Al-berti's perspective, with its geometric forms defined by centric rays and polygonal outlines (*circumscriptiones*).[4] Skins are not the theoretical appara-tus of some geometry, or the equations of modern physiological optics. They are the echoes, the ripples, of bodies, and they carry the sense of body toward us together with the details of form. Lucretius says he is thinking of "something like skin," and he compares the membranes to the "brittle summer jackets" of cicadas, the cauls or allantoides shaken off by newborn calves, and the shed skins of snakes.[5] As Diskin Clay puts it, in Lucretius's imagination the atmosphere is "fluid with films or cauls."[6]

I

Lucretius is concerned that clouds, unlike all other mundane objects, are not solid enough to be able to shed those skins, and that point of difficulty in his theory shows his need to begin from bodies, and not just objects. A cloud can be rounded and discrete like a body, but it lacks two primordial attributes of bodies, firmness and skin. So Lucretius puzzled over clouds, which are visible and yet impalpable. The theory of vision that he shares with Epicurus reveals itself as a theory of bodies by the way it pauses over the idea of a body that is also weightless. Vision, in its deepest source and impetus—in its somatic origin (*Quelle*) and its rooted force (*Drang*), as Freud might have said—may be the determined search for bodies.[7] If I choose the Stoic philosophy as an antecedent for this idea instead of Merleau-Ponty, it is because Merleau-Ponty puts things in terms of "flesh" and "carnal being": he is concerned with the identity of the body as a whole, while I am interested in its parts and particularities, and above all its appearance *as a body*, with a shape as well as a feel.[8] Visual existence, in the account I will be developing, has to do with the apparition of *specific* bodies—skins in the shape of objects, or bodies, or parts. Epicurus is more exacting about the body than Merleau-Ponty (he is more aware of pain and the body's insistent complaints), and Lucretius is more precise than either. A picture of a body can never be anything other than specific: it cannot stand for touching, or fleshly existence, or identity, or any other general term of experience, unless it does so *in* its specific skin.

Here is a particular body, or part of one: a portrait of the Japanese philosopher Isaku Yanaihara, by Alberto Giacometti (Figure 1).[9] It is part of the record of an obsession Giacometti had with this particular face and body—he painted Yanaihara more than fifteen times, and paid for his airfare from Tokyo to Paris in the summers of 1957, 1959, 1960, and 1961—and because of that obsession, it is an exemplary portrait. It is labored, anxious, and uneasy: a half-gray halo rises to the middle of the picture, marking the place where Yanaihara's figure was once painted, but then he shrank, compressed by the intensity of Giacometti's gaze, to the puny location where Giacometti left him. The little Yanaihara is a house of cards—a stack of black and white streaks, washed in pale white, and topped by a smudged brown nose that almost succeeds in looking solid. The painting's surface is shiny and gently undulating, like the wood of a cult statue that has been caressed until it is smooth. Manifestly, the painting is a failure. Giacometti abandoned it, as he abandoned the other four-

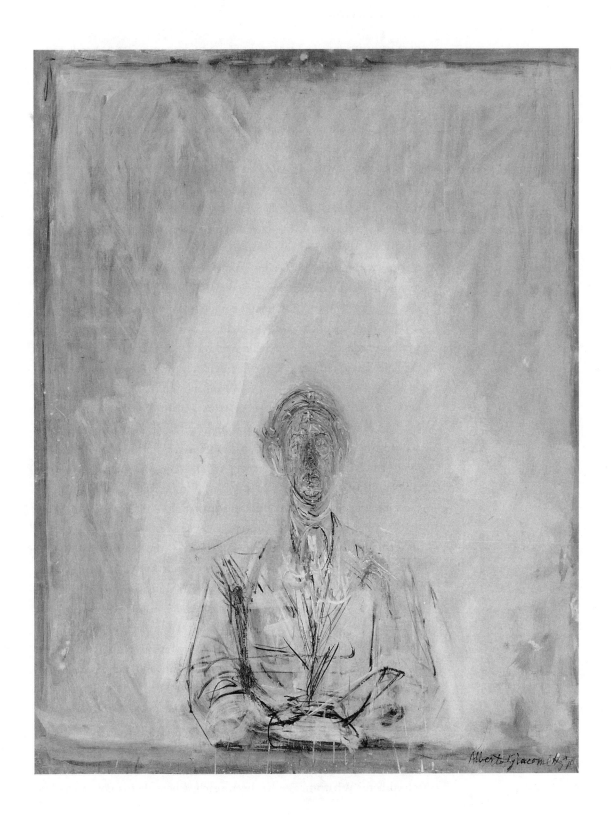

teen paintings in the series and the many drawings that he made at the same time. Nothing went wrong, exactly—but the body's force failed to impress itself on the canvas, and what the canvas found could not hold the body.

Something about this picture—and I mean to say by extension, all portraits—makes me pause, throws me into a state of intensified, unsatisfied looking. Part of what I want from any face is a speaking, moving response, and I can't get it from a face that is painted. But is that enough to account for my restlessness? In another sense, perhaps more fundamental or prior to the demand for a living face, I want a face to behave *as a face*: to be complete, to be unified and distinct from what is around it, to be there before me without any uncertainty, to be clear enough to interpret, to keep some sensible distance from my own face. Yanaihara's face fails on each of those counts. Despite Giacometti's compulsion about distance and size (he insisted that Yanaihara place his chair on red spots marked on the floor, and he moved his canvas up and down in small increments using pieces of clay), the face is neither near nor far, high nor low.[10] The looming soft halo is the memory of a larger or closer Yanaihara, and the delicate armature of lines encloses echoes of smaller or more distant Yanaiharas. The figure emerges from its white background, and then melts back into it. There is no firm surface, no hard skull, no resistance. Even the brown nose, the most firmly finished passage, is spongy and damp. And the painting is fascinating because of those failures: I want it to be whole and articulated, I want it to occupy a reasonable place in its setting—and what are those demands, if not desires I have in regard to all depicted bodies, and finally to all form? Isn't there a deep resonance between the desire for a tangible head and the desire for clear shapes of any kind? I would like to say that we prize distinctness and clarity, in objects as well as in philosophy, ultimately because we need distinct and clear bodies and faces.

Looking at Yanaihara, I want a sureness about his form that I know the painting does not want to give, and Giacometti is successful to the extent that his work persuades me to give up that desire and entrances me with uncertainties. It is not a pleasant kind of seeing, but a demanding and imbalanced experience, a kind of vertigo. The skull contracts into an uncertain flat grayish envelope of space. It shrinks—it continues to shrink as I look, like an afterimage slipping from my field of vision—and it trembles, like a tree flushed by a breeze. What problems, however provisional, are solved here? What impasse has been reached here that is not reached, or

that is avoided, in some other more conventional portrait? We know from Yanaihara's journal that an intense emotional drama ran alongside the demanding all-day posing sessions (Yanaihara had an affair with Giacometti's wife beginning the first year that he posed), and we know that artist and model also talked continuously during the posing, and then again afterward in cafés, about existentialism and phenomenology, about the identity of the Other and the unsettling slight difference between one male and another, between a Westerner and a Japanese. All of that forces the experience of the portrait into channels I do not want to follow here. But finally, even if the biographical details cannot find their places in the portrait itself, even if we cannot find a way to understand them as signs, say, of the disruption of the face, the portrait continues its incessant self-destruction. And it is that motion, the unremitting denial of the security of the body, that accounts for the queasiness and nausea that the portrait elicits. I would read it as compelling evidence of a basic need for the body.

First and Second Seeing

When there is a body to be seen, we focus on it with a particular relaxed concentration: there is a determined, sinuous, insistent gaze we reserve for bodies and faces. When the body in question is as fugitive as Yanaihara's, we feel that peaceful seeing on account of its relative absence: I am anxious when I try to see Yanaihara because I know and need the peace and the pleasure that can come from seeing a body. Let me call this "first seeing," denoting the way we look when there is a body to be seen, or part of one. In everyday conversation, first seeing is relaxed and languorous: my eye rests in the eyes of the person I see, and it slides and caresses the person's skin as it moves from place to place. Even if the face I see is frightening or repulsive—like some I considered in another book, *The Object Stares Back*[11]—a certain repose exists in my way of looking. A face, and perhaps especially a naked body, is a place of rest and meaning in a setting of boredom and meaninglessness. Everything—from chairs to light switches, from landscapes to asphalt—is partly empty and dissatisfying in contrast to the repletion I feel when I see a body. Even if I am embarrassed or tense or if I am compelled to look against my will, I can still sense the relaxation, the correctness of my gaze when it falls on a body. The *Portrait of Isaku Yanaihara* is on the far edge of that experience because it refuses to congeal into a firm, continuous face and because, like all pictures, it cannot move

or reveal its true distance, its shape, or its size. Even so, the anxious irregular shifting in my gaze is not enough to annul the conviction that this is a face, and therefore my way of looking is fundamentally satisfied and reposeful.

The world is full of scenes and patterns that contain no bodies. This is the more complicated, and more common, occurrence of "second seeing": a restless, nomadic way of looking that begins when I fail to find bodies or body parts.[12] Even the most narcotic objects—a deep twilight, the sight of a freshly made bed, a well-designed garden—provoke something of this more restless seeing. I do not mean that my eyes must flit from place to place or that second seeing needs to have any determinate physical symptom. But I think that whatever is not a body inaugurates a restive intermittent search for bodily forms or metaphors. If I am alone in a garden, then I will look around—meaning that I will look at everything in turn, at nothing in particular, at one thing after another. My eyes may be restive in both senses of that word: unruly, or else static and fixated. If a person or an animal (a nonhuman body) strays into my field of vision, then I will immediately fix on it, by an unconscious reflex that cannot be denied.

In the absence of bodies, I think we embark on a search for body metaphors—for bodily lengths, weights, colors, textures, shapes, and movements—and in that second search we tend to be easily satisfied and content with the most obvious choices. A psychoanalyst tells a story about a little boy and his father, out for a walk in the woods. The boy squats down, shits, and notices that his excrement stands up "straight on end in the underbrush." He is evidently amused and satisfied, and he proclaims, "Look, I made the Chrysler building." The analyst wonders whether "such a joke uttered by a naïve child provides any hint as to what may be meant when a man in soberer and politer years dreams of making a tall building."[13] I have no argument with this line of reasoning, and I am not convinced that we usually do much better with our metaphors. This is the sense in which upright buildings can be said to resemble upright people, or erections, or arms or noses or fingers. These rudimentary metaphorics do not usually occupy the conscious mind, but I think they are more than just reflexes: they are conditions for the comprehension of the world in general.

Within second seeing, the moments when we locate body metaphors are secondary moments of rest, but they can never be entirely satisfying. Body metaphors are evanescent in our consciousness, and they dissolve un-

der the slightest pressure of thought. That is why efforts to list them, such as Elaine Scarry's list of the "bodily sources of culture," are unsatisfying: they are true, but they are also too well articulated.[14] The Chrysler Building isn't really much like a pile of shit, because it has a metal surface and geometric arcs—but then when I seek to understand those arcs, they seem to require more body metaphors. They might recall, or (to put it more gently, since these phenomena are scarcely conscious) gain some of their meaning from, the sweep of a forearm or the arc of an iris. The metal sheathing is like a perfect skin, and so on. Even to mention these kinds of metaphors is to think far too coarsely and literally about what it is to see a form like the Chrysler Building, but they are normative examples of the continuous and swift search for body metaphors that constitutes the more mobile second seeing.

Second seeing animates and directs everyday sight, and it is made explicit in painting. To D. H. Lawrence, Cézanne "terribly wanted to paint the real existence of the body," and Meyer Schapiro has said as much by observing the figural disposition of Cézanne's apples on their cloths and plates.[15] The peculiar anxiousness of second seeing is a constant source of expressive power in Cézanne's still lifes and landscapes. Stephen Bann praises Lawrence's "deeper" realization that "it was the body that was in question" and adds that "embodiment resided in the translation of the movements of the painter's hand into the weave of interconnected brush marks."[16] That kind of equation, moreover, is only a surface residuum, a trace of the deeper dialogue between the painter's body and the inhuman bodies of the objects he watched. As Merleau-Ponty knew, the object is in question throughout Cézanne's work, and the still lifes are a rich and largely unexplored field for that inquiry.[17] Cézanne saw bodies as apples, but he also saw bodies as scraped impasto, as modulating earth tones, and as collections of fractured fields; it is extremely difficult to begin to compose a longer list of such terms or to reconstruct the *bodily* relations between them. Cézanne sometimes concentrates on the centers of his pictures and lets the margins fall away, in the manner of a portrait painter—almost as if each picture were the premonition of a body, which then appears in another guise, as a human form or as a tree, a boulder, a mountain, or even a principle of color or of fragmentation.[18]

A way into these questions is provided by Balthasar Klossowski de Rola, known as Balthus—not incidentally, a painter who thought a great deal about Cézanne. Balthus has an intensely and obviously sexual way of

looking at the world, and his interests are highly specific: despite the protestations of his biographer Jean Lemayrie and his son Stanislas Klossowski de Rola, it is almost meaningless to deny he was both initially and finally an observer of adolescent girls.[19] He saw them in ways that have to do with the exact demands of his desire: the paintings focus on the underpants, the top inch of the inner thigh, the hem of the skirt, the rounded forms of the vulva, the hair (especially when it is pulled or brushed), and the double arc of the tops of the breasts. His paintings of domestic interiors are precise demonstrations of the ways in which it is possible—in imagination or in a painter's studio—to look up, down, or obliquely in order to see around obstacles and observe the curve of the cunt. That kind of seeing is demonstrated in the most exhausting way whenever there are figures in the paintings, and it is present just as insistently in the few still lifes he painted (see Figure 2). The obvious analogies are all here: the knife, thrust into the loaf of bread; the cloth draped in a double curve over the chair (exactly mimicking the pose taken by models in several paintings). And there are old-fashioned *vanitas* elements as well: the broken pitcher recalling the punctured hymen, as in Jean-Baptiste Greuze's paintings of lost innocence, and the rounded forms recalling hips, arms, and breasts.

Balthus's hothouse dramas are luxuries that Cézanne stifled, or rather that he never controlled and *knew* well enough to put in such obvious forms, and they are ultimately less interesting than the specific angles and encounters between objects. On the right, the stopper and a glass fragment nearly touch one another; they are neither horizontal nor upright, and they are not quite disposed so that we can see them clearly. Some of their curves are pointed toward us, and others away—it is the same kind of half-hidden, ambiguous, and sexually charged meeting that Balthus demanded of his models. The cloth bends forward, unfurling itself and almost touching the mallet handle. An entire dynamics of the eye could be written about Balthus's still lifes, setting out the full range of conceivable orientations and views that determine the shapes of his desire. This particular still life is more eloquent on that account than many others by other painters, because it resonates against the evidence of Balthus's figure paintings: but any still life partakes of the obvious sexual and bodily meaning of knives and fruits, as well as this more hidden but precise geometry of the ways in which the body is seen.

Still lifes are a common example of a bodiless genre suffused with bod-

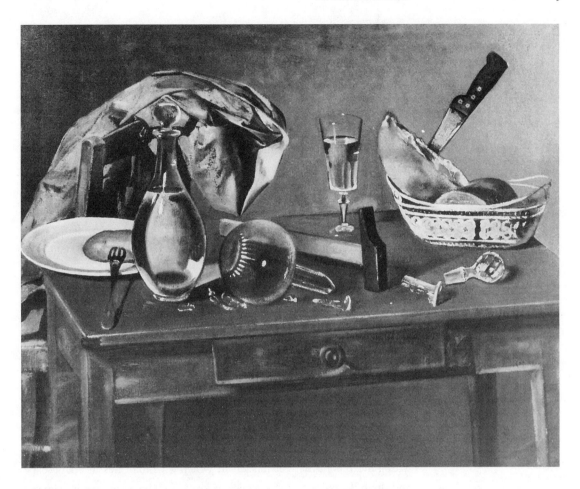

ily invitations and overtones, and landscape is another. Western landscape has long taken meaning from parallels between natural forms and bodily contours—so much so that Chinese and other non-Western landscapes are susceptible to specific kinds of misreadings as Westerners attempt to see them in terms of the bodies they do not possess. John Hay has made the provocative suggestion that Western pictured bodies (in the sense of solid, naked, sensually and politically charged representations) may have their analogues in the "convoluted, foraminate, complexly textured" rocks so ubiquitous in Chinese gardens and paintings.[20] The rocks would then indicate a particular sense of the body largely foreign to Western meanings: they would have to do with *shen*, *qi*, and other Chinese concepts (roughly, "spirit" and "energy"), and they would evoke the body's bulk, its gestures, its orifices and proportions, in oblique and unstable ways. Hay's proposal opens a risky interpretive field, since in accord with Western habits of see-

FIGURE 2

Balthus. *Still Life*, 1937. Oil on canvas. Hartford, Connecticut, Wadsworth Atheneum.
© Artists Rights Society (ARS), New York/ADAGP, Paris.

ing it would be tempting to extend his observation to ordinary painted rocks and mountains that seem to depend so much on erasing the body's specific forms.[21] A painting by Dong Qichang, for example, that has an eccentric rock in the foreground might also have a range of fractured and crumpled cliffs that do not respond to bodily readings.

It could be argued that interpretations that locate the body in Chinese and other non-Western landscapes will not make significant progress until we can better understand how Western response depends on the body, and for that reason I want to continue for the moment with the fundamental elements of the Western perception of pictured bodies. Balthus is again a good introductory example; in his painting *The Cherry-Picker* (Figure 3), a woman is depicted halfway up a ladder, provoking thoughts of voyeurism—her legs are together, and her skirt is lifted just above her knees, but with another few steps up the ladder, she will be overhead. Thanks to the hypereloquent sexuality of Balthus's vision, the landscape itself expresses the same desire, so accurately that the figure is almost superfluous. Cherry-picking is always a matter of peering upward, and craning the neck, and Balthus places a few cherries in the leaves just out of the girl's reach. The whole scene is set on a steep hillside that accelerates into a cliff that brushes the very top of the picture—with a vertical Lombardy poplar for extra emphasis—so that the viewer, or rather the voyeur, is entirely absorbed in the act of *looking up*. In other paintings, Balthus mobilizes a more common convention in which a woman lies in a landscape and the hills undulate with echoes of her hips. The effect can be obvious and also overwhelming, as if the landscape were an ocean and every hill a wave rehearsing the outlines of her body.

If Western landscapes are imbued with these structures, the exception that proves the rule is the geometrized landscape. When Cézanne painted the curve of Mont Saint-Victoire, he tended to cut it into architectonic fragments, and in general he made sharp lines out of opportunities to represent gentle curves. In order to say that those decisions are moves made *against* the body, it is not necessary to invoke the history of sexualized landscape back to Giorgione; it is enough to realize, as the pictorial logic itself reveals, that Mont Saint-Victoire has a curved back, and that Cézanne has broken it. Balthus painted one extraordinary landscape according to these rules of negation: a view of the small town of Larchant (Figure 4). The picture is unmoving and empty, and the town's few houses are regimented into an austere convocation of geometric planes. As in some

FIGURE 3

Balthus. *The Cherry-Picker*, 1940. Oil on canvas. Collection of Mr. and Mrs. Henry Luce III. © 1997. © Artists Rights Society (ARS), New York/ADAGP, Paris.

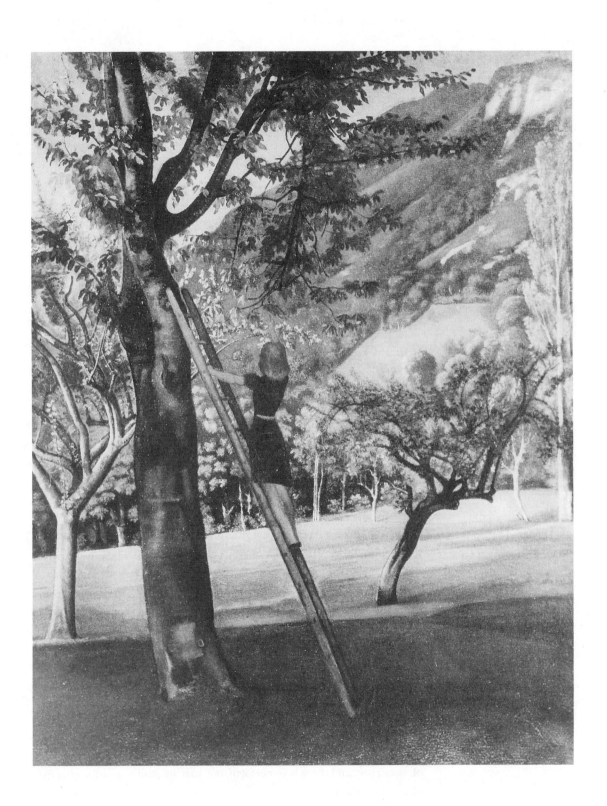

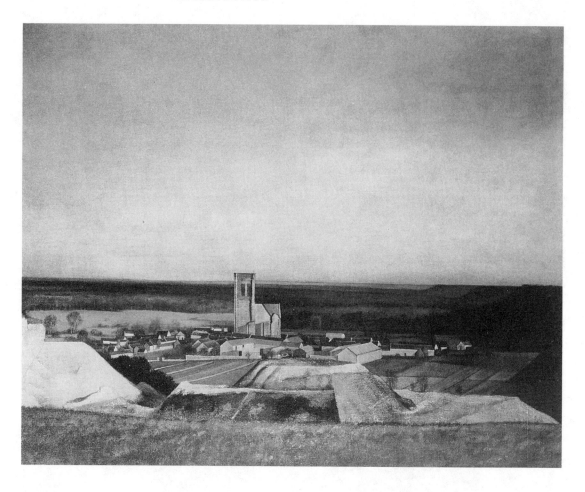

of Cézanne's landscapes, there is nothing nearby. A field leads down at an indeterminate angle toward a quarry, and the town only begins in the far distance. The quarry has a pit and a central mound of tailings, and it is not a coincidence that Cézanne was attracted to the same two forms in his paintings of the Bibémus quarry. The heap is an attractive obstacle—that is, a body, or the faint echo of one. It is soft and truncated (in Cézanne's paintings, the Bibémus quarry is more formidable, riven with impassable clefts and overhangs), and in the distance the mound is completed by the even more strongly figural shape of an old church. *Larchant* is painted in parsimonious late-winter colors, smothering any strong chromatic effect and putting a chill on Balthus's accustomed sexual heat. Since most of Balthus's paintings are set in close, humid rooms, this is an unexpected act of asceticism, and the whole performance may be read as a quiet, effective silencing of the body.

Bodily Forms in Abstraction

These are some of the ways in which a sense of body can be crucial even where there is no body or obvious body metaphor. Abstraction is only farther from the body if we say a body has to have certain naturalistic conventions such as a recognizable face (or an object recognizable as a face), limbs in a determinate order (although that order might not be the human one), opacity, adherence to gravity, or organic rather than sharp-edged contours. In general, it is difficult to reform the body so radically that its fragments begin to operate, as Pierre Klossowski de Rola (Balthus's brother) has said, somehow outside the circuit of possible desire and possession.[22] But the possibilities are variable and not easy to pin down. Abstract pictures can resonate with a sense of the body more strongly and persuasively even than photographs or academic studies of the nude. The second seeing they initiate can be more engrossing than the obviously fruitless searches for a body in landscape or interiors. Abstraction, it could be argued, is virtually a discourse on the represented body, made all the more insistent by its obliquity.

There is gesture, first of all: the marks in Jackson Pollock's *Grayed Rainbow* (Figure 5), for example, are records of the exact bodily motions that made them, and they evoke the affects a viewer might associate with those motions. The drip paintings are about leaning, stooping, and stretching as well as all the things that Pollock's contemporaries found amusing about the new technique: drooling, peeing, and stomping around. When Pollock discovered the drip technique in 1947, he was doing battle against his own Picassoid figures, trying to enmesh and overwhelm them in new marks; as Rosalind Krauss has emphasized, "what seemed consistently at stake was to do violence to the image."[23] The horizontal surface, and the awkward bending and reaching (and crawling, and tiptoeing), are all part of that purpose, and they leave their traces in the work. The allover paintings are compelling in this regard because they exhibit specifiable degrees of anger against the figure. Some continuous swoops are lazy, half-controlled gestures, and the kind of motion that made them would have been something gentle but imprecise, like strewing seeds. (In *Grayed Rainbow*, such marks are mostly white loops and strings.) That kind of motion, in turn, conjures informal relaxation, both bodily and mental. Other marks are more violent, and there are splatters, gobs of paint, and even hand- and footprints that speak about less comfortable motions.

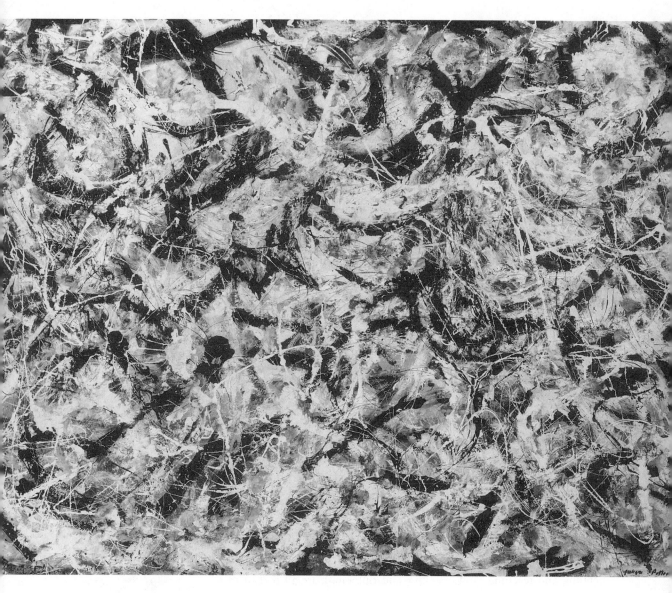

It has been said that Pollock's drips are perched between contours (that is, outlines, which could contain figural shapes) and areas that would be enclosed between contours.[24] In one place, they are as thin as lines, and in another as thick as color areas or objects, but they neither catch the light nor throw shadows, and they neither confine nor compose areas. At first glance, that modernist criticism might appear to be a recipe for avoiding the apparition of the body and concentrating on the pure play of abstraction. With no way to be certain whether a drip mark is an outline bounding a figure or a thin figure with its own outline, it would not be possible to be sure of the vocabulary of figural metaphors. But the body has many voices, and it can express itself through motions and ambiguous contours as well as disambiguated forms. There is no need to roughen the experience of the painting by trying to set out the bodily metaphors in any detail; it is enough to note that there are many kinds of gestures and associated emotions in the painting and that the body is the vehicle of their meaning. If we do not think of the body—no matter how faintly or quickly—the gestural language remains inaudible.

Abstraction, and abstract moments in all visual art, also involve the body when they exhibit the shapes, colors, and feel of the skin. Like all oil painting, *Grayed Rainbow* takes place on a skin (the raw canvas is a skin, both in its thinness and its opacity), and the paint itself forms another skin with its dry surface and potentially, or originally, viscous interior. It could be argued that *Grayed Rainbow* expresses more about skin than many illusionistic paintings because it does not yield information about what lies beyond the picture plane. Despite Clement Greenberg's assertion of Pollock's planarity, the painting's "cuts" and streaks are wounds to the skin of the canvas, and they make the skin metaphor that much more insistent.

Gesture and skin are two modes by which the body is metaphorically present in abstraction; another is scale. As Robert Rosenblum has observed, paintings such as *Grayed Rainbow* can be ambiguously human-sized, microscopic ("atomic"), and macroscopic (like "galaxies").[25] Those two alternatives are more dramatic than my own experience of the painting—I'd rather say that *Grayed Rainbow* offers an oscillating series of scales, all roughly human-sized. The largest forms in the painting aside from the surface itself are the sweeping black curves that line up across the canvas. They are the painting's principal surrogate figures, not because we need to think of them as figures, but because they are almost human-sized and human-proportioned. I instinctively respond to them in that way, as if

my whole body is an appropriate echo to each one of the forms. Still, Rosenblum's observation is correct as a reminder that scale is an open question; at other times, I find myself responding to small portions of the painting, thinking of the finer lines as plantlike shapes, or inadvertently constructing imaginary landscapes. Once again it does not matter in this context exactly how the scales operate (although such information would be essential for a more involved reading of the painting); what counts is that the body is also immediately available through choices of scale.

A fourth source of bodily metaphors in abstraction is provided by the distances at which we situate ourselves when we are looking at a represented body. The ordinary choices can be put schematically, as shown in the following table.

Normative distances are in the middle range of this table—for example, if the representation strikes me as a bodily shape and size, I might unthinkingly stand at the same distance I would stand from a person to whom I am talking (number 4). The conversational distance is instinctive, and I sometimes find myself drawn toward it even in front of abstract

TABLE I. POSITIONS IN FRONT OF A PICTURE OF A BODY.

1. Myopic positions	Deliberately overly close, scanning or inspecting the surface inch by inch.
2. Figure mark positions	The farthest position from which it is possible to see individual painted marks on the body.
3. Ground mark positions	The farthest position from which it is possible to see individual painted marks on the ground.
4. Conversational positions	The places from which the painting comfortably fills the visual field and possesses the same size-to-distance ratio that we sense in talking to people.
5. Inferred center of projection	The position at which the perspective schema, or other structural clue, implies we should stand.
6. Hyperopic positions	Deliberately overly distant positions, from which large features of the painting cannot be seen.
7. Anamorphic positions	Positions deliberately too far to one side, from which the picture is willfully distorted.

compositions. Often, too, I might stand just close enough to see the marks that make up the figure or the (often larger) marks that comprise the ground (numbers 2 and 3). In some Renaissance paintings, those "figure mark" and "ground mark" positions are close to the panel or canvas, and they balance the more distant inferred center of projection, which is frequently a little farther away than I might care to stand (number 5). With painters such as Raphael, the choices are quite clear: either I can walk close up to one of his paintings and try to see how it was done, or I can stand back near the place specified by the perspectival or structural cues in the picture. The figure mark and ground mark positions are usually within touching distance of the painting because they correspond with the distances from which the painting was made, and therefore they are also the distances I might occupy if I mean to touch another person.

Then there are "improper" positions, which I call "myopic," "hyperopic" (farsighted), and "anamorphic" (numbers 1, 6, and 7); each avoids the cluster of places that address the picture. The normative positions afford more or less intimacy and naturalness, and the improper positions are ways of spying on the painting, seeing it from places it does not sanction. Anamorphic positions are surreptitious, and in that respect Balthus's paintings are all anamorphic. Although I might position myself front and center before one of Balthus's paintings, in imagination, and in accord with the picture's logic, I am bending low, squatting, turning, or twisting myself to see something out of the corner of my eye.[26] Hyperopic positions are essentially rejections, in that I refuse to be close enough to see (or talk to, or hear) the figure or the painting; and myopic positions are pathological or medical, and are beyond the bounds of common human intercourse. I can refuse a painting either by staying away from it or by approaching and examining it so closely that I do not take in the entire image.

Needless to say, this list is only a sample of the possibilities, and it is too coarse to explain what happens in front of an actual painting. But it illustrates another way that the body can reverberate when it is absent, pushing me toward a picture, or pulling me away, in accord with rules that are ultimately derived from my interaction with bodies. When a painting disrupts the body as Pollock's does, dispersing its forms to all parts of the canvas, cutting the work loose "from any analogies with the gestalt of the body whole," it refers even more insistently to the body's lost wholeness and to the "aggressivity and formlessness" of its repression.[27] And when, in addition to that violent dispersal, the painting declines to observe the hierarchy

of human scales, it provokes a vertigo of continuous unfocused displace-ment—as I walk back and forth, up to the painting and away again—and I am returned all the more insistently to the question of the absent body.

Certainly gesture, skin, scale, and distance are sources of bodily mean-ing in abstraction, and I might add a fifth term, the specific modes of looking that pertain to bodies. *Grayed Rainbow* has its own rules of look-ing: staring along and around the large black gestures, peering through and among the smaller ones, looking up and down, tying visual knots and flourishes by following the curving paths of the dripping paint. Some of those are modes of looking that I feel most strongly when I look at bodies: the caressing motions are certainly bodily, and so is the motion of looking *around* or *along*, since it names the curvilinear motions of the eye that I as-sociate with organic forms, and ultimately with the body. Other kinds of looking, such as the scattered surveys I make of the painting as a whole or the kaleidoscopic feel of its lack of center, do not pertain to the body: they are the more anxious, less rooted kinds of second seeing, in which my eyes rove in search of bodily forms or echoes.

Beyond these five categories, I would not be sure where to go. Would it make sense to say that heat, texture, growth, and hue are body metaphors in the same way as gesture or scale? I believe, as some aestheticians do, that the final source of visual meaning is the body, and so I would have no a priori difficulty in accepting new categories of picture making as signs of the body. But this is not an easy subject, and the relation between the terms is far from clear. The operation of the eye, or of scale, or of position in any given work can quickly pass beyond the power of analysis or de-scriptive language. For that reason, it seems best to remain aware of the multiplicity and nuance of second seeing and of the resourcefulness of the eye in locating body metaphors, rather than attempting to systematize the field into a taxonomy of bodily responses. Part of the skittishness or anx-iety of second seeing may well be due to this exact conceptual disorgani-zation: as we look from object to object in search of bodies that are not there, we also look from metaphor to metaphor, hoping to find one strong enough to rival an actual body in its solidity and permanence.

Representation as Bodily Distortion

With this extended prologue, I arrive at the main subject of this book: an attempt at a general account of the pictured body. Throughout the process

of writing and rewriting these chapters, I have resisted the temptation to frame what I say with philosophic prefaces on topics such as the link between body and representation or the conceptual stability of terms such as "body," "mind," or "picture." It could be argued that such issues form the discursive fields in which "the body" and "the pictured body" gain their meaning, but to the extent that is so, it is also unnecessary to try (once again) to define them as if from the outside. Instead, I have tried to speak as specifically as I can about individual images, in the hope of showing how general philosophic questions might meet the exactitudes of the pictured body. To that end, it has been necessary to find guiding concepts and figures that could operate both as philosophemes and as critical or historical terms capable of describing specific images. The literature is replete with general categories such as the ecstatic, grotesque, recessive, immaterial, or "dys-appearing" body and with broad concepts such as the "denigration of vision," scopophilia, visual culture, and "visibilization," but these terms are more appropriate to surveys of philosophic positions and cultural trends than to individual images.[28] Hybrid concepts that allow historical and critical nuance to play against philosophic clarity are more promising, and I want to introduce a few here as a way of opening the argument of the book.

"Distortion" is such a term: it is connected to philosophic discourse on representation in general, and it is both elemental and specific in body images of all kinds. Claude Gandelman names one aspect of the equation between the represented body and distortion when he says that the "reality of the body *qua repraesentatio* is its essential distortion,"[29] and I would argue that the opposite and correlative aspect is the essential *bodily form* toward which all representation tends. Any representation of a body involves distortion, because all representation is distortion, and conversely, representation works within a logic of the body, so that representation is embodiment: it produces and projects bodies.

Hence I would posit a series of increasingly large domains that might be imagined as concentric circles in a Venn diagram: innermost is pictures, which I am taking throughout this text as a synecdoche for all visual artifacts. Larger than the sum total of visual images are representations of the body, since there are also imaginary representations—representations that are not metaphorically embodied in the outside world but that remain literally embodied in the mind. Outside representations of the body are representations in general, or representations in the philosophic sense, because

there are surely representations that do not involve the body—although I would be less certain that there are representations we would not attempt to read in terms of bodily metaphors. And the largest category, the one I propose to elaborate, is distortion. As a logician would say, even though all representation is distortion, some distortion is not representation—for example, a broken leg does not represent itself—and therefore distortion encompasses all the other categories.

It is common to argue the inevitability of distortion in all representation by appealing to the mathematical problem of projecting or otherwise mapping a sphere onto a plane. No such projection or mapping is possible without distortion, but maps are not simply distorted. Instead, they are distorted in particular ways that are designed to preserve useful properties of the globe. Azimuthal maps retain the sense of direction, equal-area maps preserve areas, and conformal maps preserve angles and certain distances. In the same way, pictures of the body normally work to preserve certain bodily properties so that distortion is usually local and specifiable. The danger is in generalizing, as Gandelman does, and implying that everything in representations of the body is *equally* within the field of distortion. Instead, bodily distortion is both a condition and a property of representation but not the whole of it—and that is what allows the analysis of represented bodies to go forward without turning into an equation of holistic properties: a body's reality *qua repraesentatio* is *some* distortion.

Even more fundamentally, and not at all coincidentally, distortion is an attribute of the body itself prior to representation. We are pressed through the birth canal, we swell to adult proportions, we shrink into old age. Our skin is elastic, and it is relevant that elasticity is the essential nonmathematical metaphor of topology, which has itself become a nonmathematical metaphor for conceptual distortions of all kinds. The skin is not elastic like rubber, but pinched folds do return to place—quickly in younger people, and then more sluggishly, until the skin appears to lose its elastic nature (Figure 6). Skin shrivels, stretches, hangs, and wiggles. When it comes to talk about representing the body, distortion is the inescapable fact. Erwin Panofsky said that perspective causes painters to distort their experience in order to represent it and that representation was the chief purpose of perspective's distortions.[30] Like perspective, the histories of bodily canons and schemata can be seen as distorting moves against the inevitable unrepresentable qualities of bodily experience; and the histories of contrapposto, poses, gestures, physiognomy, and the passions can be read as attempts to

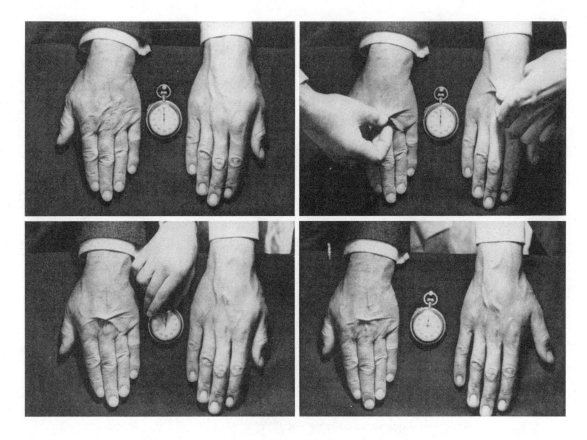

embrace those same experiences while also representing them. The vacillating attitudes toward distortion and the varying urges for and against representation would be a fruitful way to organize the history of the body, and this book could equally have been subtitled "A General Theory of Distortion."

But there are other words that might serve better in place of distortion. The word "distortion" comes from the Latin *torquere*, meaning "to twist," and so the verb "to distort" means "to twist out of shape." Yet not all representation is twisting, specifically. Another term is "deformation," which comes from *forma*, or beauty. The Latin *deformis* means "ugly," and our English word "deformed" also carries this connotation; hence to "deform" is to make ugly. Much of what I will be considering has to do with this boundary between beauty and ugliness, and between what has form in this sense and what does not. These words are related to "disproportion," "distension" (from *distendere*, "to stretch"), "dissolution" (from *solvere*, "to loosen"), "dissection" (from *secare*, "to cut"), "disruption" (from *rumpere*, "to break"), and "disjunction" (from *jungere*, "to join"). "Disfiguration" has

FIGURE 6

Robert Douglas Lockhart. Elasticity of skin contrasted in a man of sixty-eight years (left) and a man of twenty-six years (right). Upper left, at rest; upper right, stretched; lower left, released—skin returns to normal instantly in a man of twenty-six years; lower right, skin in the sixty-eight-year-old man remains wrinkled fifteen seconds later. From Lockhart, *Living Anatomy: A Photographic Atlas of Muscles in Action and Surface Contours* (London: Faber and Faber, 1974), Figs. 203–6.

some resonance in literary criticism, where the term "figure" or "figure of thought" does much more general duty as a near-synonym for "trope"; "disfiguration" is sometimes a good name for what happens in pictures when bodies are divested of their forms by being impressed into noncorporeal objects, dissolved into backgrounds, or shredded by broken light.[31] Just as every occurrence of a linguistic figure is both a usage and a partial effacement or distortion of that figure, so each picture of the body is both a figure and its disfiguration.

Because it has so many forms, "distortion" is not a word that can provide a skeleton key for questions of bodily representation. In the pages that follow, "distortion" will appear as "schematization," "analogy," "anatomy," "dissection," "projection," "inversion," "metaphorization," and many other names. But it is worth stressing the *idea* that a process that can sometimes adequately be called "distortion" is so fundamental, so universal, that it governs representation itself. In its guise as continual motion, distortion is the body's quality of liveness, and it is also the essential property of representation. (And this may be one of the reasons why death, the state without distortion, is not easily susceptible to representation.[32]) The two appearances of distortion (in the body and in pictures) are not at all coincidental, because they speak for the intimate relation between embodiment and representation.

Pain and Metamorphosis

Although words such as "distortion" and "deformation" are indispensable general categories, they lead to an unhelpful formalism. Instead of trying to create a topology of failed representation, I am going to opt for a distinction that employs topology in the service of a description of the bodily effects of bodily representations: the distinction between distortions that are felt and those that are thought. A headache or a broken bone exists in two states: in one, we feel it, and often we cannot think of anything else; and in another, we think of it, and feel nothing. These two possibilities, never entirely separate, are ways in which the self encounters the represented body, including our own body as we sense it and represent it to ourselves. Either something that distorts the body *feels* or it *means*.

"Pain" in this book does not denote aching or throbbing, or even unpleasantness of any sort, but rather the nonverbal experience of sensation as opposed to the cognized memory or analysis or name of sensation.[33] I

choose the word because it makes the confusing passage from somatic re-
flex to analytic reconstruction into a more strongly polarized choice be-
tween soma and psyche. Hence pain is the *general condition of being alive*, a
state of sensation, a sensual monitoring of the body, a care or awareness of
its health and its status, an attention to what are sometimes known as "raw
feels." A neurological concept is close to what I mean here, and that is
"proprioception" (also known as cenesthesia and *tactus intimus*): the body's
internal sense of itself.[34] Proprioception is among the body's fundamental
senses, even though it has not gained the canonical status of the five senses.
When I number the senses that seem independent of one another, I count
at least eight: sight, smell, taste, hearing, and touch, and also gravity (inde-
pendent of the five, since it does not require touch), heat (independent for
the same reason: I do not need to make contact to feel temperature), and
proprioception. This last sense names the way we know how our limbs are
disposed without looking at them or touching them. It is the body's inter-
nal muscular and organic sense of itself. Proprioception is not equivalent
to the sense of touch, since the skin tells us not only about what happens
in the outside world but also, independently and without any act of touch-
ing, something about the disposition of the limbs underneath. In medical
cases in which proprioception disappears, patients report a faint sensation
on the skin (they can feel the wind blowing against it, or the light brush-
ing of objects), but there is a general helplessness about the body. These
patients have to learn to look at their limbs to remain seated or to walk. If
they lose sight of their bodies, then they tend to collapse, so they can only
walk while looking down and they have to learn to sit by the tedious ex-
pedient of memorizing the motions and places of each limb. Grasping ob-
jects is difficult, since it is not easy to monitor the strength of the grip by
eye: either the knuckles grow white, or the object slips from the fingers.

The quality I am calling "pain" certainly has to do with this, although
there is no reason to exclude the senses of touch, heat, balance, or even
smell and taste in the same general category. Pain signifies that mode of
awareness that listens to the body and is aware of its feeling—whether
that feeling is the low-level muttering of a body in good health or the
high pain of illness. Most of the time, in looking at visual art I am con-
cerned with simple things like the feeling of a turn of the head, or an eye
that moves and focuses. "Proprioception" is apt because it denotes feeling
that occurs in the body rather than bodily movements. I may not actually
move in responding to a picture, but I often feel something like moving—

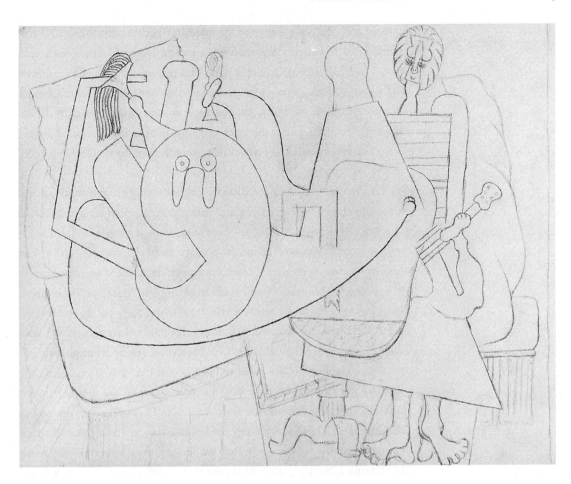

FIGURE 7

Pablo Picasso. *Lying Woman and Guitarist*, summer 1914. Drawing. Paris, Musée Picasso (Zervos VI.1151). © 1997 Estate of Pablo Picasso/Artists Rights Society (ARS), New York.

ing," because I do not know how to place the moments when language begins to be attached to objects of experience. Instead, I will be using a polarity between pain and metamorphosis, for the reason—and it is not at all an easy or apparent connection—that images which do not call forth bodily sensations tend to involve graphic simplifications, rearrangements, and transformations of the body. I do not wince when Picasso turns a face into a flower, as I do sometimes when Francis Bacon turns a head into a bloody stump. Do even the most convoluted and violent of Picasso's creations (Figure 7) make me feel for the represented bodies? I do not think so. Instead, viewing this picture is like solving a puzzle. I see a cascade of hair at the upper left, and I deduce that an arm must be supporting it; I recognize a face at the upper right, and I conclude that it belongs to a lionlike man. Gradually, the pieces fall into place: I see that the woman is holding up a mirror or hairbrush, and then I notice the man's hand on the guitar, his

splayed feet, the long curve of the woman's body terminating in a tiny bundled foot, and two breasts (with hanging shadows) in the form of a face. Gradually I come to understand that this is a picture of a man playing a guitar while a woman listens and brushes her hair. I do not feel much when I encounter such images, because I am too concerned with deducing and decoding, and sometimes also too filled with admiration for the artist's clever inventions—what the sixteenth century would have called *concetti*, or "conceits."[40]

The images that elicit the analytic side of seeing are mostly those that analogize the body, rearranging and substituting its parts for symbolic and allegorical purpose, and otherwise toying with it intellectually. Here a man is a lion, a woman's abdomen is a face, her head is a vacuum cleaner, his arm is a machine part. Those changes are best called metamorphoses, as opposed to the images I will associate with pain. Metamorphosis effortlessly changes the body into that which no living body can be. It is significant, and often unremarked, that in the classical literature metamorphosis is a painless matter. The changes Ovid describes can be an unpleasant experience (Daphne did not want to become a laurel, or Syrinx a reed), but they are not painful (Daphne does not scream when she sees her fingers tightening into twigs, but she feels "numb and heavy"—the opposite of discomfort).[41] The characters cry out because they are being unjustly punished, or else they cry because they are leaving their lovers and the world of humanity. But they do not *feel* their transformations at all, except as impartial observers of the wonder of the moment. Even the most extreme distortions can be painless if they are metamorphoses—a woman into a tree, or a man into a mixture of lion, paper collage, and rubber band.

I think this is an essential fact about the concept of metamorphosis: although it is sensual, it does not present itself as a matter of feeling. The idea of metamorphosis is odd, and it has never been clear to me what attracted Ovid to the theme apart from its poetic and narrative opportunities. But the answer may be connected to the painlessness of it all. Although every metamorphic distortion attracts our bodily sympathy to some degree, and although no painful distortion is without intellectual meaning, the distinction between pain and metamorphosis holds because metamorphosis exists *as an idea*: we have the clear notion that bodies can be either broken or merely metempsychosed, and only one of those possibilities entails pain. In that sense, *Metamorphoses* is a poem of escapes, of demonstrations that transcendence is painless and dazzling.

It might be said that this division is not the only organizational principle for the distortion in bodily representation. A prominent alternative would be the distinction between the organic in all its forms (the round, flexible, soft, wet, warm, asymmetric, and living) and the inorganic in all its forms (the geometric, hard, cold, dry, symmetric, and dead); the two are doppelgängers. Joseph Wood Krutch has written eloquently on the disturbing difference between an ice flower, growing on a frozen windowpane, and the apparently similar frond of a fern.[42] The ice flower is seductive because it looks like it is alive, although it also has the orderly and inevitable aspect of inorganic "death." The organic/inorganic polarity is a generative force in many texts, from the later Socratic dialogues, in which Plato's love of mathematics begins to infect the Socratic moral questioning like an "unliving" virus, to books on chaos theory, in which the newly discovered "chaotic attractors" appear as lifelike patterns found in nonliving nature.[43] If I avoid this way of ordering the text, then it is partly because too much of what happens in visual art is organic and the result would be a lopsided exposition of organicity, but a history of the pictured body could certainly begin with the opposition between life and inorganic "death."

On the other hand, the pain/metamorphosis axis may also be the name of something even older and even more common in the Western conversation on art and visuality. It is, after all, the same problem that has also been written as the mind/body problem, or the difference between language and feeling, or reason and instinctual drive. From Empedocles and Pythagoras to Cambridge Neoplatonism and beyond, the body has been understood as an object mediated by the mind (or the psyche, or soul, or *pneuma*, or logos, or *ratio*). I am content in following that most ingrained of Western constructions and equating or reducing my polarity of pain and metamorphosis to body and mind. I would propose that my only contribution is the idea that reason, when it is transposed into pictures of the body, takes the form of metamorphic change, and that a sense of the body, when it is pictured, becomes a specifiable range of signifiers of sensation.

The Argument Dissected

In this book, I attempt to bring the enabling axis between pain and metamorphosis into a more articulate contact with images by dividing the two realms into six further categories. In doing this, I am less interested in de-

fending a precise classification than I am in saying something orderly and clear enough to be useful and susceptible to critique.[44] The six categories are as follows:

TABLE 2. SIX CATEGORIES OF PICTURED BODIES.

Distortion	Pain	In membranes (the concept of skin)
		As psychomachia (the movements of skin)
		In cut flesh (the tearing of skin)
	Metamorphosis	By looking alone (bodies merely presented)
		By analogy (metaphoric substitutions)
		By schematization (geometric reductions)

By the pain of membranes (which is the subject of Chapter 1), I mean sensation that is evoked by certain ways of picturing the skin. Given its importance in images and in the body, skin is remarkably undertheorized. Questions of visibility, sensation, the dichotomy of inside and outside, smoothness, and identity all depend on skin. Chapter 1 explores the concept of pictured skin, extending it to a general theory of depicted membranes by drawing parallels between psychoanalysis and dermatology. Pictured bodies offer a range of solutions to the problem of skin: at one extreme, there is nothing but skin, and the body is pure visible surface; at the other, there is no skin, and the body is surfaceless flesh. But skin metaphors, or their elision, need to be present in order for represented bodies to be perceived as living or intact figures. That is true whether the artist is especially attracted to the skin (as is Lucian Freud or Matthias Grünewald) or avoids it in such a way as to make it seem that the very idea of skin is being denied (as I'll argue about Jacopo da Pontormo and Michelangelo). Between the two possibilities are artists who use a wide range of metaphors—wax, oil, paper, glue—to imagine the pictorial form of skin, and much of Chapter 1 is aimed at contemporary explorations of visual equivalents for skin and membranes.

Skin is the starting place of this book and the fundamental possibility for images of the body, since it is what is visible before and apart from any further meaning. Psychomachia (discussed in Chapter 2) denotes sensation produced by the sight of *bodily motion*: either in contorted faces (as in the practice of physiognomy) or in bodies that are twisted and turned about themselves (as in the practice of contrapposto). It can be argued that the

fifteenth and sixteenth centuries explored the majority of configurations of the naturalistically conceived human body, and that the Renaissance vocabulary of figural postures has remained in place despite attempts to rescind it by imagining purely frontal or non-Western figures. The same may be said of the abandoned discipline of physiognomy, which is as close as the West came to systematically describing the meaning of expressions. These two moth-eaten disciplines, physiognomy and contrapposto, are the subject of Chapter 2, whose purpose is to demonstrate the richness of their possibilities and the futility of avoiding their histories.

Chapter 1 concerns skin itself, and Chapter 2 explores skin that is put under tension. Last of the three classes in the general category of pain concerns skin that has been cut open, revealing the flesh beneath. Flesh has a different constellation of meanings than skin, some of them involving metaphors of liquidity, as if the body is a bag of skin holding a fluid interior. In general, the invisible inside of the body has been considered too painful to represent, and few artists have made pictures of the opened body. Most of the history of cut flesh, therefore, takes place in medical illustration, and it is the story of an alternation between pictures that attempt to show the inner body in all its bewildering specificity (sometimes revolting, other times dangerously seductive) and those that abstract what is found there in favor of comprehensible portions and simplified views. The incomprehensibility of flesh, and its close proximity with the inconceivability of death, brings the first half of this book to a close.

Metamorphosis, the subject of the second part of this book, belongs to a different world of experience. Metamorphosis "by looking alone," the subject of Chapter 4, concerns the effect of some photographs and other pictures that are not overt rearrangements or distortions of the body (that is, they are perceived as normative in regard to conventions of naturalism) but that at the same time work to change their subjects by turning them into types or specimens. What happens in such images can be as violent as what occurs when the body is willfully twisted or cut. Pornography, sexism, and racism belong here, among the representations that purport to be merely truthful, and I propose a connection between those kinds of images and the simple frontal pose that has long been central to Western picture-making. Pictures such as Botticelli's *Birth of Venus*, Watteau's *Gilles*, and Velázquez's portraits of the Infanta all participate in the same visual field as ethnological photographs used in racial research. The linking concept is the possibility of mere presence—the simple *thereness* of the body, which seems to

need no narrative or other linguistic frame in order to express meaning. That assumption is a dangerous one if only because it puts the image at the mercy of a sometimes rapacious ideological context. The concept of mere presence opens the way to a revaluation of racist and pornographic images, since they become examples of a more general phenomenon—the desire to consolidate our sense of ourselves by comparison with a represented body. I suggest that the daily assessment of our image in the mirror is not different in kind from the comparisons afforded by fine art, by racist imagery, and (in the realm of sexuality) by pornography. Each of these kinds of images can be considered an opportunity for specific acts of self-definition, as well as a sometimes harmful reduction of the body for racist or sexist purposes.

A second strategy that appeals more to the mind than to visceral reaction is "analogic seeing" (discussed in Chapter 5), which denotes representations that create analogies for the body as a whole, or for its parts. Picasso's drawing is an example when it turns a woman's body into a spoon, her head into a whisk broom, her breasts into a leering face, and her left arm into jelly. It seems to me that analogic seeing is more than a formal game or a surrealist strategy and that it underwrites much of our ability to comprehend bodies in general. Chapter 5 opens with a look at the workings of analogy in analytic cubism, arguably the most important and fruitful bodily metamorphosis in modernism; the chapter concludes with an attempt to describe what happens when analogies become difficult to locate and the comprehension of the body itself is in danger. The assembled monsters that populate Greek myths and medieval bestiaries have probably seldom been frightening, perhaps because their obvious principles of assembly (man + horse = centaur) are screens that block out the greater terror, which is that monsters might have *no comprehensible organization*. Bodies of animals found in the ocean abyss, in plankton, in Cambrian fossils, and above all under the microscope provide the closest examples of truly disorderly bodies, where the ability to comprehend by finding analogies fails and the eye is thrown into a kind of confusion I call "visual desperation."

In linguistic terms, Chapter 4 is about the notion that it is possible to merely describe (that is, merely look) at a body, and Chapter 5 concerns metaphoric substitutions. The final chapter completes the possibilities by inquiring into the reduction of writing to bare logic—or in visual terms, the attempt to deny the body its basic organic chaos and to substitute ei-

ther the rigors of geometry or the labels of language. In a way, the rule-less or transgressive body that Mikhail Bakhtin called "grotesque" is the inverted reflection of the linear simplifications that have been imposed by proportional systems from the Egyptians onward. In order to imagine a body as an object that can be adequately represented on a grid, or as a scale of head heights, its grosser functions and shapes have to be repressed, and for that reason the history of bodily schemata can be understood in terms of what the body is not: each grid and scale erases some specific un-thinkable bodily function by confining, repressing, and idealizing it in the name of an impossible perfection. As in the reduction of writing to logic, there will always be an expressive remnant that speaks, sometimes very strongly, about what is not being said. In the course of reviewing the ma-jor systems of bodily schemata, Chapter 6 approaches and finally opens a double question that runs throughout the book: the nature of the unrep-resentable and the inconceivable.

What is unrepresentable might be so because it seems untoward, inap-propriate, or illicit, but it might also be that a bodily form has no graphic equivalent and therefore vanishes from pictures because it is taken to be out of the reach of representation. An eighteenth-century medical illus-trator, for example, might omit the textures of mercury poisoning because he can find no way to represent them in a lithograph. Inconceivability, on the other hand, signifies whatever is utterly absent from the expected forms of the represented body, so that the body might appear complete to a certain set of viewers. Leonardo's figures seemed replete to some of his contemporaries, as if the paintings contained the sum total of Renaissance artistic capabilities as well as a surplus—what Vasari, in another context, called "grace"—but in terms of contemporary art they can seem chained to a set of nearly immobile dogmas about proportion, motion, emotion, light, and texture. It is reasonable to think that Freud's idea that Leonardo fantasized a penis shaken in his mouth would have been inconceivable to the artist, but the concept of inconceivability works outside the assump-tions of metapsychology. Both inconceivability and unrepresentability are names for the necessary omissions—the blank stretches of paper between marks, the gaps and missing portions, the blind spots that the artist doesn't see—and as such they constitute all pictures. I have chosen to let them work quietly throughout the book rather than making them explicit, in order to avoid implying that the entire subject of pictured bodies can be reformulated as a negative question of lack. The unpredictable peculiari-

ONE *Pain*

There it sat

in the projecting angle of the bridge flange

as I stood aghast and looked at it—

in the half-light: shapeless or rather returned

to its original shape, armless, legless,

headless, packed like the pit of a fruit into

that obscure corner—or

a fish to swim against the stream—or

a child in the womb prepared to imitate life,

warding its life against

a birth of awful promise. The music

guards it, a mucus, a film that surrounds it,

a benumbing ink that stains the

sea of our minds—to hold us off—shed

of a shape close as it can get to no shape

—William Carlos Williams[1]

one Membranes

A diffuse pain exists somewhere inside the body. A muscle throbs, or a headache pounds. An entire body, straining under a fever, feels dull and hot. These are the kinds of unlocalized pain that tell us something is wrong with the inside of the body. With the skin, it is different. If I hurt someplace on my skin, then I know exactly where that place is. I can see it, perhaps with the help of a mirror, and search the origin of the pain up to the limits of my vision. Is it even possible to imagine a vague pain of the skin? Sensation on the surface is sharp and well focused. Even if my skin hurts all over—in a severe sunburn, a neuralgia, or an allergic reaction—it also hurts individually in each place.

I would compare this sharp, ocular quality of pain on skin to the sharpness of the way we perceive the beauty of skin. Skin is beautiful, and often skin is what is beautiful. Its beauty is local, like its pain: a wrinkle or a pimple is a brief ugliness, and a flat stretch of skin is a moment of pleasure. A person's skin is not beautiful in a vague way, but by virtue of specific qualities and forms. This pain and this beauty are linked by their exactness.

These thoughts make me wonder if skin isn't the place where all sensation is most precise, or—to invert the equation, in accord with the preeminence and priority of the body itself—if sensation doesn't speak most eloquently using the language of skin. Perhaps the forms and possibilities of skin are the words and the grammar of sensation, and everything else somatic (the viscera, the excreta, food still to be eaten, the disembodied self) is only a smeared reflection, an abjection, or a failing echo, of that primary source. It is interesting how far the optical metaphor takes us in a domain

where there are no eyes: in skin, everything is immediate, bounded, in-stantaneous, and *sharp*. Skin is like the thin plane of perfect focus in an optical system: everything beyond it (outside the body, in the world) and everything in front of it (in the body, in the more-or-less hidden insides) is blurred.

The subject of this first chapter is represented skin in its most general and abstract forms. Given the conceptual disarray of the subject, my pur-pose is not to encompass the field but to set out what I find to be some of the most interesting ideas about skin in philosophy, criticism, medicine, and art history. Skin may be the most sensitive and eloquent signifier of the body, and the organ most aligned with sight, but it is also so poorly de-scribed in the art historical literature that it can appear entirely blank, as if it had no presence and no function other than the nearly empty surface where the viewer's gaze meets the pictured body. On the contrary, it seems to me that skin is so rich in expressive significance and artistic strategies that it is almost bewildering. The purpose of this chapter is to describe some of that meaning.

The Concept of Membranes

It is reasonable to begin by considering the differences between skin and the more general category of membranes. In anatomy, a membrane is any tissue that is spread thin, so that it serves as a boundary. Since a membrane can be considered a barrier or an interpolation between two forms rather than a form in its own right, it becomes the structural analogue of an ab-stract mark in the theory of drawing. Like a mark, a membrane can be a delimiter, a nonspatial division between two adjacent spaces. Just as a con-tour (*contorno*) in drawing is that which separates and defines two forms, two color fields, or two spaces, a membrane in anatomy is that which sep-arates two regions of differing constitution. It may be, therefore, that skin is not a *part* of the body but a condition of its intelligibility, a marker of the oppositional difference between inside and outside, body and world.[2]

"Membrane" is preferable to "skin" for several reasons, not least because skin only separates a living inside from a nonliving outside, whereas mem-branes in general also divide outside from outside, or inside from inside. Another reason is the variety of membranes, each dividing the body in a different manner. (Figure 8 shows a device that decorates the opening page of an eighteenth-century book of medical illustrations; like more ordinary

printers' devices, it encapsulates the author's interests—in this case, the or-
namental display, in a luxurious elephant folio, of the body's surfaces and its
dark interior membranes.) Here as in many other areas, gross anatomy is a
well of metaphors for artistic practice. Where it once seemed that visual art
could make do with just the skin (although that was never the case, as I
will argue later), contemporary art is exploring somatic forms in a much
more thorough and empirical fashion, and the medical distinctions be-
tween membranes have echoes in current practice. Mucous membranes,
for example, are continuous with the skin, providing a covering for orifices
that remain in contact with air such as the bronchial tubes, the nose, the
esophagus, and the intestines. The liminal passages that so fascinated
Jacques Lacan, where familiar skin turns inward to the body, are mostly
transitions from epidermis to mucous membrane—and contrary to La-
can's schematism, they take different forms in each orifice. The vagina
gives way to skin along an irregular, fleshy contour, but the membranes of
the mouth become the epidermis of the lips along an almost linear path.

FIGURE 8

Jan Van Rymsdyk. Printer's
device, showing skin, vessels,
and membranes. From Charles
Nicolas Jenty, *Demostratio uteri
praegnantis mulieris cum foetu ad
partum maturi . . . Abbildung
der Gebähr-Mutter aus einer
schwangeren Frau* (Nuremberg,
1761), opp. pl. 1. Department of
Special Collections, University
of Chicago Library.

Serous and fibrous membranes are skins to internal organs and separate them from various outsides: serous membranes divide internal cavities (the chest and abdomen), and fibrous membranes divide pericardium, muscles and joints, and brain tissues (the dura mater, arachnoid, pia mater, and falx). Membranes are also associated with glands and the fluids they excrete. Mucus and serum are excretions that lubricate the interface between these variously defined insides and outsides. Like sculpture that uses fabrics set in varnish or glossed with oil, membranes are skinlike but also wet and private, and they have the appearance of being sensitive to the touch.

Each kind and example of membrane is different. In cooking, the tough white membranes that have to be picked from the bulbs of kidneys are different from the more weblike membranes that must be soaked and peeled from calves' brains. Fascial sheets are the silvery envelopes that allow muscles to slide by one another in the arms and legs. In strong bodies, these membranes are iridescently beautiful, and in weak and old bodies they are thin, like layers of wet Kleenex. More tenuous webs of connective tissue separate lumps of fat cells from one another, and form bags and drop cloths for fat just under the skin. Pouches and dimples in the skin are the outward signs of these structures. They are not continuous; they branch and divide and do not fully enclose the fat—they are more like hammocks or pockets than closed bags. Connective tissue is a source for webbed and slit constructions by artists such as Robert Morris and for dangling hammocks by Eva Hesse and others. It is also more complex than their works are, since it is unbound by the necessity of answering to traditions of painterly gesture or compositional coherence, and for that reason, connective tissue—like much of gross anatomy—is a persistent challenge to the schematics of organic abstraction.

The closest that critical theory has come to these branching possibilities is Freud's bizarre assertion in *Beyond the Pleasure Principle* that all life aspires toward the simple protoplasmic cell, the irreducible water balloon exemplified by the mouthless, anusless amoeba.[3] To Freud, that desire is a form of the death instinct, the impetus toward self-annihilation: with no arms, viscera, or mind, a body would draw near to its origin in a sperm or an egg. Gilles Deleuze's account of the "body without organs" grows out of and against Freud's account and tends toward questions of cultural restrictions and sadism. In *A Thousand Plateaus*, Deleuze and Félix Guattari discuss the sadomasochistic practice of sewing up the body in order to deprive it of orifices, and they speak of the body's desire to end itself in the

absolute freedom—in their terms, the "deterritorialization"—of a single "level of sensation" instead of the miasma of failing organs that is the human condition.[4] In such ways, the "body without organs" echoes and strengthens Freud's account without relying on the troubled notion of the death drive. In *Francis Bacon: Logique de la sensation*, Deleuze describes Francis Bacon's paintings in the same terms, as if Bacon's figures were nearly unrepresentable, churning, fluid bodies straining to escape through the confining envelope of their skin (or trying to burst the armatures or stages that function as skin metaphors).[5] In Deleuze's account, if Bacon could make a painting of the moment of escape, when the fluid body evacuates itself through its mouth (vomiting into a drain, or screaming), or leaks out into its own pooling shadow, or exits as a froth, or a drip, or a jet of water, then the body would become unrepresentable. In *Portrait of George Dyer Staring at a Blind Cord* (Figure 9), that nearly happens: George Dyer's body spurts in a white splatter and also oozes off into a corner, out of the picture. To Deleuze, Bacon's paintings must always exhibit the same three elements: the fermenting "meat" of the figure, the sharp "circle" that encases it (whether this is literally a circle or an elliptical platform, a railing, a surreal cage, or an airy frame with two flimsy blind cords), and the harshly colored "material substance" that beckons to the figure from beyond its reach. In Bacon, the body without organs is inaccessible, but its possibility is very near. Deleuze's thesis fits Bacon's paintings quite well, and Bacon is said to have admired it. There are also a few—very few—pictures before the twentieth century that might bear out Deleuze's theory. Vicenzo Cartari's image of Lucina is one (see Figure 11), and another is Antoine Wiertz's bizarre painting of a woman who has dismembered her infant for food (she sits with the remains of her child wrapped up on her lap and stares wildly at the soup pot).[6]

Freud's and Deleuze's theories are suggestive, but as acts of imagination they cannot approach the complexity and metaphorical richness that exist in the body's actual membranes, or the varieties of pressure and turbulence in Bacon's paintings. For thinking about the ways that a boundary can divide two regions, I would rather read *Morris's Human Anatomy* than Deleuze and Guattari's *A Thousand Plateaus*. Consider for example the possibility that membranes might become more complex instead of simpler, or that they might fold in, rather than confining the body against a force that threatens to rupture outward. A membrane is something by which we are enfolded: it can be skin, or skin metaphors from underwear and

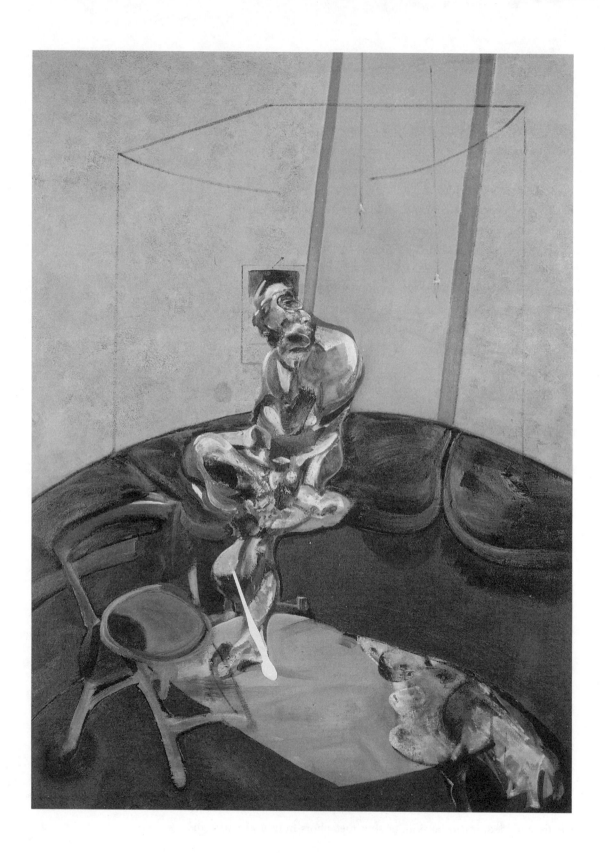

bedsheets to the forms of interior architecture. But membranes also *infold*: they turn inward toward one another, involving, forming skin upon skin, hiding and protecting what is inside. Involvement means "in-turning," and invagination, the standard medical term for any infolding, is a common occurrence in membranes. (In the same way, an irruption is a violent break or tear in an infolding, propelling the contents inward, while an eruption expels contents outward.) The same happens in the mineral world: agates, for example, begin as green silicate skins lining gas cavities in rocks. As time passes, the skin receives an inner lining of clear chalcedony—a second transparent skin, inside the first—and eventually the gas is expelled and the cavity fills with solid agate. In the process, the skin may become infolded, or slough "fragments" and "pendants" that become coated with chalcedony.[7]

As it is with rocks, so it is with the body. One of the difficulties with Deleuze's reading of Bacon is the possibility that his narrative might be reread at any point as a description of bodies, or "circles," that are *imploding*, crushed by the weight of the "material substance" beyond them, rather than leaking outward into it. In the end, and despite Bacon's admiration for Deleuze's book, what happens in any one of Bacon's bodies is more troubled than a single urge. The bodies are specific about their contents—their mixtures of membranes and cartilage, pieces of bone and newspaper, plastic and muscle—and they are exact about their forces—pushing outward, but also infolding, ripping, scraping, and seething without direction. If Deleuze's, Lacan's, and Freud's accounts of the skin fall short when it comes to pictured bodies, then it is on account of the body's sheer complexity.

For the purposes of comparison, the ancient and medieval way of comprehending the body can be described as a science of orifices, since Greek and Christian physicians attended to the number and function of bodily openings before they looked at the skin between those orifices. Psychoanalytic accounts continue in that tradition even where they seek to reduce the concept of orifices to its minimal or essential elements (in the simple protoplasmic cell) or to approach the concept of skin by concentrating on the places where orifices meet the enveloping skin (as in Lacan's descriptions of the liminal forms of eyelids or anuses). The Enlightenment fascination with the skin itself is an important moment in an alternative genealogy, which flowered into recent medical illustration, sculpture, drawing, and painting. For that genealogy, the medical specifics of membranes are

FIGURE 9

Francis Bacon. *Portrait of George Dyer Staring at a Blind Cord*, 1966. New York, private collection. From Lorenza Trucchi, *Francis Bacon*, trans. John Shepley (New York: Harry N. Abrams, 1975), cat. 95.

the most promising and challenging formal and metaphorical source for visualizations of the body.

Inside and Outside

In the normal functioning of visible bodies, skin separates whatever is visible from the parts of ourselves that are hidden. As Albrecht von Haller first pointed out in the eighteenth century, the skin not only divides the inside from the outside but it is also itself divided into an inside "cellular fabric"—the dermis—and an outside "horny fabric"—the epidermis.[8] So the skin is both dividing and divided, at one and the same time inside, outside, and between. The inside/outside dichotomy, with its metaphors of public and private life, intelligibility and opacity, has been explored by Jean Starobinski, in an essay on the Greek polis, and by Angela Zito, in a description of the Chinese body as an "interfacing membrane."[9] Starobinski has also written a book on the anatomy of the body, and he knows that the inside/outside distinction breaks down when it comes to actual bodies (instead of political bodies).[10] "Multicellular organisms," he observes, "rapidly outgrow the homogeneous membrane enveloping them: morula becomes gastrula, the sphere becomes hollow, then forms tubes, orifices, and so forth, so that exchanges with the outside are no longer conglomerately assigned to the entire surface."[11]

The body has orifices; some are stoppered, as the ear is, and some are permanently open, like the nose. Infoldings and outfoldings quickly become too various to sustain the inside/outside polarity. The vagina is an invagination, but anatomy texts also list the umbilical fovea (navel) as an invagination, and it has nothing but thickened skin inside. Foveas are shallow invaginations (other examples are dimples on the cheeks and chin and the coccygeal foveas, which are dimples over the "posterior iliac spines" on the back of the pelvis), but what sets them apart from deeper invaginations? There is also the matter of size, since surfaces like the tongue are covered with deep macroscopic foveas, called "follicular crypts," with serous glands at their bases. (In form, these foveas resemble the serous membranes of the intestines more than skin.) The complement to invaginations are outfoldings, and these are primarily sexual: the labia, clitoris, penis, prepuce, and scrotum. The midcentury Texan artist Forrest Bess was fascinated with such elements of anatomy, both in his art and in himself. His canvases are records of his visions, or hallucinations; they have a per-

sonal repertoire of symbols for such things as "testicles," "hermaphrodite," and "vagina" and for actions including "to cut," "to cut deep," "hole," and "to stretch hole." He put his visions to work on himself, by undergoing an operation that punctured the base of his penis into the urethra, creating a "vagina" large enough to insert a tapered candle (which he used to masturbate). The whole operation, Bess's theory, and the result are documented in an essay in the *Journal of Sex Research*—making Bess possibly the only artist whose genitals have been published in a medical journal.[12] His small paintings, and the small photographs of his penis that he took himself, are equally strange—part of a project that was always nearly hermetic, but also drew on universal ideas of maleness, femaleness, and the way one folds into the other.

Another way to critique the inside/outside dichotomy is to consider the implication of skin in other organs. To say that skin is between inside and outside is to minimize its attachment, its near-identity, with the inside. "Quid me mihi detrahis?" screams Marsyas as he is being flayed, or "Why do you rip me from myself?"[13] Our ambiguous identity with our skin is the principal failing of accounts that imagine clothing as "second skin" or architecture as a projection of both clothing and skin. Both skin and nervous system derive from one of the three embryonic germ plasms, the ectoderm, and the terminal filaments of the nervous system extend into the skin. The spinal cord is farthest inside, protected from the world by the largest number of membranes and tissues, and yet it is intimately connected with the skin, which is closest to the outside. The cardiovascular system seems to deliquesce into the skin, and the majority of its length lies near the skin's surface. Some muscles attach to the skin, and many fascial sheets bond the skin to underlying bone and fascia. Lumps of superficial fat adhere to the skin. As hunters and torturers know, the skin can be easily peeled off the body, but it takes with it parts of other organs. The rare cases of self-castration are poignant in part because the patients' mental states prohibit them from admitting that cutting that skin is inflicting a wound that is more than skin deep. One such patient kept his testicles in a cloth bag clasped to his chest; he called the sack—in a futile gesture of reappropriation—his "money bag."[14]

The more I attend to membranes, to folding and invagination, enclosure and layering, the less certain I become that there is a solid body inside the skin. When anatomists count skin as an organ, it becomes the largest organ of all—and in that sense, skin is not merely a boundary between

what we are and what we are not, but it *is* the body, and we ourselves *are* skin: we are interface, coating, and membrane. (This is the opposite and complementary conclusion to the idea that skin is nothing but a defining boundary, an abstract mark signifying the division of an inside from an outside.) The body as skin is a principal figure in contemporary sculpture made of glass or fiber, where there may not be an inside at all. It has also found resonance beyond the visual arts: Jacques Derrida and others have emphasized this bodiless body by concentrating on the fold (*pli*) instead of what is enfolded; and Pierre Boulez wrote a piece titled *Pli selon pli*, following Mallarmé's image of endless folding.[15]

Whenever it seems more interesting to talk about infolding than enfolding, the nature of the "pocket" becomes a primary concern. Multiple membranes enclose pockets within the body—the heart, the chest, parts of the brain, the joints—and there are so many such pockets that it can again begin to appear that it would be adequate to define the body as a collection of pockets. If I turn a sock inside out, then the area that once enclosed my foot now "encloses" the world, and I have trapped the outside in the inside. For that reason, the world on the other side of the skin can be reimagined as an inverted pocket, analogous to the smaller pockets within the body. The same kind of topological fantasy reveals that pockets leak, so the outside world also continues for a few inches inside the empty sock. A vagina is not only a pocket within a body, lined by a mucous membrane, but also an extension of the world, a small cul-de-sac of the world outside the body. The rectum is similar, and both are narrow at their inner ends— but the vagina closes off completely, while the anus continues in the narrow anal canal and then broadens, turns, and finally empties into the world through the mouth. (Topologically, therefore, it is not a pocket but a tube, and a topologist would say that the body is a doughnut, since it could be deformed into one by broadening the tunnel from anus to mouth.) In this way, the world itself divides into pockets, sacks, tubes, and doughnut-shapes, and there is no topological difference between a shoulder joint, enclosed in its capsule, and its negative space, the entire remaining universe. From the point of view of skin, the world is a series of invaginations and pockets, with no meaningful way to distinguish what is inside from what is outside. We become the folds themselves, and their contents become the world.

This position, anti-Freudian and anti-Deleuzian as it is, has the virtue of explaining why all metaphors of containment must fail. To Deleuze, the

moment of most intense fascination in Bacon's paintings occurs when the body is about to force its way out, to escape from the circle into the blank, inhuman substance of the outside world. To the extent that his reading makes sense of the paintings, it is also a drama *of the skin*: I do not feel for the slurry of illegible strokes and scumbles that constitutes one of Bacon's painted figures, but I do feel for the impending tragedy of failed containment. There are at least four skins in the exemplary paintings: those that wash back and forth "inside" the bodies; the bluish or black contours marking the boundaries of the bodies; the airless space inside the cages, rooms, or armatures; and the cages themselves. Deleuze mentions only the last, but what are the bodies if not mangled and disarranged *surfaces*, sliding, shearing, and piercing one another, in translucent layers and opaque containers? Although I can see the paintings as Deleuze does—as scenes in which bodies, circles, and material grounds exist in precarious tension— I can also look again, and see that beyond those generalized terms there are membranes in varying states of equilibrium and decomposition. The whole Deleuzian drama can be understood as an internal affair, a matter of relations among competing forms of enclosure, rather than between enclosures and that which is enclosed. Instead of the simple protoplasmic cell or the radically deterritorialized body, pictured bodies are frequently not bodies at all, but scenes where we are invited to witness dramas of failed or failing membranes.

I offer these comments as elements of a more reflective definition of skin, but I leave them as a loose collection of thoughts because I do not think that visual art or theory has settled on a way of picturing the skin. Most of the investigations that prompt these ideas are taking place not in philosophy or psychoanalysis, but in contemporary art, where fiber artists and others are making skinlike and clothlike constructions out of a wide variety of materials. In the last five years, I have seen works made of sheets of homemade felt; oilskin stuffed with lint; panty hose dipped in wax; silicone caulk piped into bras; bedsheets painted with vaseline; pigs' hearts coated in salt; wallpaper splattered with tobacco juice, oil of eucalyptus, and camphor; sausage casings filled with dried rabbit skin glue; wet sand in panty hose; condoms soaked in water and filled with tapioca; vaginas made from folds of chewing gum; iridescent mylar painted with liquid light; translucent latex sculptures cast from molded shit; mosquito netting dipped in honey and oil of clove; and untanned hides sewn inside-out. There is increasing interest in making fragments or reminders of the body

out of paper, by weaving and spinning, by producing impermanent and organic sculpture, and even by making film and photographic emulsions. The artists' group known as Art Orienté Objet even made a work from patches of their own skin, which they cultured in a medium, attached to pigskin, and tattooed.[16] The expanding list of materials in works by artists such as Louise Bourgeois, Robert Gober, and Kiki Smith have this one essential property in common: they circle around and eventually return to the concept of skin or membrane.[17] Architecture, fashion design, fiber, and even photography all return to skin. For that reason, it is crucially important both to open this wider discourse on skin and to avoid closing it into some restrictive metaphoric domain.

Expressive Dermatology

The skin communicates between the body and the outside world in a variety of ways, serving as an intermediary, an interface, between the two realms. In the jargon of biology, it functions as a semipermeable osmotic membrane, exchanging air and fluids with the outside in accord with laws of partial pressure. Normally, we think of losing substances through the skin, such as sweat or blood, but we also gain substances: poisons seep into our bones, and the body gains a little weight each time we bathe. (Bathing is the only way of gaining weight without eating or drinking.) Those are communications outside of any mental state: they happen according to physical laws. The skin also communicates by representing states of the body and mind to the outside world. It is a conduit, and it is also a writing surface on which the body's thoughts are inscribed.

Sometimes this is literally true, as in hysterical dermography (in which the slightest touch of the doctor's finger makes the patient's skin swell and redden) and when animal hides are used as parchment; in those cases, the skin is written on from the outside, as if it were paper. James Joyce's *Finnegans Wake* contains a scene of unsurpassable density in which Shem "the Penman" turns his own body into a parchment, writing all over himself with an ink made partly from his own shit. Once he has made the ink, the flow of words continues without stopping: "the first to last alshemist wrote over every square inch of the only foolscap available, his own body, till by its corrosive sublimation one continuous present tense integument slowly unfolded all marryvoising moodmoulded cyclewheeling history."[18] Since Shem wrote with ink made of shit, he must have had an anus, and eyes to

see and hands to mix his ink, but his body became an endless continuous scroll that filled with words and "waned chagreenold and doriangrayer in its dudhud." Joyce may have thought of the puckered, furrowed bodies of nineteenth-century Maoris, where the tattooing was so intense and protracted that it made the skin into a relief map; or he may have known the Japanese custom of dense black tattoos, where the skin becomes a shining dark pelt; or he may just have been remembering fusty manuscripts like the *Book of Kells*.[19] Still, Shem went farther than any tattoo: he took his ink from himself, and he molted, or molded, into the interminable "radiooscillating epipistle" that is *Finnegans Wake*. In other words, he *became* writing.

The body can also write on the skin *from the inside*—the soul, the mind, and the passions rise to the surface in boils, blushes, and rashes, and the invisible inside speaks by writing from the other side of the page.[20] This raises the very large question of how the skin communicates the self. In the face, the skin becomes expressive by moving—the subject of Chapter 2. But elsewhere, and even on a motionless face, skin is expressive without moving. The dried skin of an old man tells his age and the work he has done. A pallor reveals conturbation or fright. Smooth skin means youth and beauty, and perhaps also naïveté or privilege. In considering the ways skin reveals beauty, health, age, and disease, it is important not to lose sight of the fact that there may be no way to separate those terms. The flush of embarrassment might also be the first sign of fever, and the itchy skin of an allergy might be due to pollen, or to anxiety, or both. When the skin becomes the paper for a text written by the body, the words are going to be ambiguous, and no statement will have a single meaning.

In contemporary culture, skin conditions are taken to be literally and figuratively superficial. They are not as serious or frightening as the unseen progress of pathologies of the viscera, the brain, or the bones. But that has not always been the case, and an interesting way to open the question of how skin conveys meaning is to consider cultures that have taken skin conditions as the most serious afflictions of all. The ancient Israelites, as they are recorded in the book of Leviticus, are such a case, and Babylonian and Assyrian liver divination is another. In the latter, the surfaces of sheep's livers were what mattered, and priests performing sacrifices watched for the patterns formed by the "subsidiary ducts and veins" on the smooth hepatic membrane (the method was later named hepatoscopy, the observation of the liver).[21] Clay models of sheep livers, marked for divination, show the close attention that was once paid to faint traces in the rich velvet skin of

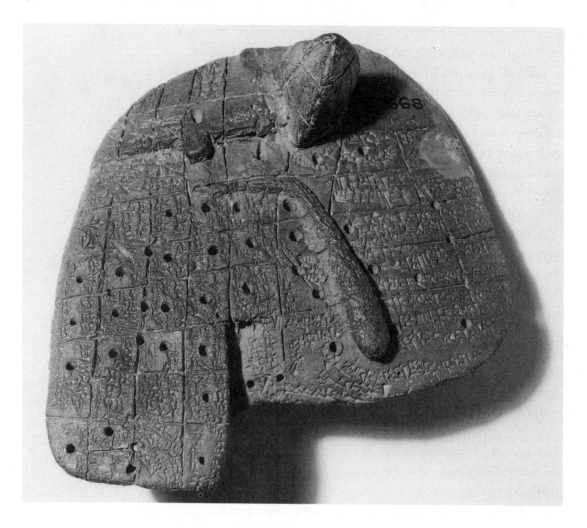

FIGURE 10

Clay model of a sheep liver, marked for divination. British Museum Bu. 89-4-26, 238. From Alfred Boissier, *Mantique Babylonienne et mantique Hittite* (Paris: Librairie Orientaliste Paul Geuthner, 1935), pl. 1. © British Museum.

the liver (Figure 10). In this example, the cells give various prognostications: "I will besiege the enemy city, but I will not capture the people within it"; "The goddess Ninkarrak says: 'The army of the enemy is in ruins'"; "The enemy has seized the border city."[22] Today it can be difficult to recapture the alarm that a misshapen membrane could provoke. It helps to think of Nietzsche's reading of the Greek interest in surfaces and superficial signs: they were always taken with an awareness of the depth that lay beneath.

It is instructive to watch how people obsessed with skin describe what they see. Leviticus 13 is a case in point: it details the clinical procedure for those suspected of having malignant skin diseases. When a man has "a discoloration on the skin of his body, a pustule or an inflammation," he has to

go before a priest to see whether it might become malignant. A positive diagnosis means that the man is pronounced ritually unclean, and a suspect case calls for quarantine and reexamination. A sore that fades is considered to be "only a scab," and a man can be pronounced clean by simply washing his clothes. Uncleanliness is declared whenever the hairs have turned white, or the inflammation is "deeper than the skin," or there is "raw flesh." When a fester or a burn has healed but is followed by a "white mark or reddish-white inflammation" (in modern terms, an infection), the priest looks to distinguish between a malignant disease and a scab or scar. The author of Leviticus also recognizes "dull-white leprosy" and two skin diseases common to the neck and head, causing the hair to fall out or turn yellow. The passage concludes with the molds and stains that affect the skins and other garments that people wear.[23]

A person who is pronounced ritually unclean on account of a malignant skin disease has to live outside the settlement, tear his clothes, "leave his hair dishevelled, conceal his upper lip, and cry, 'Unclean, unclean.'" These strictures are discussed in the sixth and final division of the Mishnah, Tohoroth ("uncleanliness"), in the tractate Negaim ("leprosy signs"). The rabbis debate the colors that have been given as diagnostic signs in Leviticus: they discuss shades of white that are like snow, like lime, like the "skin in an egg," and like white wool. When red is mixed with white, they say, it might be the color of snow in wine, or blood in milk. One rabbi concludes that there are sixteen colors of leprosy; another says thirty-six, and a third, seventy-two. There are also problems of race: "In a German the Bright Spot appears as dull white, and in an Ethiopian what is dull white appears as bright white. The Children of Israel . . . are like boxwood, neither black nor white." The solution, according to one rabbi, is to provide an intermediate color against which the hue can be better judged, and his comment leads to one of the rare mentions of painting in the Mishnah: "Painters have colours to depict figures in black and white and in intermediate shades. A man should bring paint of an intermediate shade and paint around the leprosy sign, so that it will appear as if it was on the skin of someone with an intermediate shade of skin."[24] The body itself—its sturdiness, its basic health, its shape—is not an issue. The rabbis discuss such matters as how a priest could still dab ritual blood on a man's thumb, nose, and toes if he had no thumb, nose, or toes ("the blood may be put in the place where they were").[25] What concerns them is not gross deformation, or what we call race, but tiny signs on the skin, shades of color and shapes of spots.

As opposed to biblical and rabbinical thinking, modern medicine attempts a close description of symptoms by means of prose bristling with neologisms. The difference may be more than grammatical. The Enlightenment historian Jean-Jacques Paulet noted the lack of words in Greek and Latin to describe smallpox, and he concluded that the ancients hadn't suffered from the disease, but it is just as likely that Greeks and Romans thought differently about the skin, and saw different things in it. It appears probable that the Greeks and Romans were afflicted with smallpox but did not see it as Enlightenment and modern observers do. Conversely, if "cutaneous pathology was the heart of darkness of the Enlightenment," as Barbara Stafford has said, it might be on account of a renewed ability to see the skin's forms rather than a shift in the definitions of disease.[26]

In modern terminology, things are again much more precise, as they were for the rabbinical scholars. Skin "lesions," which in the vernacular denote ulcers, boils, pustules, and other breaks in the surface of the skin, signify "circumscribed pathological alteration" of tissue. "Benign pigmented lesions" include those forms that are known as liver spots, warts, freckles, and moles; and modern dermatology works with a still more specific vocabulary when it distinguishes "simple lentigines" from "nevi" of various sorts and "seborrheic keratoses." These are all names for pigmented lesions, but they are objects of special attention because it is not always possible to distinguish them from the early stages of cancerous lesions. Dermatologists have tried to sharpen their ability to distinguish precancerous from benign lesions by using hybrid terms that are partly definitions of types and partly descriptions of qualities. The words they use include "macular" (spotted), "reticular" (netlike), "smooth," "jagged," "sharply defined," "verrucose" (wartlike), and "papular" (pimply). Typically, such terms are insufficient, and they are augmented by color photographs, measurements, and clinical judgments.[27]

Both the Mishnah and contemporary Western oncological dermatology are examples of attempts to pay close attention to skin. But even after almost twenty centuries, the choice between a nevus or a lentigo is little better defined than the choice between a white egg skin or powdered lime skin. At issue in both lexica is the boundary between two very different physiological states: in modern terminology, for example, the choice might be between dysplastic or malignant nevi and those that are congenital or benign. The difference is a harsh one—malignant cancer or harmless discoloration—but the signs of the difference are dangerously blurred.

Like the appliqué patches popular in the Baroque, skin signs can denote beauty or the hidden presence of a secondary syphilitic lesion; they can mean expulsion from the community or purification and acceptance. Marks on the skin tend to inhabit this area of uncertain significance: either they are harmless (and even beautiful) ornaments, or else they are marks of corruption and death, and the difference often comes down to the most elusive questions of color and form. Is the patch the color of wine? Or of wine with a little milk? Does it have a very irregular border, or only a slightly irregular one? Is it a beauty mark, or a mark of death?[28] Unlike linguistic signs, skin signs are finely balanced and sometimes excruciatingly difficult to read—and the penalty for not reading them can be high.

Still, might it not be the case that some skin conditions speak an intelligible language—that they denote something more than health or disease? Part of our inheritance from the Enlightenment is an understanding of the skin as a sensitive and versatile expressive organ. Dermatology and neurology both began in the Enlightenment, and the history of dermatology has always been entwined with the semiology of the soul.[29] In the language of the eighteenth century, the skin was a "cushion," touched from beneath by a delicate webbing of "sensitive" and "irritable" nerve fibers. To Robert Whytt, children had "moist" nervous systems and "tender nerves and fibers."[30] (For Plato, on the other hand, the skin was just "felting," laid on to protect the innards.[31]) In the mid-eighteenth century, the French Academy promoted a kind of drawing based on a smooth, delicately managed touch, and some of the more accomplished academic nude studies of this period evoke a sense of smooth touching.[32] Enlightenment literature about physiological perception was centered on the question of nervous sensation, irritation, and pain (*sensibilité, irritabilité, douleur*), and the ugly vivisections and tortures (cutting the tendons of dogs, painting them with acid and butter of antimony, burning them) were aimed at determining which tissues felt pain and which did not. The debates centered on the proper identification of insensate tissues (including cartilage, tendon, joint capsules, the dura mater around the brain and spinal cord, and the pleura) since it was agreed that pain, irritability, and sensation all reach their apex in the skin.[33]

In our own century, the skin is still occasionally taken as a transparent text for both soul and body. We still think of the skin's "irritability," and we retain eighteenth-century thoughts in phrases such as "thin-skinned."

Blushing, pallor, piloerector reflex (gooseflesh), hyperhydriosis (clammy skin), and itching have been associated specifically with embarrassment, anger, fear, anxiety, and disgust.[34] According to one twentieth-century author, S. H. Zaidens, "eczemas, urticarias, seborrheas, exudative lichenoid and discoid dermatoses" are related to specific emotions. At times, it makes sense to read "rubbing or scratching of the skin, fondling, tugging and pulling of the hair, eyebrows, eyelashes, nail-biting, and thumb-sucking" as compulsive substitutes for infantile oral gratification, although a consensus of contemporary physicians would not agree that the scurf, or "thickened scaly skin," of psoriasis occurs in patients who have feelings of vulnerability, immaturity, or failure or that "erythametous, weepy lesions" occur in patients who "strike out at psychologic disturbances." Yet to writers such as Zaidens, the skin remains an encyclopedically resourceful expressive organ, capable of expressing:

> self punishment, self-denial, self-castration and self-destruction as expressed in neurotic excoriations and trichotillomania [obsessive hair-pulling]; exhibitionism and self-pity as seen in dermatitis artefacta; auto-eroticism, displaced sexual discharge or just plain release of nervous tension as seen in some of the pruritides; feeling of sexual contamination and infestation as witnessed in the paranoia of acarophobia; guilt and self-punishment as witnessed in neurotic excoriations, syphilophobia, herpes simplex and herpes progenitalis; [and] projection of hostility and aggression as represented in neurotic excoriations.[35]

There is always the temptation to understand the skin as a parchment, and to read skin discolorations and lesions as if they were the characters in some native somatic script. Patients who suffer delusions of worms or "threadlike insects" crawling on their skin, or who manufacture expressive dermatological conditions by rubbing or picking at their skin (*dermatitis factitia*), or who obsessively pick at "little islands of epithelial debris, . . . stubby hairs, acne lesions, milia" and "crusts," are only the pathological correlates of everyone's concern with the state of the skin as a sign for inner health.[36]

The skin, as we see it, uses the outside world to help it express what needs to be said. There is no way around that intuition, and so the question is less how it can be critiqued than how we negotiate it in any given case. How do we want to say the skin communicates? What kinds of truths do we want to allow it to express? Under what conditions does it make sense to take it as a divinatory text or a mark of the soul? If I say a

rash is psychosomatic, then I betray how poorly I have thought out these issues, since the word conjoins the psyche and the soma and ends up assigning the trait to nothing in particular. It would be clearer to say "psychic" and "somatic" separately, and to distinguish both of them from something inhuman, like a pathogen. In that way, we could begin to see that we often assume the skin has three languages: it can show signs of the mind, of the chemical and organic body, and of the presence of toxins or pathogens; and often, the three scripts can be read one on top of another, like a palimpsest. We maintain those distinctions, I would say, but the skin blurs them—and that is one of the reasons expressive dermatology can be at once compelling and defective as a language.

Excursus on Horror

These are by their nature unpleasant subjects, and I will be evoking questions of revulsion, disgust, and horror throughout this book, but also keeping them to one side of the principal arguments. It is an important fact that doctors and medical illustrators soon lose their squeamishness; for them, images of the body take on more nuanced meanings. It is possible, in other words, to get over the reflexive recoil that some images provoke and begin to see other expressive possibilities. That will be an important possibility later in the book, when I consider pornographic and racist images, because I will want to say that images can be expressive *independently* of their most apparent political and ideological charge. A large percentage of all images of the body remain unexplored because they seem too strong—too bloody, disturbing, violent, or painful—but those same images can also be compelling for reasons that remain hidden as long as their unfamiliarity continues to call forth what are unhelpfully called "visceral" reactions. I have put some "disturbing" images in this book so that they can be available long enough to begin to reveal the ways they work.

Pain pales and thought takes its place—and that is also why I am not entertaining Julia Kristeva's wonderful idea that the Israelite interest in leprosy was caused by an unconscious horror of the useless remains of the afterbirth. In Kristeva's account, the refusal of the memory of the clinging useless placenta is replaced by the notion of self-generation, so that "the subject gives birth to himself by fantasizing his own bowels as the precious fetus of which he is to be delivered; and yet it is an abject fetus" because

the bowels are an abomination, "devouring, and intolerable." She concludes that "the obsession of the leprous and decaying body would thus be the fantasy of a self-rebirth on the part of the subject who has not introjected his mother but has incorporated a devouring mother."[37] Aside from the interpretive problems of tying the description of such a general phenomenon as the expressive skin to the specifics of a psychoanalytic program, there is also the question of whether the best approach here is to emphasize horror and the "abject." In order for the theory of abjection to have a purchase, the final terms of the accounts in Leviticus and in the Mishnah would have to be revulsion, expulsion, contamination, and impurity. But there are too many other ways of looking at the forms of unhealthy skin to make that a workable theory—even the Mishnah goes into much more detail than Kristeva acknowledges. There is also fascination with the skin, its colors and textures, its variety, and the difficulty of its semiotics. Although I am wary of Kristeva's theory in this case, where the issue seems to be more a question of reading than revulsion, I make use of it in other settings throughout this book. The "abject"—roughly, whatever is despised, rejected, expelled, but also *our own*, from nail clippings to excrement—is a fundamental condition of the body and its representation, even if horror is not always its proper name. (It is also the case that Kristeva opposes abjection to Freud's notion of the uncanny and Lacan's *objet petit a*, even though all three concepts are closely related, and even though they offer ways around the exclusive identification with horror.)

If abjection fits visual practice, then it is the "perverse" contemporary sense that the *disiecta membra* of the body can have religious or sacred meaning. Heterology, the study of unrecuperable violations in bodily unity, has become one of the last remaining sites of the spiritual in recent images. Annette Michelson describes the heresy of heterology in terms of excretion, including even laughter as a form of excrement, since we lose something of ourselves when we laugh: "Thus death and decay in their diverse aspects and figures, the body's excreta (tears, sweat, shit, blood, and menstrual blood), those substances cast off, excluded, hedged around with silence and interdiction, partake of the sacred. And manifestly, as well, those states of loss of self work now in rage, laughter, orgy and sacrifice."[38] This form of abjection, stressing the equation between utter rejection and the sacred, provides a useful frame for reading Kristeva's text and for understanding its affinity with contemporary art, from "sacred" Venus-of-Willendorf pastiches to Joel-Peter Witkin's very serious and very personal sense of the sa-

cred.[39] But the strength of the concept of abjection is also a limitation, because the very instability of the semiotics of the skin undermines a purposive identification with either horror or spirituality.

Minimal Requirements for Skin

So little has been written about skin outside of the specialized medical literature that it might be worthwhile to try to sketch the outlines of a general account of pictured skin. In a minimal sense, and speaking only of pictures and not of other experiences of the body, skin is a surface with certain properties of uniformity and continuous transition. In order to appear as skin (or as a metaphor for skin), a depicted surface has to be fairly uniform in color—either light or dark, but not a mottled combination of the two. The proof of this kind of general assertion, insofar as it is susceptible to justification at all, is that cases of mottled skin have historically attracted attention as unclassifiable phenomena. The eighteenth-century physician Pieter Camper wrote a book on the colors of Negroes, positing that Adam and Eve might have been black; but if so, he adds, they might also have changed slowly until their skin was more fair.[40] To Camper, that kind of transition makes sense, but the *simultaneous* existence of black and white is a problem. Dutch women, he writes, sometimes have black eyelids and black tongues when they are pregnant, but these are unusual examples. In general, the eighteenth century was fascinated and repelled by cases of mottled coloration, and in the nineteenth century those conditions were among the first to be photographed and printed in hand-colored editions.[41] The oppressive wax models in the Musée de l'Hôpital Saint-Louis in Paris, and the detailed investigations by Marie-Jean-Pierre Flourens, are signs of the exquisite attention that was given to the smoothness of skin in the first half of the nineteenth century (see Figure 47).[42]

If unified or uniformly changing color is one property of skin, then the same might be said of texture. Skin can be consistently wrinkled, flabby, or even scabbed, but it is difficult to assimilate a collection of variegated textures under the concept of skin. The abrupt changes in texture that mark neurofibromatosis make it especially incoherent as a skin condition.[43] In one place, the skin is normal, and in another it is a hard excrescence; then again it is flaccid, and then suddenly pockmarked. Yet in general, we subsume under the name "skin" a very broad variety of different

textures, from the downiest pink infant's flesh to the crusted calluses of an adult's foot. This specificity is one of the limitations of Merleau-Ponty's interest in skin as a reciprocal touching. In his account, the sense of skin— and finally, the sense of the body itself, as "flesh"—depends on the am- biguous near-identity of toucher and touched. If I touch my right hand to my left, then I sense an impending confusion between the finger that de- scends and the palm that receives it, which is itself the indispensable prop- erty of touching in general. The two vacillate and nearly intersect, trading identities in a chiasmatic fashion.

Yet it might be asked how far this doctrine of chiasmus, or reversibil- ity, which Merleau-Ponty took as a central idea, depends on the example of touching the self, and even touching corresponding portions of the self.[44] Skin is so various that the experience is more often a question of measuring difference, and what I experience is a *range of differences* that al- lows me to see or feel skin.[45] Touching my palm, or seeing pictured skin that can remind me of that experience, may not be the definitional mo- ment of touching but its zero point, the identity from which difference arises. The question in this context would then be what counts, in visual experience, as skin, and how much the smoothness or sameness of skin is necessary for it to exist as skin. (Perhaps, instead of trying to define con- cepts such as "skin" or "touching" only by reference to skin, it would be helpful to think of many other kinds of textures, such as those described in the book *Surfaces*, a materials science text that presents an array of im- plied tactile experiences that go far beyond the human. Books like *Sur- faces* help skin emerge more clearly in its specific ranges of hardness and smoothness.[46])

The limit of smoothness is well shown in a plate in Vicenzo Cartari's *Imagini de gli dei delli antichi* (Figure 11), depicting Lucina, the patron god- dess of childbirth, under the moist influence of the moon.[47] Her limbless body, open only at the bottom, is an image of the womb, and in partial ac- cord with Kristeva's intuition, her body beneath the sheet becomes her own fetus. As a woman, and especially as a woman engaged in gestation and parturition, she does not need a head, mouth, eyes, or even the ability to speak or gesture. Her body becomes an undifferentiated lump, a prim- itive embryo, a limbless sack, like the frightening (and more genuinely ab- ject) body-sack that William Carlos Williams met under a bridge (see the epigraph to this chapter). This is skin as it is rarely shown, as the envelop- ing condition of life: continuous, smooth, and moist. It is detachable (soon

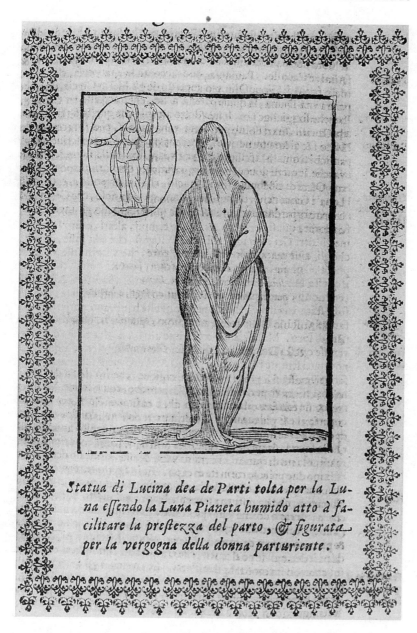

Statua di Lucina dea de Parti tolta per la Luna essendo la Luna Pianeta humido atto à facilitare la prestezza del parto, & figurata per la vergogna della donna parturiente.

FIGURE 11

Lucina, the goddess of child-birth. From Vicenzo Cartari, *Imagini de gli dei delli antichi* (Padua: Pietro Paolo Tozzi, 1626), p. 93. Department of Special Collections, University of Chicago Library.

the fetus will emerge and throw off its drape) and also essential (since Lucina's "skin" stands for a nourishing and protecting membrane): a more profound instance of parergonal forms than the clothed statue mentioned in Kant's third critique.[48] An opposite to this dream—or nightmare—of perfect smoothness, and one of the most troubled depictions of skin, is Lucian Freud's practice of letting small knobs of paint accumulate over the

FIGURE 12

Lucian Freud. *Leigh in Stripes*,
1993. Oil on canvas. Private
collection, photograph courtesy
of Acquavella Contemporary
Art, Inc.

surfaces of his figures (Figure 12).[49] The effect comes from working over
areas that are half-dried so that the skin of paint, together with whatever
dirt clings to it, is torn from its place and rolled along with the brush. Very
dirty skin, such as a child's unwashed back, can be peeled and rolled in this
way, and it also evokes old furniture—for example, the arms of old
chairs—where constant touching has left a dense layer of sticky wax that
can be rubbed with a dry cloth into little pills. In Freud's paintings, the
areas where those bulbs of paint accumulate contrast against relatively
smooth, and even shiny passages, creating an unusually variegated skin.
When it doesn't work, we might prefer not to continue seeing it as skin

and regard it instead as an artifical construction—a sign of the work of painting, or of the sometimes unaccountable intensity of Freud's reactions to skin. His textures are also deliberately ill-matched to their subjects: the verrucose texture is fitting where the subject is an old man or woman, or an unusually ugly model, but in most cases his chosen textures jar against the more naturalistic elements of the paintings, creating a disjunction that helps pry the appearance of the paint away from the specific skin it would ordinarily be meant to depict. In terms of the metaphorology of skin, Freud's practice is on the boundary line between a painted surface we might accept as skin and one that varies too widely, in texture as well as color, to represent skin according to the standards of naturalism that are set elsewhere in the same paintings (in the floors, the sofas, the drapes, and the chairs, all of which are better behaved, and less intensely seen, than the skin of his models).

Skin is also something that must not vary too much in its degree of tension. If the skin is loose and fatty, then we expect it to be so more or less uniformly throughout the body. Artists such as Ivan Albright who experiment with skin that is alternately tight and flaccid also push up against the limits of the concept of skin—both Freud's and Albright's figures sometimes appear to be clothed in something other than skin. Albright's pocked and flaking surfaces are alternately chitinous, desiccated, flabby, and decrepit, and they make sense as skin only from a distance, or as a metaphor of decay. Even in uniformity, however, there are limits, and extremely loose skin textures might not be recognizable as skin (Figure 13), just as excessively "wired" bodies begin to seem mechanical or otherwise inhuman.[50]

A fourth criterion has to do with topological complexity: we expect skin to be moderately complex, with a numerable set of kinds of invaginations and outfoldings. Normal epidermis has four kinds of invaginated folds: ordinary skin folds (the results of flexed limbs and torsos), skin creases (the smaller folds that gather around skin folds, as on the flexed wrist where skin compresses on the forearm), wrinkles (these are still smaller and are caused by dryness and age), and the macroscopic lines on the scale of fingerprint ridges that cover the entire surface of the body. If any of these elements become too predominant, then the skin may cease to appear as skin. The case of the "monstrously fat" woman, Catherine C., shows the peculiar difficulty posed by topological complexity. Her navel and pubic fat have more to do with knotted wood than with skin, and her

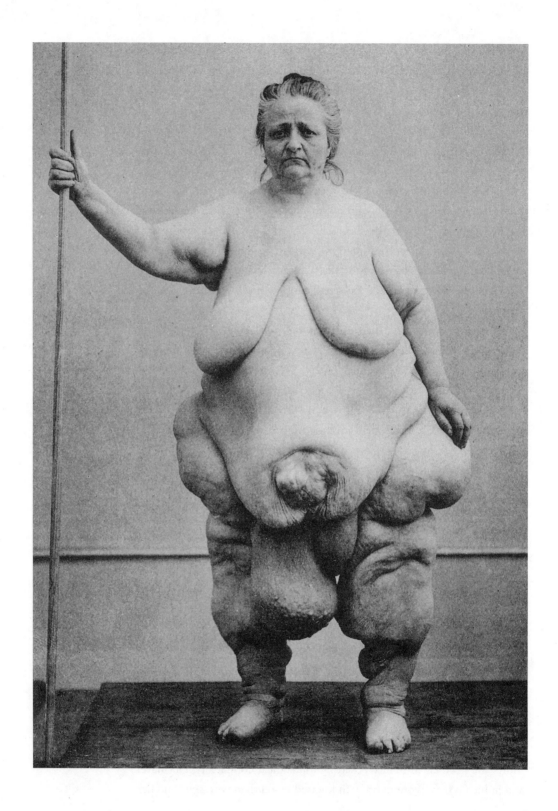

legs look like congealed lava flows. On the other end of the scale, an un-
usually featureless smooth body might also look unnatural—as if it were
the effect of airbrushing, or plastic surgery, or burn reconstruction. The
"Lindow Man," who was found in a bog near Wilmslow, Cheshire, in En-
gland, is so severely wrinkled and compressed that it is hard to see his skin
as skin—it looks like rotting leather. Even so, scientific studies have man-
aged to smooth him out (there is even a Lindow Man "topographic map,"
with numbered contours like a conventional map), and then it is easy to
comprehend the skin and what remains of the flesh.[51]

And finally, skin also has to be a continuous surface, unbroken except
for orifices. There is some evidence that one of the original etymological
senses of "skin" was "cut," perhaps because of the association between an-
imal hides and human skin. An old Irish word for "skin," *cneas*, is related
to the Irish *cnead*, "wound," and similar examples can be cited in other
languages, with words such as "tear," "scrape," "rub," and "cut" clustering
around words for "skin" and "hide."[52] Since canvas and paper are often
implicit skin metaphors, when they are cut the reference to skin can be-
come explicit. Leon Golub's paintings of monumental figures raise the
question of skin by their unusual technique (he sometimes dissolves part
of the paint with a solvent and then scrapes the images with an eight-inch
meat cleaver), and the reference to skin becomes more forceful when he
cuts the canvas itself, so that the picture becomes a "skin hanging on a
wall."[53] In general, a cut or opened surface can be presented as skin, but
in the normal state of affairs even the smallest abrasion will take the im-
age out of the normal roster of representations of the body and place it
within the special class of images that signifies pain or death, and because
of that change in signification I reserve such images for Chapter 3.

These four criteria of reasonably uniform color, texture, tension, and
topological complexity are just barely specific enough to serve as elements
of a description of the concept of visible skin. They are sufficiently narrow
to exclude some other kinds of objects—they would not apply, for exam-
ple, to the color changes common in the sky, to the uniform hardness of
china, or to the value scale typical of water—but I am not presenting the
four criteria as an empirical definition. Instead I mean them as elements
of a working awareness of what pictured skin is. As we consider some ex-
amples of skin from earlier Western painting and drawing, I want to note
the ubiquity of these qualities and the conceptual cost of transgressing
them.

FIGURE 13

The patient Catherine C.,
a "monstrously fat" woman.
From Dartigues and Bonneau
[no initials given], "Lipomatose
monstrueuse, principalement
localisée a la partie sous-
diaphragmatique," *Nouvelle
Iconographie de la Salpêtrière* 12
(1899): 216–18, pl. 31, opp.
p. 216.

The Unimagined Skin: Marble, Lacquer, Animal Hide, Jelly, Ointment

In many ways, the Western tradition of depicted skin begins with what Heinrich Wölfflin called the "Latin Renaissance," during which skin was often signified *as an absence*. By way of describing the relative lack of Renaissance interest in skin folds, dimples, softness and hardness, hairs and pores, translucent veins, white knuckles, and the entire catalogue of visual forms specific to skin, scholars usually point to the emulation of Greco-Roman sculpture. The paintless statues and reliefs, it is said, corresponded to Christian thoughts of the ideal bodies and skins that would be donned in heaven, so that marmoreal textures were natural candidates for expressing the new amalgam of Catholic doctrine and recovered antiquity. Still, the fact that more can be said is evident from the *different* ways Renaissance artists negotiated that ideal: skin surfaces in Michelangelo's paintings (and especially in the *Doni tondo*) *strenuously* deny the palpable texture of skin or the difference between skin and smoothened rock or finely woven fabric (Figure 14).[54] Sculptures such as the rough-hewn back of the *Giorno* in the Medici tombs can seem to be flayed, so that the marble represents a stony idea of the body rather than its normal succession of organs. In Raphael, skin is not so much denied as refigured in terms of very fine, even brushmarks that derive from the late medieval drawing practice known as "iron filing" marks. They make the skin look like a closely combed or petted surface—a soft, warm, inviting *animal* surface of the kind that Hermann Rorschach imagined in the dense ink spills of his cards, rather than anything strictly human.[55]

Bronzino, famous for representing skin in terms of cold stone, actually does something more complex: his surfaces are both slick and frozen, like aspic on chilled fish, or thickened animal glue spread on stone (Figure 15).[56] A close look at his most labored figures reveals that when he has the time and the interest, his way of avoiding skin takes him away from metaphors of marble or ice and toward oil glaze, tacky resin, or shellac—the skin is not so much petrified as embalmed, encased in a brittle or viscous second skin. Sometimes the lacquered faces evoke—I think intentionally—the divine tegument that all souls will wear at the second coming, and other times their resinous surfaces refer to the medium itself, pushing the figures that much farther from any obvious reality and making them into brilliant conceits, painted representations of figures made from paint. In cases like

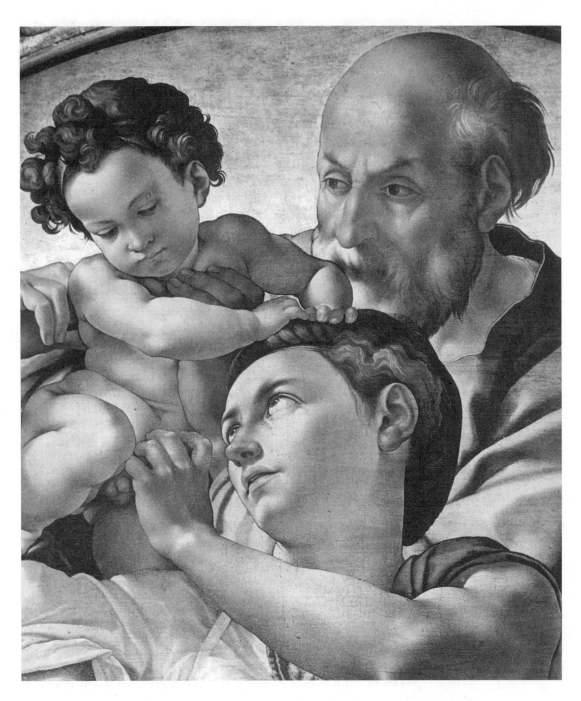

FIGURE 14

Michelangelo. *Doni tondo*,
detail, 1504. Tempura on panel.
Florence, Uffizi.

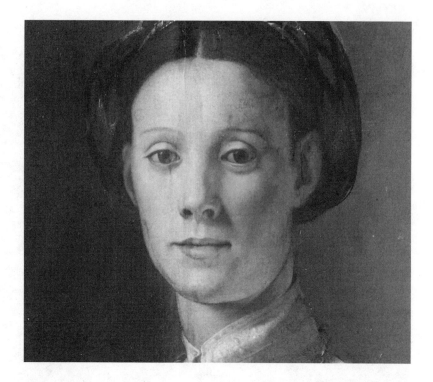

FIGURE 15

Bronzino. *A Lady with a Dog,*
detail, c. 1529–30. Oil on
panel. Frankfurt, Städelsches
Kunstinstitut.

this, it is insufficient to speak of marble or to say that the idea of skin is
elided: skin is *inconceivable* in the sense that it does not present itself as part
of what a pictured body might be, even though it is represented as any
number of things. Still, it is important to be cautious in correlating skin
metaphors with determinate meanings: it's appropriate that the skin of a
haughty aristocrat looks chilled or embalmed, but it may not make any im-
mediate sense that a figure of Venus should look clammy or damp. I don't
think Renaissance painters such as Bronzino, or even Michelangelo or Ra-
phael, thought of skin in any consistent way as a symbol, and that is because
they did not often think of skin at all: their minds were on marble, or ab-
stract smoothness, or perfect warmth.

Jacopo da Pontormo's drawings are especially vexed on the subject of
skin (Figure 16). This drawing was done in the last few years of his life,
and it is typical of the work he did for the destroyed frescoes in San
Lorenzo—it is at once elegant and tortured, ornamental and awkward.
The figure looks unstable: like a seesaw, it could tip either way, or it could
float effortlessly in space like a spent helium balloon. Perhaps it occupies
a flat plane, as if pressed under glass; then again, it might lie in an uncer-

tain volume or recede voluptuously. It is also metrically unstable and at-
rophies unexpectedly: at first, the shoulders and arms bulk too large for
the feminine pose, but they waver and end in faintly traced paws that have
no fingers. The thighs too taper quickly toward the knees, and then the
legs trail off the page without ending in feet.[57] The body doesn't seem to
be made of flesh and bone. Its interior swims with eddying contours, the
same no matter what they describe. The penis is made of curves much like
those of the folded right side under the ribs, and both parts have a similar
flaccid resilience. What is skin in this picture? At first, we might say it is
something rubbery and translucent, a jelly or an ointment spread over the
body. In that case, it would be close to a membrane, something that be-
longs inside the body. Here the skin—to the extent that it is possible to
treat something so obviously *not* drawn as if it were present—is a frail cov-
ering for the seething insides, more like a damp mucous membrane than
a fully developed epidermis.

The whole figure is skinless, but its skin is absent from its body in a
different way than it is absent from its face. Pontormo was a master of *dis-
egno*, but he ignores Michelangelo's faithfulness to anatomic possibility,
and lets the contents of this body shift and mutate where they will.[58] He
tolerates, and even ignores, misplaced muscles and bones, and he allows
the body to swim with its own rhythms. On the other hand, the head is
stable, shrunken and rounded into a kind of geometric mold. The figure
stares at us with his right eye and beyond us with his left, and the stare is
constant and somewhat paralyzing. At first, he seems amazed, or at least
interested, but the eyes are glazed and in the end disconcertingly incuri-
ous, almost absent. (And this is odd considering he is a witness, either to
the destruction of the last world in the *Flood* or to the creation of the new
world in the *Resurrection*.) The nose is as wide as a lath; the ear simple as
a button.

The unexpected juxtaposition of an immobile head-sign and a body
that moves and shifts is one of many affinities Pontormo has with Mi-
chelangelo. Michelangelo frequently omitted the heads altogether from
the initial studies for the *Last Judgment* and either studied them separately
or filled them in from his imagination. In some instances, he left ghostly,
half-realized outlines atop naturalistically elaborated bodies. Yet in Mi-
chelangelo, the missing heads and half-limbs are simple absences; in Pon-
tormo, they are—formally speaking—wounds, because the atrophied fig-

ures are complete rather than fragmentary.[59] In drawings like Pontormo's, skin is absent in two different ways: on the body, the liquid metaphors that replace an observed skin are figures for the mind's restlessness and for the melting *disegno*; and on the head, the flat geometric absence of skin is a figure for the difference between the body (conceived as an articulable torso, with variable motions and poses) and the head or the terminal forms of the limbs (conceived as expressive *additions* to the body).

These few quick examples show how much work remains to be done to understand what happens to skin even in the restricted range of sixteenth-century Florentine and Roman art. The measure of our ignorance is the fact that the common explanation for the Renaissance lack of interest in skin (that it reflects the admiration for antique marbles) is so widely accepted. One way to approach the problem would be to find out what counted as the depiction of skin, and to that end I want to describe, with equal brevity, a single counter-example in which skin is directly at issue.

Creeping Flesh and Open Sores: The Body of the Painter Matthias Grünewald

Outside Italy, there are sixteenth-century representations that concentrate on skin, on stretching, turning, wrapping, and distorting, and on pain and monstrosity. Unlike Michelangelo, whose surfaces deny the palpable texture of skin or the difference between skin and viscera, Matthias Grünewald has an attachment to skin that may be unparalleled in visual art before modernism and outside of dermatology. It may be that his fascination can be traced, as some historians have proposed, to his historical position, halfway between the Italian Renaissance sense of a unified composition and the Germanic attention to "episodic" seeing.[60] But this art historical construct is not enough to account for his interest in painful, twisting poses or—more important in this context—in the macroscopic form of sores, skin folds, and skin creases.

The wrenching of the body does not stop with bones and muscles, as it does in Pontormo: Grünewald continues on, past the Italian norms, stretching and pulling at the skin, or letting it hang in flaccid heaps. For Grünewald, the four kinds of epidermal contours—folds, creases, wrinkles, and macroscopic lines—are a single continuum of distortion. It's a seamless descent from the major articulations of the joints, with their deep flexion folds, through the smaller supernumerary creases around the wrist or elbow, and into the little wrinkles and tiny corrugations that cover the entire surface of the body. Skin *is* deformation for Grünewald: it exists in a state of nearly excessive tension and complexity.

No matter what the subject might be, Grünewald's real interest is often skin. A magnificent drawing for the arm of the St. Sebastian on the Isenheim altarpiece (half of a larger sheet, now divided between two museums) doubles as a myopic inventory of the vicissitudes of the stretched skin (Figure 17).[61] Grünewald carefully records the creases on the inside of the elbow, and he sees how they pull all around the arm. There is no break between the normative folds of the elbow and the rarely depicted wrinkles that continue on around the sides. Around the point of the elbow is a dry patch where the skin has developed a fine webbing of dry cracks. Above the elbow, the skin stretches over the biceps tendon, and it looks unbearably tight: it's as if the body were coated in plastic wrap, pulled airtight around the viscera and muscles. Some parts of the drawing are scarcely touched: the side of the stomach is almost blank, and there is only

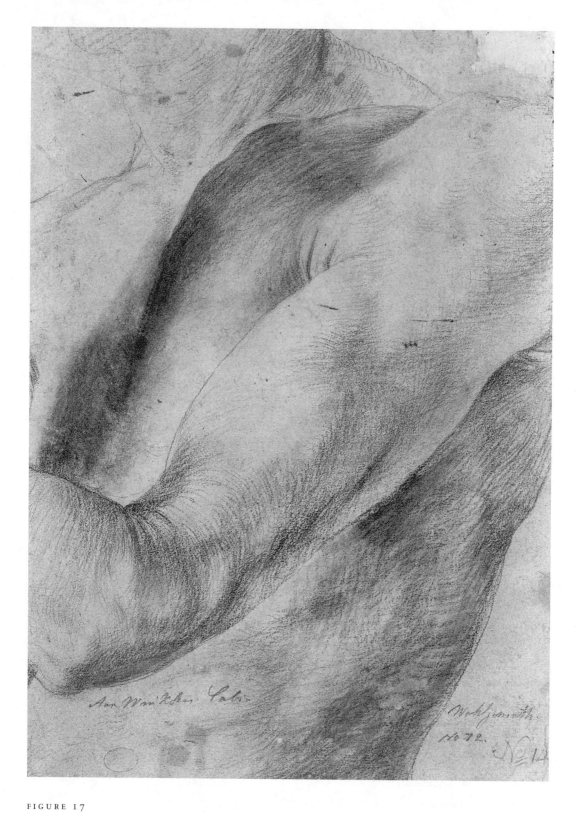

FIGURE 17

Matthias Grünewald. *Study for the Arm of St. Sebastian*, 1512–15. Black chalk on paper. Staatliche Museum zu Berlin, Kupferstichkabinett.

vague, pale, and negligent modeling on the shaded part of the upper arm. In such places, his chalk must have barely rested against the paper, brushing back and forth like a mosquito feeling for a place to land. Other passages are compulsively overdrawn: the ribs are hatched and scuffed, and the chest has been rubbed down into a dark trench of pigment. The chest and flank have all the signs of a repetition compulsion, an obsession more like Lady Macbeth's frenzied washing than like the sweet evenness we might expect of contemporaneous central Italian drawing. The very dark, worried parts of the drawing make a patchwork with the very tenuous, skittish parts—as if rubbing were a compulsion and tapping its antidote.

Pictures that look too closely at skin tend to be about touch, irritability, and hypersensitivity. (Among contemporary artists are Eva-Maria Schön and Yves Trémorin, whose photographs betray a macroscopic fascination with the little hills and valleys of the flesh.[62]) In Grünewald's full drawing, the saint prays toward the crucifix with his hands stretched out and his fingers knotted together. The pose reenacts the Crucifixion itself, and the tortured skin reenacts Christ's suffering. Saint Sebastian's taut, flaccid, scraped, and wrinkled skin is a dulled echo of Christ's distorted body, draped with knotted and congealed ropes of blood, sagging as its weight drives the nails along through the flesh, perforated with swollen wounds from the scourging. (Grünewald was a close observer, and he even noticed how the skin swells white around a puncture wound.) Motion is everything in this conception of skin, because the skin must be stretched in order to wrinkle—that is, in order to become expressive. In this drawing and the corresponding painting, skin is a figure of divine agony, and also in the end the agony of the body ill at ease with itself—the topic of the next chapter.

In brief, always and everywhere, the normal blond has
positive, dynamic, driving, aggressive, domineering,
impatient, active, quick, hopeful, speculative, changeable,
and variety-loving characteristics; while the normal
brunette has negative, static, conservative, imitative,
submissive, cautious, painstaking, patient, plodding, slow,
deliberate, serious, thoughtful, specializing characteristics.

—*The Job, the Man, the Boss*[1]

t w o Psychomachia

Before it became popular in the humanities, semiology was a branch of medicine, concerned with the ways in which the body could be read. Like contemporary semiotics in art history, medical semiology finds itself committed to with the impossible task of reading a seamless, organic object in terms of discrete linguistic units. To the extent that art historical semiotics remains within a narrow conception of semiotic operation, involving the search for certain kinds of symbols and significant marks in pictures, it might find the wider variety of medical practices a fruitful model. In a short list, the body has been read in at least a half-dozen methodologically distinct ways, as shown in the following table.[2]

It would not be difficult to augment and subdivide this chart, adding disciplines such as dermatoglyphics (the study of skin folds), keiromancy (palmistry), and dactyloscopy (fingerprinting). Metoposcopy (or metoscopy, or mesoposcopy), which began in the sixteenth century, is the study of lines in the forehead (the first crease above the eyes is usually taken as a solar-lunar axis, followed by the lines of Venus, Mars, Jupiter, and Saturn).[3] Symbolic gestures, such as the right hand raised in benediction, are another partial system that has varied across cultures.[4] Many of the systems are incomplete or specialized. In metoposcopy, for example, folds above the eyebrows are significant, but Venus's necklaces (folds in the neck), crow's feet, and other facial lines are not. Part of the face becomes a text, and most remains a cipher—or more exactly, a meaningless pattern. Manuals of fingerprint analysis are very precise about the "delta," the "loop," the "core," and other features, but say next to nothing about palmprints.[5] Symbolic

TABLE 3. SYSTEMS OF MEDICAL SEMIOLOGY

Doctrine	Typological key	Sources
Humoralism	The four humors: sanguine, melancholic, phlegmatic, choleric	Hippocrates, Galen, Avicenna, Sennert, Rivière, Laycock[6]
Physiognomy	Movements of the face	Polemo, Adamantius, Della Porta, Lombroso, Morel[7]
Phrenology	Cranial topography	Gall, Spurzheim, Combe, Fowler[8]
Physiology	Body systems: digestive, muscular, respiratory, cerebral	Cabanis, Troisvèvre, Rostan, Chaillou[9]
Anatomy	Intestinal length, scaoular form, embryonic layers	Spiegel, Treves, Huter, Graves, Beneke, Bean, Swaim[10]
Somatotypology	The weight and dimensions of the body	Näcke, Bauer, Kretschmer, Sheldon[11]
Encyclopedic semiology	Synthesis of the above	Lichtenberg, Lessa, Blackford, Burger-Villingen[12]

gestures are common in some settings, such as Roman reliefs and late-medieval narratives, but they are often omitted or ambiguous. Since all interpretations of pictured bodies must employ some semiotic system, this book might have been cast as a matter of negotiating these and other ways of reading. I have resisted that narrow structure because the most interesting and widespread systems are also the least amenable to rational exposition: metoposcopy and fingerprint analysis are precise in their limited realms, but "expressive dermatology" is both general and semiotically elusive: skin appears to have the capacity to express specific meaning, even though it normally eludes any exact interpretation.

The subject of this chapter is another general semiotic system I am calling "psychomachia," by which I mean expressive twistings and turnings of the body—as opposed to the expressive *existence* of the body, which was part of the subject of Chapter 1. I take it that the two principal examples, physiognomy and contrapposto, together constitute a basic field of possibilities for meaningful motions and positions of the depicted body. Physiognomy is an attempt at a semiotics of the face, and contrapposto is

a language of bodily motion. Deleuze marks the difference by calling the face a "faciality machine," capable only of generating facial effects, but I would hesitate to insist on such a clear-cut division because there are so many other ways of reading the body that depend on divisions *within* the body or the face.[13] The existence of practices such as metoposcopy, which does not apprehend the face as a single visual or linguistic field, shows the limitations of a general (and largely nonvisual) account such as Deleuze's. Palmistry reads some lines, while metoposcopy and dermatoglyphics read others, and none of them depends on the distinction between a "faciality machine" and other mechanisms of meaning.

Still, the face as a whole is often separated from the (headless or face-less) body, and the two subjects of this chapter are the places where theo-rization about those two regions has been most acute and systematic. In accord with the different ways in which the face and the body are said to convey meaning, the semiotics of contrapposto and physiognomy are in-compatible. In particular, they reach their limits in different ways: phys-iognomy suffers because it tends to become too precise, too much like a simple language (or language game, in Wittgenstein's original sense), and contrapposto fails because it is too vague—the body can never quite con-vey determinate meaning without the support of narratives and symbols. Their failures provide two models for art historical semiotics as it seeks to read the visual; in a larger book, each of the other semiotic systems could also provide lessons in the ways that linguistic constructions are bent, and finally broken, on the illegible surface of the body.

On the Disconnection of Physiognomy and Modernism

Although physiognomy (and its later sister science, phrenology) is a dead issue in modernism and postmodernism, it might be better to describe our century as antiphysiognomic, rather than nonphysiognomic. Contempo-rary artists are generally uninterested in telling the story of the soul on the face, and even those few portraitists who can be regarded as central to twentieth-century art (for example, Bacon, Picasso, and Max Beckmann) typically do not belong to the tradition of psychological portraiture that begins with Leonardo and flowers in Rembrandt. Instead, they are anti-psychological. Beckmann gives us mask after mask, never revealing him-self as Rembrandt does even under his theatrical costumes, and Picasso quickly abandoned his early experiments in using analytic cubism to ex-

press psychological nuance. The weird portraits Picasso attempted around 1910–11 are enough to show that cubism and psychological portraiture are a particularly unhappy mixture, and that fact, apart from any other, may be decisive for the twentieth century's rejection of psychological portraiture.[14] Our distance from psychological portraiture can be brought out by a look at an artist who believed in it, and founded his practice on physiognomic criteria.

As Rudolf Wittkower has emphasized, Gian Lorenzo Bernini was once the "brightest star" of the constellation of seventeenth-century artists, which also included Caravaggio, Rembrandt, Velázquez, and Poussin.[15] Given the immense industry that art history has become, it is always risky to call an artist underappreciated, but at least for undergraduate courses Bernini gets perhaps a little less than the usual summary appreciation. Students hear of Bernini's accomplishments as a litany of formal breakthroughs—in Wittkower's words, the "choice of a transitory moment, the breaking down of restrictions imposed by the block, the elimination of different spheres for sculpture and spectator, and intense realism and subtle differentiation of texture"—but somehow he does not often come alive to late-twentieth-century students, or to contemporary artists. Yet his is certainly not an instance of that slow, gentle slide into oblivion that is the fate of lesser artists—for example, Bernini's near-contemporary, the elegant, taciturn François du Quesnoy, who was also once ranked with Michelangelo.

I would suggest that Bernini's physiognomic practices help account for his current absence from some lists of essential artists. The majority of Bernini's portraits adhere to the physiognomic tradition, which enjoins artists to depict expressions in the midrange of human beauty and emotion, avoiding ugliness and caricature. Relatively little of Bernini's work has the kind of physiognomic excess we find congenial. When he wants to depict a violent emotion, he tends to explore formulaically contorted facial expressions—the *Condemned Soul* (*Anima dannata*, c. 1619) grimaces wildly, and the *Neptune* (1620) has a raggedly determined face. Bernini had a few precedents for these distorted faces—he was thinking of Hellenistic sculpture, the Carracci, and early Caravaggio—but he tempered the excesses of Hellenistic and Caravaggesque work by adhering to the ideals of physiognomic balance and decorum that are so much forgotten in the twentieth century.

It may be that we do not respond as strongly as we might because to a late-modern sensibility, truly extreme emotions—those that express what

we take to be the greater horrors of our century—cannot be conveyed by tragic masks or simple grimaces.[16] Just as the Laocöon no longer moves us, so Bernini's efforts at emotional extremes seem more contrived than passionate.[17] Since German expressionism, the most intense suffering has not been directly represented; instead, it has been conceived as something entirely off the scale of possibilities that facial muscles afford: beyond the classical woe of the Laocöon are the desolate blank masks of Kirchner's street waifs. We have come to expect great suffering to be shown to us by bodily distortions and not silly grimaces. After all, a wince may be the same whether it is in reaction to a stubbed toe or an amputated leg. I think we have developed a triple distrust of baroque physiognomy: we don't feel that emotions come in measured varieties; we wouldn't risk depicting a strong emotion by a grimace that might look trivial; and we are rarely satisfied to remain in the gray areas between the extremes, where passions are muted, mixed, and calmed by reflection and a sense of balance. A fourth obstacle is Bernini's idea, which he held in common with physiognomists of the time, that faces should exhibit emotions that can be interpreted as "anger," "frustration," "sorrow," and other common states. It is not an accident that the recent scholarship on seventeenth-century portraiture almost entirely eschews affective description in favor of economic, biographical, or formal questions. We prefer illegible complexity in faces, even though we have lost all confidence in our ability to put even a little of that complexity into words.

As a science, physiognomy has entirely vanished: not only do current art historians and artists not believe it but also they do not care about it, and contemporary artworks that concern the face avoid implying recoverable or specific psychological meaning. The twentieth century is immoderate and skeptical. Yet physiognomy remains central to figurative painting despite these differences because no one can entirely disbelieve that the face is a text for the soul. In order to carry on even the most rudimentary conversation, I have to be able to look at a person and make a rough guess about what that person is like. If we truly thought that the face is disconnected from the soul, then we would be as likely to look at a person's face as at the brick wall behind it. And because physiognomy in this general sense remains necessary, it stands to reason that the fund of ideas we apply to our informal decryptions comes from traditions of interpretation that are already in place—that is, from physiognomy. The old doctrines are arguably more important than ever because they are only half-known.

When physiognomy flourished, at least it was possible to question a given reading and to come to a working agreement about what some expressions meant. Contemporary artists read and create faces without noticing that the potential and the limitations of psychological portraiture are largely inherited from the Renaissance and baroque physiognomists.

Physiognomic Awkwardnesses

Like the other semiological systems, physiognomy and phrenology raise fundamental questions: Since the face is not inscribed with letters, how can it be read as if it were a text? In what way does it exhibit signs or propositions about the soul beneath? To ask these questions is to inquire about physiognomy from the inside—that is, to ask the kinds of questions that the eighteenth-century doctors asked themselves. Johann Caspar Lavater's admittedly fragmentary *Essays on Physiognomy* (originally called *Physiognomische Fragmente*) is the principal document in this history, the closest the science came to producing a standard reference.[18]

As with so much of physiognomy, an initial problem with reading Lavater is that he is difficult to take seriously. I do not say this carelessly: even the physiognomists had their doubts about their enterprise—they realized it was unreliable, potentially misleading, and "fragmentary." Despite its voluminousness, Lavater's work is repeatedly silly. He tries to read parts of bodies other than faces, and he even interprets the emotions of snakes, queen bees and worker bees, flies, mosquitoes, and fish (Figure 18). Of fish number three, for example, he comments dryly, "what stupidity in the mouth . . . and particularly in its relation to the eye." Lavater does not credit the "Sea-horse" or "monster" at the bottom—a hippopotamus— with much intelligence. He finds it "destitute" of gentleness and tenderness and says its mouth and teeth are "stupid, ignoble, [and] insensible, made for devouring without the pleasure of enjoying," and in sum "the throat of the Sea-horse is a profound and horrible gulph, formed only to crush and swallow."[19]

Lavater also studied parts of the face, including birthmarks and even warts, and he warned that women with hairy warts on their chins were industrious but also "amorous to [the point of] folly." (He recommends that the right way to treat such women is with "a mildly cold dignity of demeanor."[20]) Physiognomy is always cousin to caricature; it is inseparable from inadvertent humor, even when the physiognomists try to use humor

FIGURE 18

Expressions in fish and in a
hippopotamus. From Johann
Caspar Lavater, *Essays on
Physiognomy*, ed. Thomas
Holloway, trans. Henry Hunter
(London: John Murray, 1792),
vol. 2, p. 126. Department of
Special Collections, University
of Chicago Library.

FIGURE 19

"The Psychological Railway."
From L. A. Vaught, *Vaught's
Practical Character Reader*,
rev. ed., with a preface by
Emily Vaught (Chicago:
Vaught-Rocind, 1902),
p. 171.

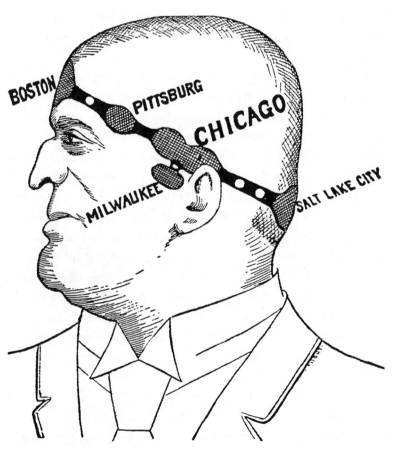

to make their points.[21] *Vaught's Practical Character Reader*, published in Chicago in 1902, is full of inventive phrenological and physiognomical caricatures (Figure 19). The drawings are humorous mnemonics, serving the very serious purpose of inculcating awareness of the significance of skull contours. "The Psychological Railway" helps readers remember that a bump on the forehead indicates good powers of thought, because Boston is "the thought center of the country." A lump in back of the head indicates "Amativeness"; and because Salt Lake City is the center of Mormonism, the text urges: "What faculty better represents polygamy?" Other cities are identified by their economic specialties: "Chicago's two dominant characteristics are pig-sticking and money-making. She is well represented by the two elements, Destructiveness and Acquisitiveness." By similar logic, Milwaukee represents "Alimentiveness," and Pittsburgh "Constructiveness."[22] The author is joking but also bringing out the unintentional, and unavoidable, humor of the phrenological enterprise itself. Both Lavater and the early phrenologists are ironic at certain moments, and their apparent naïveté may be partly a strategy for stifling the corrosive silliness of the new sciences.

On the other hand, physiognomy balances this comedy with a desire of great moment: the daily necessity of reading peoples' souls on their faces. Physiognomy has a universal purpose, but beyond the most basic, self-evident propositions, it becomes counterintuitive. Why did the physiognomists compound the passions into unlikely concatenations—such as Lavater's faces denoting "violence, tempered by cowardice and malice aforethought" or "candor, innocence and weakness"? At one point, Lavater considers a series of nearly indistinguishable faces and reads "an insufferable countenance, an absurd mixture of foolish terror and factitious rage"; a man who is "furious, passionate, vulgar, and ungovernable"; another whose face exhibits "the excess of rage of a low man, suffering, and divested of energy"; one who shows "the fury of a fool under flagellation"; and one who displays "a mixture of greatness and triviality—the grimace of a fool and an idiot." It is no wonder that Mirabeau thought Lavater was a "bizarre mixture of dementia and wit, ignorance and knowledge"— itself a very Lavaterian diagnosis.[23]

Part of the answer may have to do with how the emotions were imagined in the late-seventeenth and early-eighteenth centuries, as discrete faculties and "passions," rather than subtle moods. In this respect, it is significant that in eighteenth-century novels, passions were still perceived as

types and the mercurial moods of the *Sturm und Drang* movement had not yet surfaced. But another way to answer the question has to do with the face itself, and its difference from writing. The signs of writing must be clearly separate from one another; they depend on what Jean-François Lyotard and others have called "oppositionality," or "distinctness." The conviction that the face may be a different *kind* of sign, one capable of holding a number of signs in fluid suspension, might derive from our habits of associating people's names (as distinct signifiers) with their faces (as indistinct signifiers). When I think of a person's name as I look at her face, the face seems to express a great deal of what that person has come to mean, without my being able to condense any of it into a single phrase or description. But physiognomy cannot comprehend such an unspecific interpretation. If a face contains an encrypted lexeme, and its corresponding meaning—its sememe—is more intricate than an emotion such as violence or candor, then physiognomy cannot dissect the sign into the wider range of emotions we might expect. There is no warrant for such analysis in the face.

Physiognomy failed because it couldn't suppress its unintended humor and because the physiognomists clung to a simple model of nameable emotions, avoiding the real complexity of even the most ordinary states of mind. A deeper reason for its demise might have to do with the pictorial nature of the face itself. A face that blends too many emotions is an unreadable palimpsest. It is no longer a text but has become—in an exemplary way—a picture, a portrait that has no verbal equivalent. Elsewhere, I have argued that the coherence we demand of faces and people might be a model for the coherence we ask of artistic styles: all are holistic forms that retain a sense of structure and an inconsistent aura of individual elements.[24] I tend to accept the features of a person's face as signs of a single personality, without being entirely conscious of what forms I am counting as elements or what principles govern their coherence. What matters is the sliding sense that there is a structure or a set of elements and that the elements do not need to be experienced separately. The same kind of partly illogical apprehension governs the experience of artistic style, where the elements of the work are present and yet blurred, and their principle of coherence is partly articulable and partly not. In this way, style, personality, and the construction of the face meet on a common ground of incomplete clarity and coherence.

Physiognomy also encounters the kinds of problems any reading finds

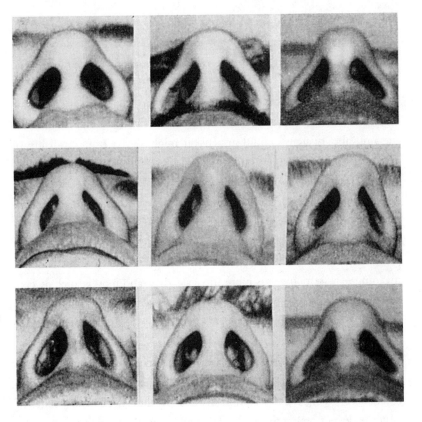

when it does not know how or when to stop.[25] Are noses and ears signifi-
cant? Are they texts in the same sense as the mouth, or the eyes? And if
not, by what metalanguage do we understand that we should cease *reading*
the face at a certain point and begin *seeing* it as a meaningless pattern of
forms? Lavater thought that features such as noses and ears were mean-
ingful, but he said that it would not be appropriate to put much weight on
their interpretation.[26] Many physiognomists have been less circumspect
(Figure 20). In this example, very large nostrils (top) are said to denote in-
satiable sensuality, small nostrils (middle) are the sign of a volatile sensual-
ity, and those that are broad in back and narrow toward the front (bottom)
signify a capacity to compensate for sensuality. (Lessing, the authors add,
possessed this third and best type of nostril, and Mme. de Staël had un-
usually large nostrils.)[27]

A fourth problem with physiognomy, aside from its unintentional hu-
mor, its mechanical model of the emotions, and its misguided hope that the
face works like a text, is its dependence on departures from a mean. Since
physiognomy is the study of passions, it equates expression with facial

forms that are not normal. In order to be meaningful, a feature has to stand out (like a bushy eyebrow) or move (like a furrowed forehead). A "zero-degree face," one that is average in all respects and at rest, becomes unreadable by definition. Pierre Klossowski echoes this eighteenth-century quandary when he writes of the body in terms of its resemblance to a "demonic" ideal outside all possible bodies.[28] The problem of the zero-degree face accounts for physiognomists' anxiety about depicting deception and falsehood, and it suggests that the semiotic system of physiognomy wavers when it comes to faces that are marked by the absence of traits rather than their presence.

In principle, a physiognomist would have no problem depicting a purely evil face because it would have to possess all manner of facial distortions, asymmetries, and tics. In practice, it proved difficult to imagine what Judas or the Devil could have looked like, because each distorted feature could be further distorted, ad infinitum. But even average faces presented difficulties. Usually, Lavater describes mediocrity in negative terms, concentrating on what it is not, as in his figures labeled as "incapable of greatness" (Figure 21) and his gallery of less than noble people. Sometimes he waxes eloquent on the defects of ordinary people. The text that accompanies this figure is a typical, inadvertently funny example:

> 1 The physiognomy of a man of intensity and courage, in whom you may confide; but at the same time an ordinary face, destitute of sagacity and elevation. The want of greatness is particularly visible in the point of the nose.
>
> 2 The face of a grovelling, sordid, cunning wretch. Though he be at present a very contracted being, his natural dispositions rendered him abundantly capable of instruction. Without being positively wicked, he is become contemptible through weakness and want of cultivation; and, in his actual state, presents a total want of honor and internal energy.
>
> 3 Impotent coquetry. The eye is strongly expressive of passion—the mouth, of weakness bordering on folly.
>
> 4 This face is neither great nor energetic—but it indicates a man possessed of considerable talents, susceptible of taste and instruction, capable of reflection, without the power of profound investigation.
>
> 5 The forehead, if I may use the expression, has not yet arrived at full maturity; and, considered with relation to the mouth, is not sufficiently furrowed, it is too childish. It is unnecessary to observe, that this is the profile of a changeling, indolent and good-natured: the imbecility is chiefly resident in the under lip, which advances far too much.[29]

If normalcy is difficult for physiognomy, then pure, untainted goodness is nearly impossible. What mark could identify a face that is unstained by any thought of evil? The face of the Savior, of an angel, or of a naïve and pious boy spell trouble for physiognomy. Lavater's image of "Weakness Innocence and Goodness," for instance, gives us something less than a real person: the boy's face is a little embryonic, as if something were missing. But Lavater loves it: "What heart," he says, "does not feel itself moved and attracted?" Physiognomy forces the strange equation of divinity—the culmination of all good qualities—and the tabula rasa.[30]

Conceptual Problems with Reading the Face

These four points are all questions that physiognomists put to themselves, and they contributed to the gradual decay of the discipline at the end of the eighteenth century. (Phrenology continued, mainly in the United States, through the nineteenth century.[31]) Physiognomy was always a fragile science, doomed by its own practitioners as much as by its sometimes brilliant critics.[32] Lavater was unsure from the very beginning: his *Essays on Physiognomy* opens by quoting an anonymous critic who says physiognomy is unreliable. At the same time, we know that there must be *some* connection between thoughts (or the soul, or the mind) and the face. Haven't we all looked at people and decided they were "childish," "ordinary," or even "wretches" or "idiots"? If we are to reject all the trappings of Enlightenment "science," then what are we left with? What can a face say, if it cannot say anything reliable or determinate?

Things only get more slippery if the people we're trying to understand are putting on faces in order to deceive us. A twentieth-century physiognomic study of the "mimetic diagnostic" of faked emotions is a case in point (Figure 22).[33] Since the author is concerned with acting problems, he is acutely aware of the difficulty of reading sincerity in expressions. But this is not merely a problem of coaching actors, since it casts doubt on the en-

FIGURE 22

"Composed Emotions." From
Philipp Lersch, *Gesicht und
Seele, Grundlinien einer mimischen
Diagnostik* (Munich: Ernst
Reinhardt, 1951), pl. 4.

tire possibility of interpreting faces. We can often tell insincere expressions
in life—but are there rules for that ability? Figure 23 shows a girl suppos-
edly responding involuntarily to the sound of a tuning fork—or is she play-
acting, like Charcot's patients? And what about cases of pathological de-

FIGURE 23

Involuntary expression in response to a note from a tuning fork. From *Nouvelle Iconographie de la Salpêtrière* 2 (1889): pl. 2.

generation or psychosis, when the facial expressions have broken free from their moorings in the mind?[34] How can physiognomists determine when people aren't sincere so that they can rescind their interpretive claims?

Certainly, we have reason to be skeptical of systematic connections between mind and face. In medieval epics, gestures were "psychophysical": the gesture meant the passion, and even though the heart was hidden—in accordance with the doctrine of the *occulta cordis*—"symbolical connections remained between the body and soul, and facial expressions were a sign of this connection."[35] But the division between the "inner man" (*homo interior*) and the "outer man" (*homo exterior*) has been remarked since the Renaissance, and the fall of physiognomy has only accentuated the difficulty of linking these two terms.[36] It is interesting in this respect that physiognomy not only demands a connection between the motions of the mind and the movements of the face but it also requires that *homo exterior* and *homo interior* remain at some distance from one another. As long as the soul has strings that allow it to move the body, and as long as the eyes remain windows to the soul, mind and skin are connected but separate, and even

when the body moves the soul—as when a deformity propels a person to-
ward evil—the two are still distinct. But physiognomy does not allow for
a soul and body that are inextricable, or are a single thing, or are unac-
countably divorced. It seems to me that the deepest criticism of physiog-
nomy springs from this source. If the soul and face are taken to be insepa-
rable, then the cause and effect relationship that physiognomy posits might
be erased or reversed.

To say that physiognomy reads the face is to conceive part of the skin
of the face as a text, and although that is a fruitful metaphor, it is not en-
tirely adequate. If we can continue to understand people's expressions
with some confidence, and if we still believe that we can interpret the sub-
tle moods and tendencies of the mind depicted in the best psychological
portraiture, then it is not because something inside is writing on some-
thing outside. The relation of the two is more intimate, and "physiog-
nomy" might ultimately be the name for a mechanical misunderstanding
of the inextricable relation between them.

The Analytic of Contrapposto

The plasticity of the physiognomic sign finds its general form in the ex-
pressive movements of the body that are still properly known as "contrap-
posto."[37] Like physiognomy, contrapposto remains centrally important for
figural art, even though it is seldom taught outside of Renaissance and
baroque art history. Beginning in the mid-fifteenth century and continu-
ing through the plurifacial figures of the late-sixteenth century, such as
those by Bartolomeo Ammannati and Giovanni Bologna, artists explored
the possible motions of the human form, pushing it further and further to-
ward the thresholds of pain or fantasy. Taken together, these achievements
still provide a catalogue of possible bodily positions that can only be re-
peated or exaggerated by contemporary artists. Even images made by
pressing the body directly against the canvas or paper, from Yves Klein's
sexist "anthropometries" to Jasper Johns's obscene self-impressions, stand
directly in the tradition of contrapposto.[38] As the skin stretches and com-
presses to fit the flat surface, the body either twists and rolls (as in Yves
Klein's figures, which echo seductive poses from Renaissance painting) or
it pushes straight onto the canvas, the floor, or the paper (as in Jasper Johns's
images, which echo earlier frontal poses from the Mandylion to the Middle
Ages).[39] Even Annie Sprinkle's *Tit Prints* are the unpredictable progeny of

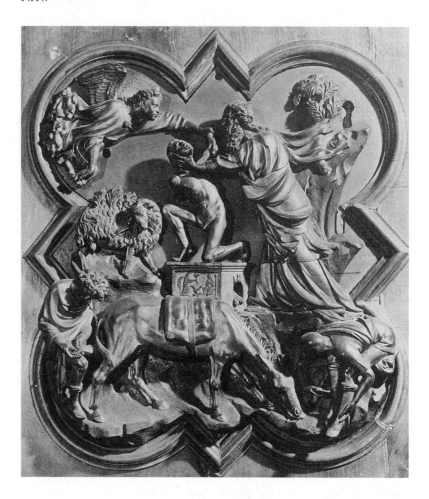

FIGURE 24

Lorenzo Ghiberti (right) and
Filippo Brunelleschi (left).
Bronze competition reliefs of
the Sacrifice of Isaac, 1401–2.
Florence, Bargello.

frontal poses, portraits, and impressions. There is no escape from the reper-
toire of poses first theorized in the Renaissance, and so it becomes crucially
important to acknowledge and explore contrapposto's original meanings in
order to see what they might contribute to new explorations of the figure.

The history of contrapposto begins with an injunction about its limits,
defining it in terms of what it is not. Leon Battista Alberti's *De pictura* en-
joins that a figure should not twist more than "shoulder over navel," both
because it is impossible and because it is inappropriate (*non condicente*).[40] In
another passage, Alberti states that a figure should be balanced, and if it
raises its right leg, it should also raise its left arm. These simple definitions
are the seeds of the later Renaissance understanding of contrapposto, since
they introduce contrapposto as something that expresses the normal limits
both of the body and of expressive decorum. At the same time, we should
not overlook the particular examples given by Alberti. The second passage

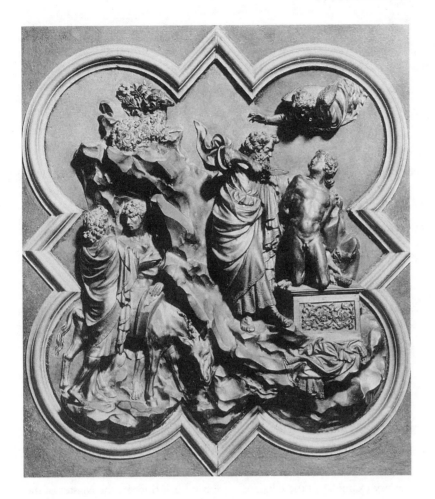

is concerned with balance, and it conjures pictures of dancing or march-
ing figures, but the first passage is a strange exercise that pits the torso
against itself. As opposed to dancing or balancing, twisting is futile and
even unpleasant, and it expresses a body badly reconciled with itself. Con-
trapposto has these two strains throughout the Renaissance: one dances,
and the other deforms. The difference can be seen in the two competition
reliefs for the doors of the Florence Baptistery by Lorenzo Ghiberti and
Filippo Brunelleschi (Figure 24): Ghiberti (right) offers a relaxed demon-
stration of his skill, close to the dancing definition of contrapposto, whereas
Brunelleschi (left) proffers several tautly knotted contrapposti. The differ-
ence between the two, which remains pivotal for an understanding of the
fifteenth century, is sometimes put in terms of the two competitors' fi-
delity to the emerging Renaissance: Ghiberti's slightly swaying contrap-
posti are said to echo the late-medieval International style, and Brunel-

leschi's are said to be more normatively Roman (he also reproduces the antique *spinario*, the boy pulling a thorn from his foot). Those historical connections can also be read as the poles of Alberti's bifurcated definition of contrapposto: the one denotes the pleasure of dance and free movement; the other expresses the displeasure of the body turning against itself.

It might be that Alberti did not want his viewers to make a connection between the figures' turns and their implied mental states (or the artists' mental states), no matter how "overly excited" (*troppo fervente et furioso*) they might be.[41] Various injunctions in *De pictura* can be read as further definitions of the limits of judicious contrapposto, including his reservations about "panache," speed, and facility of execution (*sprezzatura*) and of judicious variety (*varietà*). But Alberti's thoughts on the subject are less important than the ways these thoughts developed in the following two centuries, when the connection became integral to the effect. The formal laws of contrapposto may be read as an expressive vocabulary of the body, and for that reason they are worth looking at in detail. What I am calling "dancing contrapposto" has three canonical rules.

BALANCE: ALBERTI'S RULE OF EQUAL AND OPPOSITE MOTION

If the limbs respond to one another in mirror reflection, so that when one arm is back, the other is forward, the body becomes a balancing act. This is not the usual way we imagine our bodies—it has more to do with artificial feats such as standing with one leg lifted high in the air. The fifteenth-century examples of these balancing acts (in paintings by the Master of the Barberini panels and by Andrea del Castagno) are showpieces for the special properties of painting, which can represent even the heaviest figures frozen in midflight or perching on a single toe. The artificiality of this concept of balance made it ineffective as a general strategy.

DIVISION: THE RULE OF THE 'STANDBEIN' AND THE 'SPIELBEIN'

A second law, which meliorates the first, requires that one leg bear the figure's weight (the *Standbein*), while another one trails ahead, behind, or to one side (the *Spielbein*). This injunction has a particular meaning in the language of psychomachia. When part of a figure bears weight and part is *nearly* but not completely weightless, the figure is divided against itself in an especially unstable manner. Renaissance sculptures tend to exaggerate the normal habit of standing that favors one leg over the other, and the poses they adopt involve a variable light touch on the *Spielbein*. If I stand upright

and shift the majority of my weight onto one foot while letting the other just touch the ground, then I can feel myself divide into two sets of muscles: one set works hard to hold me upright, and the other is kept subtly tensed so that the *Spielbein* can remain in place. I can feel the muscles of the *Spielbein* pull and relax as they attempt to maintain the leg's position. It is much easier, but not in the Renaissance spirit, either to have the *Standbein* carry all the weight and let the *Spielbein* rest against it, toe down (as many people naturally stand) or to stand symmetrically, so that each foot carries about half the weight. (Only a few Renaissance images opt for that very common pose—for example, Castagno's *David* in the National Gallery, Washington, D.C., who stands confidently, feet apart and almost equally weighted.) In Renaissance sculpture, the body is usually hard at work maintaining a difficult balance between those two more reasonable possibilities. Michelangelo's *David* is one of the best examples—to hold the *David*'s pose, it is necessary to plant the *Standbein* (the figure's right foot), preferably by wedging the heel against a support (in the *David*, the heel is clamped in the double trunk of a tree stump). Then with the *Standbein* secured, extend the *Spielbein*, raise the heel slightly and curl the toes, pressing lightly *down* onto the ground so that the body does not cant to the opposite site. The pose is remarkably unnatural, taut, and uncomfortable, and it brilliantly expresses the half-rigid, tentative state of mind that the figure appears to evince. Donatello's bronze *David* in the Bargello, Florence, performs the same exquisite balancing act, this time with less force and more obviously sexual meaning. Both poses are nearly impossible to hold: half the body becomes exhausted cantilevering the other half, and then the body begins to tremble with the effort of mingling forceful tension and delicate balance.

CONSTRAINT: THE RULE OF THE PLUMB LINE

Some Renaissance theory calls for a median or a plumb line that drops from the pit of the neck, through the center of gravity, and down to the weight-bearing *Standbein*. From the second law, we learn that a figure should not stand straight up (to use the odd modern expression, it should not stand "foursquare"), but at the same time it must employ this geometric law of balance. For this reason, figures that are disposed according to the plumb line rule tend to look constrained, if not off-balance, and it is rare that the pit of the neck is over one ankle. In addition, the line tends not to bisect the figure, so that it looks lopsided in relation to the figure's outline. In pictures in which the plumb line can still be seen, such as

Masaccio's *Tribute Money* in the Brancacci Chapel, Florence (where plumb lines were scored in the wet *intonaco*, the final layer of the plaster), the effect—looking at the figure together with its plumb line—is unbalanced and awkward. Standing farther back, so that the plumb line is invisible, the figures begin to appear more natural. This disharmony between the plumb line and the figure is important because it shows that contrapposto contains a principle of constraint as well as of balance and division.

The other contrapposto, which I will call the "twisting contrapposto," also has several rules, which were elaborated in the late sixteenth century.

THE TAPER: THE RULE OF DECREASING ENERGY

The "serpentinated figure" (*figura serpentinata*) is defined in two passages in Giovanni Paolo Lomazzo's *Ideal del tempo nella pittura*, and in the first he uses four similes to describe what he means.[42] The figure, he says, is like a pyramid, or flames, or serpents, or S-shapes. Each is a tapering form, strong and wide at its base and attenuated near its tip. Lomazzo also says that the pyramid can be upright or inverted, opening the way for figures that are spindle-shaped and swell in the middle. What is important here is less the exact form of the taper—Lomazzo is rather diffuse in his descriptions and metaphors—but the concept of tapering, so that the body is imagined as possessing a relatively stable center of motion, with twists applied to give it motion. In some figures, that center is the feet and legs, and in others it is the torso. The *figura serpentinata* is a stable form—the *figura*, which has been attenuated into a flame or a serpent, *serpentinata*. The center is protected, and the unprotected margins of the body flail around it. Although the full figure is the normal model for this structure, it can occur in limbs as well—for instance, in the Christ in Matthias Grünewald's *Isenheim Altarpiece*, whose fingers and toes almost twist free of the hands and feet even though the rest of the body is nearly rigid. (The taper ends with an inverted "flame" of blood, which falls in ropes—themselves twisted—from the toes to the ground.)

THE HELIX: THE RULE OF TURNING

Pyramids, flames, serpents, and S-shapes are things that spiral *against* some center or weighted axis, and in that sense they are different from the helix, which turns endlessly and with no resistance or diminution. When a contrapposto is imagined as a helix, the model is probably a twisted column, whose turns are artificially terminated at the top and bottom rather than

organically spent like a serpent's coils or physically exhausted like a candle flame. A column can spiral gently, without the force or energy of snakes or flames. Quintilian was thinking more of helices in this sense than of tapering turns when he wrote about "that curve, I might almost call it motion," that "gives an impression of . . . animation . . . grace and charm."[43]

THE MULTIPLIED TWIST: THE RULE OF FIGURES "MULTIPLIED BY ONE, TWO, AND THREE"

After his discussion of flames and S-shapes, Lomazzo declares that figures should be "multiplied by one, two, or three."[44] Like much in Lomazzo, this statement is unclear; it has been taken to mean that there should be more than one figure, or that the proportions in the figures should be 1:1, 1:2, and 1:3.[45] It is also possible that Lomazzo means twisting one, two, or three times, so that the figure turns once at the hips, again at the shoulders, and once more at the head. In a second passage, Lomazzo speaks of motions (*moti*) in addition to twistings (*ravvolgimenti*).[46] The former are up and down, right and left, backward and forward, and he comments that there are "probably" others. If this passage is read together with the obscure comment on multiplying by "one, two, or three," then it appears that Lomazzo might intend to evoke the idea of multiple motions within a single figure, and as evidence of that I note that this second passage is where Lomazzo introduces the term "*figura serpentinata*" by commenting, "it is best to give such figures a serpentine form."[47] Triple turnings in single figures are common in mannerist art. Michelangelo's *Victory* turns more than three times—it twists at the neck, shoulders, hips, and ankles. The figure of *Victory* is not a helix—double or otherwise—because different parts turn in different directions. The simple helix, taper, or spiral is an image of infinity, of transcendence from the body and metamorphosis into flame; the multiplied twist is a figure of mortality, of a body struggling uselessly against itself.

These two forms of contrapposto, together with their six more exact components, can be used to help map the possibilities of the contorted figure from the Renaissance to the present. In the twentieth century, for example, expressionist figures that seem initially to go beyond these concepts can be shown to be applying them more thoroughly than the Renaissance dared. A figure by Max Beckmann (Figure 25, left) that looks like a man dangling the broken bones of his legs, or a scarecrow blown off its stays, is nevertheless an example of the rules of multiple twistings and of equal

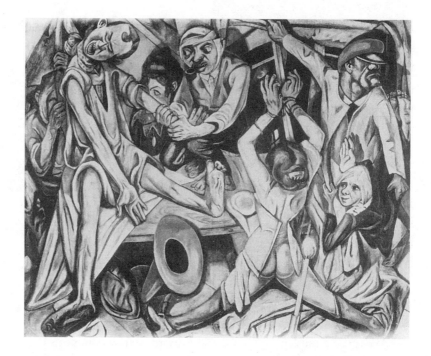

FIGURE 25

Max Beckmann. *The Night*,
1918–19. Oil on canvas.
Düsseldorf, Kunstsammlung
Nordrhein-Westfalen.

and opposite motion. Here torsion is not applied to the vertical sequence
from ankle to neck, but to individual limbs from shoulder joint to wrist,
and from ankle to knee. The rule of equal and opposite motion distin-
guishes not only one arm from the other but also one wrist from the other,
and each finger from every other, so that the figure looks splayed and bro-
ken, and there is no clear difference between the painfully wrenched wrist
and the feet that turn and curl in sympathetic pain. Historically, Beck-
mann's figure suffers a double torture: it is twisted and broken in itself, and
it is racked by history—by the need to show the pain that Renaissance
figures first showed, but to do it even more intensely.

The Indelibility of Contrapposto: the Lesson of the "Dread Figure"

Contrapposto is still with us because it encompasses the possibilities of
normal human movement and because depicted bodies will often echo
others made in very different contexts. Twisting contrapposto in particu-
lar has become so densely woven into our sense of the human figure that
we probably cannot depict the body without it.

One of the common paradoxes of history is that ideas have often been
critiqued most effectively by the very people who first proposed them.

Twisting contrapposto is an example of that phenomenon because the impossibility of escaping or overturning it was demonstrated most conclusively by one of its best exponents, Michelangelo. Late in his life, beginning around 1550, Michelangelo attempted to erase the very repertoire of poses and movements that he had been elaborating since the last decade of the fifteenth century. In place of the conventionally twisting figure of the crucified Christ, Michelangelo tried to draw what are now known as "frontal" figures, in strictly symmetrical poses. His attack on contrapposto was motivated in part by the same reasons that prompted twentieth-century expressionists to return to "primitive," hieratic, and frontal figures: he mistrusted the ideological trappings of the Renaissance and wanted to find something that would not be tarnished by what the Renaissance had come to mean. The drawings in which this hopeless struggle take place are a diary of his failed attempt to extinguish, inch by inch, the last vestiges of visible agony from the "Dread Figure" (Figure 26). A close inspection of the sequence of overlapping marks reveals that the drawings began with strongly twisted poses, either in the Renaissance modes of fully articulated contrapposto or in one of the late-medieval forms of S-shaped or C-shaped figures. Michelangelo rubbed out his first efforts, or covered them in opaque whitewash, repeatedly trying to constrain the figure to a more directly upright pose, but even the final drawings of the series preserve a faint but telling curve or turn of the body that recalls the entire panoply of differentially weighted contrapposti. Charles de Tolnay first showed that Michelangelo's contemporaries would have associated the perpendicular pose he was after with the holy "plague crosses" of the thirteenth century, which were carried in processions to ward off the pestilence. The choice of the thirteenth century cannot be chance, and I read it as Michelangelo's attempt to take art backward, to before the corrupted period that included his own lifetime and toward a more spiritually and artistically pure period before the history of modern art had begun.[48]

Michelangelo's failed assault on the repertoire of contrapposto concentrated on the central figure of Christian art, and on the most pained moment of Jesus' life. It is therefore an exemplary case for the study of contrapposto in general. Doctrinally, Jesus' agony is our agony, and his suffering is the type of all pain; even outside Catholic art, the "Dread Figure" continues to be central to the pictorial imagination. That is why it makes sense to say that the limits of contrapposto, and its grip on our sense of the figure, turn on how the crucified Christ can be imagined and depicted.

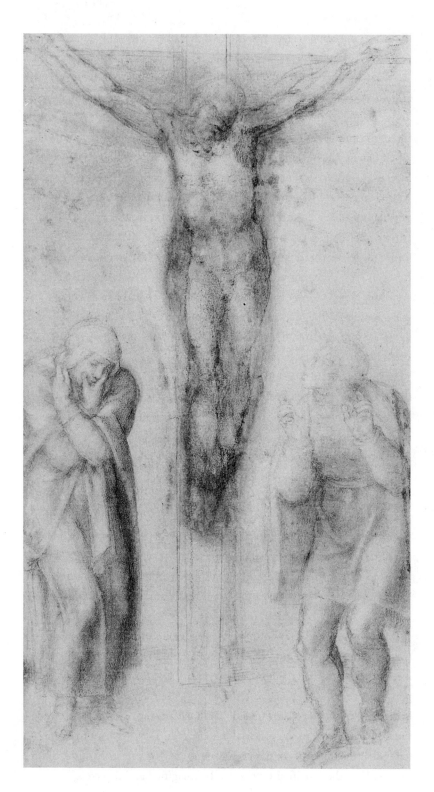

FIGURE 26

Michelangelo. *Christ on the Cross Between Mary and John*, detail, 1555(?). Black chalk and white lead on paper. London, Windsor Castle, Royal Library, no. 12775. The Royal Collection, © Her Majesty Queen Elizabeth II.

Formally, the possibilities are limited: there are not very many ways of disposing a figure on the cross, short of abstraction or anatomically impossible expressionism. One thing an exhausted body does naturally when it is suspended by its arms is to bend at the knees. The L-shape that results is found throughout the thirteenth century; in a drawing by Villard de Honnecourt, Christ is snapped at the knees, frozen in a geometric schema (Figure 27). A second possibility is the zigzag, in which the body bends at knees and waist. A third is the C-arc, best known in Cimabue's *Crucifixion* in Arezzo—a sinuous pose that Francis Bacon admired because when it is inverted it reminded him of a worm "undulating" or "crawling down the cross."[49] The rigid frontal pose, the L-shape, the zigzag, and the C-arc were the principal options for a hanging body before the age of naturalism. In the Renaissance, these options were adapted to the new ideals of balance and contrapposto. A tightened version of the L-shape (straight axis for the torso, rotated at the hips, knees together, feet crossed) was used by Mantegna and northern European artists such as Veit Stoss. Sinuous forms of the zigzag, called "the Gothic wave" (*l'ondeggione gotico*), found their way into Renaissance practice as versions of the gravimetrically balanced contrapposto preferred by Brunelleschi.

From Rubens and Rembrandt (who painted slack-bellied figures slumping down toward the Deposition) to Picasso, Graham Sutherland, and Francis Bacon, the Crucifixion has been an opportunity for meditation on the body's gross weight, its struggles against itself, and its weakness in death. The literature on the ways that the nails must have been placed in order to avoid ripping out of the hand (supposedly they would have had to be put between the carpals rather than the metacarpals) is all modern. So too are attempts to verify Jesus' most probable position; in at least one case, a corpse has been crucified to determine the most naturalistic pose (Figure 28). In this example, a Chelsea pensioner, one James Legge, was crucified by the anatomist Joseph Constantine Carpue shortly after Legge had died from a bullet wound to the chest. The resulting pose was cast in plaster, and afterward the corpse was flayed and a second cast was made from the *écorché*. (Only the *écorché* version survives.) Benjamin West, who was one of the artists involved in the project, is said to have remarked that he had "never before *seen the human hand*" before he realized the way it is stretched under the pressure of crucifixion.[50] The exercise shows that a crucified body might hang nearly vertically, with virtually no contrapposto—at least no more than the hint in Michelangelo's last drawings of the subject.

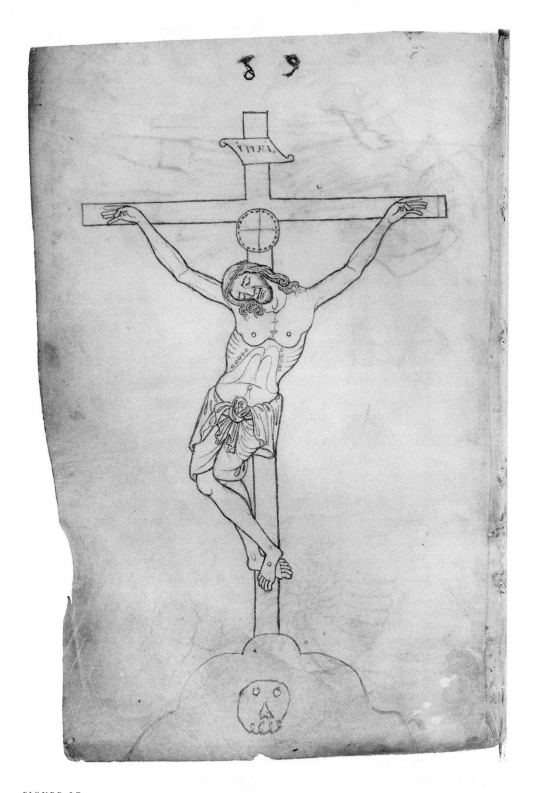

FIGURE 27

Villard de Honnecourt. *Crucifixion*,
second half of the thirteenth century.
Pen and ink on parchment. Paris,
Bibliothèque Nationale, MS français
19093 fol. 2v. Photo: Bibliothèque
Nationale de France.

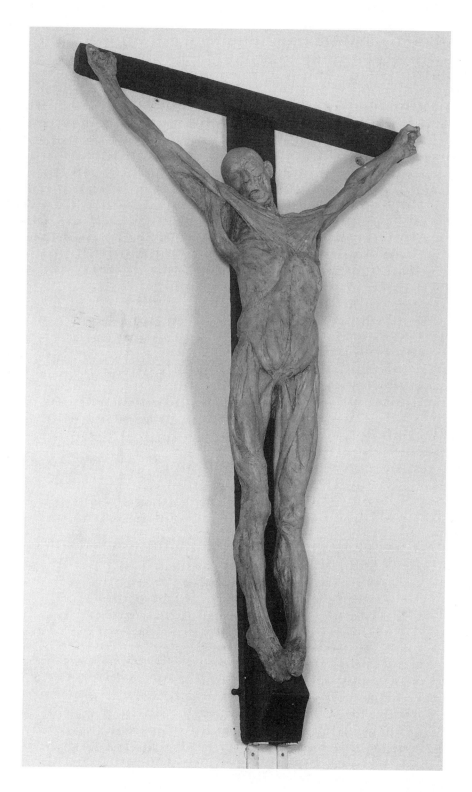

FIGURE 28

Thomas Banks. "Anatomical
Crucifixion," a cast of the flayed,
crucified corpse of James Legge,
1801. Plaster, on wooden cross.
© London, Royal Academy of Arts.

A full history of crucified bodies would also have to include the twentieth-century representations of the crucified Christ as a carcass, as a nearly abstract net of lines, and as a heterological assembly of wet rags, joints and ligaments. Because this subject is so important to the history of representations of the body, and so little studied, the following table shows a working chart of the possibilities.

TABLE 4. POSES OF THE CRUCIFIED CHRIST.

Period	Option	Examples
I. Medieval	Frontal, rigid	Anonymous images, from the second to the thirteenth century[51]
II. Gothic	L-shape	Villard de Honnecourt[52]
	Zigzag: Geometric	Examples from the fourteenth century[53]
	Zigzag: Gothic wave (*l'ondeggione gotico*)	Examples from the twelfth to the fourteenth century[54]
	C-arc: Gentle curve	Examples from the tenth to the fourteenth century[55]
	C-arc: Strong segment	Cimabue, *Crucifixion*, 1280–85 (Florence, Uffizi)[56]
III. Renaissance	L-shape	Masaccio, *Trinity*, 1428 (Florence, S. M. Novella)[57]
	Zigzag	Giotto, *Crucifixion*, c. 1312 (Florence, S. M. Novella)[58]
	C-arc: *Figura serpentinata*	Grünewald, *Isenheim Altarpiece*, 1510–15 (Colmar, Musée d'Unterlinden)
IV. Modern	"Wet-rag" body	From the seventeenth century: Rembrandt, Rubens
	Carcass: made of flesh	Francis Bacon, *Crucifixion*, 1965 (Munich, Staatsgalerie Moderner Kunst)
	Carcass: made of bones, thorns, etc.	Picasso, Crucifixion drawings, 1932; Graham Sutherland, *Thorne Crosses*, 1952–55

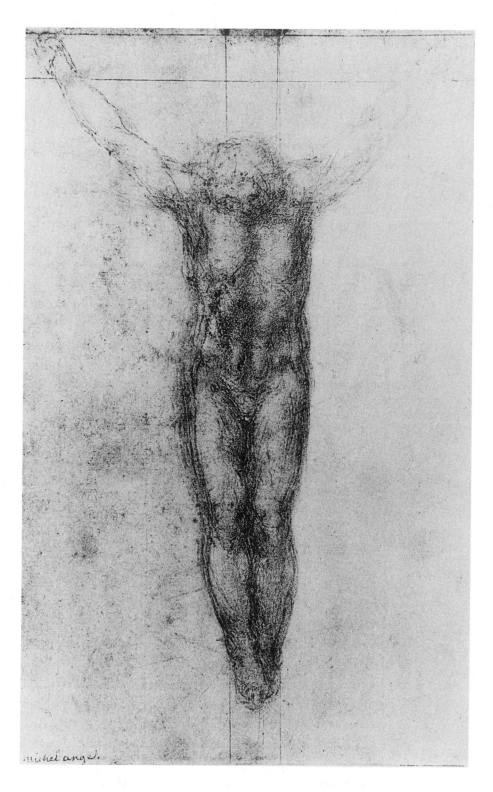

FIGURE 29

Michelangelo. *Crucified Christ*,
1560(?). Black chalk on paper.
London, collection of Count
Antoine Seilern.

Michelangelo knew the Renaissance derivatives of the Gothic C-arc, L-shape, and zigzag. He reproduced the C-arc in the Crucifixion for Vittoria Colonna, easily the most dramatic and least constrained of the series, and he also adopted the L-shape and zigzag in several drawings, progressively forcing it to move less and less, until he ended with a "sort of contrapposto": the faintest of turns to the torso, matched by the faintest of motions in the opposing leg (Figure 29).[59] Yet even this exercise in Counter Reformation austerity does not silence the echoes of contrapposto. The reverberation of his former interests in the moving figure can be read by looking up and down the body's midline: the eye that follows that line sways first to one side, and then to the other. Michelangelo never managed to erase the repertoire of off-center balances that he had himself invented over the previous five decades, and so the series of Crucifixion drawings ends with a tremendously subtle, and nearly perpendicular, figure of Christ that still betrays the curves of Renaissance contrapposto. Michelangelo's failure should be taken seriously, especially by modern artists who seek to move beyond contrapposto by abstracting figures, or disassembling them, or taking them from outside Western art. Contrapposto's resistance to even the most concerted attack, launched by the person who knew it better than anyone since, is a sign of how deeply it has stained our imagination of the figure.

'Telos,' the Winding Sheet

Twisting contrapposto has been used to express many things, but it is normally taken as a sign of psychomachia, of the mind's struggle against itself. In that interpretation, the body is just an outward sign, and the soul is what matters. Just as physiognomy depends on distinguishing the mind and the face, so contrapposto requires the soul (or mind) and body to be distinct. If the face and the soul aren't kept at arm's length, the doctrines of physiognomy break down, and the same can be said of contrapposto. What if the body doesn't merely express the torment of the soul—what if they are entangled in the same struggle? In that case, a twisted body might be trying to get away from itself: the soul might be trying to pry itself out of its wrapping of skin, or—even more hopelessly, and more carnally— the flesh might be at odds with itself, allergic to its own weight, its own fluids and masses.

On this fundamental level, contrapposto expresses discontent with the ordinary condition of the body. Figures that stretch and twist might be

plagued by guilt or bad conscience, or they might be aspiring to break the bonds of their sensual existence (as the Neoplatonic reading of Michelangelo implies), but they are also more or less ill at ease with their normal, resting bodies. Turning pulls the skin taut and makes limbs and joints twist against one other. Even in figures with gently balanced poses, contrapposto conjures unrest: if one part of the body is extended, raised, or turned, another part is forced to make a symmetrical movement in the opposite direction. Violent contrapposto expresses alienation from the skin as well as from the mind, and in doing so it evokes a more unsolvable unhappiness and a long-term, disconsolate struggle.

The way to this wider meaning was opened in the Renaissance. In the sixteenth century, psychomachia, the battle within the soul, lost the special significance it had in Prudentius's original text (late fourth century), or even in Marsilio Ficino's Neoplatonism (late fifteenth century), and became the site of a more universal and indistinct sense of unease or tension.[60] As specifically Christian meanings receded, the body's struggle became more inward, more about itself, but even in what Leo Steinberg calls "modern oblivion," where Renaissance concepts are largely forgotten, the twisting and turning of contrapposti and the *figura serpentinata* still signal both bodily and spiritual discomfort.[61] Writhing bodies can express purely sexual tension, as in advertisements and pornography, or tortured self-hatred, as in some German expressionism; either way, the body is partly exhibiting the motions of an unsatisfied mind and partly turning against itself, as if it were trying to twist free of itself.

The Greek word *telos* is interesting in this connection. It is usually translated as "end" or "consummation," but in the *Iliad* and other early Greek sources it has a more specific meaning, something like "band," "wrapping," or "winding sheet," depending on the passage.[62] "The *telos* of death covered his eyes and nostrils as he was speaking," Homer says of one soldier.[63] According to Richard Onians, "in sympathetic magic men used bands or wrappings to produce the effects produced by the mystic bands or wrappings of fate."[64] I would take this archaic sense of *telos* as a term as an essential quality of contrapposto that has so far gone unnamed: the sense that such figures are wrapped, wound about and confined, by their own skins. Literal wrappings are a sign of death and the grave (as in Sebastiano del Piombo's *Lazarus*, who sheds a white winding sheet) or of the struggle against whatever is mortal or "lower" in human nature (as in Michelangelo's so-called "slaves," who fight against flimsy swaths). But in the

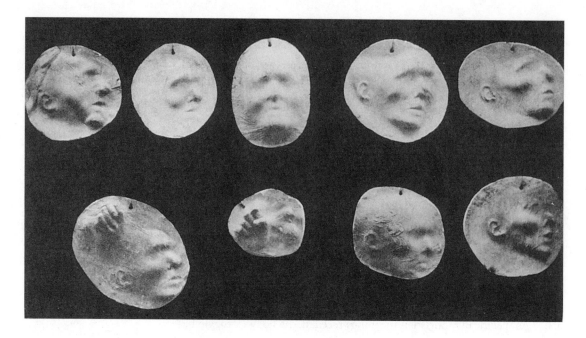

FIGURE 30

Eusapia Palladino. Astral faces
impressed in plaster. Naples.
From Fanny Moser, *Der
Okkultismus, Täuschungen und
Tatsachen* (Munich: Ernst
Reinhart, 1935), vol. 2, pl. 59,
following p. 832.

end, the adversary is the skin itself, the emblem of mortality and decay, the
"filthy sack" of medieval theologians.

Sometimes the body presses against its skin, as if it is trying to escape.
That happens, for example, in the history of bandages, torture devices,
prostheses, traction systems, death wrappings and mummifications.[65] It
also occurs when the body is pressed into a resistant medium like plaster,
as in various contemporary body-molding techniques. The ancestor of re-
lief plaques by George Segal and others are fin de siècle occultists' casts of
astral beings, in which ghostly faces strain to impress themselves on the
real world (Figure 30). In the best of them, made by the medium Eusapia
Palladino, the hands and faces look as if they are trying to break through
a skin separating their world from ours.[66] Any forceful pressing of the
body against a mold will conjure the body's hopeless struggle against its
own skin. Twisting contrapposto is one of the most eloquent forms of that
desire because it is least dependent on mechanical devices, plaster, and
other props.

In the end, the twisting contrapposto wins against the dancing con-
trapposto because a body's battle against itself means more than its tilt
against gravity. The figure must turn against itself, manacle itself, make
movement impossible. In the words of Paolo Pino, another Renaissance
theorist, such a body will become forced, unnatural, mysterious, and diffi-

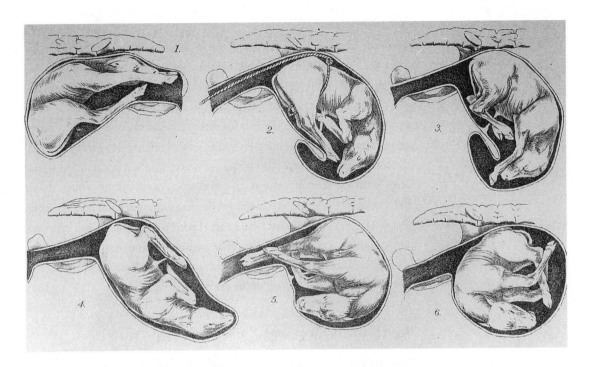

cult ("*tutta sforciata, misteriosa e difficile*").[67] In Renaissance terms, figures struggling against themselves were bedeviled by loss of faith or sin, and the more desperate the fight, the more evil the figure. There are grotesquely contorted figures of Judas, writhing in agony at his imminent betrayal of Christ. In some paintings, his figure is so contorted that it looks as if it is literally broken by sin; such figures may well have reminded viewers of bodies broken on the wheel and other torture devices.[68] In less virulent fights, the soul might still be saved (as in Michelangelo's "slaves"). In the twentieth century, specifically Christian and Neoplatonic thoughts have been dispersed, but the fundamental meaning of the figures remains clear enough: contrapposto is still a matter of discontent, excessive unease, and pain, and its formal vocabulary will remain in place as long as the human anatomy remains constant.

In this respect, contrapposto is not only a Western invention, although certainly its more specific meanings are Western. There are figural possibilities in non-Western art that were never explored in the West—for example, terms describing how corpses can be fit in cramped graves (the Yamnaya posture, with knees up; the Lepinski Vir posture, with knees splayed to either side and feet together), and many other examples in Indian dance and the *asanas* of hatha yoga.[69] I would only claim that in each

FIGURE 31

Abnormal positions of calves in utero. From Atkinson [no initial] et al., *Report on the Diseases of Cattle* (Washington, D.C.: U.S. Government Printing Office, 1912), pl. 17.

instance, the body's discomfiture at itself, or the figure's mastery of its own rebellious body as it is expressed in the "lotus position" and other yoga poses, will be part of its meaning. Contrapposto is a universal sign for unease, and it can even be found outside of the human figure—for example, in a dog that wrenches its body around in search of a flea, or in the contortions of calf fetuses incorrectly aligned for delivery (Figure 31).[70] These are not human postures, but they express confinement even more directly because they are not. It would be painful to twist into a position like number 6, with the feet almost touching the nose and the head pushed down and sideways; the inhuman shape speaks about compression and claustrophobia in a way no human figure can. There is nothing beyond contrapposto, and no way, I think, to leave it entirely behind, but there are new poses to be explored, and images like this are the most promising places to look for new configurations of the body.

The Very Shape of Our Idea of Bodily Motion

The body doesn't separate and arrange affective signs the way language does. Signs of emotion on the face are subject to blurring as one emotion clouds another, and they are prone to disappear when the face becomes neutral. Signs on the body fail to communicate reliably because they are indistinct, and even though it can be argued that the body has a larger repertoire of positions than the face, those positions are not unambiguously correlated with individual emotions, but rather are collectively related to a small number of emotions that converge on thoughts of unhappiness and torment.

Still, it does not make sense to abandon either physiognomy or contrapposto, because each is the only available lexicon of expressive motions aside from the narrower systems of medical semiotics or the transient systems of symbolic gestures and expressions that each culture reinvents for itself. Bodies can only be in contrapposto, and they must finally take their meanings from the heritage of contrapposto, unless they choose one of five non- or anti-Western options: attempting to return to the periods before the Renaissance or before classical Greece, where frontal rigidity was the only available mode; trying to escape from Western modes altogether, by adopting non-Western conventions; breaking the body itself, as Picasso and Beckmann have done; exaggerating it in plastic or expressionist deformations, as Bacon has; or abandoning it for abstract gestures. But how sure can we be that even those strategies can avoid contrapposto? I have

argued that Michelangelo's attempt at the first solution was unsatisfactory, and I would argue that the search for non-Western forms will ultimately fail because even the most unfamiliar kinds of bodies will quickly come to be seen as signs of their specific Western time and place. (Just as the collection of pictures in this book is a sign of late-twentieth-century interests.) What about breaking the body, or pulling it into an outlandish shape (Figure 32)?[71] It seems to me that this strategy will also fail because despite whatever meanings are elided by the fantasy of bonelessness, it won't be possible to evade the basic possibilities of the normal body, and those possibilities will be circumscribed by Renaissance explorations of contrapposto. Like a great deal of comic art, the undistorted part of the standing figure in this cell is pure Renaissance contrapposto, fleshed out with muscles that Michelangelo taught us to see and shaded with a twentieth-century version of academic hatching, which was itself practiced most influentially by Michelangelo. When the battle is over, both these figures will snap back to their art-world molds.

These strictures apply even more strongly to the face. What expressions have been invented in the last five hundred years? Even though each individual face continues to differ from every face that has appeared before it, the catalogue of expressions has not changed. And for that reason, even the most ridiculous publications of the physiognomists deserve study because they remain the closest inspections of the nameable positions of the face.

So that story was ended; somebody began another, about
that satyr whom Latona's son surpassed at playing the
flute, and punished, sorely, flaying him, so the skin all
left his body, so he was one great wound, with the
blood flowing, the nerves exposed, veins with no cover
of skin over their beating surface, lungs and entrails
visible as they functioned.

—Ovid[1]

My body is infested with worms,
my skin is cracked and discharging.

—Job 7:5[2]

And you die living, and your bones are no more than
what death has left, and committed to the grave. If this is
correctly understood, every man would find a *memento
mori*, or a death's head, in his own mirror; and every
house with a family in it is nothing but a sepulcher filled
with dead bodies.

—Quevedo[3]

three Cut Flesh

Few pictures of the living, conscious body open the skin and reveal what is inside. There are the medical videos of tiny cameras crawling along passages deep in the body, photographs of operations done with local anesthetic, and news footage of people stunned by explosions, looking down at their torn bodies. There are also faked wounds, from *Night of the Living Dead* to *Dead Ringers*, from Hermann Nitsch's bloody performances to Philippine "psychic healing" operations done without surgical instruments.[4] These examples are marginal not only because they are painful to watch but also because the inside of the body is a powerful sign of death. Even in *Beowulf*, bodies are "houses of the spirit" or of "bone," and any cut can be a "wound door" (*bengeat*) that allows the spirit to escape.[5] It is normally impolite even to look at the places where the inside of the body becomes visible—the twilight of nostrils, ears, mouths, anuses, vaginas, and urethras. The inside is by definition and by nature that which is not seen.

The early Babylonian demon Humbaba (Figure 33) is a spectacular counterexample: he had a face made out of his own intestines.[6] (This particular object has an omen inscribed on the back that relates to the divination of intestines.[7]) In the epic *Gilgamesh*, Humbaba appears as the Guardian of the Cedar Forest, a terrifying monster who challenges the heroes Gilgamesh and Enkidu. When they meet, Humbaba screams out an imprecation that is only partly legible in the surviving versions, and all the more frightening for that: "Gilgamesh, throat and neck, / I would feed your flesh to the screaming vulture." But Humbaba's awesome face is oddly hidden from our view because there is a lacuna in the tablet just

when the heroes get their first look at him. Gilgamesh stares, and whispers to Enkidu, "My friend, Humbaba's face keeps changing!" The line might also mean "Humbaba's face looks strange" or "different," but the image of roiling intestines is clearly legible.[8] At this point, two more lines are missing, so Humbaba's face, as a modern editor puts it, is "lost in a break." How does one kill a monster who wears his insides on the outside? Gilgamesh slays him by turning him once again inside out ("they pulled out his insides including his tongue"). But how could that have been done? What was *inside* Humbaba when his intestines were already outside?

This is all we know of the battle in *Gilgamesh*, and ancient images do not add much more.[9] It is possible that Humbaba was wearing a tegument of intestines, the way that the Aztec god Xipe Totec, "Our Lord of the Flayed One," wore human hides.[10] Perhaps Gilgamesh did not recognize Humbaba's inversion and killed him the ordinary way, by evisceration: but it may also be that Humbaba already was eviscerated, and could only be killed by being returned to his normal state. I would rather read the story that way, since it provides a myth of origin for the question of inside and outside: before Humbaba, the myth might say, it was still pos-

sible to wear intestines on the outside. In Humbaba's time, the intestines might come out of the body and swarm over its surface. After Humbaba, a normal person will die if his intestines are exposed and a monstrous person will die if his intestines are hidden. For Humbaba, evisceration was life, and death was a paradoxical, fatal restoration of the insides to their proper place.

In my reading, the story is about the importance of keeping the insides where they belong. After Humbaba, we all hide the insides of our bodies: we patch and bandage wounds, and we hide the moments when the inside

has to come out. It may seem that Humbaba is a one-of-a-kind monster, but his descendants are still around. He was the ancestor of the archaic Greek Gorgon, from whose face we have the Medusa and ultimately our stagy science-fiction monsters like *The Blob* and *The Thing* (Figure 34) whose insides spill out and kill whoever comes near. Just before this scene, the Thing emerged from a dog by inverting the dog, Humbaba-fashion. Then, to defend itself, it sprouted insectlike appendages. For a moment, it suited the monster to use the dog's face, but then it grew large arms and pulled itself up into the rafters. Carpenter's film is among the most extreme and inventive fantasies on bodily metamorphosis in the history of motion pictures. There is a moment, just before the monster is apparently killed, when it is nothing but a lump of sodden viscera, as if it were resting from its many transformations. But then, in the frame shown here, it senses its attackers and pops out eyes to see them better. It assesses the danger it is in, and at the last moment eviscerates itself, projecting a lampreylike mouth. In *The Thing*, bodies change at the speed of thought: whatever the Thing needs, it can grow in the span of a second or less.

The Thing owes its more purely visceral moments to movies like *The Blob*, which in turn derives from a British film of the 1950s, *The Creeping Unknown*, a story about a formless mass that coalesces from the melting remains of an astronaut. The movie was created in consultation with Graham Sutherland, who had been experimenting with crucifixions in which carcasses and abstract heaps of organs and bones are draped over the cross and studded with thorns and nails. Like Francis Bacon, Graham Sutherland had gotten the idea largely from Picasso, who had toyed with the idea of a crucifixion of bones and tattered flesh in a series of paintings and drawings done in the late fall of 1932.[11] In this way, the inverted bodies of *The Thing* have their antecedents in British and Spanish painting of the midcentury, and before that in the Greek Gorgon and ultimately in Humbaba, the eviscerated monster. Sándor Ferenczi's reading of the Medusa's face—as a sign of the female genitalia, according to him the most horrifying thing that can be seen—is one of many possible meanings of Humbaba's body.[12] It must have been a difficult body to comprehend (as Gilgamesh said, it kept changing). What did Humbaba's genitals look like? Was his penis an invagination? Was his anus a snaking penis? Humbaba's total, encompassing, changing inversion and evisceration is the worst of the catastrophes that can overtake the body.

To keep the inside hidden is to stave off death. When a body is opened

FIGURE 35

Eighteenth-century sutures.
Source unidentified. From
Jean Starobinski, *A History of
Medicine* (New York: Hawthorn,
1964), n.p.

accidentally, we do everything possible to keep it closed. The history of
bandages involves sutures, knots, staples, pins, bolts, clamps, and other de-
vices, all intended to make an airtight closure (Figure 35).[13] Older sutur-
ing methods include the use of skin substitutes (leather patches, parch-
ment), tied in place with animal cords (catgut, horsehair, silk) and secured

with animal paste (fish glue, bone size). A wound is a deficit of skin; hence, the cure was an excess of skin.[14] In non-Western cultures and in early Europe, the skin of the type of animal that had caused a wound was sometimes believed necessary to heal the wound. The Irish writer Tomás Ó Criomhthain describes how his leg was saved after it had been bitten by a seal: his friends killed another seal and "stuck a lump of the seal's flesh tight" into the gap in his leg—literally sculpting his calf into shape with animal meat.[15] Suturing has found new resonance in fiber arts, where it has become entangled with the histories of sewing, crocheting, and weaving. The confluence of torturous devices to mend the body and "feminine" closures in clothes and fabrics makes an interesting field of possibilities, and contemporary art often plays the themes of domesticity and pain against one another, as in works by Annette Messager. Her fabrics and stitched pieces are overtly domestic, but so are her hanging collections of photographs of body parts, which are reminiscent of walls hung with arrangements of family photographs (Figure 36). Some, like this one, are in bodylike clumps, and the strings that hold them up are like sutures as much as stitching.

The subject of this chapter is as much the defense against death as the depiction of pain, because where viscera predominate over skin pain is no longer the ruling meaning. Suffering is certainly implied in representations of opened bodies, but it is not the twinge of a sensation on skin (as described in Chapter 1) or the sharp pull and compression of limbs turned in violent contrapposto (as described in Chapter 2). Pictures of opened bodies conjure states that edge from pain toward shock, unconsciousness, coma, and death.

The Fluid Flesh

Flesh, as opposed to membranes and skin, is a fluid. According to the linguist Carl Buck, Russian, Lithuanian, and Lettish (Latvian) words for "flesh" all derive "from the notion of a filmy, 'floating' covering." They are related to the Sanskrit prefix *pluta-*, meaning "floating," and ultimately to the Indo-European root *pleu-*, denoting "flow" or "float."[16] In those languages, as in Indo-European, flesh is something that floats, a liquid rather than a solid such as the bones. The skin is like a scum congealed on the body's surface, and the muscles are like curds, sunk in its depths. Greek terms for the body also partake of these liquid metaphors: Greek *thumos*

can mean "spirit" or "anger," but it can also be a liquid that "boils and swells in the innards."[17]

This way of imagining the body as a congealed jelly, part fluid and part solid, has its echoes in eighteenth-century experimental medicine. In the course of pondering the nature of bodily "fibers" and tissues, Albrecht von Haller was struck by the profusion of "net-like" membranes in the body— some hard and thick, others "pervaded by a flux of some juice or liquors" or formed in the shape of tunics or coats, cylinders, or cones. According to Haller, these watery or oily "web-like substances" are one of two kinds of tissues in the body; the other is "a mere glue" between that lubricates them. But on closer inspection, he says, it proves difficult to tell the "mere glue" from the membranous fibers. Cartilage, for example, appears to be "scarce any thing else than this glue concreted," and in the end "even the filamentary fibres are all first formed of such a transfused glue." Bones are constructed from a "compacted gluten," a fact demonstrated by diseases in which "the hardest bones, by a liquefaction of their gluten, return into car-tilages, flesh, and jelly," and the opposite happens when the muscles age and dissolve into "mere jelly," or when bones, skin, and tendons are boiled down to make size (animal glue). The development from fetus to adult is the transformation of fetal "jelly" into the inextricable colloid of mem-brane and glue, which dissolves again in old age.[18] Seen this way, the body's membranes are nothing but a temporary state, a flux of jellies:

> It seems, then, that a gelatinous water, like the white of an egg [*aqua albuminosa*], with a small portion of fine cretaceous earth, first runs together into threads, from some pressure, the causes of which are not our present concern. Such a filament, by the mutual attraction of cohesion, intercepting spaces between itself and others, helps to form a part of the cellular net-like substance [*cellulosam telam*], after having acquired some toughness from the neighboring earthy particles, which remain after the expulsion of the redundant aqueous glue. And in this net-like substance, wherever a greater pressure is imposed on its scales or sides, they turn into fibres and membranes or tunics; and in the bones, lastly, they concrete with an unorganized glue. Hence, in general, all parts of the body, from the softest to the hardest, seem to differ in no other wise than in this, that the hardest parts have a greater number of earthy particles more closely compacted, with less aqueous glue; whilst in the softest parts, there is less earth and more glue.[19]

Let me propose this as a way of thinking about flesh that refuses the dis-tinction between skin and viscera, inside and outside, hard and soft, in fa-

FIGURE 37

Oskar Kokoschka. *Boy with a
Raised Hand (Hans Reichel)*,
detail, 1910. Oil on canvas.
Private collection.

vor of jellies, oils, "albuminous water," and viscous matter. This perspective
is especially apposite to the visual arts, since there is an affinity between
the slurry of fluids in a surgical operation—the saline wash, blood, and cut
tissues—and the mix of pigments and oils in a painting. Artists who have
tried to depict the body's insides have often drawn parallels between the
body's thickened liquids and the sticky media of oil painting; among the
painters that come to mind are Francis Bacon, the later Ivan Albright, and
the early Oskar Kokoschka.[20] For Kokoschka, the paper or canvas surface
is already a skin, and he worries it, scratching, gouging, and tattooing his
figures and backgrounds (Figure 37).[21] In 1909 and 1910, his painted or
drawn skin sometimes became translucent, revealing vessels underneath,
just as it is possible in life to see the network of capillaries by using color
infrared film or discern superficial arteries through light-colored skin

(these are not veins but are made bluish by the intervening yellow fat). Kokoschka describes his vessels as "nerves," and one of his biographers thought of *écorchés*,[22] but they are not anatomically specific; unlike real arteries, nerves, or lymph vessels, Kokoschka's painted "nerves" are spiky branched things that do not lead anywhere. Their bunching makes them more like varicose veins or cleavages in rock. Around the time of *Murderer, Hope of Women* (in which a figure is shown flayed, revealing the same "nerves"), Kokoschka's paintings show an intense preoccupation with skin and with the possibility of scratching it away, tearing it off, or seeing through it. Portraits such as *Boy with a Raised Hand* are scraped and abraded, as if seeing itself had to become so violent that it could gouge and rasp at the flesh. I have no simple explanation for his strange fascination (I doubt it is related to his thoughts about tensions between the sexes, or to his poverty).[23] Something about the skin seemed wrong to him, and for a while when he was young he invented bodies that are both torn and not torn, or ripped but miraculously alive and whole.

Kokoschka worked with a deep and broad awareness of history, and many currents mingle in his work on subcutaneous forms, translucent skin, and themes of flaying or ripping. His preoccupation with innervation can be traced back to the eighteenth-century interest in the nervous system and the sense of touch, as it is exemplified for instance in Giambattista Piranesi's "flayed" ruins, in which the architectural forms become metaphors for the opened body.[24] Many of Piranesi's plates are large (one is literally the size of a person's body), and the buildings they represent are irresistibly reminiscent of skulls, arms, and torsos or of the body's more abstract "architecture"—its scaffolding, its insulation, its waterproof covering, its often decayed interior. Figure 38 shows a detail of two tiny figures, far up and in the background of a large illustration; they are examining a colossal wall of ancient stonework, called *opus incertum*. Like flies caught in a web, their limbs are bent into the angular forms of the stones, and their bodies are on the point of dissolving into the swirling marks of the etching needle. (The fingers of the more prominent figure are already hopelessly entangled.) Everything here has to do with the body: its flexible skin, its mechanical skeleton, and its unexpected sympathy with stone.

Another source for the awareness of skin's translucence is the seventeenth-century painters' discovery that fingers glow when they are held close to a candle flame. Although the more familiar examples of this come from Georges de La Tour and Michael Sweerts, Adam Elsheimer is respon-

sible for the strangest image—a scene from the *Metamorphoses* in which Hecate, who is mortified when a young boy laughs at her, prepares to transform him into a lizard (Figure 39). In Elsheimer's version, the body is already glowing with the heat of metamorphosis, as his bones begin to liquefy into amphibian softness. In the *Metamorphoses*, the boy, Stellio, becomes a gecko; in Elsheimer's picture, he is on his way—he's a wavering, lacertine mixture of a human, a softened candle, and a salamander.[25] In the nineteenth century, the incandescent flesh of Dutch scenes of sensualism became one of Ingres's broadening range of historical allusions. His images of melted-wax fingers, which Robert Rosenblum noted as his special ob-

FIGURE 38

Giambattista Piranesi. figures looking at *opus incertum*, detail of "Rovine delle antiche fortificazioni del monte e della città di Cora," *Antichità di Cora* (1764), Fig. 1.

FIGURE 39

Adam Elsheimer. *The Mocking of Ceres*, c. 1608. Oil on copper. Madrid, Prado. Ampliaciones y Reproducciones "MAS."

session, owe something to the candent fingers and tapers in Michael Sweerts and Georges de La Tour, and before them to the entire tradition of translucent bodies that began with Caravaggio and Elsheimer.[26]

In our century, there have been various attempts to show the body's fluids, and the cuts that make them accessible. Sally Mann's photographs explore the fluids and bodies of children; Kiki Smith juxtaposes photos of the skin with pools of blood; Andres Serrano's work involves both the fluids themselves (including urine and blood) and their appearance on the body's cut surface (in the series of morgue photographs).[27] Arguably, Francis Bacon has been most successful in thinking his way toward a kind of fluid body that is at once inside and outside, where there is no longer any

sense to the inside/outside dichotomy. "There is this great beauty of the color of meat," he reminds his interviewer, David Sylvester.[28] The early paintings are only about cutting or slaughterhouses, and they display vast, monstrous carcasses, strings of vertebrae that could only come from dinosaurs, and popes whose mouths are bloodied as if they had been assaulted. After the 1960s, however, Bacon achieved a synthesis of inside and outside, surface and viscera, that is unique in the history of art. (His few followers have tended to return the body to an exposition of mixed viscera, in the manner of Sutherland's monster or *The Thing*.[29])

One might say to begin that Bacon's later paintings still have a notion of skin, although it is not a *surface* anymore but a sense of translucence (Figure 40). The faces appear to be several inches thick, as if they are built of painterly marks and smears, and we are invited to see through to . . . what? A concoction of floating veils, oily smears, sodden cloths, greasy spills, damp papers laid one on top of another. The canvas sometimes looks printed, as if Bacon had rubber-stamped and blotted it; other passages look sharp, like pieces of splintered bone drifting among loosened tissues. When the flesh is deep, it may be a warm pool of slurred organs, and those organs seem to *include* scraps of skin, so that the face is effectively left without any covering. Michel Leiris's face is mixed with itself: his body's armor has retreated into his body, and mingled with it. Bacon's best images are awash in all the body's parts, private and public, human and mechanical, nameless pieces of anatomy and painful pieces of flesh, autonomous organs and dead bones.

Bacon is almost alone, I think, in wanting to break down the dichotomy and see everything by seeing it all at once. Most of the history of pictured and sculpted bodies has to do with skin. Figurative sculptures, for example, tend to identify the skin with the body, in that the texture and density of the bronze or stone is continuous from the skin to the heart of the statue. (Large statues are hollow, but their thicknesses are not skins. What is missing from a monumental bronze sculpture is the organs: the thickness of skin, fat, muscles, and bones remains, but the sculpture has been hollowed like a mummy.) The historical antecedents of Bacon's disheveled bodies are the Renaissance Venetian experiments with the softness and *depth* of the skin, especially some paintings by Titian in which the body's imperfect opacity is represented by translucent layers of paint. Titian's glazes—some of them rubbed until they are almost invisible—remind a viewer of the process of painting, which builds from the bony white gesso

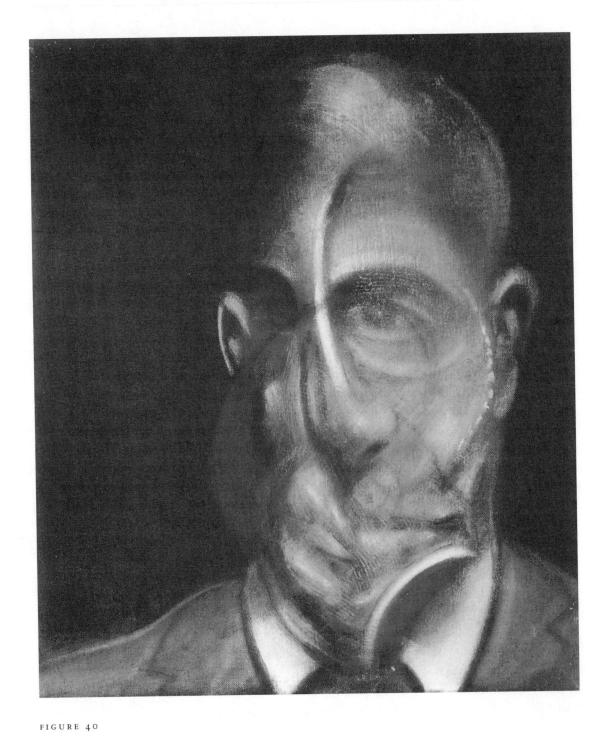

FIGURE 40

Francis Bacon. *Michel Leiris*, 1976.
Oil on canvas. Musée Nationale
d'Art Moderne, Paris. Photo:
Photothèque des Collections du
Mnam-Cei, Centre Georges
Pompidou, Paris.

FIGURE 41

Titian, *Saint Sebastian*, detail.
Oil on canvas. St. Petersburg,
Hermitage.

through thickening layers to a final paper-thin membrane. Such paintings make body into a sequence of oiled sheets. In Titian's late paintings (Figure 41), the delicate veils of flesh are also cut by sharp dry impasto, so that the body becomes a mix of hard and soft, very much as it is in Bacon.

It remained for Bacon to anatomize the body, and to display the process of painting as an anatomic metaphor. He confuses the body's layers, just as the patiently built layers of Venetian oil painting were tumbled together in the thick, impetuous *alla prima* painting that began in the mid-nineteenth century.[30] The works I consider in this chapter, which break the decorum that normally hides the body's layers, are rarely central to Western art. Instead, they help define the mainstream by showing what it is not—by showing what happens when the rules, like the body's membranes, are broken.

Strategies of Resistance

I will not begin with the history of fine art images that represent viscera, both because the history has been told and because it remains marginal to much that is interesting about the body. The exceptions—medical images of unusual power or accomplishment—are rare. Erwin Panofsky has chronicled some in *Tomb Sculpture*, and isolated artists such as Hans Baldung have made persuasive mixtures of nauseating decay and perfect beauty.[31] A less well-known example is the extravagant inventions of Juan de Valdés Leal, especially one of the pair of paintings titled *Los geoglíficos de las Postrimenás* (*Hieroglyph of our last days*), a catalogue of *vanitas* symbols and corruption (Figure 42).[32] The painting illustrates the thirteenth-century legend of the "Three Living and the Three Dead," in which three riders come upon three corpses, one freshly dead, another decomposing, and the third a skeleton. One of them says to the Three Living: "What you are, we were; what we are, you will become."[33] In order to drive home the point, Valdés Leal puts the most horrifying figure in the foreground, in the manner of medieval and Renaissance tomb sculpture. The foreground corpse is *en transis*—in the process of liquefaction, as Poe would say—and so he is a stronger reminder of the painting's moral than the dried skeleton or the fresh corpse. But even here, in a painting so extreme that it was even disparaged by a historian who wrote a book on Valdés Leal, there is little more than a hint of what lies beneath the skin.[34] As Panofsky's examples show, a corrupted skin is enough to show that the body is decomposing. In *Los*

FIGURE 42

Valdés Leal. *Los geoglíficos de las Postrimenás* (*Hieroglyph of our last days*), detail, c. 1672–77. Seville, Hospital de la Caridad. Ampliaciones y Reproducciones "MAS."

geoglíficos de las Postrimenás, worms thread their way through the skin, toads lick at its orifices, and flies settle on its desiccating remains. For Valdés Leal, as for Hans Baldung, the decomposing body is literally only skin and bones. Hans Baldung's figures of Death are skeletons dripping with skin rather than organs. Viscera are unrepresented and often unimagined, even where there is evidence that the artists had spent time looking at rotting animal or human bodies.

In such cases, the repressed inside of the body often returns in the form of metaphor. If we were to look for signs of viscera in fine art, then one of the best places would be Dutch still-life painting, where meat and fruit are commonplace reminders of the body's ingredients. Pieter Aertsen, Frans Snyders, Willem Kalf, and other painters have an affection for objects that have both skin and "viscera": peeled oranges, torn bread, mincemeat pies with flaky crusts, translucent sausages, melons with dried rinds and juicy insides—not to mention freshly butchered joints.[35] There are also reminders of the body's fluid insides: carafes of red wine, pats of butter, tubs and basins of lard, pitchers of milk, bowls swimming with egg yolks. Just as Balthus's still lifes reveal relationships between bodies, any one of the Dutch still-life painters could be studied for their ways of setting out the relationship between elements in the body. In the seventeenth and eighteenth centuries, still life may have been the best excuse for artists who wanted to remain in the fine art tradition and still depict the opened body; in contemporary art, a wide range of materials and forms can evoke the body's insides without needing to allude to the death of any individual person. In that sense, contemporary soft sculptures made of perishable materials are the descendants of baroque still life. The resins, perfumes, oils, and pelts of fiber art speak about the body's insides without leaving the field of fine art, just as their painted equivalents did in the seventeenth century.

To actually depict viscera, it is necessary to partly abandon fine art painting and drawing in favor of medical illustration. Dissection is an especially powerful tool: literally, it is a medical specialty, with its own terms and techniques distinct from surgery; figuratively, it can stand for any act of systematic analysis, from a tentative "probe" to the "sharpest" critique. It can be argued that pictures of dissections are the clearest examples of the desire to see through or into anything, whether it is a body or—by metaphorical extension—an idea. A picture of a dissected body can also be experienced as a literal version of a common trait of seeing, in that the mind's desire to analyze and the eye's desire to pierce and separate are kin-

dred motions, and they are both embodied in cut flesh. Dissection is there-
fore one of the most apt metaphors for the experience of intense, directed
thinking or seeing: the Latin *perspicere*, from which we have the words
"perspicuous" and "perspective," means seeing *through*, as in piercing a fog
or penetrating a dark night. Analytic thought often borrows those visual
metaphors, but ultimately perspective, piercing, and penetrating may all
depend on the fundamental desire (or fear) of seeing through the skin.[36]

The concept of dissection is also philosophically versatile. We speak of
dissecting, revealing, opening, or cutting through to a problem, and the
narrative form known as "the anatomy" commemorates its bodily origins
by avoiding linear or systematic exposition in favor of detailed examina-
tion. When critical inquiry approaches dissective methods, it relinquishes
optical metaphors in favor of bodily ones. Robert Burton's *The Anatomy
of Melancholy* exhibits a wry awareness of the somatic model of thought in
its subtitle, where Burton declares melancholy will be "philosophically,
medicinally, historically, opened and cut up."[37] Anatomizing has to do
with pain, shock, and death: hence, I believe, the "pain" of analytic thought
and of intense vision: they devolve from the partial failure of the covering
metaphor. When Wittgenstein speaks of the unpleasantness and labor of
philosophic thought—its harshness, its closeness, its "slippery" quality—he
is not far from speaking openly about its *pain*.

Pictures of dissections are the most intimate and exact record of those
motions of the mind, and it helps to look at them with the medical termi-
nology in mind. Medicine dissects dissection into a half-dozen specific
procedures, each of which can function as a metaphor for analytic thought.
There is the uncovering of a specific organ in situ (known as "prosec-
tion"), as well as its removal ("excision" or "exeresis"). A doctor can tie to-
gether two separate organs ("grafting"), divide the healthy from the patho-
logical ("diaresis"), or implant a foreign body ("prosthesis").[38] Each of
these terms names a way of thinking about a problem: Jacques Derrida's
neologisms, such as *différance*, are prostheses in the text of philosophy—im-
plants, which may or may not be assimilated. (They may "take," or they
may be rejected.) Each term also has its corresponding narrative forms.
Montaigne, for example, touches on most of these strategies in the course
of failing to speak in a logical fashion about his subjects.[39] Given the con-
fluence of words for dissection, seeing, and thought, it is not surprising that
these words are also well fitted to describe the process of *depicting* bodies.

Many of the ways artists build bodies have their parallels in the ways

doctors disassemble bodies. An artist might separate one shape from an-other, in order to make it clearer (thus performing a prosection), or as-semble an image by placing disparate forms on top of an existing field, collage-fashion (thus adding prostheses to an organic base). De Kooning's abstractions come to mind, especially those strewn with incongruous toothy grins and women's body parts. When a woman's face or breast emerges from the surrounding slurry of gestures, it is prosected (artificially heightened); when a mouth is pasted onto the canvas, it is prosthetically inserted (literally forcing the abstraction to become figural). All image making involves diaresis since it is the act of identifying useless, "patho-logical" forms and salvaging interesting, "healthy" ones. In both medicine and painting, part of the challenge is to create a structure of clearly artic-ulated forms out of a state of incoherence and confusion.

Older medical illustration is a better place to study these ideas than contemporary medical imaging, because the latter has been built, over the last two centuries, on ideals of simplicity and schematization. The kinds of questions asked in the literature on medical imagery have to do with the density and arrangement of information, rather than the meanings of the images as representations of the body. How much of the tangle of tissues should be depicted in a single illustration in order to retain "readability"? To what degree is idealization preferable in order to help the eye "process information"? The ongoing interest in "painless" computer-assisted im-ages, together with these questions of efficient visual communication, can be read as a double resistance: on the one hand, medical imaging represses the complicated and unsettling presence of the opened body; on the other hand, it resists the potential power of the images themselves by draining their visual interest, leaving a pure and uninteresting residue.[40] One might say, for example, that if contemporary digital medical images were to be-come more intricate (or even if their resolution were to increase), they would become more effective at expressing pain, and so the simpler visual displays commonly in use serve both to repress thoughts of the living body and to avoid being seen *as pictures*. The former quality has been stressed by E. J. Cassell, who describes the recent history of medical illustration as a matter of "depersonalization" and connects it to what he sees as the med-ical profession's reluctance to come to terms with the suffering of pa-tients.[41] In any case, a more reflective history of recent medical imaging would have to take into account the lingering feeling of discomfort and pain that accompanies even the most artificial and highly processed im-

ages; it might be argued that computer-generated images of the body are likely to cause uneasy twinges of recognition, since the observer is likely to be reminded about what such images exclude.[42]

Older medical illustration is not different from contemporary imaging in its content so much as in its attention to the body's more unruly or anatomically meaningless forms, and for that reason it is more often the site of interesting visual thinking about the body's insides. Cassell distinguishes older from newer medical illustration in part by pointing to the "metaphorical" content of some older illustrations. But when a Renaissance medical text shows a woman with a prosected bladder accompanied by picture of water running under a bridge, or a skeleton contemplating a skull, is it operating so differently from contemporary medical illustrations? More recent medical treatises gain a powerful metaphorical meaning of their own by displaying fragments of bodies rather than whole revivified bodies. A comparison might be drawn between that fragmentarian program and atlases of architectural details, mechanical movements, or machine parts. In each case, a single illustration will normally show only a part of a larger mechanism, and it will decline to depict the totality of the object or its function in relation to other objects. For these reasons, I would not want to cast the history of medical illustration as an increase of interest in efficient visual communication as opposed to an interest in pure visual incident, nor as the gradual ascendance of a scientific mentality over a "metaphorical" or religious one. Instead, it seems that the question is which meanings are excluded, and which permitted.

Andreas Vesalius's version of the dissected body, a traditional starting place for histories of anatomic illustration, is robust and curvilinear (Figure 43).[43] Even in the long tradition of copies and imitations, Vesalius's woodcut lines are harsh and strong, and they have spring and tension—what Hogarth later called "the inimitable curve or beauty of the S undulating motion line."[44] Another version of the body, best realized by the eighteenth-century anatomist Bernard Siegfried Albinus and the artist Jan de Wandelaer, is elegant, slim, and perfectly measured (Figure 44).[45] Albinus's figures are engravings rather than woodcuts, and they have some of the most attenuated and beautifully controlled lines in the history of that medium. Together, Vesalius and Albinus may be taken as paradigmatic images for the Western history of anatomic illustration; the two choices they represent ruled much of the succeeding history. But at the same time, it would not be entirely correct to account for the difference by describing

FIGURE 43

After Andreas Vesalius. Male skeleton.

Vesalius as protobaroque or Albinus as protoneoclassical. There is more at stake in Vesalius's strong line than a version of Roman contrapposto, and there is more to Albinus's renunciation than the geometrizing tendencies of the mid-eighteenth century.

The Vesalian body is a rough attempt to describe the opened body itself, to minimize what I am calling the "resistance to death." He denies the fact of death outright by representing a living (sometimes a sleeping) figure. A live model, displaying its own viscera, is the paradox of choice in much of older medical illustration as well as medical sculpture. But here we need to be cautious, because few anatomic illustrations present figures as if they were unambiguously alive. How, after all, does an eviscerated figure sleep? How relaxed can a flayed figure hope to be? In medieval anatomic illustration, "Wound-Men" show their opened bodies with the indifference of a demonstrator pointing to an actual corpse.[46] That tradition is strange enough, but it became openly paradoxical when Renaissance naturalism made it possible to give the "Wound-Man" an expression so that he might begin to show some psychological awareness of his position. Charles Estienne's work contains inappropriately elegant scenes of women lying or sitting in their beds, in exquisite *maniera* contrapposto, with their skin cut away and their entrails hanging out.[47]

Some figures in Giovanni Valverde's *Anatomia del corpo humano* retain the medieval obliviousness to their own suffering, but others evince an odd sense of discomfort. In one (Figure 45), a figure grasps his skin in his teeth, and he turns aside and winces—partly from the effort of pulling the skin, and partly, it seems, from pain. Valverde's description echoes that strange possibility without quite saying what is happening: "This figure," the caption reads, "shows where the intestines are, and demonstrates the net of vessels, and turns backward, and pulls with its teeth."[48] How are we to read such an image? I would prefer to think that there was some awareness on the artist's part that the "Wound-Man" convention was illogical and that he might have felt some empathy with the figure he was drawing. Earlier, Vesalius had tried to solve the problem by representing an eviscerated torso as if it were a marble sculpture that had been truncated along the lines of the Farnese torso: where the abdomen is cut it reveals organs, but where the limbs are fractured they show blank marble. The figure even has the kind of "Roman joints" by which sculptures are assembled: one side of a limb is carved into a peg (that is, a bonelike structure), and the other is drilled (so that it resembles a deboned carcass).

FIGURE 45

"Wound-Man" demonstrating
his own intestines. From
Giovanni Valverde, *Anatomia
del corpo humano* (Rome:
Antonio Salamanca and
Antonio Lafreri, 1560), book
III, p. 94, pl. 1, Fig. 3.
Department of Special
Collections, University of
Chicago Library.

All medical illustration retains these paradoxical features because it is rarely entirely clear whether the body is alive and anesthetized, or a corpse, or a cadaver, or merely a schematic or mnemonic for the body. Fundamentally, the situation is irreparable because the uncanny look of anatomic illustration proceeds directly from the uncanniness of the corpse, which trespasses on the places of the living until it is buried.[49] Vesalius's inhuman robustness denies the body by strengthening it into sculpture, and that denial is even more effective because it led his artists toward the "undulating motion lines" that have often been read as the fruits of close observation even though they have only a fortuitous, intermittent correspondence with the body's forms. Albinus's taut linear manner denies the body by weakening it into a geometric diagram, and his strategy is most persuasive when his exactitude forces the viewer into a false sense that the pictures are close to reality. There is pain in both texts, but it is muted—in the one case by sculpture, and in the other by geometry.

Toward Pain and Incoherence

It is nearly impossible to come to terms with the inside of the body. Organs and cut flesh are virtually excluded from fine art in favor of the abstract pairing of skin and skeleton, and in medical illustration they are largely replaced by subtle abstractions that turn the body toward the domains of geometry, architecture, or sculpture—or toward the weightlessness of the cathode ray tube. Metaphorically, such images elide the real hazards of analytic thought. Yet there are pictures that do justice to the fact that dissective thinking is harsh and uncompromising and takes place in a domain of radical complexity. Among the most accurate representations of the body's inside before the invention of photography are plaster and bronze écorchés (some of them made directly from wax casts of muscles and bones).[50] Ludovico Cardi da Cigoli's écorché called *The Beautiful Anatomy* (*La bella Notomia*), made shortly before 1600, is the usual starting place for the history of Renaissance anatomic models, but wax models are attested in Pliny, and from 1200 to 1600 many anatomic wax ex-votos, called *bóti*, were made in honor of the Madonna in Or Sanmichele.[51] Major collections of wax models are found in medical museums in London, Paris, Vienna, Budapest, and Florence; some models have an unsettling degree of realism—they are fitted with human hair and arranged on real linen beds (Figure 46).[52] (The woman in the Specola Museum can be disassembled,

FIGURE 46

Clemente Susini and Giuseppe
Ferrini. Life-size wax model
of a pregnant woman, 1782.
From Benedetto Lanza et al.,
Le Cere Anatomiche della Specola
(Florence: Arnaud, 1979), p. 57.

Masson et Cⁱᵉ Editeurs. Paris. *Impⁱᵉ Firmin Didot et Cⁱᵉ Paris.*

FIGURE 47

Trichophytie afflicting the upper chest. Color lithograph, based on a wax model at the Hôpital Saint-Louis, Paris, no. 1760. From Ernest Besnier et al., *La Pratique dermatologique* (Paris: Masson, 1904), vol. 4, pl. 13, facing p. 496.

all the way down to a fetus in her womb.) The Musée de l'Hôpital Saint-Louis in Paris has a large permanent display of dermatological diseases sculpted using a mixture of beeswax and resin (Figure 47).[53]

At the limits of this kind of replicative realism are cadavers that have been preserved by injection or varnishing; they are the ancestors of latex body casts by John De Andrea and other contemporary artists. The Renaissance practice was to coat corpses in honey; the eighteenth-century anatomist Frederick Ruysch preserved bodies more permanently in a mixture of talc, wax, cinnabar, wine, and black pepper.[54] Honoré Fragonard, a nineteenth-century anatomist, made exquisitely detailed and pedagogically useless models out of varnished cadavers.[55] Like De Andrea's sculptures, the most accurate preserved bodies are astonishing from a dis-

tance, and repellent close up—in De Andrea's case, the dusty hair and opaque skin seem particularly inhuman, and in the preserved bodies, the alcohol or varnish shines in a way that fresh viscera do not. The wax bodies in the Specola Museum in Florence lie on tattered beds, and they are inevitably covered with a film of dust. De Andrea's immediate sources are performance art, surrealism, and illusionistic sculpture, but his deeper affinities are with polychrome sculptures in baroque churches, mummies preserved in church crypts, and naturalistic medical sculptures by Ruysch and others.[56] Varnished bodies and wax *écorchés* are among the most unflinching representations of the body, but they belong largely outside the history I am recounting because they are one-to-one reproductions, rather than representations. They demonstrate that it is possible to visualize the inside of the body, but that in order to do so it may also be necessary to lay down the tools that Western artists have always employed in favor of the almost mechanical duplication of the body.

The few pictures that come to terms with the viscera tend to be marginal even in the history of medicine. By rescinding the artificially clear shapes and colors of most medical textbooks, they risk becoming pedagogically useless: an inexperienced viewer, such as a first-year medical student, is apt to search in vain for a recognizable landmark in the chaos of fat and poorly dissected tissues. Such pictures can also seem unpleasantly close to their subject, as if they were the products of pathological fascination, rather than scientific curiosity. The necrophiliac effect is best seen in works that predate photography, such as Govert Bidloo's *Anatomia humani corporis* (1685).[57] The plates in Bidloo's work were commissioned from a number of artists, and they vary widely in quality (the best are by Gerard de Lairesse), but they share an interest in accurate transcription that can be well described as an offshoot of contemporaneous Dutch realism.[58] Parts of dissecting tables, knives, knife-holders, ropes, and swatches of white linen appear alongside the corpses as if they were props in still lifes—or as if bodies had been dumped in the middle of ordinary still lifes. Custom-made blocks of wood, dowels, and metal skewers serve to prop up sprawling organic forms. In some plates, large hunting knives are strewn about or thrust into the tabletop, and bodies are held up with ropes (Figure 48).

At first, it might seem that this is not only necrophilia but sadomasochism as well, but that would be too harsh a verdict, since the knives and ropes are the stock-in-trade of contemporaneous still life. The mus-

FIGURE 48

Gerard de Lairesse. Superficial
muscles of the back. From
Govert Bidloo, *Anatomia humani
corporis* (Amsterdam: Joannis à
Someren et al., 1685), tab. 27.
Department of Special
Collections, University of
Chicago Library.

cles are seen with an artist's eye, which is to say that they are seen too
well, with a useless precision. Here the trapezius, the large muscle of the
upper back, is shown in all its asymmetric detail, with its corrugated in-
sertions into the fascia around the spine—details omitted from the great
majority of anatomic texts because they are not medically significant. The
half-flayed right arm is shown in full, with globules of fat still adhering to
it, and a relaxed hand resting on the tabletop—all irrelevant to the sub-
ject. The book had less success than Bidloo hoped, largely because of its
inappropriate fastidiousness and Bidloo's habit of doing elaborate prosec-
tions that destroy all sense of the relation of anatomic parts.[59] If Bidloo's
book is still occasionally perused (as far as I know, it is never *read*), it is on
account of its author's sensuous attachment to flesh. Mario Perniola has
said that Bidloo's work is "one of the high points of Baroque eroticism,"
an opinion that can have two very different meanings: on one hand, it
might refer (as Perniola intends it) to a general erotics, which includes
other illustrations of the "little death" such as Bernini's ecstatic *St. Teresa*;
on the other hand, it might indicate a displacement of the desire for the
skin onto the viscera—a dangerous and illicit attraction, specific to med-
ical illustration.[60]

Albrecht von Haller's *Icones anatomicae*, first published in 1743, is an-
other text in this tradition.[61] At times, his plates can be nearly unrecog-
nizable abstract patterns of tissue (Figure 49). In this instance, the subject
is the female reproductive system. The only parts that are external are at
the bottom, where the labia and clitoris are clearly visible, along with a
scattering of pubic hairs.[62] Above them hangs the vagina and ovaries, as
encrusted with fat and other tissues as a ship with barnacles. In the adhe-
sions—they would be cut, literally and figuratively, in an average anatomic
illustration—it is possible to discern vessels, skin flaps, fascial webs, bags of
fat, lymph networks, and neighboring organs. Here one of the strains of
Western anatomic illustration, the stubborn desire to see everything and
to make everything representable, is taken to an extreme that is also close
to the pathological.

A few even more extreme examples exist, such as Jan Van Rymsdyk's
elephant-folio mezzotints of a pregnant woman, but the real extent of the
body's strangeness did not become apparent before photography.[63] Pho-
tographs show the body's disorder at its most acute: even atlases comprised
of stereoscopic slides can fail to bring out salient features and end up pre-
senting textures rather than nameable parts (Figure 50). Photographs cast

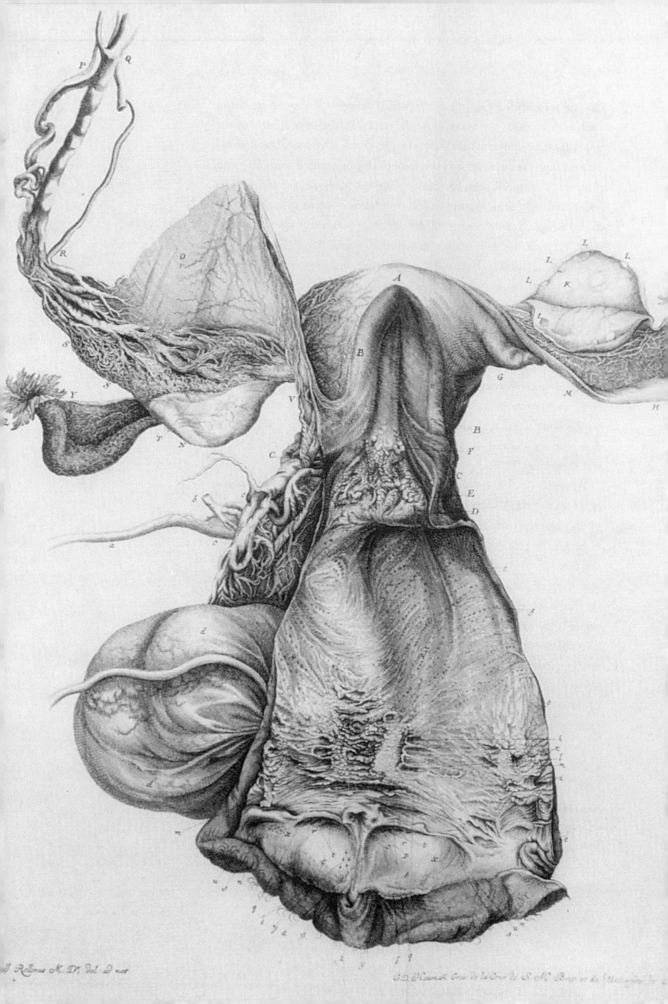

a cold eye on their subjects, and it can be hard to tell whether the photographer is unduly fascinated or just inexperienced—but images like these document the bewildering sight that greeted the early anatomists. Nothing is visible but raw tissue, cut, torn, shriveled in preservative—the very stuff of pain and death.

Toward a Painless Body

Albinus's artist, Jan de Wandelaer, was taught by the Dutch painter Gerard de Lairesse, who had been Bidloo's illustrator, but the difference could not be more marked. Albinus's purpose was to pass over "all trifling varieties" in order to make a "general system" of "most perfect" proportions. The schematic ambitions of neoclassicism, and its interest in linking accuracy and decorum loom large: "I have not only studied the correctness of the figures," Albinus remarks, "but also the neatness and elegancy of them."[64] Although there have been innumerable copies of Albinus's principal plates, few authors reproduce the outline schemata that he put on facing pages. Enlightenment diagrammatics and optical veracity reach a high point in these schemata; their lines are so fine they need to be enlarged before they can become visible in reproduction (Figure 51 reproduces a detail of the key to Figure 44).[65]

The backdrops, which Albinus tells us were Wandelaer's contribution, were intended to make the plates easier to comprehend. (They are therefore an important early example of the trend toward more efficient communication of visual material.) But the settings cannot be entirely ac-

FIGURE 49 *(opposite)*

The uterus and vagina of a young woman. From Albrecht von Haller, "Icones uteri humani," in *Icones anatomicae* (Göttingen: Abram Vandenhoeck, 1761), Fig. 2. Department of Special Collections, University of Chicago Library.

FIGURE 50 *(above)*

Daniel Cunningham. Stereoscopic photographs of a female pelvis. From Cunningham et al., *Stereoscopic Studies of Anatomy, Prepared Under the Authority of the University of Edinburgh* (New York: Imperial Publishing, c. 1909), sect. [volume] VII, "Pelvis and Lower Limb," no. 14.

FIGURE 51

Jan de Wandelaer. Skeleton,
detail of schematic key. From
Bernard Siegfried Albinus,
*Tabulae sceleti et musculorum
corporis humani* (Leiden:
J. & H. Verbeek, 1749–53),
pl. 3. Department of Special
Collections, University of
Chicago Library.

FIGURE 52 *(opposite)*

Jan de Wandelaer. *Écorché* and
young rhinoceros, detail. From
Bernard Siegfried Albinus,
*Tabulae sceleti et musculorum
corporis humani* (Leiden:
J. & H. Verbeek, 1749–53),
pl. 4. Department of Special
Collections, University of
Chicago Library.

counted for in those terms, since they become sinister as the dissections
proceed. The first plate is a skeleton, backed by a fluttering cherub hold-
ing a swag of drapery. The landscape is not deep, and it is foliated and rest-
ful. But as the succeeding plates first restore the flesh and then gradually
pare it away, the progressively revealed body is the object of increasing anx-
iety. The second plate, an elegant *écorché*, stands in front of a Dutch or an
English country house. The third plate's figure, which has lost some super-
ficial muscles, stands in some discomfort in an unaccountable Hell of fire
and brimstone. Its eyelids have been removed, revealing the deep muscles
in the eye sockets and giving the figure a wildly staring expression—ap-
propriate both to its surroundings and to the viewer's growing concern and

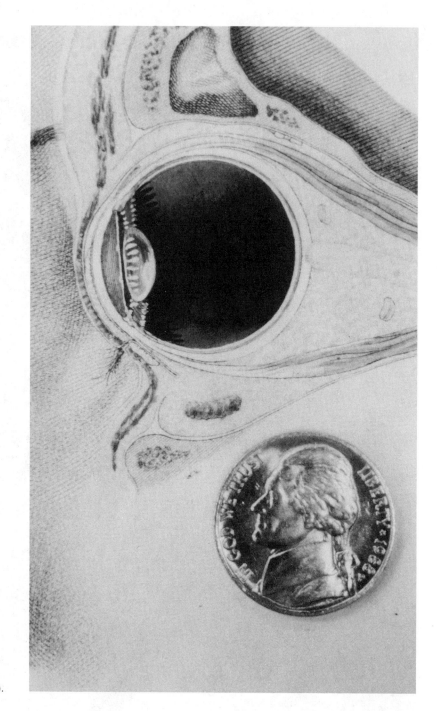

FIGURE 53

Samuel Thomas von
Sömmerring. Cross section
of the eye, detail, with coin
added to show scale. Hand-
colored engraving. From
Sömmering, *Icones oculi
humani* (Frankfurt am Main:
Varrentrapp et Wenner, 1804).

fascination about what is being shown. The fourth plate is an even deeper incursion into the body, with many large muscles missing, and Wandelaer took the initiative of supplying a young rhinoceros as a backdrop, grazing in front of a sepulchral pyramid (Figure 52 shows a detail). It is important to read this element correctly: although Wandelaer says it is only to give the eye a refreshing contrast, it is more deeply expressive of the strangeness of the body itself. At this point, when death—in the form of a sepulchre— is beckoning insistently, the viewer's thoughts are forced onto the inescapable bizarreness of the body. The forms are frightening, alien, and yet they are our own. Wandelaer's implicit proposition—that a human body is like a rhinoceros—can hardly brook contemplation, and his own eye runs a little wild in an excruciating comparison between the rhinoceros's wiry tail, the sectioned penis, and the figure's lacerated right hand.

In such ways, the themes of death and perversion reappear where they seem most effectively silenced by rigorous geometry. Albinus's immediate followers sometimes outdid the fineness of his representations, creating pictures of the body that seek to control its horror by concentrating on geometric precision. Samuel Thomas von Sömmerring's works, such as the *Icones oculi humani* (Figure 53), are the summit of technical skill in medical printmaking.[66] Some copies, like the example shown here, are hand-colored, and many details are too fine to see without a magnifying glass. The eye is shown life-size, like an unmounted jewel. Sömmerring's oeuvre is the apotheosis of the detailed connoisseur's gaze that was first honed on antiquarian studies of carved gems and ancient coins—as I mean to imply by the coin I have added here for scale. At this extreme, the body escapes from itself by pretending it is a miniature: a cameo, something seen through a magnifying glass, a flawless jewel.[67]

Envoi, on the Power of the Body

These are some of the ways that the opened body has been portrayed or that its forms have been avoided. Today the question proliferates in several disciplines. Although most imagery continues to depict the body as a weightless soft cloud—as in positron-emission tomography (PET), computerized axial tomography (CAT), and magnetic resonance imaging (MRI)—the more elaborately prepared images take on the kind of eerie substance that I have suggested raises the specter of real pain. When the images are scanned at higher resolution, refined with image-processing

software, and given artificial colors, they can begin to evoke the body's tex-
tures and weights—and its sensations. An image by Karl-Heinz Hoehne of
a cross section of a mummy's head shows the current possibilities (Figure
54). Here, bone, cartilage, muscle, and blood vessels are not given the tex-
tures we might expect in a naturalistic depiction; instead, they are rough,
heavy looking, and a little spiny, like the back of a desert toad. But the odd
surfaces are definitely solid objects, and their difference from living tissues
only brings real tissues more firmly to mind. In the original, the image is
color-coded in bright yellow, green, blue, and red, and the unnatural colors
work the same way—reminding the viewer of the reds and pinks of a
healthy muscle, or the grayish amber of the brain. Hoehne's image is in-
tended to show how part of a palm frond was driven up the spinal column

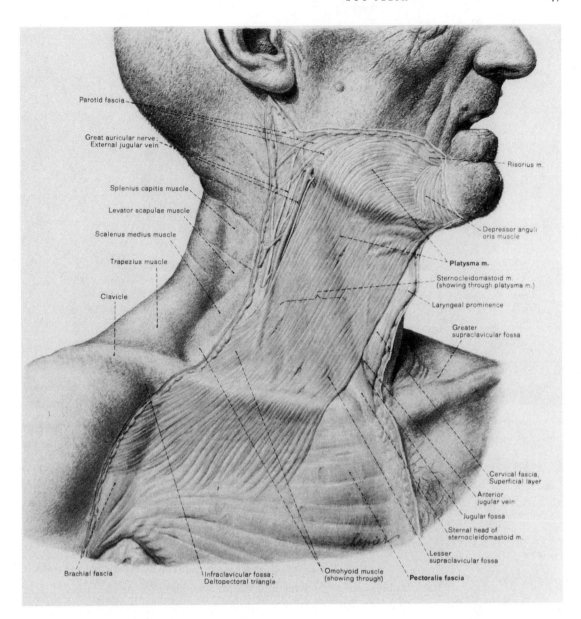

Parotid fascia

Great auricular nerve;
External jugular vein

Splenius capitis muscle

Levator scapulae muscle

Scalenus medius muscle

Trapezius muscle

Clavicle

Brachial fascia

Infraclavicular fossa;
Deltopectoral triangle

Omohyoid muscle
(showing through)

Risorius m.

Depressor anguli
oris muscle

Platysma m.

Sternocleidomastoid m.
(showing through platysma m.)

Laryngeal prominence

Greater
supraclavicular fossa

Cervical fascia,
Superficial layer

Anterior
jugular vein

Jugular fossa

Sternal head of
sternocleidomastoid m.

Lesser
supraclavicular fossa

Pectoralis fascia

and wedged under the brain, and his colors and textures bring home the force and hardness of that act. It's not that far from images like this to openly painful renditions of "painless," noninvasive CAT or PET scans.[68]

The older tradition of drawn and painted anatomic illustration is also thriving, even though most of its products have descended to an abysmal low of airbrushed, transfer-lettered simplicity. Introductory medical texts continue to be published with new illustrations, even though many

FIGURE 55

Erich Lepier. The right platysma muscle and pectoral fascia. From C. D. Clemente, *Anatomy, A Regional Atlas of the Human Body* (Philadelphia: Lea and Febiger, 1975), Fig. 426.

FIGURE 56

Joan Livingstone. *Resistances*,
studio view, 1997. Courtesy
the artist.

nineteenth-century texts exist that are not in copyright and are more ac-
curate than the new work. The twentieth century has a few medical il-
lustrators whose skill ranks with the best of the previous centuries; one of
the most interesting is Erich Lepier, whose plates are reproduced in a
number of contemporary texts.[69] His mode is architectonic, weighty, and
solid, but his forms have exemplary clarity (Figure 55). When he has the
chance to illustrate the undissected body, his work recalls the naturalistic
tradition in art and medical illustration whose common origins are in
fifteenth-century Flanders and Italy; and when he works with the inside
of the body, he balances naturalism with just enough schematization to
transform irregular anatomic forms into legible structures. The platysma,
his subject here, is a disorderly collection of muscle strands (it is the mus-
cle that shows in irregular stripes when the neck is tensed), and Lepier
combs it into a roughly collinear set of fibers. He permits himself a fuller
degree of naturalism only in marginal forms that do not intrude on the es-
sential anatomic lesson: the stubble of the man's beard (which has contin-
ued to grow after death), his warts, and the delicately torn webbing of the
fascia over his chest.

Pictures of the body's inside are also being made in the fine arts, and there we reenter the world of tissue metaphors that we began exploring in Chapter 1. Contemporary work tends to disassemble the body so that it is no longer legible *as a body*, but rather functions as a series of references to the body that take place at various levels and with varying coherence. Artists have made use of medical textbooks since the 1930s and 1940s, taking nearly abstract components and reworking them into diluted references to the inside of the body.[70] An artist such as Lepier would not be of interest for his scientific realism, but he might be attractive because his paint textures are so solid and claylike and his gouache is so dull and flat. In the last several decades, works that refer to the body's insides have become much more versatile. Joan Livingstone's sculptures and prints are replete with body references, and they are carefully distanced from any literal representation (Figure 56). She uses organ- and tissuelike media such as felt and resins, working with the body's textures, weights, and colors rather than with its literal components. Looking at a work like *Resistances*, a viewer might well think of dangling breasts, hanging testicles, or full stomachs—but the thought is softened by the degree of abstraction. This is the body as a sack, a medieval metaphor for the human condition, and an entirely acceptable way to speak about the body's insides from within the art world.

As the exploration of abstract elements proceeds, it follows the tradition I have attempted to sketch here: flirting briefly with the opened body itself, and then avoiding it by reimagining it as something simpler. There have been so many strategies for *not* seeing the body—from television images to architectural elevations—that the choices can seem to be motivated principally by the desire to escape the body's harsh reality. The history of medical illustration can be written as a negotiation between different styles of evasion: the body as an abstract morass of tissue, as an encyclopedia of arcane forms, as a geometric schema, as a jewel. The consequences of *not* avoiding the viscera are dire: to really see the inside of the body is to risk falling in love with the heady proximity of death, with the incomprehensible tangle of unnameable vessels and chunks of fat, and with the seductive textures of the smooth, sensitive membranes—more delicate than ordinary skin, more sensitive and vulnerable, and above all more redolent of the most intense pain.

But in fact all I am is a photographer.

I describe what I see.

—Jean-Martin Charcot[1]

four By Looking Alone

A certain Dr. Jan Dequeker has diagnosed Simonetta Vespucci, the Florentine beauty pictured in Botticelli's *Birth of Venus*, as a sufferer from tuberculosis-related rheumatoid arthritis (Figure 57). As telltale signs, he notes her slightly deviated fingers, a "sausagelike swelling of the left index finger," and "decidedly swollen" ankles.[2] Those symptoms, he remarks, are not entirely unrelated to the qualities for which the painting is admired. The bloated, painful fingers of her left hand repeat the sinuous curves of five strands of hair just off her thigh. An interviewer argues with the doctor: Why, he asks, could it not have been the other way around? Why couldn't Botticelli have drawn the hair first, and tried to rhyme the fingers to it? But Dequeker protests that we do not know which was painted first. Why abandon the medical interpretation for an aesthetic one?

Enclosed in this bare dialogue, reported in the *Wall Street Journal*, are the seeds of an interesting exchange. If Simonetta Vespucci was deformed, then it could be that Botticelli demanded pathology from his women, that he conflated ideal beauty with clinical abnormality. Simonetta's enlarged fingers, toes, and ankles would then have been perceived as if they were of a part with her shaved forehead and plucked eyebrows—as well as her sharply angled elbows, sloping shoulders, swanlike neck, and other forms that Heinrich Wölfflin has described so well as the products of Botticelli's own eye.[3] In that case, an influential aesthetic of the female form would be partly based on a killing pathology. Looking at *The Birth of Venus*, we still need to learn how to *see* that puffy fingers and sharp elbows go together, and the possibility that pain and natural proportions both play a part can

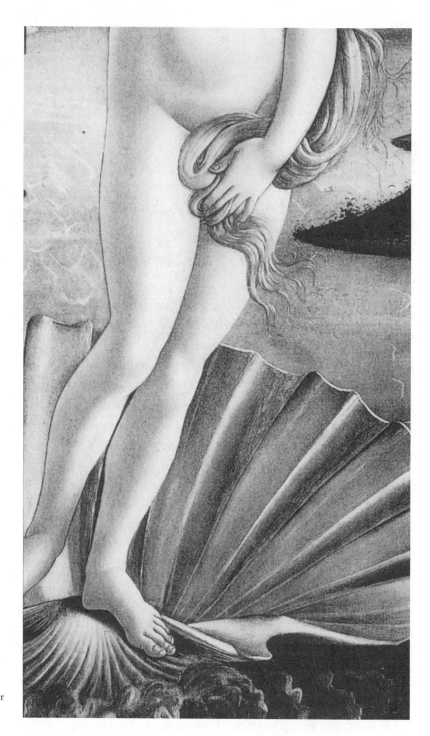

only make that more difficult. We might also want to ask whether Botticelli searched out Simonetta in some degree *in spite of* her condition, and so he might have learned his sense of the female body from an abnormal case. Either way, Simonetta died shortly after the paintings were made, possibly in considerable pain.

I take this story as an epitome of a kind of seeing: it shows how the addition of a few words can radically change the way a pictured body is perceived. No matter what I choose to think about Dr. Dequeker's diagnosis, I will never be able to see the painting again without thinking, no matter how briefly, of pain, medicine, and the doctor's cold and overly firm opinion about the relative unimportance of Botticelli's aesthetic choices. Simonetta's painted figure will force me to recall twinges I have felt in my own joints and to think how her pose might reflect her discomfort—in short, Dr. Dequeker's hypothesis has forever cast her figure into the domain of empathetic reactions that has been the subject of the first three chapters of this book. In another respect, however, his theory transforms what was once a rich set of associations with Renaissance culture, the courts of the Medici, the poetry of Angelo Poliziano, and the ideals of education—all of which are involved in the original context and intentions of this painting— into a much narrower range of medical meanings, in which the historical figure of Simonetta Vespucci is reduced to an illustration of a kind of arthritis.[4] It is that second effect that I will trace in this chapter: Dequeker's verdict does not involve any sense of sympathy—in fact, it's a remarkably cold diagnosis—but it shrinks her significance, turning her from a figure in a painting or a character in late-fifteenth-century Florence into a specimen, a mere example. This is what I will call "metamorphosis by looking alone," and it is one of the deepest bases of racist and sexist imagery.

Bodies That Are Simply There

Some images of the body record attempts—always failed, always hopeless—*not* to alter the body, but to show it as it is: neither cut, nor injured, nor tortured, nor even passionate, but rather simply there. The body becomes a fact, an object, or even a specimen, that can express itself *merely by being seen.*

Here is a body, the artist, doctor, or ethnographer says, standing or sitting or even posing, but just there to be seen. When it seems that the body is merely given, when it is irreducibly *there*, it also appears most in need of

articulable meaning, most suffused with unspoken significance. "Thereness" is the quality I am describing—mere presence, or something merely to be seen—and it is accompanied by a notion, never attained but always declared, that a body can be presented without being manipulated either physically, formally, or ideologically. Thereness is related to the philosophic concept of hicceity, or "thisness": a heightened sense of the object itself, clothed in the perfect mute eloquence of its essential nature.[5] The idea finds some of its most resonant expositions in Heidegger's attempts to speak about the "being" of the work of art and the "place" or "region" beyond metaphysics. In the late texts, such as "Conversation on a Country Path," he tries to be scrupulous about the mode of being that is appropriate to a particular work, even if that work is a nonverbal object, an inchoate mood, or an untranslatable experience; and in doing so, he pushes against the limits of ordinary language. "Regioning," he says at one point, "is a gathering and re-sheltering for an expanded resting in an abiding."[6] Here Heidegger's language springs from a reticence to open a dialogue that would lead back into metaphysics. But I would stress that these hymns to "mere existence" also work to preserve a dangerous silence. An image that says nothing, that has no explanation, that is merely there, is also an image that can seem to be full of meaning: and that meaning will be safeguarded from inspection by virtue of its apparently intimate grounding in unmediated presence.

In visual representation, it's usually quite clear that mere presence must fail or become incoherent, but the conviction that there is such a thing persists.[7] It is not easy to see how Charcot could claim that he was only a photographer, since the photographs he made at the Salpêtrière are redolent with projected and arranged meanings. Indeed, it seems impossible to read them any other way, as Georges Didi-Huberman's study suggests.[8] But Charcot thought that he was being impartial—a "mere" photographer—and therefore that he was merely recording objective truths about his patients. In Lorraine Daston and Peter Galison's terms, Charcot would have subscribed to the myth that the photographic apparatus constitutes an impartial mechanical intervention between object and eye.[9] We know better, and yet we don't know better—as the myriad paintings and photos of "simple" standing figures and nameless subjects attest, from Charcot's patients at the Salpêtrière to the most recent photojournalism.

Given the recent interest in hysteria—which has now taken a central place in some accounts of gender construction—it is important to note

that hysteria, and Charcot's work, was not the focus of the Salpêtrière journal.[10] The full run of the journal, including the *La Nouvelle Iconographie de la Salpêtrière*, contains a wealth of images that have not been discussed in modern scholarship, including many varieties of photographed bodies that each seem to offer the nosography, symptoms, and diagnosis of their own illnesses without uttering a word (see Figures 13 and 23).[11]

The photographic division of the Salpêtrière, like those in German and English hospitals, was staffed by photographers conversant with the fine art conventions of the day, and so it can be expected that some of the medical meaning emerged from planned poses and gestures, and even from arranged lighting and expressions.[12] Sometimes the printed word intrudes on the wordless image, as in hysterical dermography, where the patient responds to the gentle pressure of the doctor's finger by raising welts that spell the name of his or her condition ("HYSTERIQUE," "DEMENTIA PRAECOX").[13] And whenever the pathology involved obvious bodily movements, such as the *arc en cercle* assumed by some epileptics, it was drawn and photographed, as were odd facial tics, tonic spasms, and compulsive rocking (*clownisme*).[14] When the patient would not assume an obvious pose, a stimulus was provided that would provoke one.[15] Needless to say, the Salpêtrière journal is also a rich source for varieties of deception and self-deception, as patients and doctors collaborated, sometimes "hysterically," to provide the mute body with visible meaning.[16]

But not all the pictures manage to graft medical meaning onto the body. Some—in my reading, the most successful—allow the uncanny "thereness" of the body to express itself more directly (Figure 58). The pathetic "wandering Jew" who came into the hospital one day and then left without explanation incited the curiosity of at least one doctor, who wondered what in the face or the gestures might allow him to diagnose the syndrome. The mere presence of a wandering Jew—an "Israélite névropathe voyageur," as the doctor says—was unsettling, but the essay is indecisive because no secure symptoms could be found.[17] In the terms I am proposing here, the body itself was unsettling because it did not obviously provide its own semiotic key, and so it could be said to stand in special need of some explanation. The photograph ends up giving virtually no information: the man, Gottlieb M., clutches his bottle as if he mistrusts the doctors—and well he might, since they have positioned him in front of a torn and stained wall (there are drips down by his right foot) and had him stand for a meaningless photograph.

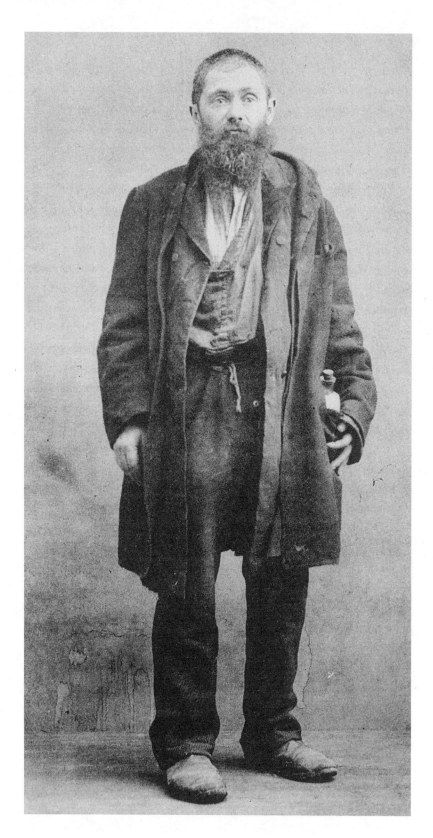

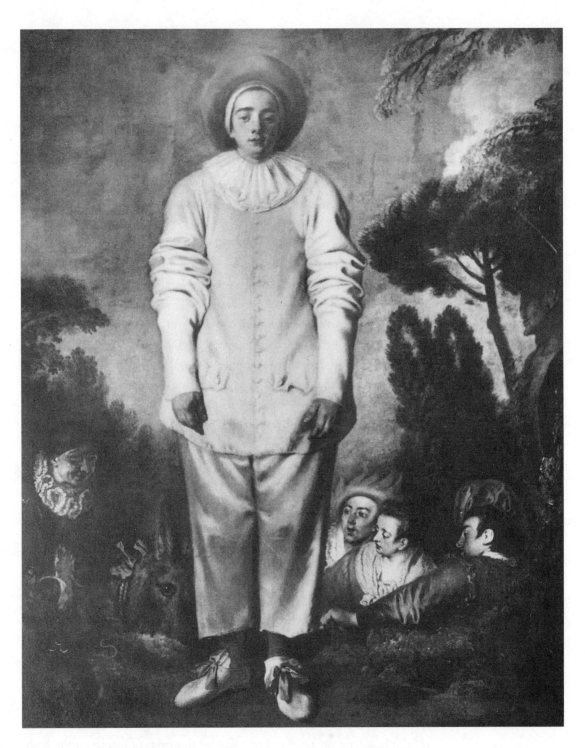

FIGURE 59

Antoine Watteau. *Gilles*, or *Pierrot*,
c. 1721. Oil on canvas. Paris,
Louvre.

Thereness, the capacity to imply meaning without requiring language, is at its purest where there is no setting (a neutral gray backdrop, or darkness), no label or text, and no clothing. Those are the signs—the assurances—that there is no message, no narrative, no *point*, and they are also the signs that the image is free to speak. Thereness names a desire to see and depict such images—a desire that is put to work in pictures as different as the "portrait" of Gottlieb M., and Antoine Watteau's equally blank and docile *Gilles* (Figure 59)—also a portrait of a stock character, a kind of sweet idiot. Racism and fine art share these moments of "simple" presence, and I would argue that there is a deep complicity between them. At the very least, the *merely* beautiful images of standing figures by artists such as Watteau, Louis Le Nain, Ferdinand Hodler, and Alfred Leslie are attempts to invoke qualities of life so simple they can be said to require no story. They express properties of human existence that are self-evident and unarguable, requiring only the presence of the person to ring true. And this is what racist images do, if they are considered apart from their texts: they begin by saying nothing and leave the figure to indict itself.

Without reducing every hieratic pose, every frontal composition, and every naked figure to these terms, I am going to try to connect the concept of merely seeing or merely representing—an indispensable and nearly universal ambition in visual images—to the most virulent kinds of racism, pornography, and ideological pressure. There is something deeply wrong with the ambition to *just present* a body, without also thinking about the metamorphoses affected by merely looking.

Beauty, Normalcy, Ugliness, and Monstrosity

Since the subject here is so utterly fundamental—nothing more than the unadorned body, without its voice, gestures, relations, or reasons—I will begin with some rudimentary distinctions at the base of our judgments of other bodies. Looking at a body that has no obvious purpose is an opportunity to rethink what I am—to see, by comparison, what I believe myself to be, what I am not, or what I may want to become. These are, I think, among the universal uncognized functions of images of the body, whether they are racist images (where the question of my relation or lack of relation to the pictured body becomes harsh and insistent) or just my own image in the mirror each morning. In each case, I start by compar-

ing myself to what I see, and I decide, in the most intuitive and auto-
matic fashion, whether I am the same as or different from the imaged
body. Assuming that I find some difference (even if it is as simple as the
thought that my reflection in the mirror looks older than I am), I set the
body in the mirror or in the picture beyond some limit, some boundary
between that-which-I-am or that-which-I-might-be and that-which-I-
am-not. Using the conventional word "Other" to denote whatever I am
not, this kind of distinction serves to consolidate identity and detach it
from difference:

Self	Other
Identity	Difference

Often enough, my reflection does not appear normal, adequate, or accept-
able. I reject whatever is not myself (say, the wrinkles I hadn't noticed the
day before) in order to set it aside, so that I can remain what I am—and
that is the founding moment of the experience of any image of another
body, whether it is a mirror reflection, a painting by Watteau, or a racist
document.

Historically speaking, normalcy is a concept that is inseparable from
statistics.[18] The statistical mean has been equated both with the moral and
the immoral, the beautiful and the ugly, and it has been opposed to the
"outlier," the freak, the "sport," and the pathological.[19] To Martin Cureau
de La Chambre, a pioneer physiognomist, normalcy was a neutral, feature-
less gray, an "indifferent *médiocrité*." Lavater's physiognomy can also be read
as a statistical enterprise, a search for normalcy or a way of thinking about
the body as a "calculable assemblage."[20] These theories, which lead from
the Enlightenment discovery of statistics to the formal racial theories of
the late nineteenth century and beyond, are approximate versions of what
happens when I assess any bodily image. In judging a body for its same-
ness or difference, I am probably closer to the older typologies of race (the
theories that treated races as classes with uniform members) than the more
recent attempts to enumerate individual characteristics and quantify the
process of judgment. Even so, there are unpleasant similarities between
each informal judgment I pass on another person's face and the harsh
judgments that have been used to distinguish one race from another, one
class from another, or one slave from another.[21]

Once I know the difference between my notion of myself and what I

see in the image, and once I begin to see how such a judgment carries with it a sense of my own relative acceptability to myself, many other more nuanced discriminations follow. When normalcy is at stake, so is abnormality, and perhaps also ugliness, beauty, and monstrosity.[22] Each of us, I think, carries with us a continuously shifting mental schema of the relation between our own appearance and our notions of ugliness or beauty. The most generous conception of self might seek to include the entirety of the human within the fold of bodies that are sufficiently like the self:

Self	Other
Beauty—normalcy—deformity—monstrosity	The non-human

Even the nonhuman can almost be included in the domain of the human by concentrating on types, qualities, passions, or behaviors—the ratlike man, the piglike woman, and so forth.[23] Both Europe and East Asia have indigenous traditions of physiological comparisons between people and animals, but it is difficult to think of the nonhumans as humans, and both traditions are treated as marginal and somewhat humorous ways of thinking about character.[24] For the most part, it is not possible to think seriously about including animals in the category of the human.

More commonly, and more realistically, the search for a well-defined self relies on a trinity of normalcy flanked by ugliness and beauty, and that trinity finds itself opposed to anything beyond ugliness:

Self	Other
Beauty—normalcy—ugliness	Monstrosity, the non-human

Another variant includes only beautiful forms among those that are identified with the viewer:

Self	Other
Beauty	Normalcy—ugliness—monstrosity, and the non-human

Conditions such as anorexia nervosa and obesity and universal processes such as aging provoke an acute, ongoing negotiation of these terms. Petr Skrabanek, who has studied the history of anorexia nervosa, argues that beauty and normalcy only became important to anorexics and their doc-

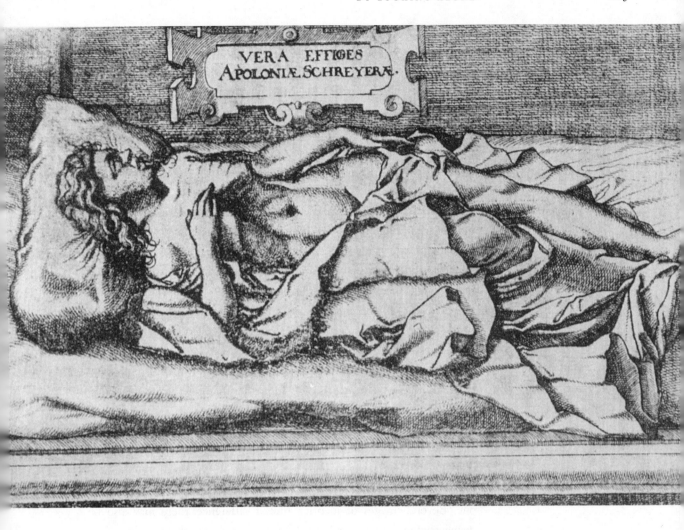

VERA EFFIGIES
APOLLONIÆ SCHREYERÆ.

tors in the last two centuries. From the sixteenth through the eighteenth centuries, he says, anorexia was described as a medical condition unrelated to beauty; and from the fifth to the thirteenth century, it was regarded as a divine miracle.[25] Apollonia Schreyer was an anorexic who gave up fasting when she was twenty-seven, in 1611 (Figure 60); her case study makes no mention of anxiety about beauty or ugliness. The terms "beauty," "ugliness," and "monstrosity" would have to be altered for the centuries before the Enlightenment, but I wonder whether the dynamic of Self and Other might not prove resilient even then.

It is plausible that as humans we have a built-in primordial desire to see ourselves, to represent ourselves to ourselves. This is the desire that is too quickly satisfied in Jacques Lacan's mirror stage—too quick, I think, both

FIGURE 60

Apollonia Schreyer. From P. Lentulus, *Historia admiranda de prodigiosa Apolloniae Schreierae, virginis in agro Bernensi, inedia* (Bern: Ioannes le Preux, 1604). Photo from Petr Skrabanek, "Notes Towards the History of Anorexia Nervosa," *Janus* 70 (1983): 116.

in Lacan's sense because the infant leaps at the possibility of identifying it-self with a certain fiction and because self-definition is an ongoing and painstakingly detailed interrogation, enmeshed in the many kinds of im-ages (besides mirrors) that we learn to interpret as adults. For Lacan, the infant experiences its self as "disconnected, discordant, [and] in pieces" un-til it allows itself to be deceived by the useful fiction that the self is a unity in the same fashion as a reflection is bounded and unique.[26] Lacan speaks of the mirror stage in relation to the "fiction" of the ego in general, but he has a lack of interest in *ongoing* visual experience; as Mikkel Borch-Jakobsen has emphasized, we do not see bodies as motionless statues, but as moving, changing images, and I would add that the bodies we see in pic-tures and mirrors are visually intricate and specific—each a very different formula of identity.[27] Lacan's account does not find a way to speak about the difference between *imagined* images that give the infant its false sense of a coherent self and *actual* images reflected by mirrors or given in pic-tures (with all their particular negotiations of reflection, representation, handedness, and distance).[28] The image is exact, and demanding in its ex-actness, as I have argued throughout this book, and for that reason I would rather try to engage daily acts of seeing rather than refer self-definition to a stage in infantile experience.[29]

Acknowledging the fundamental nature of the desire to see one's self and compare one's self with others helps to give the concept of the repre-sented body a certain coherence by underscoring the possibility that it is not one of many acts of representation but a foundational and definitional one. Beyond images of identity and of difference, there may also be deeply rooted desires to see representations of places where we live, or of places where other people live, or of the earth, or of Heaven, or even of pattern.[30] But the account I am exploring here works on the assumption that the body image is both prior to these others and indispensable to them, rather than the other way around. We need bodies—even in dreams, as ghosts, as memories of bodies—in order to make sense of landscapes and places. (And that may be why dreams of empty places and meaningless objects can be among the most terrifying, because they lack the bodies that might give them sense.) These simple terms—"beauty," "normalcy," "ugliness," "monstrosity," the "nonhuman"—accompany our daily sense of ourselves; they are a link between the least cognized mo-ments of self-awareness, the more interesting works of visual art in the Western tradition, and racism.

Racism

I am heading toward the thesis that racist images of the body are best understood as an unwanted part of the ongoing study of difference that each of us undertakes in order to maintain a sense of self. The example of William Herbert Sheldon, the American "somatotyper," can help show how this makes sense, and it can demonstrate how racism, sexism, and other discriminatory purposes are entangled with the apparently uncomplicated acts of making and viewing photographs of bodies.

Sheldon is remembered for his three somatotypic categories: ectomorph, mesomorph, and endomorph (roughly: thin, average, and bulky body types).[31] His *Atlas of Men* is an illustrated dictionary of bodies, arranged from the most skeletal ectomorph to the most obese endomorph "in full blossom."[32] (An *Atlas of Women* appears in many American library catalogues, but it was apparently never published.) Sheldon intended to construct something like Mendeleyev's periodic chart for bodies, using criteria from past research (including humoralism and various anatomic signs) and augmenting them with detailed measurements.[33] The *Atlas of Men* collates 4,000 college students who were measured up to 30 times each. Despite his careful methods, Sheldon was continuously anxious to prove his neutrality, and at one point he even constructed a machine that could measure bodies by itself: it had 76 switches and 18 rows of lights, and as extra proof of its veracity he claimed it could even be operated by a chimpanzee.

The results of these dubious exercises are tabulated in a kind of chart, common in the sciences, in which three variables determine the positions of points on the interior of a triangle (Figure 61).[34] In this case, the three vertices are the pure somatotypes, and each point in the triangle is a single body type. There are two "trigraphs," one for each sex, and aggregations of points reveal common types of bodies in each gender. Some parts of Sheldon's project, such as his statistical tables and these "trigraphs," seem methodologically unimpeachable, but others, like the bizarre machine and the growing collection of photographs of naked volunteers, remain odd. In my reading, the declared purpose—the creation of a scientific catalogue of *all* body types—begins to fade in those places where it becomes apparent that Sheldon also has a personal interest in *certain* bodies. The trigraph of women's bodies has a blank region, a place he says no woman can occupy. The corresponding trigraph for men has no unoccupied place, implying that men can exist in more bodily configurations than women. Perhaps,

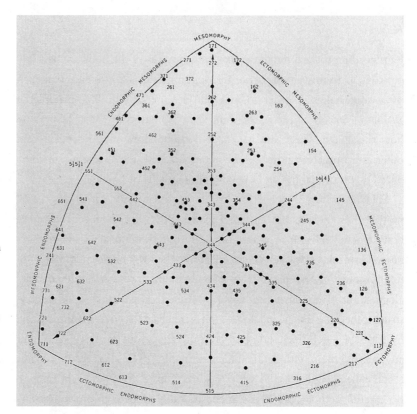

FIGURE 61

Somatotyping triangles. Left: distribution of somatotypes for a male college population of 4,000; each dot represents 20 cases. Right: same, for women. From William Herbert Sheldon: *Atlas of Men, A Guide for Soma-totyping the Adult Male at All Ages* (New York: Harper and Brothers, 1954), p. 12, Fig. 1, and p. 13, Fig. 2.

Sheldon proposes, men are naturally more variable than women. The south and west sides of the men's trigraph maps body types that are similar and sometimes identical to common women's body types (Figure 62). In this case, the two physiques are the same somatotype—number 411—"in all regions of the body except . . . the thoracic trunk," so that one is higher in women's traits ("gynandromorphy") in relation to the average of somatotype 411.

Sheldon isn't interested only in shape; he is also concerned with psychology, and what are now called gender roles.[35] Men with somatotype 411, he remarks, tend "toward gynandromorphy and also toward gynandry of behavior."[36] Feminine men, in fact, do not live as long as masculine women. In general, women live longer, "yet when men approach women somatotypically, instead of advancing their biological cause they retard it." Behind this is the idea that men need to be different from one another in a way that women do not—a strange notion, which is not immediately explained.

Why, he wonders, is the "male gynandromorph" commoner than the "female andromorph"?

> There has been a controversial question whether this was merely because the male genitals are external and the condition therefore more overt and obvious in men while more covert in women, or whether males are in fact more gynic than women are andric. The evidence of the somatotype distributions would appear to support the second alternative. In the human species nature appears to cloister the female. The male seems to be more expendable, more experimental, more widely variable, and his variation takes him frequently into female territory.[37]

Sexism, sexual interest, and body forms bubble together in Sheldon's work; if I were to put this in psychological terms, I might say Sheldon is fundamentally concerned with the nature of sexual difference, *as it applies to himself*: he is nearly obsessed with what a man is or can be, and how it is possible to be sure a man is not the same as a woman. Ultimately, his anxiety and interest are directed to the question of *certain kinds of male bodies,*

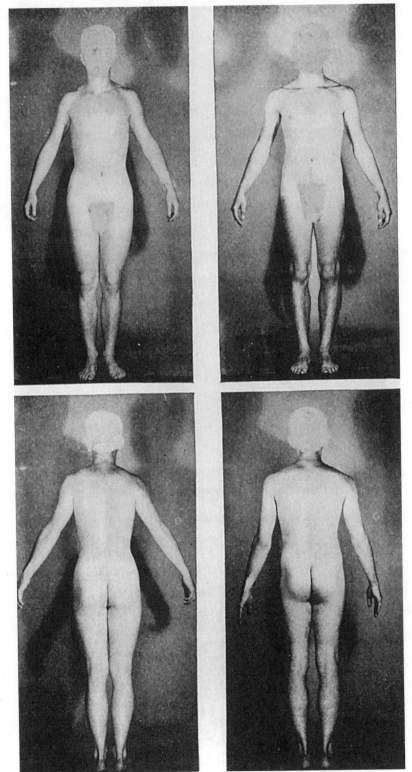

FIGURE 62

Two men of the same
somatotype, 442, showing
more (left) and less (right)
gynandromorphy. From
William Herbert Sheldon,
*The Varieties of Human Physique:
An Introduction to Constitutional
Psychology* (New York: Harper
and Brothers, 1940), Fig. 5A,
facing p. 74.

and I would identify that interest with concern about his own identity: it's as if he wants to know whether he is himself a secure example of his sex or something more like a woman, a gynandromorphic man. (He is concerned with "gynandromorphic" male bodies, but he himself is androcentric, not gynaikocentric.[38]) A further reading of Sheldon's papers might profitably explore this direction, which would lead also toward questions of psychotic identification with the other sex (as in, for example, Freud's Schreber case). But this is enough to indicate that the collection of more than 8,000 front, side, and back views of college-age men and women is not only a matter of attempting to understand people's bodies in general, or even the more dubious and potentially racist goal of subsuming all possible bodies into three types, it is also a very personal inquiry into the nature of the inquirer.

Sexual Racism

To the extent that any fascination with images of the body is evidence of an unsettled anxiety about the self, it is bound to have a sexual component. Some of the ugliest racism can be found in research with a high component of sexual curiosity: it is "ugly" in the sense that it involves sexual revulsion or attraction, because it equates sexuality and gender with identity in general. A plurality of current art historical scholarship that deals with gender is open to this kind of interpretation—a later generation of readers might well look back on what was written at the end of the twentieth century and see it as a partly covert or sublimated project of self-definition. The studies of gender and sexuality in various periods, and in artists such as Michelangelo, Caravaggio, Watteau, Fragonard, David, Manet, Degas, Monet, Cézanne, Eakins, Picasso, Pollock, and Warhol, are inevitably also diaries of the historians' own thoughts about gender in general, which is to say their own gender.[39] Or to put it slightly differently, such studies are historically modulated versions of a desire that is continuous, through a series of increasingly objectionable texts, with what I am calling "sexual racism."

One of the central facts about the history of racial research is its ubiquity until shortly after World War II, when the UNESCO conference of 1950 declared research on racism to be pernicious and intellectually bankrupt. Margaret Mead's *Science and the Concept of Race* (1968) spelled the end of the study of "innate" racial characteristics, defining race as a "sta-

tistical phenomenon . . . *not* a typological phenomenon."[40] That sudden disavowal is important since it suggests that ways of thinking that were deeply ingrained are now unavailable for debate, and among the most strongly repressed are questions of sexuality. As a measure of how far we have drifted from attitudes once considered natural, consider this statement: "All Negroes stink." It was made by Immanuel Kant in the course of an investigation of the concepts of racial difference. Kant continues with a chemical explanation of what must be read as an expression of psychological, and ultimately sexual, revulsion. The "spongy parts" of the body increase in a hot climate, he writes, and the skin "must be oily" to moderate the loss of water through perspiration and to prevent the absorption of noxious vapors in the air:

> The superabundance of the iron particles, which are present in all human blood, and which are precipitated in the reticular substance through evaporation of the acids of phosphorus (which make all Negroes stink) cause the blackness that shines through the superficial skin. . . . The oil of the skin which weakens the nutrient mucus that is requisite for hair growth, has permitted hardly even the production of a woolly covering for the head . . . the Negro is . . . well suited to his climate; that is, strong, fleshy, supple, but in the midst of the bountiful provision of his motherland lazy, soft and dawdling.[41]

To Kant, it is a "pleasant" business distinguishing between what he calls races, sports, varieties, and strains, and observing the effects of climate and good breeding. (And how, although this is not my topic here, might this change the way I read Kant? What are the limits of the effects of this kind of naked prejudice? What is "pure reason" or "judgment" after I have seen these passages? Is there any place where sexuality and "pure concepts" do not interpenetrate?) Charles Darwin also thought race was a partly mental, emotional, and intellectual category. In one text, he is struck by the contrast "between the taciturn, even morose, aborigines of South America and the light-hearted, talkative Negroes"; and he ascribes the beauty of Europeans in part to the powers of intellection: "With civilized nations . . . the increased size of the brain from greater intellectual activity, [has] . . . produced a considerable effect on their general appearance when compared with savages."[42] These are the kinds of things it was possible to say only a hundred years ago, and they should give us pause to consider whether we have found viable new ways of thinking through such issues or have merely banished such thoughts from our public speech.

FIGURE 63

Palau nipples and small penises.
From N. von Miklacho-Maklay,
"Anthropologische Notizen,
gesammelt auf einer Reise
in West-Mikronesien und
Nord-Melanesien im Jahre
1876," *Verhandelungen der
Berliner Gesellschaft für
Anthropologie, Ethnologie, und
Urgeschichte* 10 (1878): pl. 11.

In the realm of visual art, sexual preferences become questions of beauty, ugliness, and monstrosity. Hypertrichosis (unusual hairiness) was associated not only with race and insanity but also with sexual identity and prowess.[43] In the Caroline Islands, one researcher noted that Palau women had two distinct kinds of nipples, one with a protruding aureole, and saw "by lucky accident" that the men from the island of Agome had small penises. He carefully recorded such features, as if he were writing a field guide to the beauties and monstrosities of the Palau people (Figure 63).[44] Hermann Heinrich Ploss, author of a monumental ethnological study of

women, attempted a nomenclature of breasts (Figure 64). He distinguishes hemispherical breasts (number 1) from pendulous breasts, flat breasts, high breasts, conical breasts, half-lemon breasts (numbers 3 and 6), and breasts that remind him of goat udders (numbers 4 and 8). In other plates, he adds half-orange breasts, half-coconut breasts, and pear-shaped breasts, and he looks carefully at areolae to determine whether they are "large" or "extremely large." Nipples are also classified into small, large, extra large, and "the shape of a finger joint" (number 11).[45]

Hans Friedenthal's *Natural History of Men* lines up embryos and fetuses to show the development of their mouths, ears, and noses, and that same penchant for unpleasant physiognomy propels his more racist research. There are plates showing comparisons of fingerprints, hair, navels, and breasts; a plate juxtaposing Negro faces with chimpanzees and mandrills; a plate comparing erections in humans and various primates; and a plate comparing labia in various people. (Friedenthal was obsessed with hair and skin, and he even owned a book bound in the skin of a black man, with an embossed silver plaque on the front decorated with a Negro head and a skull.[46]) A particularly unpleasant image in the *Natural History of Men* places a peach-colored female torso alongside a female chimpanzee (Figure 65). The woman's torso is as smooth as the lithographer's crayon could make it, and the chimp's dimpled anatomy is rough, rude, and dark. The woman is taken from the Venus de Medici, but she is treated as if she were a live model (Friedenthal says she is approximately twenty years old, and the body is colored as if it were alive). The chimpanzee, which is in harsher pinks and grays, was drawn from life in the Berlin zoo. Friedenthal reviews the relevant anatomic differences, implicitly (and pointlessly) denigrating the chimpanzee throughout (he says that during her menses, the female chimpanzee's vaginal area will swell to "the size of a child's head").[47] What happens here? Are we looking at the ugliness of racist and sexist ideas, bleeding onto an "innocuous" anatomic comparison? Friedenthal's plates are the visual equivalent of the ruthless "objective" comparisons of the sizes of erections and the shapes of labia that can be found in books such as *The Cradle of Erotica*.[48] There the differences between Asian, Arab, Chinese, and European "cracks" and "slits" form the subject of several pages, and the conclusions are always subtly in favor of the Europeans: their women have more aesthetically pleasing genitals, their men have harder and longer erections. Here too the chimpanzee is not explicitly maligned, but its expressive purpose is violently blended with its "scientific" meaning.

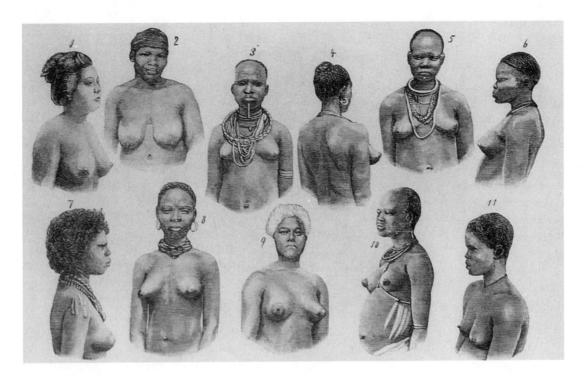

FIGURE 64

Hermann Heinrich Ploss. Forms of breasts: 1. Japanese (small hemispherical breasts); 2. Hottentot (pendulous breasts with extremely large areolae); 3. Schuli (African; conical, half-lemon-shaped breasts); 4. Abukaja (African; goat's-udder breasts); 5. Abukaja (flattened, slightly pendant breasts); 6. Magungo (African; conical, half-lemon-shaped breasts); 7. Australian, (North Queensland; small hemispherical breasts with very prominent areolae); 8. Makraka (African; goat's-udder breasts); 9. Samoan (Oceania; conical breasts with constricted, extremely prominent areolae); 10. Bari (Africa; hemispherical breasts with constricted, extremely prominent areolae); 11. Loango (small flat breasts with nipples the shape of finger joints). From Hermann Ploss, *Das Weib in der Natur- und Völkerkunde*, ed. Max Bartels, 4th ed. (Leipzig: Th. Grieben's Verlag, 1895), Fig. 101.

Each of these texts, I think, is an uncontrolled and perhaps uncognized exposition of the writers' sexual anxieties. They are uncontrolled because the anxiety has reached the point at which it has become necessary to undertake systematic, public comparisons of acceptable bodies with animals and other races; and they are uncognized because instead of solving or repressing the anxieties that generated them, these authors stamp their images with the imprimatur of ethnology, anthropology, or natural science. Friedenthal and Ploss are sexually oriented racists, but there is no clear division between their images and the routine display of sexual identity and difference in mainstream medicine and art. Perhaps the distinction is not between a true or potentially true discourse and a potentially psychotic

FIGURE 65

Rear view of woman and
chimpanzee. From Hans
Friedenthal, *Beiträge zur
Naturgeschichte des Menschen,*
Part V, *Sonderformen der
menschlichen Leibesbildung*
(Jena: Gustav Fischer, 1910),
pl. 46. Department of Special
Collections, University of
Chicago Library.

one as much as it is between a moderate discourse and one that seems too
strident, insistent, and dogmatic. If I choose Freud instead of Friedenthal
as a model of the truth about sexual difference, then it is ultimately be-
cause Freud works slowly and carefully, and not because Friedenthal shows
me anything I can identify as untrue.

Hysterical Racism

Assuming, then, that inquiries into sexuality and race are hypertrophied
versions of the ordinary curiosity about one's own identity, it is not difficult
to see how a strong anxiety about identity can result in dogmatic, airtight
conclusions about sexuality and race. Some people, for example, feel the
need to reassure themselves that women will remain women and not be-
come men. In one compendium of semiological lore, Dr. Mary Walker, the
"oldest American women's activist," is described as a "mannish" (*Mann-
weib*) type, meaning she has a man's soul and part of a man's body (Figure
66).[49] The authors, R. Burger-Villingen and Walter Nöthling, report that
Mary Walker wore men's clothing for more than forty years, and they note
that her face is square and her nose is powerful and sharply cut. The proper
physiognomic conclusion is that male features mean male disposition:

FIGURE 66

Dr. Mary Walker, a *Mannweib*
type. From R. Burger-Villingen
and Walter Nöthling, *Das
Geheimnis der Menschenform*,
6th ed. (Wuppertal-Barmen:
Burger-Verlag, 1958), p. 480,
Fig. 663.

"Those who understand the science of forms [*Formenlehre*]," they write,
"will see at once why Dr. Mary Walker fought for women's rights: because
she was a *Mannweib* by nature." Given the speed of this conclusion, and the
evident haste of the authors' typecasting, it is not surprising that they often
fail to distinguish sexism and racism. To illustrate a "typical Negress," they
show a photograph of an anonymous woman and declare that she shows
"strong instinct and petty or inferior intellect" and so is likely to be "limp
and peevish (*lasch und launisch*)" (Figure 67).[50]

At its most frantic, this kind of reasoning becomes what I will call "hys-
terical racism": it accelerates into a breathless rush from conclusion to

FIGURE 67

A "typical Negress." From
R. Burger-Villingen and Walter
Nöthling, *Das Geheimnis der
Menschenform*, p. 385, Fig. 575.

conclusion, because the author shies from even the slightest ambiguity. No
schema of Self and Other looks sturdy—it always seems that the two
might collapse into one another, trapping the author, condemning him or
her as an instance of the rejected Other. Francis Graham Crookshank is
one of the most hysterical racists I have read (he is hysterically funny as
well as seriously hysterical); his books are feverish attempts to cement his
basic thesis of "homologies." His central claim is very simple: that the
"three races" of man each has a corresponding mental illness and species
of primate. The following table demonstrates how Crookshank sets out his
theory in a book called *The Mongol in Our Midst*.[51]

It is typical of hysterical racism that the basic schema is never sturdy

TABLE 5. CROOKSHANK'S RACIAL HOMOLOGIES.

Race	Corresponding animal	Corresponding mental illness
White	Chimpanzee	Dementia praecox
Mongol	Orangutan	Langon-Down's syndrome
Black	Gorilla	"Ethiopic" idiots

enough—it always needs more criteria to ensure that it doesn't collapse. Dementia praecox is the forerunner of the conditions now identified as schizophrenia; Crookshank describes it as a "mental disease . . . midway between acquired insanity and congenital imbecility."[52] "Mongol" is defined a particular way: not by the vertical epicanthic fold, since that occurs in some whites and blacks, nor by an attenuation of the corners of the eyes, since that occurs only in some Mongols, but—following Il'ia Il'ich Mechnikov—by a fold within the upper eyelid, marked at the inner angle of the eye. The fold is actually ill-suited to normal human life, Crookshank says, since it traps eyelashes and causes irritation, giving a "bleary look to racial Mongols and to imbeciles, as well as to elderly Orangs." He finds the tongue of Mongols to be "large, beefy, rough, warty, and pithecoid." Those who suffer from the corresponding "mental illness," Langon-Down's syndrome, he calls Mongoloid idiots, and says that they "are placid, docile, and gentle": "They are not nasty and do not masturbate. Herein they are orangoid rather than chimpanzoid. They are as imitative and fond of make-believe as are the little Eskimo and will, for hours at a time, pretend that they are students or parsons. But the play-acting element is obvious, and, as Hunter has said, their laughter when acting is a 'sham.'" Orangutans and Mongoloid idiots both have furfuraceous and xerodermic skin, which Crookshank explains as the persistence of lanugo, and in addition their skin tends to be myxedematous (dry and swelling). These traits can be recognized in "infirmary Mongols," "hospital Mongols," and "asylum Mongols," as well as in the Kirghiz and in orangutans.[53]

According to Crookshank, each of these three races and three animals has a typical way of crouching or sitting. Orangutans and "Japanese priests" prefer the Buddha position (Figure 68, top). Negroes tend to crouch in the "Negro position," more like chimpanzees (Figure 68, bottom). "Gorillas and Chimpanzees," Crookshank reports, "do not dispose of their lower limbs horizontally, as do Mongols, Mongolian imbeciles, and Orangs, but vertically, as do Negroes and primitive 'Whites.' Moreover, the

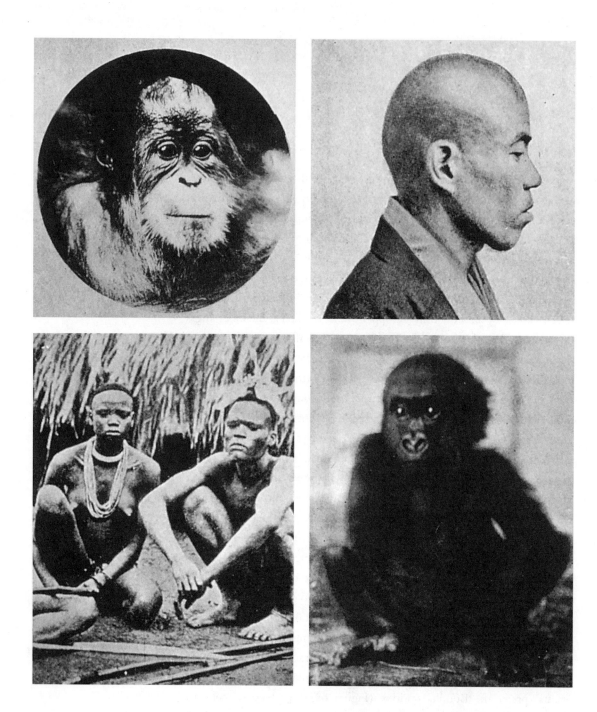

Gorilla more commonly adopts the Negro, and the Chimpanzee what may be called the Semitic or Aryan variant." Whites squat in a different way. People with dementia praecox (the disease typical of Whites), "if deprived of chairs or permitted to squat upon the ground," will squat "not as Orangs or Mongols, but as Chimpanzees. . . . But, if compelled to sit upon benches or chairs, the chimpanzee attitude becomes at once converted into what Dr. Steen has called the 'ancient Egyptian attitude.'"[54]

In this frenzy of interpretation, any sign can be read as a racial definition. Crookshank claims that the life line (the principal vertical line on the palm), the heart line (the horizontal crease running toward the ulnar or little-finger side), and head line (the horizontal crease just below it, running toward the radial or thumb side) are different in different primates and their corresponding mental disorders. In his view, the most "human" disposition of the hand can be found in Leonardo da Vinci's *Virgin of the Rocks*, in which the angel points with a hand whose fingers are gently curled and whose index finger is not quite straightened. "If the hand be placed in the position of the hand of the Angel in Leonardo's *Virgin of the Rocks*," Crookshank asserts, "the relation of these lines to the execution of a gesture that is exclusively human, and characteristically elevated, will be at once evident." But if the life line is too strongly developed, or if it is multiple, that means the hand is well-suited to a gesture in which the thumb and fingers are straightened and pressed together into an arrowhead shape. Multiple life lines are "not essentially 'human'," and their "functional adaptation is to that pose so necessary to *accoucheurs* [obstetricians], conjurers, and pickpockets, when it is desired to pass the hand through a small circular orifice." Mongoloid idiots and "certain low-grade racial Mongols" possess only a single head line, and the "functional correlation of this single line is with the gesture of the ill-bred lout who holds his knife and fork transversely across the palms." Among "anthropoid apes," the single head line is found only in the orangutan. Moreover,

> this type of hand-marking is definitely shewn in many of . . . the Chinese and Japanese representations of Buddha. In any case, Chinese and Japanese artists are well aware of this simple type and that it has significance, though they are reticent when interrogated. I have only twice seen this single transverse line delineated in England: once in Beamish's *Psychonomy of the Hand*, where it is said to have been seen on the hand of an idiot at Cork; [and] once in a collection by Chiero, who told me he had seen it on the hand of a doctor of Chicago who was executed for murder. . . .

FIGURE 68

Top: an orangutan and a Japanese priest. Bottom: A Fajelu man and woman and a chimpanzee in the "Negro position." From Francis Graham Crookshank, *The Mongol in Our Midst: A Study of Man and His Three Faces*, 2d ed. (London: Kegan Paul, French, Trubner, 1925), pl. 7, Figs. 1 and 2; pl. 13, Figs. 1 and 2.

> The hand of the chimpanzee, which has generally two *parallel* and
> obliquely transverse lines, is characterized by a set of lines in the long axis
> of the limb, branching V-fashion from the wrist. Such lines are very common
> in the Chimpanzoid hand of the Dementia Praecox patient, as well as on
> those of certain types of neurotic 'artists.'[55]

The Mongol in Our Midst presses on at this breakneck speed for more
than two hundred pages, piling up dubious sources and wild criteria to
support the racial homologies. Although Crookshank's method is nearly
mad, I would still read it as a version of the ordinary processes by which
we each discover who is like us and who is not. To locate the boundary
between what we are and what we want the Other to be, we need to
make use of rapidly shifting criteria, and perhaps Crookshank's real path-
ology is not that he asks such questions, but the way in which he asks
them—he is insistent, literal-minded, rigid, and dogmatic where ordinary
thinking might be evanescent, heuristic, and scarcely cognized. Like
Friedenthal, Crookshank is harsh and loud, but the impetus behind his
reasoning (as opposed to his logic, and his particular claims) is not differ-
ent from what I indulge in every time I see an image of another body.

Metamorphosis into a Pubic Hair

Under the instruction of the emerging empirical science of anthropology,
the early nineteenth century learned how to measure the difference be-
tween races instead of merely describing it. In scientific journals, it was
no longer necessary to depict an entire figure because the type or race
could be determined by *samples*: a body could be reduced to a diagram of
the shape of the hand, the ridges on a fingerprint, or the fissures of the
brain.[56]

Investigators were especially drawn to sexual details, in part because it
can be compelling to see such details presented as neutral objects of sci-
entific inquiry. Pubic hair, for example, was studied with some intensity,
and there are monographs on such subjects as the faintly bluish hair that
allegedly grows in the middle of Asian children's backs.[57] Even today,
there is a large literature on the racial and sexual meaning of hair, from
Reginald Ruggles Gates's *Inheritance of Hairy Ear Rims* to books that clas-
sify people by the shapes of their pubic hairs.[58] Figure 69 shows a picture
of a pubic hair; it is from a contemporary Chinese manual that predicts
people's character by such details as the pattern of hair in armpits, on

不懂得愛，喜歡同性戀的怪癖。

一の字型 188

◎一字型：不懂得愛，也沒有慾望，見到女性麻木不仁，這種人可能是同性戀好者。

FIGURE 69

A pubic hair denoting homosexuality. From anonymous, *Fortune-Telling Through the Identification of the Body* [in Chinese] (Kowloon: Kurhwa, n.d.), p. 71.

calves, and the shapes of individual pubic hairs. The caption informs us that "a person with straight pubic hair usually doesn't know how to love, and has little desire for people of the opposite sex."[59]

By the end of the nineteenth century, it had become optional to represent the entire body in much biological and ethnographic illustration, almost as if the whole body were a picturesque addition to the real science

undertaken at the level of details, microscopic views, and other "samples."[60] Figure 70 is not so much an illustration of a Niam-niam from "inner Africa" as it is a documentation of two hair samples (one from the top of the head and the other from the beard) and a swatch of skin reproduced in natural color. (The author says he took notes in the field and had a painting of the skin done in oils by an artist in Cairo.)[61] The result is a kind of portrait of biopsies, an image of the body as a collection of typical pieces. Given its date, 1873, it is recherché in the sense that the ethnographer, one Georg Schweinfurth, arranged his scientifically collected material around a central figure—to a modern viewer, its closest analogues are the plates in natural history field guides—but it is also modern in its willingness to reimagine the body as a disarticulated collection of samples.

In medicine, the characteristic development of these sampling methods is the abstraction of contemporary histology. From the early nineteenth century on, there were books with strange plates of the "morbid" anatomy of various organs, showing diseased tissues as if they were decorative swirling endpapers or twentieth-century exercises in abstraction.[62] Some of these books contain lithographs executed in such exquisite color and detail that they could not be adequately reproduced by any photographic process. In one plate, a liver tinged in reddish-browns opens to reveal glassy spheres in yellow, gray, and red—an apparition of textures and colors unlike anything that had been seen in fine art. Elsewhere, a cancerous liver becomes a lunar landscape of pastel colors, a diseased brain is laced with a forest of red veins, and a liver shines with deep crimson, blue, and pale pink blisters—a beautiful, disembodied way of understanding illness.[63]

Fragments first came to stand for the whole body in the eighteenth century, and in the nineteenth century they spread through histology, gross anatomy, ethnography, and anthropology.[64] In the twentieth century, we take partial bodies for granted (the sequence begins with Picasso's disjointed nudes and Magritte's paintings of women parceled out between picture frames), but it may not be coincidence that the most concerted, far-reaching disassemblies of the body took place the century before. Without making similarities into equations, or linking racism and modernism as partial cause and unintended effect, it is still worth emphasizing that ethnological and medical images are among the first formally disassembled bodies. At the least, it is curious that the immediate precursors of the frag-

FIGURE 70

A Niam-niam. From Georg
Schweinfurth, "Das Volk der
Monbuttu in Central-Afrika,"
Zeitschrift für Ethnologie 5
(1873): pl. 9.

mented bodies in modern art are "scientific" texts that we now count as
both sexist and racist.[65]

An especially influential early figure in the history of bodily fragmen-
tation was Pieter Camper, a Dutch surgeon, painter, sculptor, numismatist,
and essayist.[66] Even though the idea for which he is best known—the "fa-
cial line" or "angle" measuring the slope of the forehead—seems to be a

racist touchstone, Camper presents himself as a person much more interested in disproving racial stereotypes than in promulgating new ones. His book on Adam and Eve is moderate, not typological. He refutes the idea that blacks come from apes and says that Jews are difficult to distinguish— his friend Benjamin West, born in Pennsylvania and therefore a supposed authority on Indians, told him that Jews have crooked noses, but Camper is not sure whether that is a true or sufficient criterion, and he points to paintings by Emanuel de Witte showing "men with beards" that are not Israelites.

Camper's best-known book, whose translated title is *The Natural Difference of Features in Persons of Different Countries and Ages; and On Beauty as It Is in Ancient Sculptures; with a New Method of Drawing Heads, National Features, and Portraits, with Accuracy* (written in 1786), is the result of two different interests: as he says in the book's introduction, he had wanted to be able to distinguish authentic ancient coins from forgeries by making an accurate study of faces, and he had also wanted to find a more efficient and easy way of sketching the face.[67] The book's centerpiece is a sequence of heads, leading from "perfect beauty" to "bestial ugliness" (Figure 71). A sculpture of Apollo starts the sequence at the lower right, and it is followed by several Europeans, a Calmuck, a young Negro "just changing his teeth," an orangutan, and a "tailed ape." The choice of a young orangutan reflects the eighteenth-century interest in what was later called the "missing link"; immature orangs were called "Pongo" and were widely studied through the beginning of the nineteenth century.[68] Camper is somewhat confused about Calmucks (who are native to Mongolia); he asserts that they live in Lapland, Brazil, "and some other places." Despite the fact that they are the "ugliest of all the inhabitants of the earth," with noses "so flat, that the sight penetrates into the nostrils," Negroes are even less beautiful and more primitive.[69]

By a simple method, Camper calculates the "facial angle," the relative steepness of the forehead.[70] His results are shown in the following table.

TABLE 6. CAMPER'S FACIAL ANGLES.

Figure 71 [top]			*Figure 71 [bottom]*		
fig. I	Tailed ape	42°	fig. I	[Normal range]	80°
fig. II	Orangutan	58°	fig. II	European	90°
fig. III	Negro	70°	fig. III	Antique coin	95°
fig. IV	Calmuck	70°	fig. IV	Pythian Apollo	100°

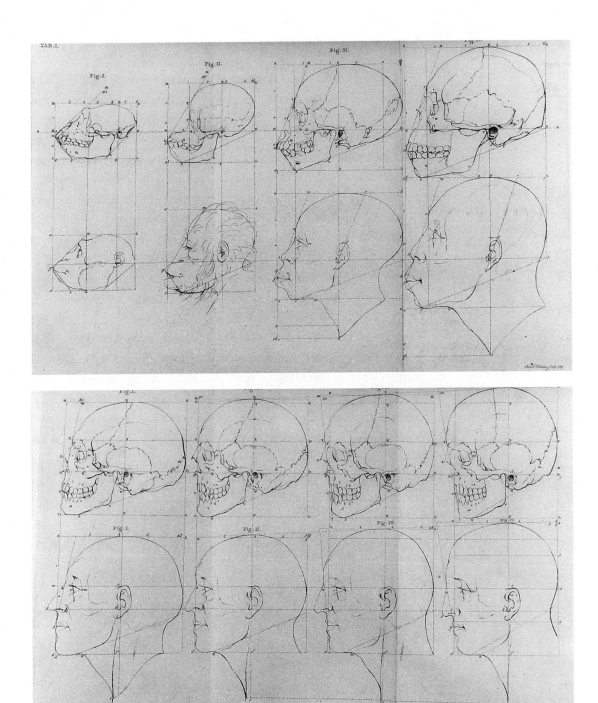

FIGURE 71

Profiles, from tailed ape to Apollo. From Pieter Camper, *Over het natuurlijk verschil der wezenstrekken in menschen* (Utrecht: B. Wild and J. Altheer, 1791), pls. 1 and 2. Department of Special Collections, University of Chicago Library.

Angles from 80 to 90 degrees are considered normal, and anything greater than 100 degrees is "misshapen." Antique coins, Camper reports, show at least 90 degrees and always less than 100 degrees.

As the diagram indicates, Camper measures other dimensions of the head, and he makes variable use of them when it comes to drawing conclusions about beauty and intelligence. He finds that Europeans possess "a certain elegance and dignity," and he notes that mouths becomes smaller as one goes up the scale of perfection. Still, Europeans are not perfect, and because their heads "remain in equipoise," they tend to have "something of an haughty mien." It is a defect if the ear is parallel to the facial line, as it is in the Negro. Antique heads have a gentle inclination which "communicates the most [stateliness] and dignity." There is much more—on the melancholy of the Chinese face, the wide "waddling" hips of the Dutch—and throughout, the *linea facialis* remains a central criterion.

Some of Camper's craniometric measurements have become standard parts of physical anthropology texts, and even today the sloping forehead is sometimes referred to as a sign of stupidity.[71] Camper's antiquarian interest in the heads of Roman emperors became the anthropologists' interest in the skulls and brains of famous people. A famous instance is the institute founded for the sole purpose of studying Lenin's brain; on smaller scale, Dante's skull is the subject of an entire book, and there have been reconstructions of Schiller's, Bach's, Kant's, and Leibniz's faces from their skulls (Figure 72).[72] In this case, the skull and the wig—lifted from an engraving—were supposed to verify the unusual breadth of Leibniz's cranium.[73] Given the tenacity of the belief in disproven correlations between brain and mind, it is an interesting exercise to measure brain size and the slope of the forehead, and I here append some instructions for making both measurements.[74]

TABLE 7. THE LEE–PEARSON FORMULA FOR CRANIAL CAPACITY, IN CUBIC CENTIMETERS.

Males

406.1 + (0.000365 x length[75] x breadth[76] x auricular height[77])

Females

206.6 + (0.0004 x length x breadth x auricular height)[78]

The following table sets out some common results.[79]

The lesson to be learned is in the power these disproven criteria still have on our imagination: despite their meaninglessness, it can be difficult

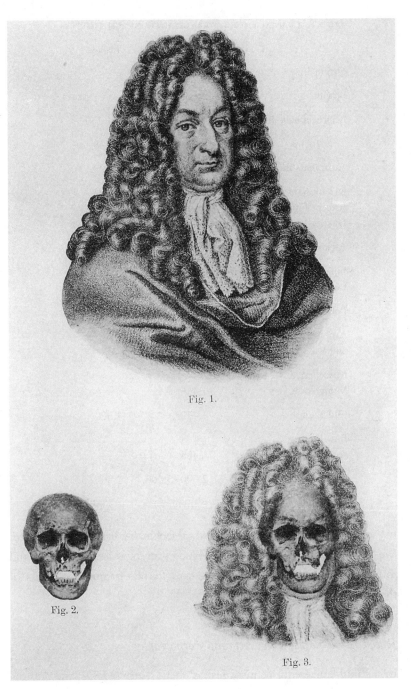

Fig. 1.

Fig. 2.

Fig. 3.

FIGURE 72

Lithograph after an engraving
of Leibniz by Bernigeroth,
Leibniz's skull, and Leibniz's
skull and wig superimposed.
From W. Krause, "Schädel von
Leibniz," *Zeitschrift für Ethnologie*
34 (1902): 471–82, pl. 15.

TABLE 8. CRANIAL CAPACITY RANGES, IN CUBIC CENTIMETERS.

	Male	Female
Chimpanzee, orangutan	Around 400	—
Gorilla	Around 500	—
Microcephalic human	<1,300	<1,150
Tasmanians	1,256	1,198
Australian aborigines	1,294	1,125
Melanesians (except Fijians and Loyalty Islanders)	1,323	1,192
Africans	1,346	1,172
Fijians and Loyalty Islanders	1,439	1,288
Polynesians	1,451	1,324
American Indians and Eskimos	1,460	—
Miscellaneous Mongoloids	1,465	—
Old English	1,472	1,320
Europeans, ancient and modern	1,488	—
Macrocephalic	2,000–3,000	2,000–3,000
Hydrocephalic	>3,000	>3,000

not to take pride in a vertical forehead, or feel inadequate at a small brain. We picture the body in fragments—blood tests, biopsies, pap smears, and so forth—and we seldom contest the capacity of a fragment to speak for the entire body.

Racist Ethnography, Fine Art, and Pornography

In the mid-nineteenth century, just as doctors, ethnologists, and anthropologists were dissolving bodily representations into quantified samples, the rise of photography was helping to reinstate the full-figure image. From approximately 1860 to 1920, there was widespread dissemination of ethnological and medical photographs of naked subjects, exhibiting the

quality of mere existence I noted at the beginning of the chapter. Perhaps the greatest exponent of this approach to racial research (and probably also one of the world's foremost collectors of photographs of naked people) was Carl Heinrich Stratz den Haag.[80] Stratz wrote books on the "racial beauty" of women, body forms of the Japanese, and the bodies of children—the last being especially suspect by contemporary standards, since it mixes photographs of naked children with racial theories.[81] Stratz's argument is that all humans evolved from an *Ur*-race that he calls the "Protomorphs," which gave rise to the "Archimorphs," comprising the white, black, and yellow races.[82] Intermarriage among Archimorphs then produces the aptly named "Metamorphs," as demonstrated in the following table.

TABLE 9. STRATZ'S SCHEMA OF THE RACES.

Race	Type	Example
	I	Australians, Papuans, Koikoins
Protomorph	II	Native Americans, Dayaks, and others
	III	Ainu, Wedda, Dravidians, Eskimo, Akka
	I	Xanthoderms (yellow-skinned people)
Archimorphs	II	Leukoderms (white-skinned people)
	III	Melanoderms (black-skinned people)
	I	Xantholeukoderms (crosses between Xanthoderms and Leukoderms, found in Indonesia, Siberia)
Metamorphs	II	Melanoleukoderms (found in central Africa)
	III	Xanthomelanoderms (none exist, according to Stratz)

The photographs Stratz uses to support his thesis were made by a range of explorers and ethnographers, and their subjects show a fascinating range of awareness, from racial pride to utter astonishment. In *The Natural History of Man, Foundations of Somatic Anthropology*, his largest collection, the plates of aborigines are charged images of embattled domination, as if the sitters both hated and feared the camera (Figure 73).[83] First one sees their incomprehension, frozen terror, anger, disdain, and stubborn reluctance— all emotions outside the comfortable range of the Western relation of artist and model. But the camera works: inexorably, it wins the contest between individual sitter and impassive eye, steadily confirming the implicit ethno-

FIGURE 73

Australian woman. From Carl
Heinrich Stratz den Haag,
*Naturgeschichte des Menschen,
Grundriss der somatischen
Anthropologie* (Stuttgart:
Ferdinand Enke, 1904), p. 280,
Fig. 212.

logical assertion that these are not so much individuals as types or speci-
mens. No small part is played by our own complicity: we stare unembar-
rassed and unashamed at the face merely because it is a portrait and has no
living eyes to return our gaze. As Peter De Bolla says, "the viewer may
look improperly upon the portrait"[84]—a fact often missed by contempo-
rary theorists of the painted and photographed gaze.

The text is unremitting. Aborigines, Stratz claims, are "poorly differen-
tiated" one from another in accord with their status as Archimorphs, or *Ur-*
people. Their women have narrow pelvises and "udder breasts" (*mamma
areolata*), powerful supraorbital ridges, dolichocephaly (long skulls), and
prognathism (jutting jaws). Their facial skeletons are large in proportion
to their brain cases; they have coarse features, broad noses, widely spaced
eye slits, and pointed auricles (which he calls "macacus-ears"). They have
slight buttocks, no calves, and a tendency to be pigeon-toed.[85]

In Stratz's schema, the Papuans, the second most primitive Protomorphs,
appear as a ferocious, camera-conscious people, and like many subjects of

FIGURE 74

Bavarian man. From Carl
Heinrich Stratz, *Naturgeschichte
des Menschen, Grundriss der
somatischen Anthropologie*
(Stuttgart: Ferdinand Enke,
1904), p. 381, Fig. 327.

ethnographic photography, they show degrees of belligerence and embarrassment. The Chinese and Japanese models are not as angry, but they appear even more uncomfortable with the idea of being photographed. In one photograph, a woman with bound feet stands unhappy and rigid for the camera. There are also "Hottentots," a favorite subject of European sexual speculation on account of their steatopygia (large buttocks), macromastia (large breasts), and the enlargement of their labia (creating the "Hottentot apron").[86] Tierra del Fuegans appear exhausted and weak, in accord with their stereotype.[87]

Occasionally, there are people who know how to pose, and who understand something of the voyeuristic contract that is universal in Western photography. Europeans, especially, understand both the camera and their own privileged position in relation to it, as in this image of an overwhelmingly confident Bavarian man (Figure 74). Stratz's book *The Beauty of the Female Body* is a gallery of women, most of them more or less reconciled to the modeling experience (the book also has a chapter on artists' models).[88] But in *The Natural History of Man*, the sitters are often uncomfortable. They show nagging unease, or unsteady compliance, or terrified submission—anything but a happy collaboration. Many seem to have a sense of what was happening, and certainly many felt put upon, violated,

FIGURE 75

Daughter and father afflicted
with chronic trophoedema.
From Karl Pearson, ed.,
Treasury of Human Inheritance,
(Cambridge, Eng.: Cambridge
University Press, 1912–48),
vol. 1, pl. E, opp. p. 32.

or condescended to. But because the photographs exist, there must also
have been at least a transient moment of complicity, when the sitter, for
whatever reason, decided to strip and pose. Even the young man from
Bavaria betrays a trace of unease: he knows he is displaying an ideal that
the photographer shares, and that it requires a nuanced pose (note the fin-
ger, pointing faintly downward, and the affected dangling foot). But it is
also clear that he knows he is a partner in Stratz's project, the living em-
bodiment of the highest ideal. There are many unpleasant moments, of
many different kinds, in Stratz's books, and perhaps the worst is when the
reader recognizes the same currents of resistance and compliance that
mark all relations between photographers, artists, and naked models, from
racism to fine art.

 There are other examples, closer to home. An image from the *Treasury
of Human Inheritance*, a collection of family histories of genetic disease, de-
picts a daughter and father afflicted with trophoedema, a painless chronic
inflammation and hardening of the joints (Figure 75).[89] This is a beautiful
double photograph, as moving in its way as contemporaneous portrait

studies by Thomas Eakins. It appears that the photographer had his cam-
era set up in one place and that the daughter and father posed separately,
for propriety's sake. The time it took the daughter to pose and then leave
and be replaced by her father (or the other way around) is marked by the
movement of the sun against the wall. They are both deeply unhappy, and
the daughter especially seems resentful—but they are also willing to stand
for their photographs and reveal their secret common disease.

Some of the most eloquent images made by looking alone are those in
which the impulse to see and the desire to be seen reach a delicate balance.
For just a moment, and for some unknowable reason, a person decides to
become a specimen, and enters into the strange world where capitulation
and self-effacement struggle against assertiveness and individuality. What
happens in these images is not different from what happens to Watteau's
Gilles as he stumbles across the commedia dell'arte stage and then pauses
in dumbfounded, simple, good-natured incomprehension. The aborigines
and the family with trophoedema are more acutely unhappy (after all, they
are not acting), and the Bavarian man is more self-satisfied, but these pho-
tographs are not different in kind. In each of them, the eyes of the sitter
are half-erased, made blurry by an impenetrable mixture of unrewarding
anonymity and the remaining sparks of displeasure.

Pornography's Expressive Potential

Moving from these questions toward pornography requires a shift in em-
phasis only, since researchers like Stratz, Sheldon, and Friedenthal are al-
ready voyeuristic and even lascivious. To the extent that racial research is
sexually motivated, it is pornography, and to the extent that pornography
is typecasting, it is racist. In both cases, it is important to continue attend-
ing to the images themselves. (An absence of information about specific
pornographic images is one of the strengths of Catharine MacKinnon's
work, but it is also one of her most stringent limitations.[90]) For that rea-
son, I offer an account of pornography that differs from current debates
concerning its legality or morality—I am not uninterested in those issues,
but I find that they can be approached more sensibly after the images
themselves have been seen as thoroughly and carefully as possible. Even
aside from its overt physiological effects, pornography has interesting pic-
torial qualities, and it seems to me that one of the most fruitful ways of
speaking about pornographic images is to try to see them *as images*, as a

genre like any other, with its conventions and its particular expressive potential. That way it becomes clearer, I think, that pornographic images are related to the universal need for self-definition that I have been pursuing throughout this chapter.

The most succinct argument that pornography should be included in the roster of contemporary visual culture has been made by the critic Thomas McEvilley.[91] McEvilley points out that pornography is so widespread in contemporary Western culture, and so integral to our sense of who we are as a society and as individuals, that it would be unreasonable not to consider it alongside other kinds of images:

> Attempts to legislate a correct-minded kind of representation can only result in a hypocritical masking of ourselves. For it is we ourselves who are objectified in our images, high and low; it is we who are represented. One of the functions that representation performs is to create a place where insights into our mental and cultural condition—our dreams, our fears, our unspoken assumptions and fantasies—are made obtainable, precisely by being objectified. Even a sexist system of representation, dedicated to the perpetuation of sexist values, can be a means whereby we become aware of those values, can see them explicitly rather than tacitly expressed.[92]

I say that this is the most succinct argument for pornography's importance, rather than the best argument, because it can also be claimed that pornography is the test case, or the central instance, of representation itself. Any bodily representation puts the viewer and the viewed in an unequal relation, and that inequality is at its clearest and strongest in pornography—hence pornography is the place where representation itself shows its colors, and we need to understand it before we can comprehend representation. Such an argument draws near to the opening claims of this book: just as all representation is distortion, and all representation is of the body, so it could be said that representation is largely, and perhaps crucially, pornographic. In Kelly Dennis's words, "the issue is not what pornography *is*, but what in fact is *not* pornography."[93] And yet this is a tricky theory, because its generality threatens to lead again away from specific images. (Dennis's dissertation ends with these words, and this book began with ruminations on distortion. It's best, I think, to keep such abstractions at arm's length. It makes more sense, after all, to speak of pornographic images as instances of representation than to speak of "ordinary" garden-variety paintings as examples of pornography.)

The next step in a critique of pornography would therefore be to un-

derstand the images themselves. What meanings can pornography convey *aside* from sexism and sexual arousal? What kind of images are these? To make a start, I offer the following four suggestions; I find the first two to be plausible, and the third and fourth more problematic.

PORNOGRAPHY DENIES RELATIONSHIPS

Its images are psychologically vacant, sometimes literally so when the head is cropped out of the frame or squeezed onto the top margin. Even when it is possible to see the models' expressions, they are vacuous or unreadable. The faked orgasm, ubiquitous in pornographic images of women, renders the most central emotional content of pornographic images suspect. This is the old problem of trickery that so absorbed the Enlightenment physiognomists—here in an extreme form, the possible misrepresentation of a height of passion. This continuous possibility of deception creates a particular kind of viewing: the "consumer" of pornography will accept almost any sign of pleasure, without looking further or trying to decipher what might actually be happening. Eyes that are rolled or closed, a head thrown back, even a wince or a grimace might all be accepted as signs of passion.

When the face is absent or unreadable, there is necessarily nothing further to be deduced about relationships. Pornography has an "inability to contact the theme of fertility," in McEvilley's words, partly because relationships bring with them "moral demands that the consumer of pornography seeks precisely to escape."[94] All possibility of human discourse begins with readings of the face, and when pornography blocks physiognomics in the name of rapid access to pleasure, it makes any thought of relationships impossible. Those negative qualities are interesting in themselves, and they could be exploited by artists who are concerned with *avoiding* psychological portraiture or reliable expressive content. The rapidly read face, or the unread face, is the most efficient way to condense a viewer's attention onto a body, and pornography concentrates the gaze on the body more efficiently and powerfully than any other kind of body image.

PORNOGRAPHY HAS A RELATIVE LACK OF REFERENCE TO HIGH ART CONVENTIONS

Pornography is an impoverished visual language to the extent that it makes limited use of the various gestural conventions of painting. Copulating bodies have occasionally been treated as extreme cases of contrapposto; the

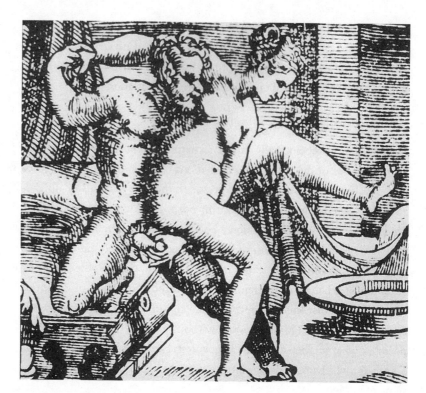

FIGURE 76

Giulio Romano (possibly after
a design by Raphael). "Sexual
position number 7." From
Lynne Lawner, ed., *I modi, The
Sixteen Pleasures: An Erotic
Album of the Italian Renaissance*
(Evanston, Ill.: Northwestern
University Press, 1988).

Renaissance pornographic booklet *I modi* ("The Modes," or sexual posi-
tions) represents some sexual acts as if they were examination questions in
contrapposto or opportunities to display artistic virtuosity (Figure 76).[95] It
has been conjectured that the plates in *I modi* were originally designed by
Raphael and given to Giulio Romano, and it would not be inconceivable
that either artist might have attempted to follow what he thought of as
classical precedent by expressing ecstasy as the apotheosis of balance and
torsion. But in general, modern pornography remains oblivious of these
possibilities, and its bodies are arranged helter-skelter in the photographic
frame.[96]

Each kind of pornography (homosexual, sadomasochistic, mass-market,
soft-core) has its typical poses and views. The exclusive interest in the
mechanics of orgasm often urges the photographer to ignore the splay of
limbs, and the coherence or composition of the picture as a whole. That
obliviousness ensures the continued newness of pornographic scenes. From
an artist's point of view, pornography offers a way to expand the roster of
possible poses, and it is one of the best opportunities to make a decisive
break with academic norms.

PORNOGRAPHY IS ABOUT POWER

McEvilley provides a beautiful description of the intimate relation between pornography and themes of power: "In the closed booth, in the private room, in the mind's eye, in the secret dark, no one can intervene between the masterful ego and its gratification."[97] Pornography is often defined as the unmediated exercise of sexual power, or as a pathological reduction of the barriers and give-and-take of real sexuality.[98] In this vein, pornography is said to objectify women (or children or men). I am not entirely convinced by this way of defining pornography—for one thing, many sexual images exist that do not serve sexist purposes. Feminists who seek to define pornography primarily as an unequal exercise of power need to consider that such a definition also fits images that are not pornographic. A still life may offer me grapes, buttered biscuits, or a sliced melon with the same abandon, and the same lack of aesthetic distance, as a pornographic image (see Figure 2). It may even offer me the knife with which to serve myself. I am alone with the spread, enticed and able: What is the difference between this proffered possession and the invitations of pornography? Perhaps the best example of the unmediated lascivious sexuality of still life is General C. G. Gordon's claim that he had discovered the Garden of Eden on Praslin Island in the Seychelles. Gordon looked at the coco de mer plant and saw male and female organs hanging from its branches, and when he discovered the breadfruit tree, he thought he must have found the Tree of Life. His manuscript "Eden, and Its Two Sacramental Trees" is an ecstatic and profane allegory of sexuality and biblical figures, as unbelievable in the abstract as it is convincing to anyone who has seen a coco de mer.[99] For Gordon, the coco de mer was a numinous apparition of sexuality, and his text is a giddy mix of sacred history and hallucinatory sexuality.

Was Gordon entirely wrong? Is it possible to experience an edible and suggestive organic form in anything other than the most direct terms? Is a grape possessed in any less radical manner than a figure in the imagination? It seems to me that several kinds of pictures are about unmediated possession, and although they work in different ways to thematize and defer that possession, they depend on it as an underlying possibility.[100] Hence to define pornography as a matter of unmediated power, or as a dangerous fantasy of control, is to describe all picture making and indict every picture. Still, this way of construing pornography has the virtue of draw-

ing attention to the one-way application of power and the fantasies of perfect control that pornography can sometimes communicate, and that meaning can be useful in settings other than the "dark room" in which pornographic image is "used."

PORNOGRAPHY IS OUTSIDE THE FINE ART TRADITION

Pornography has historically been isolated from fine art, although the "two-track system" of forbidden and licit images sprang up only after fine art became chaste in the early eighteenth century.[101] When artists have been able to allow themselves high sexual content as part of their ordinary secular commissions, pornography has tended to disappear, or to fail to appear on the cognitive horizon.[102] Apparently, Jean-Honoré Fragonard did not produce pornographic images—paintings that had to be secreted in men's libraries and bedrooms—but he did make images that today would be called "erotic art" (Figure 77).[103] Pornography in the modern sense was unavailable to Fragonard, by which I mean literally inconceivable; instead, there was a stepped sequence from religious paintings to genre scenes, and sensuality was implicit in different ways in each.

The term "erotic art" owes its unpleasant flavor to the sense that such images have an inappropriately high quotient of sexuality, higher than art that could properly be called fine art. Erotica, and erotic art, is sleazy and sometimes kitschy, and it has only been possible in the last three centuries, after fine art began to separate from images with high sexual content. Where the term "erotic art" or its equivalent can be found, pornography may also exist; and conversely, before erotic art was a category (or a problem), sexuality and painting coexisted in a different way.[104] Artists such as Fragonard are on the cusp of this development—he could conceive images with too high a sexual content to be acceptable to many patrons, but the same themes and poses that he explores in the more sexual images recur in veiled forms in many of his more public works. In the Renaissance, pornography could not have offered itself as a way to escape from high art traditions because it was itself an example of those traditions (albeit a specialized one, not suitable for all settings). Today, when concepts such as sleaziness, coyness, erotica, and pornography are so natural that they seem to have always existed, pornography offers one of the most decisive ways to abandon the higher "track."

It is interesting to study the vicissitudes of these categories over the last century, as the gulf between the two tracks has grown wider. Artists such

FIGURE 77

Jean-Honoré Fragonard.
Drawing for Jean de la
Fontaine, *Contes*. Paris, Musée
du Petit Palais.

as Jeff Koons and David Salle who appropriate pornographic images are widely perceived to be accomplishing (or failing) at an inherently radical endeavor.[105] The excitement their work generated was partly a consequence of the repeated disasters that have overtaken artists who attempted to mingle fine art and pornography—including Millet,[106] Van Gogh, and even Francis Bacon (Figure 78). Bacon's painting is a typical disaster: the

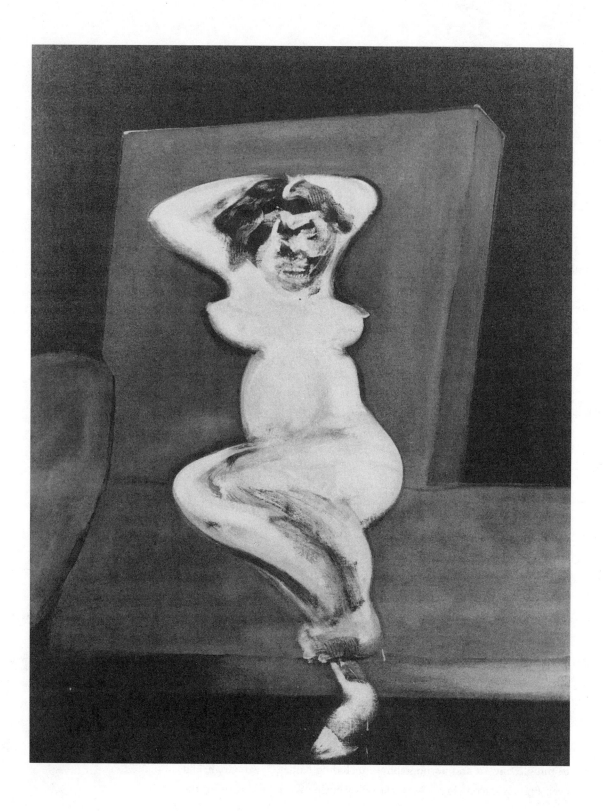

central portion of the figure's body is smooth, and her breasts and hips are almost untouched. But her legs have been twisted and fused into a single appendage and her face is mangled beyond recognition. It may be the unevenness of the deformations that is so unpleasant about this picture, since we accept more thoroughgoing rearrangements of the body in other pictures. It is not easy to know whether it makes sense to mention Bacon's homosexuality in this context; nor is it clear whether this painting was based on a pornographic image or a posed model, but the picture is eloquent testimony to the near-impossibility of mixing the two modes of image making. It's no accident that this painting was reproduced in a book called *Erotic Art Today*: it has all the signs of a sterile hybrid.[107] Fine art and pornography can occasionally be mingled, but usually they appear to our imaginations as an oil-and-water problem: after they are stirred together, they will separate. Our certainty about that, or rather the impossibility of imagining any other situation, constitutes a fourth property of pornographic images. Pornography is a large and contested field, and this is not the place to expand on this analysis: I only want to suggest that if pornographic images are treated as we treat other images (that is, as historically and expressively specific objects), then they take their place with other images that are ostensibly the products of looking alone.

The Attraction of Merely Seeing

Images that change the body by the mere act of looking include some of the most disturbing, offensive, and dangerous pictures in the Western tradition. "Thereness" is anything but an innocuous record of light or a neutral observation. Yet it is that same simplicity that makes these ideas and images so important in all depictions of the body. Many kinds of pictures can elicit the selfish, visceral absorption that I might feel in front of sexual or culinary images. And how would it be possible to describe the difference between that kind of experience and the slightly less intense effect of an enticing landscape painting, or a ravishing abstraction? The same can be said of the way some racist and sexist images reduce individuals to specimens. In front of *The Birth of Venus*, I can only intermittently recover my former understanding of the picture's meanings. Most of the time, I am thinking, or trying not to think, of Simonetta Vespucci and her debilitating illness—at the very least, that thought is crowding at the edges of my awareness. And is Dequeker's reduction of the events of Simonetta's

FIGURE 78

Francis Bacon. *Nude*, 1960. Oil on canvas. Darmstadt, Collection Ströhler. Photo: Museum für Moderne Kunst, Frankfurt am Main. Photo: Axel Schneider, Frankfurt am Main.

life any less violent than Stratz's appropriation of contextless images of aborigines? At first, it might seem that Crookshank's desperate racism is a strange perversion, a serious neurosis. But what, in the end, is the difference between his search for the identity of his own race and our own incessant, but infinitely gentler, thoughts about our own identity and difference? Do we really use images of our bodies, or other people's bodies, any differently than Sheldon? What, in the end, would allow us to distinguish between the most virulent racist image and a painting such as *Gilles* or *The Birth of Venus*?

Since I am not sure that such criteria exist, I have been arguing that we need to attend to the similarities between several kinds of pictures that purport to represent the body in a straightforward manner, without distorting it, engaging it in a narrative, or otherwise explaining it. It is the general case in art that a picture will do nothing but present a body, whether it is a naked figure—in the case that I have suggested is most fundamental—or a clothed figure, or a fruit, or an abstract form. Mysterious wordless presence itself inaugurates the most intense form of the desire to understand, control, name, identify, and—in the case of the human form—reject or possess.

Plato calls the head the "citadel" of the body; the neck
is an "isthmus" constructed between the head and
the chest; the vertebrae, he says, are fixed underneath
"like pivots." The heart is a "knot of veins" and
"fountain of the blood that moves impetuously round,"
allocated to the "guard-room." The spleen is for him
"a napkin for the inner parts, and therefore grows big
and festering through being filled with secretions."
"And thereafter," he says again, "they buried the whole
under a canopy of flesh," putting the flesh on "as
protection against dangers from without, like felting."

The passage contains countless similar examples;
but these are enough to make my point, namely
that tropes are naturally grand, and that
metaphors conduce to sublimity.

—"Longinus," *On Sublimity*[1]

There Scylla came; she waded into the water,
waist-deep, and suddenly saw her loins disfigured
with barking monsters, and at first she could not
believe they were parts of her own body.

—Ovid[2]

five Analogic Seeing

Heraldic shields and crests are also pictures of the body. Like the body, they are comprised of named parts disposed in canonically defined positions. Heraldry is a rigid, additive pictorial system, and its parts cannot be moved out of place, altered beyond certain bounds, or fused with other parts, except in order to produce fantasies or caricatures.[3] A full heraldic device has a half-dozen principal elements—whose analogues would be the appendages of the body—surrounding a central shield.[4] Like a torso, the shield wears a head, in the form of the crest and crown, and it rests on legs, synecdochally supplied by the supporters. Like the abdomen, the shield may be further dissected into its many component parts. The parallels are implicit but systematic, and as far as I am aware body metaphors only come into play in the literature in eccentric instances, such as shields that bend and twist as if they were cuirasses, or "compartments" (bases) that look like actual places where bodies might stand. Nevertheless, it is a suggestive analogy, and the history and development of heraldic rules and nomenclature might be read as a history of the changing concepts of the human form—medieval heraldry is more organic, and less precisely articulated; Renaissance heraldry is more theoretically elaborated, and prone to distortion; and modern heraldry has largely disintegrated into its component parts (crowns, spheres, banners, and so forth), which have become the simplified logos of companies.

Most other pictorial systems are less articulate in this sense, but I think even the least figural patterns can be read as analogies of the depicted human form. Conversely, a fundamental strategy for picturing bodies is to

FIGURE 79

Martin Schongauer. *Temptation of St. Anthony*, detail of a demon (inverted), 1470–75. Engraving.

search for a substitute or an analogue: a hook for a hand, a stick for a leg, a flower for a face. Sometimes, as in Picasso's painting of Françoise Gilot as a "woman-flower," the analogy is whimsical; in other cases, as in his transformations of Olga Picasso into a carnivorous, half-bald lamprey, the meaning is misogynist.[5] The body can even serve as an analogy for itself—for example, when the torso becomes a face or the anus becomes a mouth (Figure 79).[6] In each case, it is apposite to recall the Renaissance term and call the picture a *concetto*—an intellectual conceit.

I think the impulse to see objects in and as bodies, and the complementary desire to see bodies in and as objects, goes deeper than these pictorial games and structural parallels. Instead, I would say that "analogic seeing" is one of our deepest ways of comprehending bodies. In this chapter, I approach this vast subject from two directions: the first inquiry concerns the nature of bodily analogy in what is arguably the most important pictorial transformation in modern art, analytic cubism; and the second explores the limits of the concept of analogic seeing in those rare cases when no analogy can be found and comprehension itself is threatened—

when the eye is disoriented and bewildered by bodies too monstrous to comprehend on *any* terms.[7]

The Metaphor Machine

Cubism, it can be argued, does not yet have a nature; rather, it has its mainstream hermeneutics, which embrace some ten or twelve interpretations. In the last twenty years that tradition has become mindful of its own history and, as a consequence, the various theories have begun to coalesce and find agreement with one another. Cubism was invisible to earlier writers in the sense that they did not address the peculiarities of the paintings but instead constructed theories to account for cubism in general, as if it were a theoretical proposition. Some of the most interesting recent accounts have stressed general characteristics such as the paintings' unfinished look, the concept of "passage," and the phenomenology of fragmented forms.[8] It is also possible to look so closely that one misses the forest for the trees and sees nothing but incremental changes of style or ephemeral innovations.[9] Leo Steinberg has written an impatient account of several theories, but we are still largely without a convincing way of describing cubism—to put it baldly, we still scarcely know what cubism is.[10]

The fact that cubism has proved so difficult to see has much to tell us about the nature of cubist painting. Something inherent in the project of cubism makes it difficult to look at, and it is not irrelevant that museum visitors do not often linger over analytic cubist paintings—they pass them up in favor of the Blue or Rose periods, or the neoclassical works of the 1920s and after. Each cubist painting is less seen and seen less than neighboring paintings in other styles, and it requires an entire exhibition of cubism to keep viewers attentive. Part of this, it should be admitted, comes from viewers' lingering expectations about naturalism. Cubist portraits are like splintered mirrors: we see part of what we expect from realist portraiture (that is, our photographic "trivial image" in the canvas, to adopt Baudelaire's phrase) but not enough to keep our attention, which is continuously deflected onto "irrelevant" ambient detail. Another part of the difficulty in seeing cubism is the "absence" of color—the paintings' fustian look of old brick, wood, and mud; and part is due to the frustrating cat-and-mouse game of identifying fragmented objects—a game that seldom comes to a satisfying conclusion. One does not finish looking at a cubist painting of 1911–12 with an exhilarated "Oh, that's it!" but

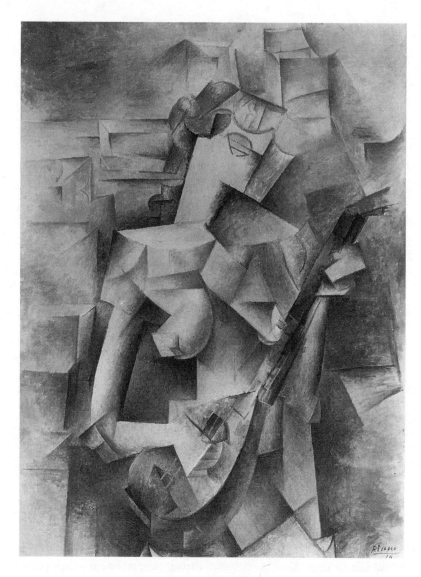

rather, in half-defeat, one walks off to the next painting, hoping to do
better there.

Leo Steinberg's two beautifully written pages on the building blocks of
cubism, now a quarter-century old, have still not received a full response,
although they remain the best account of what happens in analytic cubist
pictures. Steinberg is rightly wary of loose talk about simultaneity or per-
spective. He chooses to look closely at a single canvas, Picasso's *Woman
with a Mandolin* (Figure 80), whose space he says is "subtly mystified." The
painting's methods are mysterious, and the mechanism of mystification
varies: in the upper left, the space is "smooth," and "stacked rectangles nest

in each other and cascade down the left margin. . . . Multiplied down-ward, they seem to fill out as geometric solids, their substance visibly interchangeable with that of the nude." The space mystifies as Proteus mystified: first it is smooth, then rectangular, and then repeatedly solid. It is apt to begin as inert matter (the rectangles mimic picture frames, and the "geometric solids" recall furniture) and turn into flesh. The incarnated void is never entirely skin or bone (that would remove the greater part of its mystery)—it insists on being both architectural and human. You might say that Picasso's nude is infected with a kind of geometrical disease. Part of her is smooth and solid, while another is already crystalline.

Would it be right to call these Protean parts "facets"? The word has a good pedigree: it comes from Matisse's comment to Louis Vauxcelles about "les petits cubes." But neither the English "facets" nor the French "cubes" are really right. A "facet" is the face of a gem, something cut from a solid. Crystal facets join, one to the next, in a seamless hard surface. And if gemology is not the correct metaphor, neither is architecture, although the facets have also been called "brickwork" and "cubist quoins." There is a fundamental problem with all the architectural and engineering metaphors: facets are often not pieces at all. In paintings like the *Portrait of Daniel-Henry Kahnweiler* (Figure 81), these facets are often missing tops, bottoms, or sides. "Individually," when they can be seen by themselves, they appear in a number of guises: not merely as bricks, quoins, and facets but also as tiles, peeling paper corners, leaves, skin, furniture joints, wood shavings, laths, marquetry strips, machine parts, metal sheeting, and cut leather. Steinberg speaks of "foreshortened facets," but not all are—some are in parallel projection, and others curl undecidably. No metaphor or method of representation can hold them: some are imbricated, like tiles; others unfold their plans and elevations like blueprints; others are as translucent as onionskin. And as Steinberg saw, many are not objects at all, but rather thickened air.

These facets slide into one another, melt, merge, and sometimes even disintegrate. Most are composed of three or four outline strokes and a little fill, but occasionally each component part goes it own way, loosening and dispersing the facet. There are three kinds of drawn lines in the *Portrait of Kahnweiler*: the undependable border lines; the shadows cast by facets and drawn as lines; and lines that stand on their own, some floating "over" the facets. The mere fact that a line might be the edge of a facet one moment and a free-floating object the next shows how tenuous the facet metaphor really is. It might be better to say that the painting is com-

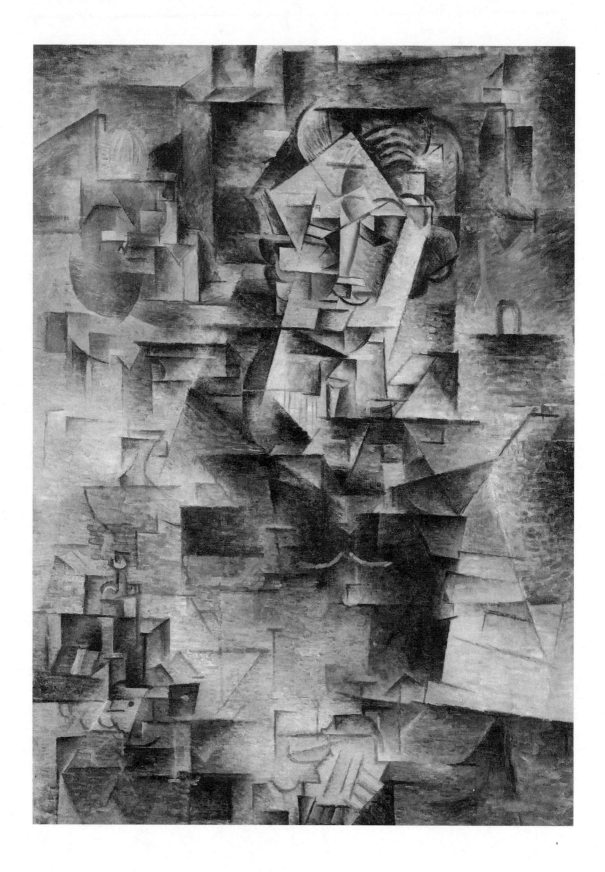

posed of lines and brushstrokes, some of which tend to congregate into facets. And what about the brushmarks themselves? Picasso has not blended his tones; instead, he has left a minuscule brickwork (the term is much more nearly applicable here) of horizontal courses throughout the painting. It does not "fortify the masonry of interlocked forms" (as Steinberg said of the facets), but it recalls solidity, as the bricks in a ruin recall its former wholeness. Generally, the brickwork is painted with a dry, feathery brush, but sometimes, as in the cheeks and jowls of the *Portrait of Kahnweiler*, it gets pasty, like cake frosting.

There are at least three problems with the notion that cubist paintings are made of facets: the edges tend to detach, letting the facets fuse with one another; there are networks of floating lines, unattached to the edges of anything; and the fill of brickwork contradicts the facets and implies a continuous substratum. The space is no easier to describe. For one thing, paintings such as the *Portrait of Kahnweiler* are irregularly and illogically lit. A cornice at the upper right of the *Portrait of Vollard* (1910) has a shadow that signifies depth, and an area to the right of Vollard's head has a conventional shadow, but in both paintings there is also an overall scheme of shadows that passes indifferently over objects and voids, as if Vollard and Kahnweiler were landscapes dappled by clouds floating overhead. The cloudy shadows neither match the lines and facets nor contradict them.

How deep is the space in these paintings? Sometimes it is shallow, almost claustrophobic—the figure in *Woman with a Mandolin* looks meshed, tied down into her space. In other paintings, it is unexpectedly deep—the recession beyond the cornice in the *Portrait of Vollard* looks yards deep. Analytic cubist paintings are often compared to bas-reliefs, but if the *Portrait of Kahnweiler* is like a carved relief, where is the *fondo*, or the back plane, that traditionally represents infinite distance? Paintings like these are like old leaf piles, at the bottom rotted and merged with the ground, or like archaeological digs half-excavated, with sharp fragments embedded in the matrix. There is nothing that is undoubtedly in front and nothing that is unambiguously deep.

Let me gather these observations. First I would note that Steinberg's description, and my glosses, do not cohere—they don't add up to a working definition of analytic cubist practice. Each of the points I have mentioned has called out for a qualification: either it is partly false or it exists in tandem with contradictory qualities. No point stands alone (cubism is not, for example, an "overthrow" of perspective). Cubism, I would say, is

FIGURE 81

Pablo Picasso. *Portrait of Daniel-Henry Kahnweiler*, 1910. Oil on canvas. Chicago, Art Institute.

involved in the production of ambiguities. In the best paintings, like these two, the work balances each ambiguity and measures out contradictory qualities: unity and simultaneity, figure and ground, discontinuity and smoothness, crisp plane and smudgy "veil," color and monochrome, acidic psychological penetration and blank disengagement, volume and species of flatness, lines that serve as outlines and lines that are independent of represented objects, tactile marks representing objects and those inventing forms "out of thin air," lively flesh and architectural ornaments, abstraction and realism, word and image, paint and collage, the feeling that something is happening to perspective and the uncertainty about what it might be. This is as close as I have been able to come to a reading of cubism: it is a balancing act, or rather a series of them—a matter of controlled ambiguities. To Steinberg, cubist paintings "impress the theme of *discontinuity* upon every level of consciousness," and I would agree: the discontinuities are caused by the paintings' exquisitely careful vacillations.

Each ambiguous pair subverts nineteenth-century academic ideals, and cubism has been seen as an act of pictorial terrorism, an anarchic search for standards that could be overturned. True—but cubist paintings also temper their radicalism by balancing so many possibilities. In these paintings, Picasso showed that things could be made less stable than they had been and that the body could move from identification with itself to a nomadic search for analogic security. It is, I would like to say, one of the most compelling demonstrations of the way we often encounter bodies.[11]

Monsters by Analogy

With that I turn to the subject that affords the best approach to the mechanism of analogic seeing: the question of what happens when the eye is baffled and needs to go in search of analogies in order to understand what it sees. The result of that search, I think, is the history of monsters. Often monsters are composed by analogy—a mermaid is like a woman, the sphinx is like a lion, and so forth. Manatees, seals, and dugongs have been suggested as explanations for sirens, and no doubt a first glimpse of a dugong would be nothing but a blurred confusion; a person seeing it might well want to turn it into something easier to comprehend.[12] It has been suggested that the common monsters of myth and fable began as genuinely horrifying birth defects: cyclopes and sirens both have their corresponding birth defects (*cyclopia, sirnomolus*), which may have helped inspire

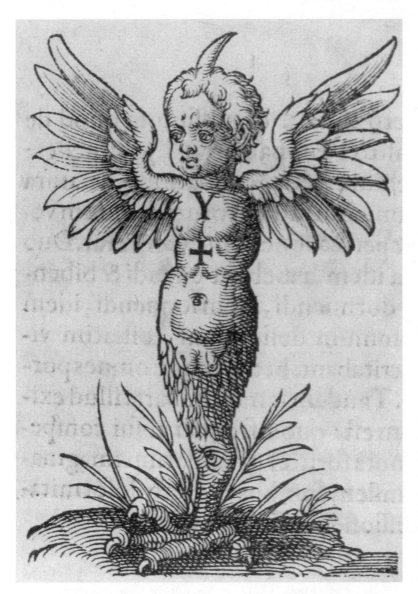

FIGURE 82

The "Ravenna monster." From
Ambroise Paré, "De monstris
et prodigis," in *Opera chirurgica
Ambrosii Paraei* (Frankfurt am
Main: Peter Fischer, 1594),
book 24, pp. 717–63, ill. on
p. 619. Department of Special
Collections, University of
Chicago Library.

the myths about them. Unicorns also occur as birth defects in animals, al-
though narwhal horns have traditionally been used to counterfeit unicorn
horns. Satyrs have some resemblance to the Brachman-De Lange syn-
drome, which involves limb reductions and hairiness in newborns. The
"Ravenna monster" was a deformed child, cobbled together—so Am-
broise Paré says—from a baby's torso and head, a curved horn, a hawk's
leg, eagle's wings, the genitals of both sexes, the letter "Y," and the sign of
the cross (Figure 82).[13] A woman gave birth to it soon after a bloody bat-

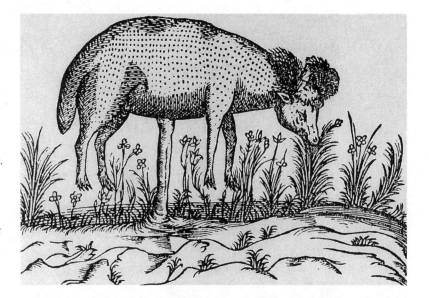

FIGURE 83

The Scythian lamb, or *borometz*.
From C. Duret, *Histoire
admirable des plantes* (Paris,
1605), reproduced in J. Priest,
*The Garden of Eden, The Botanic
Garden and the Re-Creation of
Paradise* (New Haven, 1981),
p. 51, fig. 37.

tle between Julius II and Louis XII in 1512, showing God's displeasure.[14]
A modern author thinks that even this monstrosity could be the mistaken
explanation of a teratology (birth defect)—except for the eye on the knee,
which he finds difficult to explain.[15] It is easy to push theories like this one
too far, but even if traditional monsters weren't "inspired" by teratologies,
it is at least plausible that the unfrightening, somewhat ridiculous monsters
that populate medieval and Renaissance texts have their beginnings in ex-
periences of more radical conceptual chaos.[16]

All such older monsters are composites (*grylli*, or *aenigmae*)—bodies
made by assembling parts of other bodies.[17] The Scythian lamb, or *boro-
metz*, is a typical example; it was a creature that supposedly lived on a stalk
(Figure 83). As it grew, its trunk stretched, until it could only look down
on the grass that had once nourished it. Eventually, it starved and died, and
its body became a husk.[18] As Duret depicts it, the *borometz* is eating the top
few inches of meadow grass, and its coat is already going to seed. It is a
sad creature, something of a melancholy hunger artist among the vigorous
fanciful monsters of the medieval bestiaries. Yet it is easy to understand
because it is constructed by analogy: its stalk is like a tree trunk, and in
that sense it is a plant, but the stalk is also like an umbilical cord, and in
that sense it is an animal. A young *borometz* is a lamb, tethered to the
ground. It becomes more plantlike when its dried-out organs, muscles,
and wool become a vegetable matrix for *borometz* seeds. Hence it is both
plant and animal, although it is never entirely one or the other.

As A. O. Lovejoy has pointed out, in the Middle Ages creatures conformed to a "chain of being"—a succession of species, each in analogy to the ones before and after it. From "God Himself" to the lowliest worm, creatures paraded in sturdy succession.[19] The great chain of being is not a rope with fibers inextricably entwined, but a chain with clearly articulated links. Both real and invented creatures had to obey these laws of fixed difference. The *gryllus*, or *aenigma*, was the operative principle of monstrous construction: monsters were formed by conjoining nameable parts taken from nameable creatures. Thus, a centaur is a man and a horse, a *borometz* is a tree and a lamb, and a heraldic wyvern is a two-legged dragon, derived from four-legged dragons, which are in turn derived from lizards, snakes, and bats. *Grylli* are always formed by combining parts.[20] The *borometz* is predicated upon clear illogical comparisons between lamb and seedpod, trunk and umbilicus, animal and plant.

Apparently, it was once necessary to think of monsters as composites, and conversely, it was sometimes entertaining to do so, although *grylli* could also be genuinely frightening.[21] Descartes was one who was not frightened by composites; in *Discourse on Method*, he comments that even when painters try to achieve the "bizarre shapes of sirens and satyrs, they are unable to give them completely new natures, but can only jumble together the parts of various animals."[22] I interpret this either as a denial— there are horrible things out there, but he will not, at the moment, admit to thinking of them—or as a Cartesian map of consciousness, a way of saying that things are naturally rational, because nothing other than *grylli* can be conceived. Yet it seems that worse monsters were in the back of Descartes's mind—otherwise, why say that artists can "only jumble together" their *grylli*? Descartes's own "evil demon" is more horrifying than any pictured monster, but it has no shape. He must have had thoughts of things worse than centaurs or griffins, but he does not seem to have had mental pictures of them.

Before the twentieth century—I would almost like to say before Picasso, the inventor of the truly monstrous—virtually all monsters were made by combining parts of animals, and in addition to the entire stable of Greek mythology, from Cerberus to the Medusa, there are all the monsters invented by medieval and Renaissance artists to illustrate scenes such as the temptation of St. Anthony. In all their permutations, they remain concoctions of common animal and human parts. The mechanical collage in Max Ernst's *Celebes* (Figure 84) is not quite a *gryllus*, because not all its

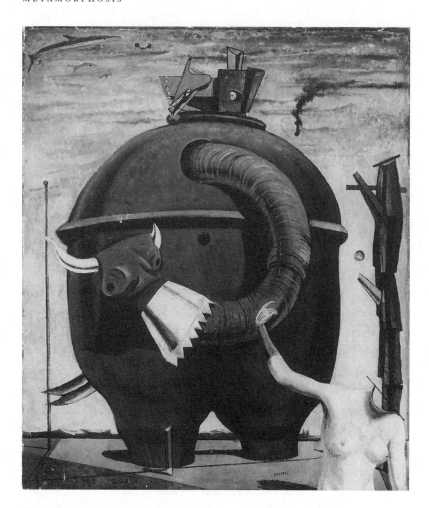

FIGURE 84

Max Ernst. *Celebes*, 1921.
Oil on canvas. London, Tate
Gallery. © 1997 Artists Rights
Society (ARS), New York /
ADAGP, Paris.

parts are nameable portions of other animals or objects. There is no spe-
cial term for the surrealists' extension of the *gryllus* principle, although
"collaged *aenigmae*" might have suited Ernst. Like the tradition of anthro-
pomorphic landscapes (in which bodies, heads, and other forms are cam-
ouflaged as landscape) and naturomorphic heads (such as Giuseppe Arcim-
boldo's allegorical portraits), the *Celebes* is readily comprehensible even
though it is not assembled according to the more elementary laws that
govern griffins or hydras. More recently, mechanomorphs, androids, cy-
borgs, and metalmorphs have appeared to blur the distinctions between
sexes, and between the human and the machine, but they continue to op-
erate according to the principles of the *gryllus* or the collaged *gryllus*.[23] The
vast majority of monsters are *grylli*, and they have been accompanied in
most cultures by some slightly less comprehensible monsters, in which

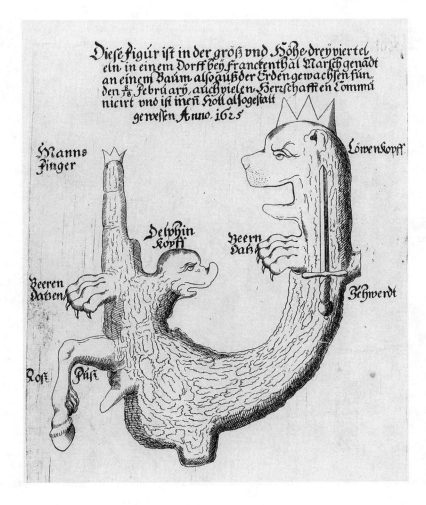

FIGURE 85

A miraculous branch,
prefiguring war. Found on
a tree near Frankenthal,
Germany, 1625. Engraving.
Frankfurt, Stadt- und
Universitätsbibliothek,
Einblattdruck G. Fr. 69,
Konto-Nr. 1.010.941.

new kinds of bodies are made of shreds and scraps rather than limbs and torsos. The difference between analytic and synthetic cubism repeats the same dichotomy: synthetic cubism is the art of the *gryllus* because its figures are made of nameable parts shifted around from their usual places. Analytic cubism is the less orderly mode because its parts, the elusive facets, don't quite have names.

Still, there are exceptions—monsters that refuse to be understood as assemblages of parts which might be detached and returned to their original owners. Some wondrous objects collected in curiosity cabinets are this kind of pseudo-*gryllus*. A miraculous branch, for example, which was found in Germany in 1625, was composed of a lion's head, a dolphin's head, two bear paws, a sword, and a man's finger with a crown-shaped manicure (Figure 85). These are nameable parts, but they are not quite assembled; in-

FIGURE 86

Anonymous, after Hieronymus
Bosch. *Temptation of St.
Anthony*, detail of lower-left
corner, 1522. Woodcut.

stead, they grow like bulbs (or like the knots they presumably were) from
an amorphous piece of wood. The branch is *almost* an assembled body, but
not quite. Instead, it hangs in suspension like the gluey creatures in Car-
penter's *The Thing* (see Figure 34). The lion's head growls at the human
finger, and the pug-nosed dolphin looks suspiciously at one of the bear
paws. (The branch was taken as an omen of war, and it may have been de-
signed to look as if it were intending violence to itself.) Three other ap-
pendages are recorded by the artist but not named: two truncated stalks at
the bottom and on the right, and a penis-shaped extrusion at the lower left.
At least one of the stalks looks as if it was cut from the tree, but the penis
shape remains odd. Because it is not quite a penis (or any other append-
age), it does not fit into the conceptual schema of the *gryllus* and it is omit-
ted from the accompanying explanation.

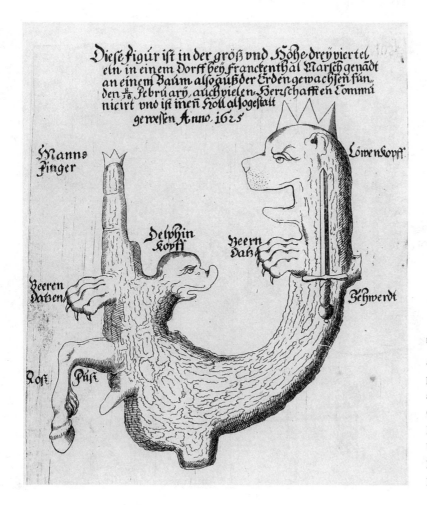

FIGURE 85

A miraculous branch, prefiguring war. Found on a tree near Frankenthal, Germany, 1625. Engraving. Frankfurt, Stadt- und Universitätsbibliothek, Einblattdruck G. Fr. 69, Konto-Nr. 1.010.941.

new kinds of bodies are made of shreds and scraps rather than limbs and torsos. The difference between analytic and synthetic cubism repeats the same dichotomy: synthetic cubism is the art of the *gryllus* because its figures are made of nameable parts shifted around from their usual places. Analytic cubism is the less orderly mode because its parts, the elusive facets, don't quite have names.

Still, there are exceptions—monsters that refuse to be understood as assemblages of parts which might be detached and returned to their original owners. Some wondrous objects collected in curiosity cabinets are this kind of pseudo-*gryllus*. A miraculous branch, for example, which was found in Germany in 1625, was composed of a lion's head, a dolphin's head, two bear paws, a sword, and a man's finger with a crown-shaped manicure (Figure 85). These are nameable parts, but they are not quite assembled; in-

FIGURE 86

Anonymous, after Hieronymus
Bosch. *Temptation of St.
Anthony*, detail of lower-left
corner, 1522. Woodcut.

stead, they grow like bulbs (or like the knots they presumably were) from
an amorphous piece of wood. The branch is *almost* an assembled body, but
not quite. Instead, it hangs in suspension like the gluey creatures in Car-
penter's *The Thing* (see Figure 34). The lion's head growls at the human
finger, and the pug-nosed dolphin looks suspiciously at one of the bear
paws. (The branch was taken as an omen of war, and it may have been de-
signed to look as if it were intending violence to itself.) Three other ap-
pendages are recorded by the artist but not named: two truncated stalks at
the bottom and on the right, and a penis-shaped extrusion at the lower left.
At least one of the stalks looks as if it was cut from the tree, but the penis
shape remains odd. Because it is not quite a penis (or any other append-
age), it does not fit into the conceptual schema of the *gryllus* and it is omit-
ted from the accompanying explanation.

In some pictures by Hieronymus Bosch, the routine combination of body parts ceases, and monsters begin to grow directly out of the slime. In the lower-left corner of a woodcut of the *Temptation of St. Anthony*, far from the ostentatiously evil and degenerate creatures that have come to taunt the saint and well out of sight of the flapping aerial orgies, a small creature climbs inexorably up toward the manger (Figure 86). It is not an *aenigma* but a more genuine problem for the understanding—a true, non-composite monster in the modern sense, resistant to analogic explanation.

On the Edge of Visual Desperation

It is my contention here that analogic reasoning is what allows us to perceive Bosch's weird little creature *as* a creature: to see that it is one creature, that it has a mode of life, and that it is, in the most fundamental sense, a body. Lovejoy's history can be reread as a handbook for the conditions of the possibility of seeing bodies at all, since its subject is the ways in which linguistic constructions made creatures comprehensible.[24] Analogic thought is resilient and resourceful, and as long as we can unearth a term for comparison, we can perceive a body and contrast it to our own. Ernst's *Celebes* is a body, and so are Arcimboldo's mannerist conceits. The analogic principle holds good for most bodies in pictures, mythologies, bestiaries, and dreams, for the classical *monstrum*, and even for the most shocking teratology. It even helps us to understand enough of Carpenter's jellies, or Bosch's bit of slime, to see them as bodies and to guess how we might respond to them.

Yet there are also the rare cases in which our capacity to complete the analogy fails, and we cease to comprehend what we have seen or to see bodies at all. This has happened most recently in the case of the Burgess Shale, the Cambrian strata in British Columbia that yielded creatures so bizarre that they were at first mis-seen and classified as members of familiar phyla. Elsewhere, I have discussed a creature named *Hallucigenia* in honor of its capacity to disrupt expectations.[25] But the most radical challenge to our capacities to analogize, and therefore to register the presence of bodies, came during the Enlightenment. That was the time of the great microscopical discoveries, when creatures were found that did not seem to be constructed by analogy with other creatures at all. Their appearance engendered a phenomenon I will be calling "visual desperation," as the microscopists struggled to find suitable analogies that would allow them

to make sense of what they were seeing. Visual desperation is not a common problem, and when it occurs it reveals how widely and naturally we rely on analogic thinking. I take it that our ability to understand the bodies we encounter, whether they are humans, *grylli*, or *borometzes*, depends on finding workable analogies. "Visual desperation" is a name for a peculiarly strained and anxious seeing that casts about, trying to construct analogies and retrieve an unknown form into the fold of vision. When it succeeds, we complacently classify what we've seen as human, animal, plant, or fabulous beast. When it fails, we become blind—we see only chaos or trackless monstrosity.

Enlightenment Microscopy as Conceptual Anarchy

The history of magnification, and especially its exemplary moment—the invention and elaboration of the idea of protozoa—recapitulates many ideas that preoccupied the eighteenth and nineteenth centuries in other spheres. To some, the microscope was an instrument of entertainment: its slides were magic lantern transparencies, and its brilliant "stages" boasted the most wondrous actors. Microscopic life was nothing short of "microscopic theater," a "*spectacle très-réjoüissant*," in which condensed lights revealed astonishing underwater comedies.[26] The acrobatics, "joyous leaps," and "frisky contortions and vaults" of "the harlequin, or insect [found in] muddy water," reminded one amateur scientist of lusty springing in the commedia dell'arte (Figure 87).[27] It looked as if it were dancing, perhaps in hieroglyphs—Ledermüller shows some of its poses at the top, with its normal appearance circled and then enlarged.

The microscopic *spettacoli* were also implicated in the Enlightenment search for origins, both spatial (in Pasteur's and Spallanzani's experiments, which attempted to isolate the living from the sterile[28]) and temporal (in the question of the "potential immortality of the protozoa" popularized by Coleridge and "proved" in the 1920s[29]). Microscopic creatures were part of the eighteenth-century debates on the primitive and its nature, and they were enlisted in discussions of the disruption of classical beauty, propriety, and decorum (here Leeuwenhoek's early observation of frog feces "swarming with little animals" is exemplary). The new creatures were difficult to fit in the existing concept of nature; they posed insoluble questions for theories of moral, sexual, physiological, and morphological classification.[30] Their astonished discoverers did not even know what to call

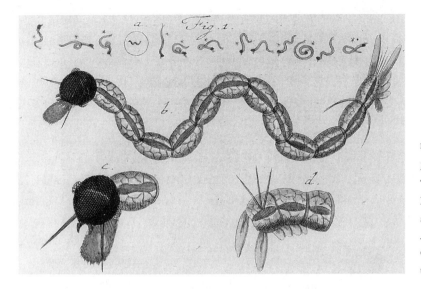

FIGURE 87

Martin Frobenius Ledermüller.
The harlequin worm. From
Ledermüller, *Nachleese seiner
mikroskopischen Gemüths- und
Augen-Ergötzung* (Nuremberg:
C. de Launoy, 1760), p. 145,
tab. LXXV.

them—they were dubbed "invisibles," "animalcules," "*dierken*" ("little animals"), "fish" (a French favorite, "*poissons*"), "protista," "protozoa," "*Ur-tierschen*" ("primitive little animals"), "insects," "*Zellinge*" ("little cells"), "molecules," and "infusoria" (inhabitants of stinking "infusions" of rotting animal and vegetable matter).[31]

They were especially troublesome for those who wanted to draw a line between humans and animals. Pieter Camper was aware that Pongoes look a great deal like hairy children and that there is a continuum between races (see Figure 71). From Camper's point of view, a few well-measured numbers could suffice to position the line between kinds of people and between people and animals. Eighteenth-century microscopic investigations showed how hopeless it is to place any such line, by doubting a far more basic, and equally hopeless, proposition: to distinguish between animal and plant. A group of free-swimming creatures, the phytoflagellates, have chloroplasts like green plants but swim like animals. Sometimes they appear as primitive "trees," coalesced from creatures that had been freely swimming moments before.[32] Some creatures change from animal-like motile forms to sessile plantlike forms in a single generation; rapid swimmers can become "seeds" (cysts) that "germinate" when conditions are improved; and many display a range of sexual and asexual forms of reproduction. As the nineteenth century recognized, the origins of both animality and sexuality are microscopic.

The early writers were faced with an array of questions that strained

the limits of analogic thought. Do protozoa have "bodies" without limbs or organs? Are they trunks or fragments? Can an arm or a finger be alive and function as a body? Can a body lie open and transparent to investigation? Isn't a body properly something with opaque skin dividing its inside from the outside? Can one body be continuous with other bodies, or with the outside world? A body—at least a human body—is potentially beautiful, and its skin can be ideally smooth, "like ivory" in the classical Eurocentric trope. Microscopy also challenged that, because it made humans disgusting. William Cowper's *Anatomia corporum humanorum* includes a minute, fascinating, and nauseating examination of skin pores.[33] The microscopic eye surfaces in Jonathan Swift's repulsive, misogynist itinerary of oils, flakes, and "Pomatum, Paints, and Slops" in "The Lady's Dressing Room." The hero, sneaking into his Lady Celia's boudoir, finds towels

> Begumm'd, bematter'd, and beslim'd
> With Dirt, and Sweat, and Ear-Wax grim'd
> and he inspects her magnifying glass,
> . . . that can to Sight disclose,
> The smallest Worm in *Celia's* Nose,
> And faithfully direct her Nail
> To squeeze it out from Head to Tail;
> For catch it nicely by the Head, ⌐
> It must come out alive or dead.[34]

Low-level magnification, which suited the blurry optics of the early microscopes, maximized the alien monstrosity of everything human, and by extension of everything that lies just below our notice. The most "wretched creatures" ("*schlechte Kreaturen*") were those barely visible to the naked eye (marine larvae, young polychaete worms, the hydra) rather than truly invisible forms. Tinier animalcules were considered less malformed in part because they lacked observable form altogether. Some books inventory repellent creatures, each with a minuscule smudge to show its life-size appearance (Figure 88).[35] In this instance, the harmless particle labeled "Fig. 1" reveals itself as a spidery creature with too many legs, and the rounder blob marked "Fig. 3" becomes a branching worm that harbors turd-like pupae—one of which is enlarged even further at the bottom to demonstrate its pinprick eyes and mouth. Even the cute "harlequin worm" is no beauty: when its head is examined too closely, it reveals a truly monstrous black faceted helmet and a shaving-brush beard (see Figure 87).

Microscopy showed horrors far worse than the monstrous births, dis-
torted animals, and hyperboreans of ancient and Renaissance lore, and it
forced questions about the nature of monstrosity. Can the nine orifices of
medieval medicine be multiplied indefinitely? Can a body include fifty
stomachs migrating freely in a milky interior? Can it be only mouth and
stomach, with no tissues to nourish? Can urine and phlegm float around
a body together with brains and stomach and then pierce a makeshift anus
and escape? Can a hundred eggs live together with a heart in a transpar-
ent body, itself "living" inside a coffee louse?[36] "Protoplasm" is a strange
word. Is it a substitute for "brain" or "soul"? Is it a kind of "sensitive" tis-
sue, something that corresponds to our own "irritable" nerves? When is an
arm a paddle or a fin?[37] Does a ciliated protozoan have a thousand tiny
arms, or are they mechanical helpmates like oars? And what does it mean
to say a body has oars? Can a body be parasitized by homuncular slaves,
each pulling at a built-in prosthetic paddle? The amoeba, called "little, or
blind Proteus" and "animalculum singularissimum," spills its "arms" into
its "legs" continuously, churns its "stomachs" into "bladders," and moves its
anus to any spot on its "body."[38] The observers were dumbfounded. Au-
gust Johann Rösel von Rosenhof, the amoeba's discoverer, waited pa-
tiently for "a head, feet, or even a tail."[39] At times, he was sure he saw
turtle-forms, antlers, or at least flippers (Figure 89). Still, despite his best
efforts, the "little Proteus" stays decidedly monstrous. John Turberville
Needham, another mid-eighteenth-century observer, watched in aston-
ishment as a "Proteus" decapitated itself and then put forth a "wheel-like
Piece of Machinery."[40]

This strange history suggests that there were two related strategies for
retrieving visually intractable forms. Analogy is always a shaky epistemo-
logical tool because it risks seeming inappropriate or fanciful and because
it rarely provides a satisfying explanation. Especially preposterous analogies
tended to collapse, and so they were not so much permanent epistemolog-
ical insights as heuristic devices that were in a sense constructed in order
to be discarded. If an odd body is seen for the first time, indistinctly, at a
distance, or in a memory, then we might say that it looks like another
thing, even if we don't really believe what we're saying. I might spot some-
thing on a foggy night and say it's a person who looks like a table—but I
don't really mean it. The analogy lets me keep looking and helps me see
what's really there. Repellent bodies can be domesticated, at least briefly,
by calling them things they aren't. The naked mole-rat (*Heterocephalus*

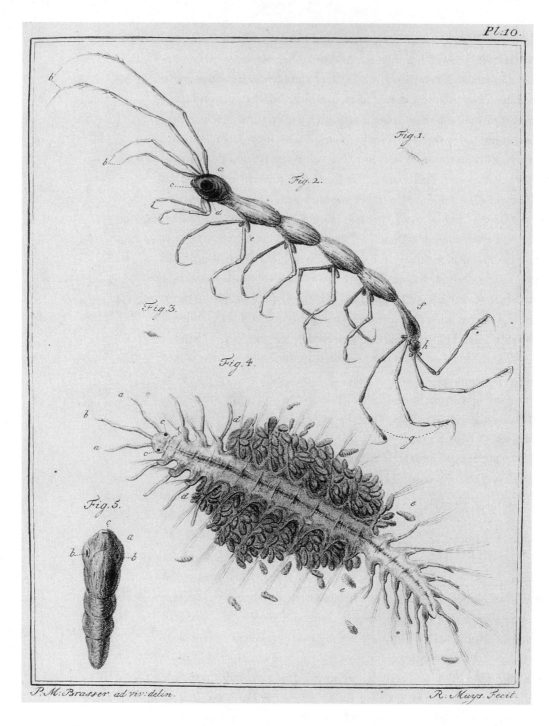

P.M. Brasser, ad viv: delin. R. Muys Fecit.

FIGURE 88

Martinus Slabber. Two *Zee-diertjes:*
the *Zee-scherminkel* (*Physica marina*)
and the *Zee-duizendbeen* (*Scolpendra
marina*). From Slabber, *Natur-
kundige Verlustigingen behelzende
microscopise waarneemnigen van
in- en uitlandse water- end land-dieren*
(Haarlem: J. Bosch, 1778), pl. 10.

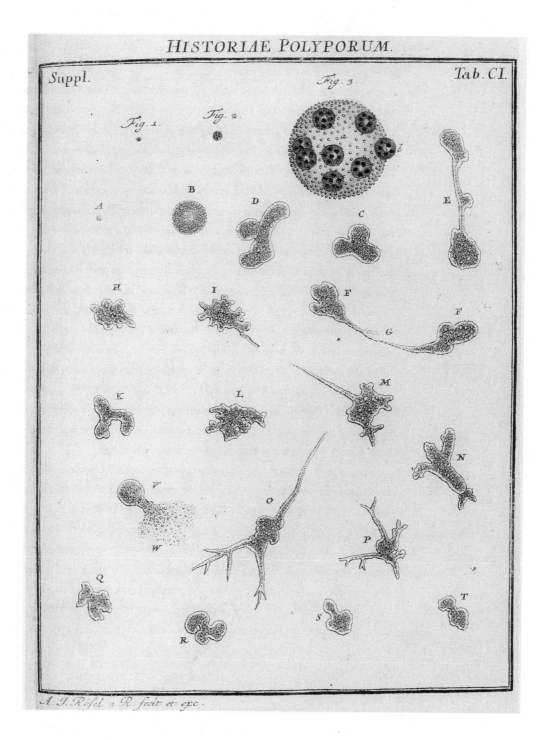

HISTORIAE POLYPORUM.

Suppl. Tab. CI.

Fig. 3

Fig. 1 Fig. 2

a b

A

B

D C E

H I F

G F

K L M

N

V

O

W P

Q S T

R

A. J. Röfel. R. fecit et exc.

FIGURE 89

August Johann Rösel von
Rosenhof. *Der kleine Proteus*
(the Amoeba), with *Volvox* sp. at
the top. From Rösel von Rosenhof,
*Der monatlich-herausgegebenen
Insecten-Belüstigung*, 1741
[1741–55], vol. 3, tab. CI.

glaber) is a small wrinkled animal, reminiscent of a dried turd. It has been described as a "saber-toothed sausage," an appellation that makes it easier to be amused, rather than squeamish, at the appearance of a body that so perfectly fits Julia Kristeva's sense of the abject.[41] "Rat kings," groups of black rats tied together by knots in their tails, have attracted attention since the sixteenth century.[42] There are a number of theories about how they are formed: their tails may become entangled in utero, or they may owe their origin to a sticky knot of frozen urine. The attention that has been lavished on them is evidence of the failure of analogies and the rise of visual desperation—there is no animal even remotely like a bizarre, wheel-shaped collection of squealing rats with fused tails. In the course of listing artifacts that are derived from bodily forms (the hammer from the arm and fist, the telescope from the eye's lens, and so on), Elaine Scarry cites the wheel as an invention that has no human analogue. "Perhaps," she suggests, "the wheel astonishes us in part because we do not 'recognize' it—that is, because we intuitively sense that it has no prior existence in our own sentient matter."[43] She lists "the ball and socket joint" and "the rotary mechanism of some insect wings" as possible counterexamples, but the point is essentially valid, and it might also explain the helpless nausea or horror people have felt upon seeing (or even thinking about) rat kings.

The second strategy for comprehending incomprehensible bodies is to avoid analogies in favor of neologisms: instead of saying the apparition is a human who looks like a table, I might choose to see it as an integrated form, and coin a term for it—say, "tabular human." The newly named creature would then defeat any further analysis—it would simply be an enigma (or more exactly, an *aenigma*, something new with a new name). Neologisms, and not analogies, are the principal strategy that modern science uses to paper over problems that bodies continue to provoke, but they were in use from the beginning. ("Sphinx," after all, was once a neologism.)

Pushing Sperm off the Edge of the World

Sperm are a central example of "bodies" that required all the resources of analogy and neologism. They are still called "spermatozoa," literally "sperm animals," but clearly they aren't animals in the usual sense. The first people to see spermatozoa recognized them as living creatures, but they balked at the thought that human bodies might be in perverse commensal partnership with mindless vermin. Calling them by the more obvious analogic

FIGURE 90

Leeuwenhoek's *vaten* (vessels).
From *The Collected Letters of
Antoni van Leeuwenhoek*
(Amsterdam: N. v. Swets
en Zeitlinger, 1941), p. 277.

names—"tadpoles," "worms," "snakes," and so forth—was even worse,
since these terms would imply that the male body harbors, and possibly
even depends on, "lower" animals. The simplest and most radical solution
was to deny that spermatozoa are analogous to bodies at all.

In a letter of May 31, 1678, Leeuwenhoek again raises the question of
the differences between these "*dierken*" in dogs and other animals, but most
of his attention is consumed in an effort to record the "vessels" ("*vaten*")
he had first seen in seminal fluid a year before (Figure 90). His ephemeral
vaten have never been explained, and they have vanished from the litera-
ture.[44] Leeuwenhoek protests that he is "not an expert" at drawing, and he
drew relatively little in comparison with Huyghens or Hooke (his first de-
scriptions of protozoa are not illustrated), but he tries hard to show the
ways in which the *vaten* lie in obscure tangles. The letters "D-D-D-D" at
the bottom of Figure 90 represent a dense interweaving that "the eye can-
not follow." Four such drawings survive, looking like nothing so much as
art school exercises or doodles; the sperm themselves, which could have
been shown swimming in this labyrinth, are absent—they appear in other
plates, lined up with specimens from other species. To Leeuwenhoek, the
dierken in seminal fluid were "nothing but the vehicle [*voerwage*] of a cer-
tain extremely volatile animal spirit [*seer vollatile animale geest*], impressing

on the conception, i.e., the ovum of the woman, the perception of life [*het levende gevoelen*]." The *vaten*, on the other hand, are not so immaterial: they are "nerves, arteries, and veins" and indeed every organ of the body, nascent in the seminal fluid. Or so he says, even though he seems to be a bit half-hearted about his own theory. "Once," he proposes, "I fancied I saw a certain form . . . which I fancied I could compare with some inward part of the body."[45]

At least, in Leeuwenhoek's theory, the body remains intact across generations: the father bequeaths the components of his body in dissected form (hence the interest in how the fibers of the *vaten* are related), together with the principle of motion, the "volatile spirit" embodied by the *dierken*. Potentially, it is a good theory (or it would have been if Leeuwenhoek had been able to see more organs in the *vaten*), but it is missing the spermatozoa themselves—nothing in the *vaten* corresponds to disembodied sperm. The spermatozoa become incomprehensible as bodies, since they themselves would require their own *vaten* to ferry them from one generation to the next.

Later observers failed to find Leeuwenhoek's *vaten*, and without them it became more difficult to account for spermatozoa without having recourse to slimy animal metaphors. Whether or not the embryo is contained in the sperm—and it is far from clear that Leeuwenhoek thought so—the question of the transmission of the body remained vexing. We can pass over the hallucinations and misguided illusions of Nicolaas Hartsoeker, who saw the head of the sperm as a womb (such solutions were too literal to be widely believed), but like Leeuwenhoek's interest in the *vaten*, many early theories were bound up with the demotion of spermatozoa to accidental or mechanical intrusions on the proper workings of human reproduction.[46] Needham's *New Microscopical Discoveries* (1745) offers a description of the "milt vessels of the calamary" in entirely mechanical terms (Figure 91): they consist of an "outward transparent case," "round head," "screw," "sucker," and a "spongy substance" containing the calamary's semen. The full vessel is at the upper right; then the insides spring out, as at the left; and finally the screw pops, releasing the semen (bottom). It's a complicated mechanical involution, and Needham wonders whether Leeuwenhoek's "supposed Animalcules" might not be "nothing more than immensely less[er] Machines analogous to these Milt-vessels."[47]

Needham's solution is, of course, incomplete, since these calamary sperm cases would presumably release tiny sperm, which would them-

FIGURE 91

Milt vessels of the calamary. From John Turberville Needham, *An Account of Some New Microscopical Discoveries* (London: printed for F. Needham, over-against Gray's Inn in Holborn, 1745), pl. 3.

selves have to be mechanical in order to preserve the separation of sperms and bodies. There would be no living-bodied sperms at all, just machines housing machines without end. The fact that Needham did not see this infinite regression might be read as willful ignorance. The Panspermist movement (whose proponents held that every substance contains a "seminal nature" or "seeds" ready to sprout) cannot be understood apart from this anxiety about status of spermatozoans. Three years later, Needham wrote "A Summary of Some Late Observations on the Generation, Composition, and Decomposition of Animal and Vegetable Substances" in which he denies that the spermatozoans are bodies composed of "head" and "tail": "These Tails were so far from being Members given them to

swim and steer by, that they evidently caus'd in them an unstable oscillatory motion; and were in effect nothing more than long filaments of the viscid seminal substance which they necessarily trailed after them."[48] P. L. S. Muller's expanded edition of Linnaeus's *Systema naturae*[49] recounts one of Needham's experiments, demonstrating how a root fibril has "horns" [*Kolben*] that generate mechanical animalcules.

Panspermist accounts show the strain of invention, and there is something of Rube Goldberg in the overcomplicated *vaten* and convoluted pneumatics of the calamary milt vessels, but at least *vaten*, machines, and inanimate parts were more acceptable as partners in male bodies than wormy tadpoles. If we choose to read this from a Freudian point of view, then we might say that male scientists took offense at being violated or polluted in an "unmasculine" fashion; certainly, the more outlandish experiments show a ferocious fixation on mechanisms and abstract, unanimal processes. In a sense, the Panspermists depended on neologisms, since their theories had to be elaborately shored up to fend off the immediate apparition of swimming worms.

One of the most striking denials of sperm occurs in an early edition of Linnaeus's *Systema naturae* itself.[50] There, in order to find the spermatozoa, a reader must turn to the last of the six "Classes of Animals," the "Class of Worms" [*Vermes*], and to its final genus, provocatively titled "*Chaos: Liberum redivivum, metamorphum in vegetante.*" There, among the lowest, unclassifiable members of *animalia*, is the amoeba *Proteus* and the even stranger slime molds, *Chaos fungorum feminum*, imagined as transexual animal spores that turned vegetable and produced mushrooms (this species is credited to the comically unbelievable name of Baron Münchhausen). At the end of the short list of the members of *Chaos* is a miscellaneous category, the *obscurae*, a darkness within a chaos, under which we read the one-line entry:

> d. *Spermatici vermiculi* Leeuwenh. ?

The whole schema goes like this, closeting spermatozoa at the very end:

Animalia
 Class *Vermes*
 Genus *Chaos*
 Proteus (the amoeba)
 Chaos fungorum feminum (slime molds)
 Obscurae
 d. *Spermatici vermiculi* Leeuwenh. ?

Spermatozoa ("spermatic worms") are therefore animals in their own right, with bodies, but they are practically pushed off the edge of the world of taxonomy.

Hacking Up Hydras

During the first decades when people were aware of sperm, there was a tumultuous effort to avoid applying the principle of analogy at all—to deny the possibility that we might be related to "spermatic worms." That virulent revulsion did not come into play with animalcules less intimately associated with human bodies. With other microscopic creatures, it was more a matter of testing the limits of analogic thinking in order to comprehend the new forms of life. The freshwater hydra is a well-studied cause célèbre. At first, it appeared to be a plant, since it spends most of its life fixed to underwater leaves and stalks. Some were found in colonies, or rather sometimes the "Polype" was a multiple creature, like conjoined septuplets (Figure 92). Then it was observed to "walk," by pulling up its "roots" and tumbling slowly end over end. The monstrous Polype seemed even more so when it was "divided"—that is, its "arms" were cut—and each fragment grew into a whole creature. It seemed to have no internal organs, only a cylinder within a cylinder, sometimes filled with green "curds." One researcher decided that the "curds" were neither "blood" nor "sap," but something else, not confined to animal or plant "vessels," but free to roam throughout the body like curds in milk.[51]

Consider the monstrous possibilities of the Polype from the late-eighteenth-century standpoint: a single "limb" (a limb, we might note, with no bones, no hand, no muscles, and no skin) could regenerate into a whole polyp, which might then develop "buds" on which smaller polyps would grow before they swam or "tumbled" away.[52] Those polyp "children" would be "sons" and "daughters" of *arms*. Some plants grow miniatures of themselves rather than seeds, but no animal can use its own arm to produce its progeny. In humans, the polyp's mode of reproduction would be entirely monstrous. (In David Cronenberg's film *The Brood*, a mother "buds" by growing external wombs, which sprout from various parts of her body.)

Hydras appeared to be sexually and anatomically deviant, but at least they had a mature form that could be described analogically (as a headless, footless, skinless, boneless trunk with arms). Other animalcules could

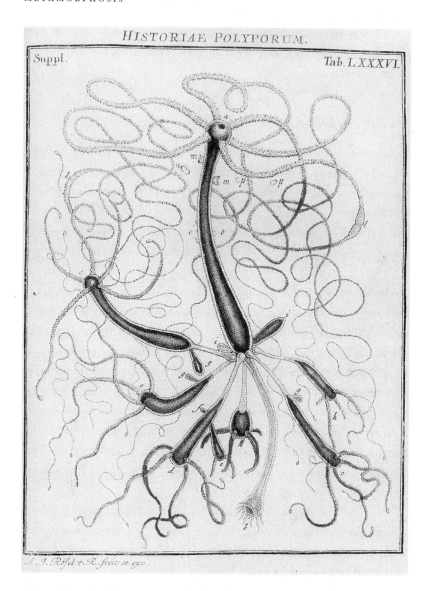

FIGURE 92

August Johann Rösel von
Rosenhof. The freshwater
hydra. From Rösel von
Rosenhof, *Der monatlich-
herausgegebenen Insecten-
Belüstigung*, 1741 [1741–55],
vol. 3, tab. LXXXVI.

not be so easily described, since they seemed to toy with the more basic
idea that a body should have a canonical form proper to its species. Hein-
rich August Wrisberg's *Observationum de animalculis infusoriis satura* (1765)
includes a description of infusoria that have no single form (Figure 93).
One such group of "molecules" (Wrisberg was probably looking at bac-
teria) exists in seven forms: in groups ("A"), lines and triangles that swim
("B," "C"), aggregates of "four, five or more" ("D," "E"), as an "animal-
culum sphaericum" ("I"), and as globules with a "tail of little bladders"

FIGURE 93

Heinrich August Wrisberg.
Infusoria. From Wrisberg,
*Observationum de animalculis
infusoriis satura* (Göttingen:
B. Vandenhoeck, 1765), pl. III.

(*cauda vesiculari;* "H").[53] The groups, as "individuals," can themselves be-
come gregarious, as at "K" and "L," where "two of the animalcules grow
together" (*duo eiusmodi animalcula, coalitioni proxima*). If the individuals
can group, and the groups can group, then the little "molecules" are on
their way along the nearly infinite scale that ends with man—the animal
who had recently credited himself with inventing the "social contract."
Wrisberg's animalcules apply the natural philosophers' principle of atoms
to living bodies. A human body becomes nothing more than a magnetic
aggregate of primal spheres and that, in turn, implies the loss of an essen-
tial quality of the body as it had been known: its unity, the dependence of
its parts.

The Polype could be hacked apart into slices and shreds, but each scrap
was still, in some unknown sense, a full body; and Wrisberg's "globules"
could build into any kind of body without themselves being bodies. Be-
tween the two extremes, comprehensible analogic bodies were being
compressed into a narrowing space.

Breaking the Chain of Being

This incipient conceptual chaos was meliorated somewhat by the thought that there might still be a continuum of forms from most complex to most simple. Martin Frobenius Ledermüller illustrates a drop of carp semen, in which he is pleasantly surprised to find "millions of little egg-shaped creatures" describing sinuous paths through the seminal fluid.[54] Circulating granulated protoplasm was taken for alarming numbers of gestating embryos. Some thought the fecundity of protozoa was unnatural, "especially if we consider the infinite number of young ones which are visible to us through the transparent skins of their bodies."[55] The "chain of being" encouraged people to see bodies within bodies, composed of bodies, surrounded by bodies. Needham wondered how such things were generated: "If in the common Way . . . the Process will be boundless," he thought, "and [each] in their seed have others."[56] Perhaps the most eloquent on this subject is John Hill, in his *Essays on Natural History* (1752): "It is not to be doubted but Creatures, even below the minutest of those we see in the common Fluids, may have existence there, and that Gradations infinite between these Atoms of Existence and nothing, may have Being."[57] Turton's edition of Linnaeus (1806) ends not with the *obscurae* I mentioned above, but with another meditation, a painterly evocation of the last visible things: "*Termo* . . . a most minute simple gelatinous point . . . in most animal and vegetable infusions: of all known animals the most minute and simple, being so extremely delicate and transparent as often to elude the most highly magnifying powers, blending as it were in the water in which it swims."[58]

Such evocations of the chain of being exemplify a holistic sense of analogy: if beings continue toward the atoms or the stars (and the astronomers' conjecture of infinite stars is significant here[59]), then one must be related to another according to a universally applicable analogical comparison. But the wholesale reinterpretation of protozoa as small creatures "like" other bodies could not be satisfying, if only because it was also a dodge, a way of avoiding their unsettling differences. Louis Joblot's *Descriptions et usages de plusieurs nouveaux microscopes* (1718) attempts to salvage analogic explanation by giving his "*poissons*" names like "Gold and Silver Bagpipe," "Turtle" (a "fish" that has "horns" "like a stag"), and "Water Caterpillar" ("*chenille aquatique*").[60] Henry Baker's "Bell-Animals, Wheel-Animals [and] Funnel-Animals" are similar solutions.[61] The end of this lit-

eral metaphorization is anthropomorphic delusion: one day, Joblot sighted a little face, a "perfect Mask" with six legs, a tail, and an unusual hairstyle ("*coëffure singuliere*").[62] He didn't literally believe what he saw, or at least, not quite—it's more a matter of a delicate and loose relation between observation and representation. Hartsoeker *hallucinated*; Joblot and others like him merely misused *fantasia* for explanation.

As observations got more accurate, analogies became more difficult to find. Thus, Baker finds a "head" on his Polype, along with a "mouth" or a "kind of snout" and possibly "teeth" (or at least a "fine scale"), a "gut" with a "stomach" and an "anus," and a "tail"—almost a full body, but he allows that the Polype's body "has no Part that can be called either Back or Belly."[63] In a footnote, he defends the use of the word "arms" for the Polype's tentacles: "As these Parts serve the Purposes of Arms rather than Horns; I shall chuse all along to call them by that Name." He names the "head" not because it looks like an animal's head but because it is "that anterior part which raises in the center between its Arms," and he asks that the reader understand that it is not "like" the heads of other animals. Other combinations of analogies are even less convincing. Hill recorded "lobster's claws" on microscopic animals.[64] *Vorticella campanella*, a bell-shaped animalcule, uses flagella to sweep a vortex of water and nutrients into its bell-shaped mouth. The swirling flagella are a confusing sight: Leeuwenhoek saw "horses' ears" ("*hoorntgens*") and Baker imagined a "bearded tongue."[65] To use a Panspermist metaphor, these far-fetched analogies contained the seeds of their own destruction: most everyone who used them knew better.

As soon as it became impossible to conceive of simple protozoans with "an Apparatus of Limbs more elaborately formed than those of the largest animals,"[66] it also became impossible to retain the once-continuous chain of being. Some Panspermists, ready to accept different seeds for different creatures, were among the first to articulate the new position: "For tho' . . . Nature seems everywhere to . . . go off by almost imperceptible Gradation; yet, in our present Ignorance of the entire Chain of Being, we are so liable to mistake distant species for the most immediate ones to each other, that the Analogy is thereby nearly extinguished, and its Traces almost effac'd."[67]

One of the last natural philosophers to hold the eighteenth-century views is Christian Gottfried Ehrenberg, whose *Infusion Animals as Fully-Developed Organisms, A Look into the Deeper Organic Life of Nature* (1838)

FIGURE 94

Christian Gottfried Ehrenberg.
Leucophrys patula. From
Ehrenberg, *Infusionsthierchen
als volkommene Organismen*
(Leipzig: L. Voss, 1838),
tab. XXXII, Fig. I.10.

has become proverbial as an example of biased observation.[68] He saw a
continuous gut with many stomachs where others saw formless proto-
plasm ("*sarcode*"). He discovered "over fifty" stomachs (*Magen*) in the mi-
croscopic *Leucophrys patula* and proclaimed that protozoa must have diges-
tive tracts on the model of higher forms (Figure 94).[69] He must have
hallucinated connecting stretches of gut, since protozoa have free-floating
"vacuoles," which are "stomachs" that are not connected by tubes to either
mouths or anuses. Ehrenberg's long texts and intricate observations are in-
nervated with the quality of visual desperation: he could not bear to see
what lay plainly before him, and so he strained to locate familiar forms in
the shifting translucent jelly. The stomach plays a strange role in Ehren-
berg's writing, since he seems to have taken it as a metonym for the body.
Once he found stomachs, esophaguses, and intestines, he could see that the
protozoan must really be like a bird, a cow, or a person. Without the stom-
ach, there is only the almost-invisible *sarcode*, a viscid formless interior,
mysteriously moving and alive.

The Difference Between an Eye and an Eyespot

The analogic chain of being finally broke under the pressure of these microscopic infractions, and at that moment the animalcules' bodies became incomprehensible. Félix Dujardin, one of Ehrenberg's many critics, was careful not to separate animals and plants too rigorously; instead, he treated living forms as a continuum punctuated by gaps. He was skeptical, for example, of the "eye" that had been seen on the "monoculous Insect" *Cyclops*. (Like the Proteus and the Polype, the *Cyclops* is common in European and American ponds and streams. The most disturbing creatures were all ready to hand.) *Cylops*'s "eye" seemed too small, and too motionless, to be a real eye. It turns out that the red or black eyespot (*stigma*) that looks so much like an animal feature, is made from plant structures like chloroplasts. We could say, in eighteenth-century terms, that either these *stigmata* are "plant eyes" proper to plants or our own eyes are descended from plant parts, so that vision itself is vegetal—a barely conceivable alternative, but one that was seriously entertained in eighteenth-century discussions about the possibility that minerals might be kinds of vegetables, with their own "seminal matter." An eyelike "red spot" ("*tache rouge*") was also cited as a primary characteristic of the protozoan *Euglena*, an animal/plant that can swim but can also pause and make energy for itself using built-in chloroplasts. Dujardin says that the "*tache rouge*" is "extremely variable, sometimes multiple and sometimes made up of irregular groups of grains."[70] Carl Theodor Ernst von Siebold, another skeptic, remarks that the "simple pigment point . . . has no cornea, and contains no body capable of refracting light" and therefore is not an eye.[71] Analogies appear especially precarious when they apply only to one small part of a body. As Dujardin remarks: "Mr. Ehrenberg, following his methodology, assumes the significance of his 'red spots,' and must then explain certain white spots . . . which he takes for a brain or at least a nerve ganglion . . . [but] that is all that the Infusoria have in the way of a nervous system; all the rest has to be provided by analogy."[72]

The frontal attack on analogy left little room for the likes of Leeuwenhoek or Joblot (whose observations Dujardin finds "*tellement bizarres et fantastiques*") and, more important for the future, it transformed a psychologically and epistemologically helpful reaction (seeing tentacles as arms) into a problem. What exactly is the "*tache rouge*" if it is not an eye, or even the analogue of an eye? Can it really be satisfying to claim that it is a variable

concatenation of unknown properties? (Even in the nineteenth century, when some protozoa were shown to be sensitive to light, it did not seem right to call their red spots "eyes." "Eyespots" is the favored term.) Dujardin says that Ehrenberg and others are wrong to assign *any* human structures to microorganisms. Instead, protozoa should be said to possess "a degree of organisation in proportion to their mode of existence" ("en rapport avec leur manière de vivre"). Instead of judging protozoa to be like humans (or turtles or bagpipes) or giving them arms (or horns or fins), Dujardin carefully speaks of structures and parts "like" others or "reminiscent" of them. But note the weight that words like "reminiscent" are forced to carry. The analogies are unworkable, but without them the bodies are incomprehensible.

By the mid-nineteenth century, analogic explanations had largely disappeared. They persisted for a while in pictures, because it was easy to simplify a microorganism so that it suggested an analogy, without actually having to spell it out in words. Ernst Haeckel's idealized plates of *Radiolaria* are a beautiful example; he presents plankton as machines or geometric constructs (Figure 95). The images are very suggestive—even geometers have picked up on them—but the text maintains strict silence about analogic forms, and the actual organisms are much less orderly.[73]

Current microbiology has not resolved these problems. Analogies still occur, but they are confined to schematic illustrations and to introductory passages in longer textbooks. They tend to be confined to parentheses or put in "scare quotes" (as I have been doing), to make it clear that the authors do not think they're true. Siebold, in a modern voice unafraid of technical neologism, speaks of "a round, pulsating cavity," the "vacuolae" and "oral aperture," and "vesicular, irregular contracting cavities."[74] Contemporary microbiology is more thoroughly grammaticized, with its "caryogamy," "syzygy," "heterothallism," and "automixis" instead of just plain "copulation." Many fossils of analogic thought are embedded in our current jargon: one need only recall "spermatozoa," with its echoes of Linnaean classification.

Clearly, the proliferation of neologism does not solve the problem of analogy; rather, neologisms defer the problems raised by analogies, pushing them outside the texts. It is still necessary to think analogically in order to come to terms with unusual objects. Karl G. Grell, in one of the best textbooks of protozoology, notes that independent fission in mitochondria and plastids has been observed, making them strongly "reminis-

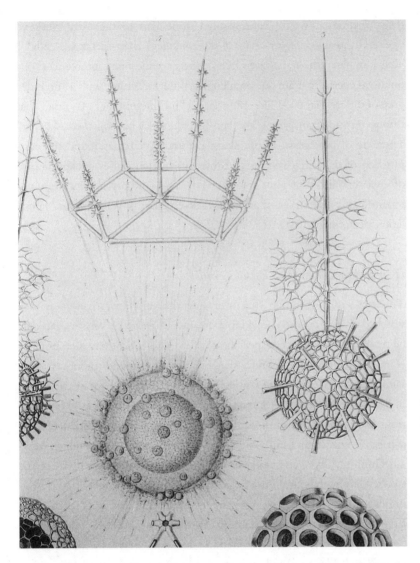

FIGURE 95

Ernst Haeckel. *Arachnosphaera oligocantha, Aulosphaera elegantissima* Hkl, and other radiolaria. From Haeckel, *Die Radiolarien (Rhizopoda radiaria): Eine Monographie* (Berlin: G. reimer, 1862–88), vol. 1., pl. 11, detail.

cent" of free-living organisms "trapped" in cells; but he doubts that organelles can be equated with organs or organisms, since organelles "are not a 'cell within a cell,'" but "have to be regarded as 'semi-autonomous.'" A plastid is "like" a cell—that is the classical analogy, the one that would have captivated Enlightenment observers—but it is also not like a cell, since it is only "semi-autonomous." Why is "semi-autonomous" in quotation marks? Everything living is semi-autonomous, and Grell wants to escape from the analogy without interrogating it too closely. The quotation marks, and the strict phrase "have to be regarded," are the formalized residue of eighteenth-century dilemmas. Protozoans, Grell says, with a

detachment that would have seemed insouciant to the early workers, "generally reach a *higher degree of differentiation*" than metazoan cells."[75] This emphasis (the italics are Grell's) skirts a philosophic problem, as obdurate as ever: What are our own bodies, if not structures with a "high degree of differentiation"? The shimmering "infinite number of young" that thronged inside transparent "mothers" would today be explained as a characteristic of protoplasm. Protoplasm commonly circulates, and the conjunction of that circulation with Brownian motion causes the appearance of vivid, conflicted life: but note how anemic—and psychologically, if not scientifically, dishonest—that modern description is: What is that "circulation" if not life?

'Kakabekia,' Bions, and Pseudo-Amoebae

The sense of desperation that overcame the early investigators as they watched orderly creation breaking apart into a myriad perversities can only be recaptured for us in rare, peripheral cases. *Kakabekia* is one such instance (Figure 96). It is an "umbrella-shaped" organism, found in only two soil samples in the courtyard of Harlech Castle in Wales. It lives in an ammonia-soaked environment—an ancient horse stable—that would be disastrous to any other organism. Still, it is not utterly alone in creation, because it has also been found in a wildly different place: in the two-billion-year-old Gunflint Chert formation in Ontario. The connections between the two remain hypothetical. As a fossil, it is called *Kakabekia umbellata*; as a living organism, *Kakabekia* sp.: the same genus, two billion years apart, unrelated to any others in the interim.[76] Another unaccountable oddity is the "green helical organism," described in 1940, that "moves by growing," recycling itself like a twisted tank tread. It remains unclassified, although it might be related to spirochaete bacteria.[77]

Other such examples exist. For the most part, however, it is necessary to go beyond science to find parallels to Enlightenment wonder. Wilhelm Reich's *The Bions* (1938) revives the Panspermists' position that "life can burst forth anywhere." Reich probably didn't know he was reprising an eighteenth-century theme, because he decided to ignore science as much as possible—he thought Pasteur was wrong, and experience had taught him how ill-disposed scientists could be.[78] He took samples of earth and various chemicals, autoclaved them, and then cultured them on sterile media. According to modern science, Reich shouldn't have found living crea-

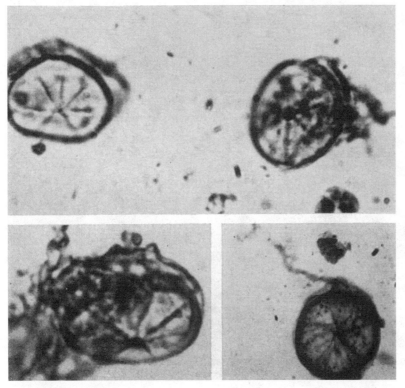

FIGURE 96

Kakabekia-like forms grown
on agar in an atmosphere
of ammonia and air. From
S. M. Siegel, K. Roberts, and
O. Daly, "The Living Relative
of the Microfossil *Kakabekia*,"
Science 156 (1967): 1231–34,
Fig. 2 (detail). © American
Association for the
Advancement of Science.
Used by permission.

tures in his petri dishes. But he did—he discovered "bions," preliving,
vesicular units that then developed into "bacterialike" forms and eventu-
ally "org-animalcules," what we call protozoa and infusoria. He states that
heat and swelling germinate the bions, which are nascent everywhere: "I
could not help but think," he writes, "that all known types of spores must
have formed when the earth was still hot."[79] (In modern scientific terms,
it seems abundantly clear that Reich did not keep sterile conditions. First
he watched Brownian motion, and later he observed bacteria and proto-
zoa.) He found a bewildering variety of forms, each struggling into life,
progressing to the next stage, working its way upward to the full com-
plexity of ordinary microorganisms. One of his photographs is labeled
"Crawling, vesicularly structured crystal"; another is a "plasmoidally mo-
tile crystal of earth." He got some of his best results by mixing the earth
with egg white, lecithin, cholesterin, gelatin, and potassium chloride. The
mixture generated, among other things, many "bionic cells" (Figure 97,
top), colonies of positively charged "packet amoebae," and a "vibrating
'amoeba'" (with "amoeba" in quotation marks) that "migrated" across his
stage (Figure 97, bottom).[80] What could be more anarchic, more at odds

FIGURE 97

Wilhelm Reich. Photographs
of living forms developed from
sterilized matter. Top: fresh,
sterile bions, magnification
2,000x. Bottom: a vibrating
"amoeba," moving from place
to place, magnification 2,300x.
From Reich, *The Bion
Experiments on the Origin of
Life*, trans. Derek Jordan and
Inge Jordan (New York:
Farrar Straus Giroux, 1979),
p. 56, Fig. 42, and p. 69, Fig. 43.

with any workable concept of a body, than Reich's "amoebae"? (Even the ligatures insist on their oddity.) They aren't alive, exactly; they don't have skins, or even shapes; they are fused with inert chunks of earth; and they are positively charged, like ions.

Reich is famously eccentric, but even things like the umbrella-shaped *Kakabekia* and the green helical organism are out of the mainstream of science. The process of analogical thinking now occurs below the horizon of scientific publication, and it is there we have to look to find what has become of Ehrenberg's "stomachs" or Leeuwenhoek's "horses' ears." The early microscopists looked at *dierken* and wondered "Who are *we*?" but the recent protozoologists look at the same organisms, which possess the same power to call into question concepts as fundamental as the nature, form, and sexuality of the human body, and they ask about "semi-autonomy" and "degrees of differentiation." Scientific terminology, italics, and quotation marks have become the Procrustean beds of analogic thinking and imaginative metaphor. At the same time, they have effectively quelled the visual desperation that threatened early accounts by redescribing the failure of analogy as a matter of language.

In the majority of cases, analogic reasoning is so rapid that it goes unnoticed. Even a *gryllus* in a medieval bestiary takes only a moment to decipher, and we don't often become aware of how analogies help us understand visual forms. I have concentrated on the most extreme cases to suggest that when artists make deliberate substitutions for body parts, they are tinkering with the underlying mechanism of bodily apprehension. Surrealist works such as Ernst's *Celebes* unbalance our expectations just enough to make us pause and work out how its analogies operate. Analytic cubism may be the most far-reaching example in the arts because moment by moment, piece by piece, the body becomes something else. At times—especially in the spring and summer of 1910—Picasso was painting figures that are difficult to see as bodies, but he soon turned away from that kind of confusion, and a little later—around 1913—he started to make bodies out of larger parts, so that eventually each part could be given a name instead of being an anonymous fragment. In the terms I have been developing here, Picasso first drew toward, and then pulled away from, real visual desperation. Most pictures of the body don't present such problems, but twentieth-century art often works on our understanding of the body by substituting parts and by toying with the principles of analogic seeing.

six Dry Schemata

There has always been tension between flesh and geometry, between bodies closely observed and bodies simplified. The perpetual adjustment between the organic and the mathematical has occupied me in various ways throughout this book, and I have reserved for this chapter those solutions that strongly emphasize the schematization of the body at the expense of whatever seems naturalistic or organic.

In regard to Greco-Roman doctrine and medieval illumination, the central example of bodily schematization is the doctrine of the humors. In some forms of humoralism, the four humors—choleric, melancholic, phlegmatic, and sanguine—are correlated with the four elements and the four Aristotelian qualities (warm, cold, moist, dry), making for an especially rigid conceptual structure. Those who are choleric are said to have an excess of "yellow bile," "air," or moistness and are prone to be excitable. Those who are melancholic have too much "black bile," "earth," or dryness and are sad and fearful. Phlegmatics are those oppressed by phlegm, which corresponds to water and cold, and those who are sanguine have a surplus of blood, fire, and warmth. Some of the most abstract schemata of the body are medieval charts based on the doctrine of the humors; occasionally, the body appears as nothing more than a cross or a circle with four quadrants.[3]

There are also images that mingle pure humoral geometry with meditations on the body's actual fluids. On the title page of Robert Fludd's *Meteorologia* (1626), a man lies, hand on his groin, looking up at a curious apparition (Figure 98).[4] This apparition is a body, rearranged and simplified

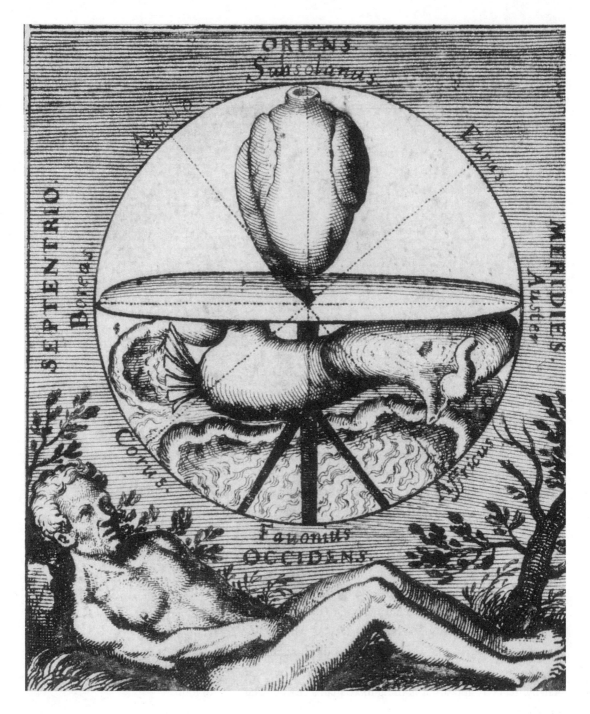

FIGURE 98

Robert Fludd. The humoral body.
From Fludd, *Philosophia sacra et vere*
christiana, seu Meteorologia cosmica
(Frankfurt, 1626), detail of title
page. Photo courtesy of Regenstein
Library Special Collections,
University of Chicago.

to serve as a humoral diagram. The heart is at the top, and the aorta turns downward through the diaphragm that divides the upper hemisphere from the lower. The aorta continues down, having transformed into the digestive tract, and exits at the bottom. On either side of the anus are the testicles (*vasa seminaria*), and so there are a total of three orifices in the fundament of the body. The mottled tissues in the lower portion are filled with the body's mingled liquids, and in this visceral ocean floats the stomach (*ventriculum*) and the liver with its gall bladder (*vesicula fellu*). The spherical body, reduced to its essential symbolic viscera, is also a globe, bisected by the equatorial plane of the diaphragm, as well as a compass, marked by the four directions and the eight winds. In modern terms, it would be called a "mechanomorph": an improper mixture of the mechanical (a compass) and the human (a tub of viscera)—an impure schema that insistently reminds the viewer of the body's messy insides. It's typical of mechanomorphs that some parts are more schematic, and others less so: the stomach, liver, and watery viscera are naturalistic, but the alimentary canal is represented by an opening at the top of the heart and by the descending aorta, which metamorphoses into the intestine and anus.

The same mixture of geometric imposition and organic slurry occurs in the theory of the humors, where symptoms have a tendency to become inextricably tangled with one another. This happens in *Hamlet*, where choler mingles with melancholy, indecision, genius, and madness. Shakespeare's characters are "sick at heart," although the nature of that sickness and even of the organ it attacks is anything but unambiguous. The best text for humoral confusions is Robert Burton's *Anatomy of Melancholy*, one of the least read of the classics despite a beautifully troubled and fiery narrative. Burton is in love with classification—his table of contents, if pasted together, would make a wall chart some three feet long—and he anatomizes melancholy in several ways. The principal division is into "head melancholy" (subdivided into "love melancholy," or *Ilisha*, and "werewolfism," or *Lycanthropia* or *cucubuthe*), "temperature melancholy," and "hypochondriacal" or "windy melancholy" (subdivided into "hepatic," "splenetic," and "meseraic hypochondria").[5] Burton defines melancholy many times over, too many times, until his definitions themselves become pathological. Melancholy, he says, is "a kind of dotage without a fever, having for his ordinary companions, fear and sadness, without any apparent occasion," although "for some it is most pleasant" and even elicits laughter.

In Burton's mind, melancholy is an affliction that also afflicts other dis-

eases, and some of his best descriptions come from imagining what diseased diseases might be like. Melancholy that dominates phlegmatism, he says,

> stirs up dull symptoms, and a kind of stupidity, or impassionate hurt: [such people] are sleepy, . . . slow, dull, cold, blockish, ass-like, . . . they are much given to weeping, and delight in waters, ponds, pools, rivers, fishing, fowling, &c. . . . They are pale of colour, slothful, apt to sleep, heavy; much troubled with head-ache, continual meditation, and muttering to themselves; they dream of waters, that they are in danger of drowning . . . They are fatter than others that are melancholy, of a muddy complexion, apter to spit, sleep, more troubled with rheum than the rest, and have their eyes still fixed on the ground.[6]

Melancholy can also attack itself, a plague preying upon a plague:

> Those men . . . are usually sad and solitary, and that continually, and in excess, more than ordinarily suspicious, more fearful, and have long, sore, and most corrupt imaginations. . . . [They are] cold and black, bashful, and so solitary, that . . . they will endure no company, they dream of graves still, and dead men, and think themselves bewitched or dead.[7]

There are parallels here with the repetitions and solemn mystifications in Fludd's text, and I would suggest that such exfoliations of meaning may be provoked by the hopeless desire to say something secure and simple about the body, either in pictures or in text.[8] The confusions in Burton, Shakespeare, and Fludd are exemplary for the relation between bodily schemata and their opposites. In texts, the body and its humors escape the bounds of schematic medical semiotics, occasionally producing texts such as *Hamlet*, the *Anatomy of Melancholy*, or the *Meteorologia* that overflow the typologies from which they begin. In pictures, the body forces the eye back onto its fluids and its excesses, so that every strongly schematic version of the body is also a strong repression, a denial of what the body seems really to be.

The Concept of Schema

A "schematic body" can be understood in two senses: as a simplification in the direction of geometry, or as a use of a body *as* a schematic diagram.[9] The former can be brought to mind by any number of figural simplifications, from ancient cylinder seals to the stick figures in the *Oz* books (Figure 99). A schematic body in this first sense is a way of pushing the body to some distance, purging its objectionable stuffing or whittling away at its

bulky skeleton until nothing but twigs remain. Stick figures are rejections of the body, and they often entail a kind of squeamishness—or worse—regarding what is tactile about the body, along with a prudish attachment to the optical.[10] The *Oz* books are a phantasmagoria of fin de siècle schematized bodies: the Woggle-Bug, whose arms and legs curl and end in diminutive needle-like fingers and toes; the Tin Woodman and His Majesty the Scarecrow, made famous by the movie; Jack Pumpkinhead, who was made from saplings, a cylinder of bark, and a carved pumpkin, all articulated with whittled wooden pegs; the Saw-Horse, a pony with a log for a body; the "3-Wheelers," a group of misshapen, boneless, aggressive beggars who have wheels in place of hands and feet; and TikTok, a mechanical man who is not unlike Max Ernst's *Celebes*.[11] They're a nightmare collection, worse in their way than the contemporaneous hallucinations of the *Alice* books. Each one is hollow, or thin as a stick on the inside; and each is essentially, and properly, dead.

The second sense of "schematic body" occurs, for example, in Leonardo's "man in a circle" (*homo ad circulum*), a schema in which a naked figure provides the spokes of an abstract configuration. The difference I want to mark has to do with the reduction of the body itself as opposed to the use of a body in a nonfigural schema, and as such a schematic body can be the name of a figure or a configuration. Barbara Stafford has read Jacques-Louis David's *Death of Socrates* as a schematic representation of the body in which the upright Socrates is in a sense the soul guiding its body, which is played by Socrates' fallen, confused followers. Socrates' body is geometric—informed by mathematics, pertaining to the intellect—and theirs are lumpish, organic, and ultimately blind. They are "misperceiving flesh"; he is "unbendable intellect."[12] In this interpretation, the entire painting is a schematic body in the second sense: a picture in which fully rendered bodies, rich with anatomic and painterly knowledge, serve schematic ends.

Both senses of the schematic body are attempts to reduce the body to a lexical sign of some bloodless concept. Both involve, in Stafford's words, a "violent intellectual simplification of mixed empirica or compounded biota." The schema is "abstemious"; it serves a Platonic or Neoplatonic agenda and therefore always to some degree rejects the body.[13] Schematizations are not operations performed on the sensate body; they are benign intellectual metamorphoses, and the schematic bodies present themselves as lexemes or syntactical units, in accord with the linguistic, and even typographical, nature of Renaissance and baroque schemata (that is, the com-

mon circular, arboreal, tabular, and heraldic diagrams that occur in scientific and religious treatises).[14] Schematic metamorphosis is a tendency, an idea concerning a possibility of the represented body. When it comes forward at the expense of fleshy incident, it can garner most of the meaning of a picture. The bodies used for international sign language (walking, waving, and sitting little black figures that have only one thickness to their torsos, their arms, and their legs) are almost entirely devoid of anything but linguistic significance—as if individuals, sexes, and races could find useful common ground in anonymous abstraction.

Yet it is not those purer moments that interest me but the idea of purity itself, as it operates in the midst of strong competing regimes of meaning. If the man in Fludd's figure had appeared alone in a painted landscape, then it would be much more significant that he looks a little worried, that he is naked on an apparently cold and damp ground, and that he holds his crotch. As part of a diagram, those features lose some of their expressive meaning and gain a more abstract force—in Fludd's terms, without knowledge man is alone, defenseless against Nature, shamed by the Fall. Despite the protestations of some authors, the schema itself is not powerfully or consistently "male," nor does schematization have a single valence with respect to the construction of the body that it skeletalizes.[15] On the contrary, it is the variety of meanings that operate in both kinds of schematized bodies that makes them such interesting examples of the repudiation of the living body.

The Grotesque Body

It is also here, in the context of agendas of radical simplification, that Mikhail Bakhtin's famous concept of the "grotesque body" becomes most fully meaningful. It is, I believe, related to the metrological schemata that I will consider next—not least because both the grotesque body and its double and opposite, the metrologically constrained body, are symbolic blindnesses. In the one case, the body becomes nothing but anus, excrement, mouth, and vomit, and in the other, nothing but grids, scales, graphs, and lines. (Freud thought an obsession with the "other face" was a matter of fear of authority, of assholes—a grotesque schematization even more radical than the simplest stick figure.[16]) The grotesque body and the schematized body are not opposites, but doubles, united in their distance from whatever might function in a given context as a normative picture of

the body. It is also not irrelevant that Bakhtin's concept does not entail empathic discomfort; at most, reading Bakhtin or looking at images of the grotesque body provokes thoughts of incontinence or memories of vomiting. The places in visual art where grotesque bodies are at their most free—in modern art; in medieval marginalia; in eighteenth-century French, German, and English political broadsides; and in Renaissance representations of the Temptation of St. Anthony (see Figure 79)—revel in anal imagery, flatulence, and diarrhea, without provoking more than a twinge or a shiver. Even the most extreme cases, such as the contemporary Japanese underground comics, in which entire narratives have been constructed around farting, do not evoke stench as much as they play with the idea. Bakhtin's discovery is an intellectual construct, even though it has been acted out in life and in art.[17]

Bakhtin argues that there is a sense of the body (he says more simply there is "a body") that is "in the act of becoming."[18] Hence the grotesque body has both a performative or theatrical status and a more static formal definition. In terms of performance, the grotesque body involves "an interchange and an interorientation" between the inside and the outside and between "the confines between bodies." Bodies shit, piss, menstruate, vomit, and merge with one another, exchanging sperm, vaginal juices, saliva, and blood—and all this is also the "theater" of the grotesque body. The formal markers are somewhat different, since they involve icons of the grotesque: pictures of projectile vomit, showers of urine, and so forth. It is essential, I think, to distinguish these two aspects of the grotesque body in order to keep a measure of conceptual clarity in analyzing visual images: on the one hand, there is the *concept* of flux, inherited from Heraclitus and Democritus, and on the other, the *instance* of flux—for example in the exaggerated phalluses of Greco-Roman sculpture. The Protean grotesque body cannot actually exist, and images—even the most fluid metamorphoses in prose and film—are only surrogates for its excessive, evanescent ontology. But the schematic body can exist, and its asceticism only points even more insistently at the necessity of transgression.

There are occasional instances in which schematic bodies are also grotesque—where geometry directly signifies blood. Johannes de Ketham's *Fasciculus medicinae* (1493) illustrates a figure covered with astrological signs, generally known as the "zodiac man" (Figure 100).[19] Although it is an ancient Middle Eastern form, known also from maps and amulets, the way in which the signs cling to parts of its body is reminiscent of the way cups

FIGURE 100

Johannes de Ketham. The "zodiac man," an astrological bloodletting diagram. From Ketham, *Fasciculus medicinae* (Venice: Joannem et Gregorium de Gregoriis fratres, 1500), n.p. Department of Special Collections, University of Chicago Library.

were put on the body for bloodletting—and that is no coincidence, since the picture is an astrological diagram for bloodletting. Cancer, the label informs us, is responsible for diseases of the lungs and eyes, and Scorpio (which grips the figure just above his groin) rules afflictions of the penis and testicles. This body, like Bakhtin's bodies, is "in the act of becoming." It is a hybrid, neither fully grotesque nor entirely orderly. But few images balance in this way. Most of them fall away into unredeemable excess—into organic perdition or dry geometry.

The Three Branches of Metrology

Beginning with these thoughts, I will explore the possibilities of schematization as systematically as possible. By their nature, geometric reductions of the body tend in one of two directions: either toward "systems," with their rules and canons, or toward what I will call "geometric anarchy," in which the body is geometrized wildly, or wildly geometrized. In Western art, the tendency has been to build systems of practical schemata and to tell their history by organizing them into sets or periods, as Erwin Panofsky did and as I will do here.[20] That custom has made the anarchic forms largely invisible. After I discuss the major groups of systems, I will show how the myriad anarchic figures might be addressed.

Metrologic systems have tremendous power, and the most striking bodies can be formed by applying simple rules. D'Arcy Thompson showed that with his distorted "deformation grids," Cartesian coordinates superimposed on animals and deformed to register and predict their growth. A single grid with rectangular coordinates defines a certain Acanthopterygian fish, and then the same grid, redrawn in triangular and radial coordinates, is used to define two other genuses of the same family (Figure 101). Even the "very curious" fish *Antigonia capros* can be described by a "peculiar deformation" of the identical grid.[21] Thompson tried to give rules to his proportional discoveries, but like Albrecht Dürer, whose idea he was following, he often had to be content with "peculiar" deformations rather than quantifiable arcs, hyperbolas, or polar coordinates.

But nothing as mathematical as Thompson's coordinate grids is necessary to entirely alter a pictured body, and even a proportional enlargement, such as artists routinely use, can produce a monstrous result (Figure 102).[22] Metrological curiosities can be made by applying a large number of "morphometric" rules to a single figure, but historically that kind of elaboration

FIGURE 101

D'Arcy Wentworth Thompson. Coordinate transformations of four Acanthopterygian fishes: *Polyprion, Pseudopriacanthus altus, Scorpaena* sp., and *Antigonia capros.* From Thomson, *On Growth and Form* (Cambridge, Eng.: Cambridge University Press, 1968), vol. 2, p. 1063, Figs. 521–24.

is rare.[23] It occurs, for instance, in some of Pontormo's figures, which follow a profusion of rules that are normally found in separate pictures and periods: they have tiny feet, attenuated lower legs, stubby thighs, chunky hips, and snaking necks (see Figure 16). If one of Thomson's coordinate grids were to be applied to Pontormo's drawing, then it would show multiple principles of distortion—the squares would be squeezed in one place and sheared or distended in another. (It would be an interesting exercise, since it might reveal consistencies in Pontormo's sense of the figure.) But in general, the actual distortion of skin is far too complex to be helpfully modeled by Cartesian grids (Figure 103). In this case, the experimenter, the Scottish anatomist Robert Douglas Lockhart, has failed even to produce grids that look adequately rectilinear, and the simple act of raising the arms deforms it even more. Most Western metrological systems have been relatively simple, but some, such as a method proposed by Dürer, approach the incommensurate rules implicit in Lockhart's photographs or in Pontormo's figures—and when they do so, they break down by becoming impossibly intricate and unwieldy.

One of the most interesting questions that can be put to these systems concerns the sense of the body that is implicit in each. What does it mean

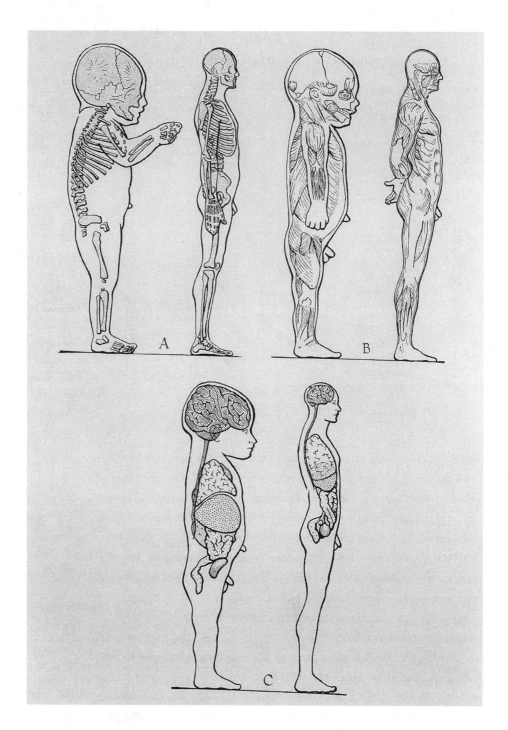

FIGURE 102

Right lateral views of the newborn infant
and the adult: (a) skeleton, (b) musculature,
(c) organs. From R. E. Scammon,
"Developmental Anatomy," in J. P.
Schaeffer, ed., *Morris's Human Anatomy*,
10th ed. (Philadelphia: P. Blakiston's
Son and Co., 1942), p. 44.

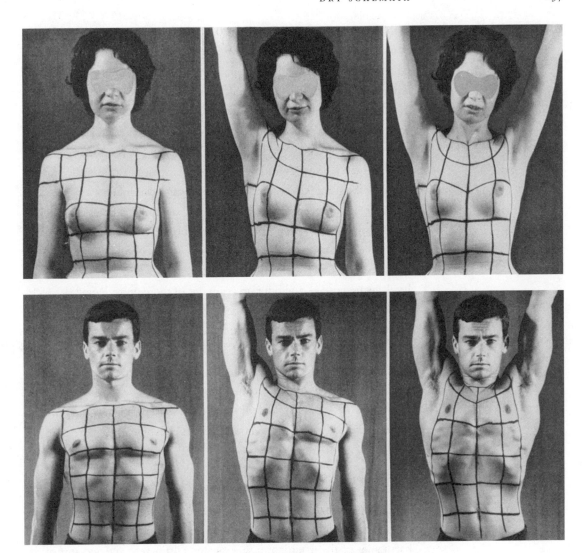

to imagine that the body can be adequately pictured by ensuring that it is eight heads tall? When Egyptian artisans drew bodies by counting finger-breadths instead of head-heights, what did that imply about their concept of the body? What kind of body is it that is built from a stack of fingers? These kinds of questions have their correlates in the beholders' sense of their own bodies. Metrology is also an *affective* science, and it changes the way we perceive bodies and the way we conceive the nature of the body. It is not at all a trivial decision to think of the body as a set of muscu-loskeletal articulations rather than a stack of head-heights. The Egyptian fingerbreadths, cubits, palms, and other units are utterly incommensurate

FIGURE 103

Robert Douglas Lockhart. A demonstration of the elasticity of skin, with the trunk marked in three-inch squares. From Lockhart, *Living Anatomy, A Photographic Atlas of Muscles in Action and Surface Contours* (London: Faber, 1971), Figs. 207–12.

with our own ways of conceiving the body. These are the kinds of questions that I want to entertain as we consider the three principal groups of metrological systems, and to that end I have trespassed on the conventional boundary between scholarship and artistic practice and included enough information so that sample figures can be constructed. The encounter with new ways of conceiving bodies takes place in large measure through the experience of new ways of *making* bodies, and the full strangeness of systems such as the Egyptian canon of fingerbreadths cannot be experienced without the kind of exacting immersion that drawing provides.

The three groups of systems, then, are: the harmonic body, imagined as the site of beautiful proportions and proportionalities; the gridded body, where the human form is pressed into, or onto, a coordinate grid; and the deconstructed body, where the body is taken apart into its natural units—heads, arms, noses—and built up again out of those units. Panofsky's pathbreaking essay, "The History of the Theory of Proportions as a Reflection of the History of Styles," explores the second and third of these systems, but it folds the first into the third and excludes the entire range of anarchic, and principally non-Western, schemata. The three systematic possibilities seem importantly different to me: the first presses geometry onto the figure, the second is content with a Cartesian grid, and the third attends to the body itself to see how it is assembled.

The Harmonic Body

In the harmonic body, the figure is constructed and expressed by geometry, and so the human form echoes the rules of nature in general, or the harmonies of the macrocosm specifically. Ultimately, any account of the history of harmonic bodies would have to evoke the lost treatises on the proportions of Greek sculpture, which contained mathematical rules for the figure.[24] After the Greeks, the harmonic body has an intermittent history: it occurs in an unmathematical way in the medieval conviction of the divinity of man's form, and again in the Renaissance promise of a perfectly proportioned figure.[25] Renaissance artists were famously intrigued by the coincidence between the human form and certain fundamental shapes such as circles and squares.[26] But although the *homo ad circulum* and the *homo ad quadratum* were widespread in the Renaissance apart from Leonardo's drawing, there is little evidence of more elaborate schemata.

The most recent resurgence of the harmonic body is tied to the inter-
est—one might say, the cult—of the golden section. In the Renaissance,
the golden section had a common use in geometry, where it was funda-
mental for the construction of the pentagon, and it is implicated in the Fi-
bonacci series and other mathematical discoveries.[27] But in the last hun-
dred years, in the wake of fin de siècle mysticism, the golden section has
been discovered in many cultural artifacts, from the pyramids to Renais-
sance sculpture.[28] In one schema, the face becomes a map of golden sec-
tions (Figure 104).[29] The golden ratio, usually symbolized as ϕ, is said to
equal the ratios

$$\phi = \frac{\text{length of face}}{\text{width of face}} , \frac{\text{top of head to eyes}}{\text{hairline to eyes}} , \text{and} \frac{\text{eyes to chin}}{\text{nose to chin}}$$

The second line claims that the golden section also equals the ratios

$$\phi = \frac{\text{hairline to eyes}}{\text{eyes to nose}} , \frac{\text{eyes to mouth}}{\text{eyes to nose}} , \text{and} \frac{\text{nose to chin}}{\text{mouth to chin}}$$

The third line shows the ratios

$$\phi = \frac{\text{width of face}}{\text{distance between eyes}} , \frac{\text{distance between eyes}}{\text{width of mouth}} , \text{and} \frac{\text{width of mouth}}{\text{width of nose}}$$

The author of this schema wants not only pure harmony (technically, the
exclusion of harmonic ratios other than the golden section) but also *full*
harmony (the exclusion of all nonharmonic ratios). In all their forms, such
desires spring from a fear of the body, since they require a smothering cer-
titude where there can only be statistical approximation.

At the close of the nineteenth century, some classicists attempted to un-
derstand Greek art in similar terms, although most historical efforts have
been aimed at Egypt.[30] Else Christie Kielland's *Geometry in Egyptian Art*
(1955) analyzes Egyptian reliefs for evidence of the golden section. Look-
ing at the Heziré relief in the Cairo Museum, Kielland begins by con-
structing a golden section along the base (Figure 105).[31] There follow var-
ious coincidences, which she reads as consequences of the golden section:
(1) a horizontal line through H and a line through A and X locates H',
which determines the frame of the relief; (2) AF equals BE, which locates
the top of the staff; (3) the length of the staff is AX; (4) BC, the hy-
potenuse of the triangle used to superimpose the golden section on the re-
lief, together with HH', a horizontal, determine the vertical DD', which
locates the vertical midline of the figure . . . and so on. The four relations
are only small excerpts from a book-length analysis, and Kielland's is only

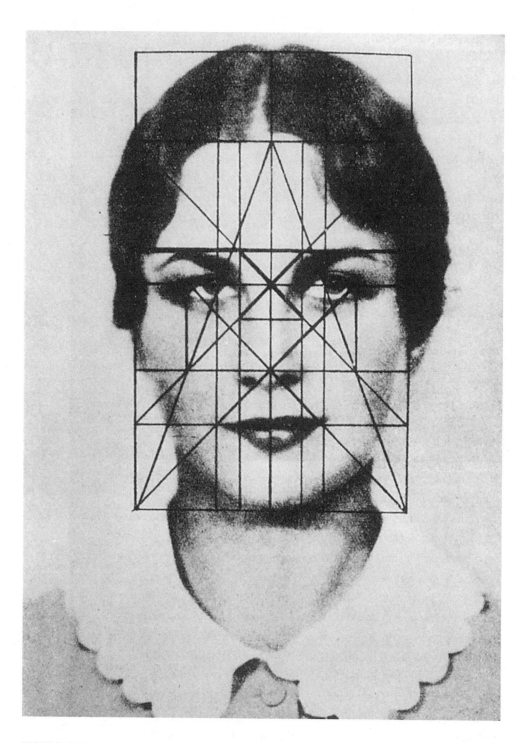

FIGURE 104

Harmonic analysis of the face of
Miss Helen Wills. From Matila
Costiescu Ghyka, *The Geometry of
Art and Life* (New York: Sheed and
Ward, 1962), pls. 36 and 37.

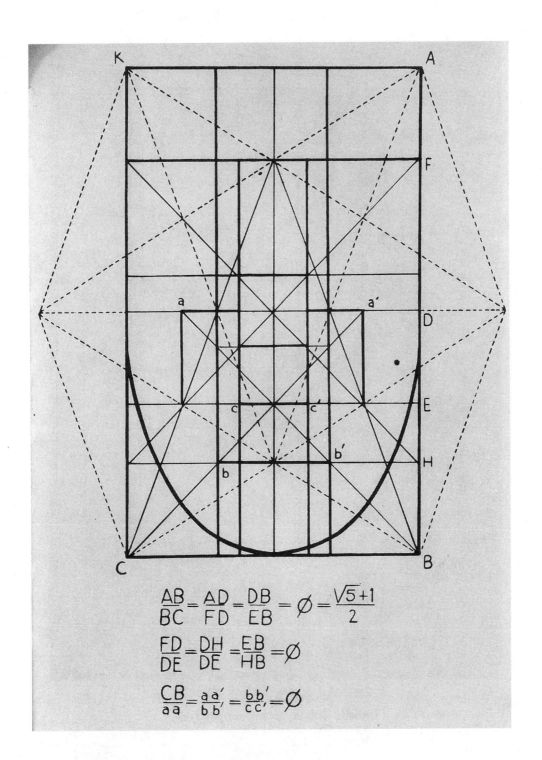

$$\frac{AB}{BC} = \frac{AD}{FD} = \frac{DB}{EB} = \emptyset = \frac{\sqrt{5}+1}{2}$$

$$\frac{FD}{DE} = \frac{DH}{DE} = \frac{EB}{HB} = \emptyset$$

$$\frac{CB}{aa} = \frac{aa'}{bb'} = \frac{bb'}{cc'} = \emptyset$$

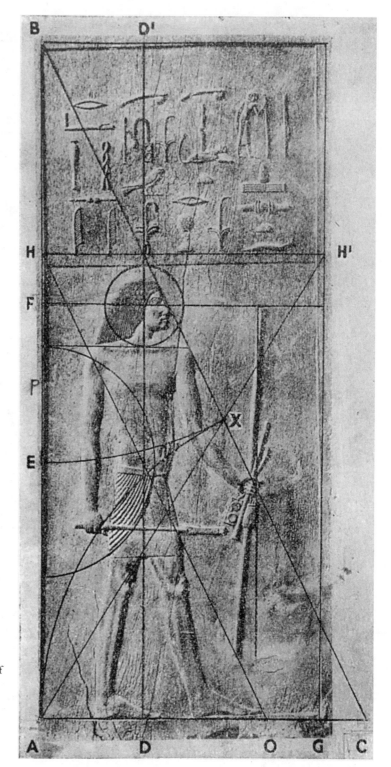

FIGURE 105

Analysis of the harmonies of a relief
of Heziré, c. 2750 B.C. Wood relief.
Cairo Museum. Analysis after Else
Christie Kielland, *Geometry in
Egyptian Art* (London: Alec Tiranti,
1955), pl. I-A.

one book among many. These are difficult texts—not on account of their geometry but because it is not easy to read while suspending disbelief. How are we to understand the dogged sleuthing of esoteric schemata, other than as a hopeless mania for the security of harmony? And would it be entirely inappropriate to extend such a reading to excessively harmonized bodies in other cultures—for example, in Tibetan iconometry, in which the body is similarly lavished with signs of its perfection?[32]

The Gridded Body

Different obsessions emerge from other metrological systems. Egyptian proportions are an interesting and especially complicated case involving grids and moduli (unit lengths taken to be generative for the body as a whole). There are three canons of proportion in Egyptian art: the vertical scale (a simple set of markers along a vertical line, as an aid to laying out the body), the 18-square-high grid, and the finer 21-square-high grid.[33] The change from one grid system to the other produced a shift from the more familiar Egyptian figures to slender, "mannerist" figures (Figure 106). Irresistibly, we see an expressive difference between the figures, and we expect that Egyptian artisans preferred the elongated figures and devised a grid system that would make them easy to draw. But Erik Iverson rejects that, saying that the 21-square grid was the result of a new unit of measurement adopted purely for commercial and political reasons. It would then follow, as a possible conclusion, that the slender figures were not perceived to have any special expressive qualities—a conclusion that I think can only be endorsed as an intellectual possibility, and not as a perceptual fact.

The Egyptian body was measured in several commensurate moduli, including cubits (Royal and Small), fathoms, fists, handbreadths, and fingerbreadths. The basic elements are set out in Tables 10 and 11. The fathom measured the height of the body, either to the hairline (in the earlier system) or to the eyebrow (in the later system). This is the first odd feature of the Egyptian metrology, since it means that the artists did not conceive the height of the body to include the top of the head. As far as I know, this did not happen in the later history of the West, although it has some echoes in the Byzantine practices. Is it possible to understand the body in this way? What is a body if it is detached from its hair and skull? It may be that the fathom emphasizes the eye, since it effectively divides the body

Comparison of 18- and
21-square Egyptian figures.
Left: an 18-square grid figure
from the *Stele of Senu*, 18th
Dynasty, c. 1400 B.C. New York,
Metropolitan Museum of Art.
All rights reserved. Right: a
21-square grid figure from a
pre-Memphite chapel, 26th
Dynasty, c. 535 B.C. Limestone.
Boston, Museum of Fine Arts,
Otis Norcross Fund.

into regions above and below the eye—but our ways of imagining the body as a stack of head-heights makes it difficult to comprehend the fathom. There are other such problems as well. The Egyptian fingers are all equal, each one $1/4$ handbreadth, and their ideal thickness measures various other parts of the body. But what is a body conceived as finger-breadths? Is it possible any longer to *see* such a body?

Four small cubits fit into one fathom, and feet are measured as $2/3$ of a small cubit; from this, it follows that feet are $1/6$ the height of a figure (minus the hair and sometimes the forehead). A typical 18-square figure is shown in Figure 107.[34] The length of the forearm from the elbow to the wrist is also $2/3$ of a small cubit, the same as the length of the foot. The 6-foot-tall body is used to mark off certain points of articulation (a foot is three squares of the 18-square grid). In this example, the Egyptian drafts-man makes use of three of the vertical foot-divisions but does not mark two others. One division marks the knee, another marks the wrist and also the point just below the seat, and a third approximates the elbow. But there is also a line that simply falls in the middle of the calf, and one that runs through the shoulder above the armpit. This is again odd, by the standards of later European metrology. Why divide the body into six parts, if two of them are invisible? And where is the principal modulus, the analogue of the head-height in recent Western pedagogy? There is a certain determinism in European metrology, a feeling that every line must have meaning, but the Egyptian sense of the body does not work that way, and their lines do not always correlate with their bodies. This 18-square canon of proportions is shown in the following table.

TABLE 10. THE 18-SQUARE CANON OF PROPORTIONS IN EGYPTIAN ART.

No.	Egyptian Unit	Distance on the Body	Grid Squares
1	Fathom, or 4 small cubits	Sole to hairline, or 24 handbreadths	18
2	Small cubit	Elbow to tip of thumb, or 6 handbreadths	4 $1/2$
3	$2/3$ small cubit	Elbow to wrist, and length of foot	3
4	$1/6$ cubit	Handbreadth (back of hand over knuckles)	$9/16$
5	$2/9$ cubit	Fist (full handbreadth including thumb)	1

FIGURE 107

Egyptian figures in an 18-square grid. Amenhophis III. From Erik Iverson, *Canon and Proportions in Egyptian Art* (Warminster, Eng.: Aris and Phillips, 1975), pl. 4.

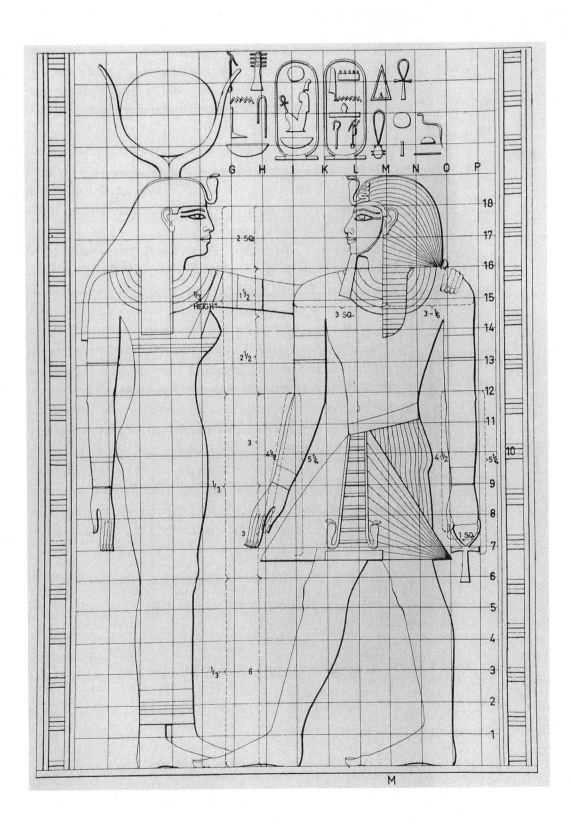

Egyptian metrology gives unexpected emphasis to the fist, the fingers, and the thumb. The number 18 was chosen because the unit square corresponds to 1 fist, not because the figure could be divided into 18 using the system of small cubits and fathoms. A handbreadth, which is the hand without the thumb, is 1/6 cubit, but a fist is marginally larger. For that reason, the grid explains parts of the figure that do not fit the schema of cubits. (Three handbreadths is 2 1/4 squares exactly, not an even number.) The body is divided in accord with two awkwardly scaled moduli; some parts are drawn with an eye to fists and squares, and others to handbreadths, small cubits, and fathoms.

To construct one of these figures—an exercise that is necessary both to understand and to *feel* the way such a body works—the draftsman begins with an 18-square grid and its midline. The divisions of the midline locate several features, and then widths are measured to either side. The corner of the eye, for example, goes at the top of the divided midline, exactly one square to the side. The waist is two squares over, and the navel one square, and so forth. The arms are placed by measuring their lengths beginning at the shoulders. As an exercise, this brings home the difference between the extreme precision of some features that are measured by the grid (such as the corner of the eye) and the articulative freedom of parts measured by lengths (such as the arms).

The change to the 21-square grid took place in the 26th Dynasty (sixth century B.C.), and it produced more graceful, leaner figures (Figure 108). The shift in metric standards that effected the change was the disuse of the Small cubit and the adoption of the Royal cubit. The 21-square canon of proportions is shown here.

TABLE 11. THE 21-SQUARE CANON OF PROPORTIONS IN EGYPTIAN ART.

No.	Egyptian Unit	Distance on the Body	Grid Squares
1	Fathom, or 4 Royal cubits	Sole to eyebrow, or 28 handbreadths	21
2	Royal cubit	Elbow to tip of thumb, or 7 handbreadths	5 1/4
3	2/3 Royal cubit	Elbow to wrist, and length of foot	3 1/2
4	1/7 cubit	Handbreadth (back of hand over knuckles)	9/16
5	2/9 cubit	Fist (full handbreadth including thumb)	1

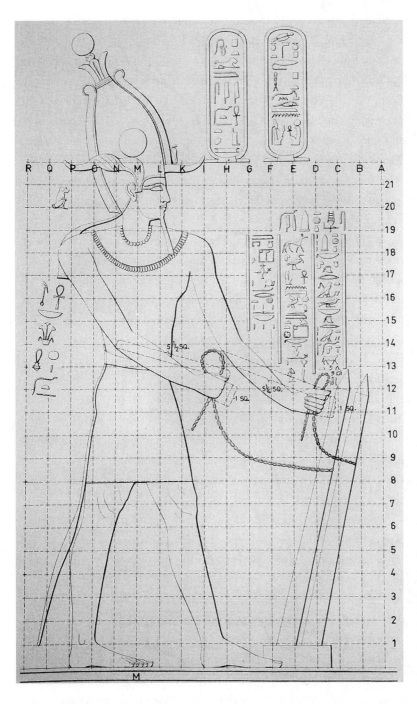

FIGURE 108

Egyptian figure in a 21-square grid. Edfu, Temple of Horus; Ptolemy XIII Neos Dionysos. From Erik Iverson, *Canon and Proportions in Egyptian Art* (Warminster, Eng.: Aris and Phillips, 1975), pl. 28.

Since it was necessary to retain the same relation between the arm and the total height, Egyptian artists increased the length of the arm until the distance from elbow to thumb was a Royal cubit. But the entire body was not scaled up in proportion. The new Royal cubit was longer than the old Small cubit, but the constituent measures—the fist, handbreadth, and fingers—remained the same. Since figures were measured in Royal cubits, and since 4 cubits still made 1 fathom, figures became objectively higher. The grid squares remained $1\frac{1}{3}$ handbreadths, or 1 fist, in width, but there were more in a figure. Three extra squares were added to the legs, the space above the navel, and the chest. In effect, the change stressed the uneasy collaboration of the two moduli, handbreadths and cubits. However we might want to construe the expressive meaning of such figures, the artisans who made them would have necessarily experienced a kind of dual seeing: first they would look at the overall vertical proportions, from sole to eye, and then, separately, at the workings of the fingers and arms.

It was apparently the Greeks who instituted the body measured in head-heights. The sculptors of the kouroi probably used the Egyptian 21-square grid and also several rules based on the head—such as the equation according to which the height of the head equals the distance from the chin to the lower margin of the pectoral muscles, which in turn equals the distance from the pectoral muscles to the navel; or the rule that the width of the neck is half the head's width; or that the shoulders are twice the head.[35] With the decay of the Egyptian civilization, the more complicated rules were forgotten, and so was the idea of gridding the body and excerpting moduli such as arm lengths, fingerbreadths, and fists.

We need to ask fundamental questions of this material. Is the Greco-Roman sense of the body as a pile of head-heights or a mannekin of anatomic articulations more coherent than the Egyptian body, which is after all a Procrustean bed of different scales? Or is it less integrated, since it divides the head from the body in a way the Egyptians would not have understood? The transition between the two forms would have been especially interesting, although virtually all evidence of it has been lost. It may be that we can understand Polykleitos's canon as an immensely complex, artificial, and doomed attempt to reconfine the body within a net of mathematics. "The beautiful comes about, little by little, through many numbers" is a sentence that could have been spoken by an Egyptian. In this context, the Greek word for "beauty" denotes a proportional relation, especially in the Chrysippean theory, according to which

beauty does not consist in single elements but in the harmonious proportion of the parts, the proportion of one finger to the other, of all the fingers to the rest of the hand, of the rest of the hand to the wrist, of these to the forearm, of the forearm to the whole arm, in short of all the parts to all the others, as it is written in the canon of Polykleitos.[36]

Outside of Egyptian art, the most thorough grids are those invented in the Renaissance. Leon Battista Alberti's system of *exempeda*, illustrated in the following table, measures the body on a grid divided first into sixths, then sixtieths, and finally into six hundred equal units.

TABLE 12. ALBERTI'S CANON OF 'EXEMPEDA'.

1	*Exempedum*	$1/6$ of the total height
2	*Unceolum*	$1/10$ *exempedum*
3	*Minuta*	$1/19$ *unceolum*

In the sixteenth century, Albrecht Dürer made an even more precise system, as shown in the following table, that divides a grid similar to Alberti's into 1,800 parts.

TABLE 13. DÜRER'S CANON OF RULES.

1	*Rule*	$1/6$ of the total height
2	*Zall*	$1/10$ *Rule*
3	*Teil*	$1/10$ *Zall*
4	*Trümlein*	$1/10$ *Teil*

The *Trümleiner*, Dürer's smallest divisions, are virtually invisible: a *Trümlein* on a 6-foot-tall body would be one millimeter high. Alberti's canon may have been used by Donatello, but Dürer's *Trümleiner* were probably never used, even by Dürer himself. Instead, they are a dream of perfect control, and their parallels are to be found in the tolerances used in contemporary robotics, rather than in Renaissance art.

Once a body has been divided into 600 or 1,800 parts, it can be exactly classified, and new figures can be drawn by looking up the relevant dimensions on a chart. Alberti gives such a chart in his book on sculpture, as illustrated here.

It becomes especially clear in the more elaborate Renaissance schemata that the grid is a powerful way of denying the body's own anatomic organization. The distance from the ground to the waist is a natural point of articulation for the body; it is intuitively whole rather than broken, as

TABLE 14. MEASUREMENTS PROPOSED IN
ALBERTI'S 'DE STATUA'.

Measurement from ground	Canon in De statua
To ankle bone	3 *unceolae*
To knee	1 *unceolum*, 7 *minutae*
To os sacrum	3 *unceolae*
To waist	3 *unceolum*, 7.9 *minutae*
To sternum	4 *unceolum*, 3.5 *minutae*
To Adam's apple	3 *unceolum*, 1 *minutae*

Alberti insists, into 3 *unceolae* and 7.9 *minutae*. Alberti's canon is more akin to his cryptographic and perspectival investigations than to the contemporaneous sense of the body, which was finding its way toward the doctrine of contrapposto and a different understanding of the body's possibilities.[37]

The Deconstructed Body

Panofsky called the opposition of grids and anatomic deconstructions the "geometric" and "algebraic" methods. I am calling them "deconstructing" and "gridding" because the first takes the body apart as a butcher might, by making use of its weak spots, and the second imprints it on a grid that does not necessarily fit those articulations. Algebra is not involved in either strategy, and geometry is present equally in both.[38]

As soon as the head is separated from the body, or is imagined as its yardstick, the body falls into pieces, and the pieces are the body's natural units—its limbs, bones, head-heights, and head-widths. Vitruvius, the principal Roman source for the history of proportions, gives a list of deconstructive proportions that is usually taken to be essentially of Greek origin.[39] Like all later systems that have survived, it takes the head as modulus, as illustrated in the following table.

The face is divided into three equal parts (forehead, nose, lower portion), and the entire body fits into a square, as a *homo ad quadratum*. When the body is spread-eagled, a circle can be circumscribed, with the navel as center, forming the *homo ad circulum*.

Most deconstructive systems owe something to Vitruvius, although there are Byzantine practices that take the face, rather than the head, as

TABLE 15. THE VITRUVIAN CANON OF PROPORTIONS.

Face, from hairline to chin	$1/10$ height
Hand, from wrist to middle finger	$1/10$
Head	$1/8$
Pit of neck to hairline	$1/6$
Pit of neck to crown of head	$1/4$
Foot	$1/6$
Cubit (elbow to thumb)	$1/4$
Breadth of chest	$1/4$

TABLE 16. THE BYZANTINE NINE-PART CANON.

Face	1
Torso, to beginning of stomach	1
Remainder of torso	2
Legs to the knees	2
Legs below the knees	2
Top of foot	$1/3$
Throat	$1/3$
Top of head	$1/3$
TOTAL	9

modulus. The *Mount Athos* canon, illustrated here, is the best-known example.[40]

Since the nose is $1/3$ of the face, it might be said that the author of the *Mount Athos* canon considers the nose to be the fundamental unit, or module, of the figure. Later texts confuse this canon with others, sometimes omitting the top of the head or altering other measurements; but they preserve the sense of the nasal module. Cennino Cennini, for example, divides the torso slightly differently; his principal landmarks are the pit of the stomach and the navel, and he omits the top of the head, resulting in a body $8^{2}/3$ face-lengths tall.[41]

The nose is also an important module in the Byzantine formula for the face, which allows a face to be made entirely out of noselengths, as illustrated in the following table.

This is one of the better documented schemata, and it occurs, for example, in the thirteenth-century *Christ the Redeemer* from Mount Athos (Figure 109).[42] The artisan would have put a pin with a knotted string at the bridge of the nose and swung three concentric arcs.[43] Here the method

TABLE 17. THE BYZANTINE CANON OF PROPORTIONS FOR THE FACE.

Circle No.	Radius	Includes
1	One noselength	Entire brow, cheeks
2	Two noselengths	The hair, the chin
3	Three noselengths	Pit of neck, halo

is simple enough so that the schema shows through the icon like a surre-
alist apparition, shifting the face from Christ Pantocrator to a bull's-eye.
All bodily schemata have this power, and I have myself experienced pic-
tured bodies as collections of Egyptian fingerbreadths, but this is the most
immediate example of the way any pictured body struggles against its un-
derlying schema.

Many Renaissance and baroque images that employ deconstructive
canons make only small variations in the Vitruvian and Byzantine schemata.
Cimabue's *Crucifix* in San Domenico in Arezzo apparently follows a 10-
head canon, which would make it an important return to the Vitruvian
schema.[44] Giotto's *Crucifix* in the Museo Civico, Padua, is 8 heads tall; it
might signal a renewed attention to classical texts or an unquantitative ap-
preciation of the less thinned figures of Roman art. Even though Cennini
insists that women cannot be measured because they "do not have any set
proportion," he adheres to the Byzantine canon.[45]

Albrecht Dürer's *Four Books of Human Proportions*, which contains the
most elaborate gridding system (the division into 1,800 parts) also offers
the most thorough deconstructive system.[46] He divides the body twice:
first into a harmonically adjusted scale of three parts, and then into a large
number of fractions in accord with the body's articulations. The initial
harmonic division, which is sometimes ignored in scholarship that seeks
to assimilate Dürer's method into the simpler history of division by heads
or faces, marks three lengths on the body: from neck to hip, hip to knee,
and knee to end of shin bone. The three segments are put in geometric
progression with the use of a simple ancillary construction. The result is a
figure marked in six places: sole, shin, knee, hip, neck, and top of the
head. At the end of this first stage, it is a curiously marked body: no im-
portance is placed on the head, the face, or the torso, and the abdomen
and arms are invisible. To complete the construction, all the remaining
points of articulation on the body are placed in reference to those initial
harmonic markers. Dürer is astonishingly thorough—he names and mea-
sures 91 lengths on each figure, more than any other metrological theory,

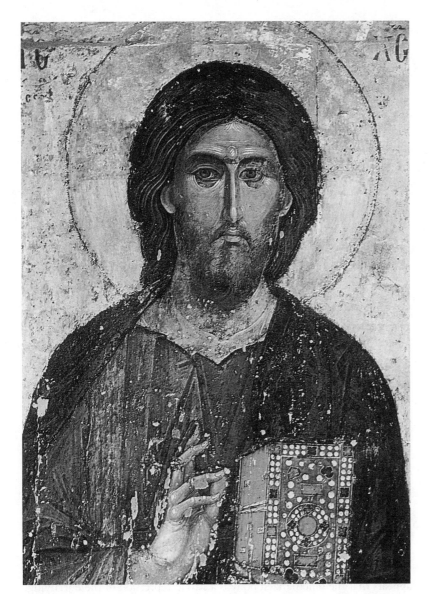

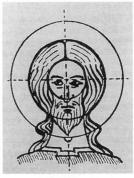

FIGURE 109

Christ the Redeemer, second
half of the thirteenth century.
Tempera on panel. Mount
Athos, Museum of the
Monastery of Chilandar.
Inset: Byzantine three-circle
face, from Erwin Panofsky,
"The History of the Theory
of Human Proportions as a
Reflection of the History
of Styles," in *Meaning in
the Visual Arts* (Chicago:
University of Chicago Press,
1979), p. 79, Fig. 2.

including the ethnological and anthropological authors we considered in
Chapter 4.

Like Leonardo before him, Dürer uses the 91 lengths to explore a range
of figures, from impossibly thin, nearly pinheaded figures to very fat ones.
Many figures are based on observation, as his drawings attest, but some are
clearly extrapolated from the system, and the line between observation and
theory has not been adequately investigated. (Just as the method mixes
harmonic and deconstructive strategies, so the illustrations mingle actual

people with invented ones.) The thinnest figures are shadowy versions of thicker ones, and so it appears that he had more fat models than thin ones; it seems likely that he had several stocky models from which to take his basic measurements. On the whole, his method is significantly stranger than it is taken to be when it is described as an attempt to understand unusual body types: it is at once normative (in its harmonic substructure) and inconsistently empirical (in its 91 fractional measurements); at once intriguing as a catalogue and useless as a practical theory.[47]

The Unrepresentable and the Inconceivable in Anarchic Schemata

Harmonic, gridded, and deconstructed bodies constitute the mainstream of Western art. But if there is a guiding principle for schematic bodies in modern and non-Western art, it is the strict avoidance of system, geometry, and harmony—what I have called "anarchic schemata." It would be precipitous to gather the remaining examples of schematized bodies, which after all constitute the vast majority of all images of the body, into a single fourth category, even though that is the way they have been treated in the history of Western artistic pedagogy and historiography up to the late twentieth century. Instead, I want to veer aside and begin to bring this book toward a deeper conclusion by considering the question of schemata in general as an example of the fundamental possibilities of picturing bodies. Broadly speaking, my approach to the schemata has been psychoanalytic—that is, I have been interested in balancing the predominantly geometric discourse of the schemata with an affective account of the desires that inform it. Although I have asked *how* the schemata work, I have also asked *why* they work: why it seems necessary, beautiful, or even possible to reduce a body to geometry. In general, it appears that the schematized body is a strong repression of the horrifying, abject, or grotesque body, and its static presence, or "thereness," is a magical gesture against the body's transgressive and continual flux. But at the same time, I would not want a survey of what I have called the intellectual forms of the pictured body to come down to a denial of the empathic or "painful" forms, so that this book would be the story of a truth and its suppression.

On the contrary, the crucial issue in studying pictures of the body must be the expressive value of each individual choice: what *kind* of pain is evoked, exactly *where* the sensation is strongest, precisely *how* the analogies

operate. The meaning leaches out of these questions when they drift away from specific images. A picture of the body is the site of a series of decisions (many of them made "in advance" or unconsciously) regarding what is *presentable*: what will stand for the body in any given instance. And for that reason, both the final and the initial question for any image of the body is: What is representable? I want to bring this book to its close by thinking directly about that question.

Some images are unrepresentable because they are forbidden by law or prohibited by custom. As Thomas McEvilley has stressed, there is a continuum between public censorship and the images we avoid or renounce as individuals—for example, I am forbidden to own child pornography, and I might also forbid myself to see child pornography, and I might be unable to make a clear distinction between those two judgments or even to conceive them *as* judgments.[48] Even though this is already enough to open a critique of the normative discourse on pornography and censorship, the issue becomes more challenging if we consider that there are also images that *are* presented but are nevertheless not seen. There may, for example, be images of the body that I am permitted to see but cannot—I may glance quickly at a car crash, half-hoping *not* to see a body—and there are bodies that I *cannot* see, no matter how hard I stare—and in that category I would place some of the images of death or unbearable pain of the kind that Georges Bataille loved so excessively. It may seem that this involves questions of desire and repression, but it is not necessary to invoke a psychological explanation in order to account for such acts of self-forbidding. The antipsychological stance Leo Steinberg adopts in speaking about Christ's sexuality, for example, permits him to describe how seeing can be "deflected" (it's a wonderful word, conjuring the idea of seeing directed at an object, and then suddenly veering aside) even when the object in question—Jesus' penis—is front and center, pointed to and even fondled.[49] So at the very least the question of what is representable encompasses images controlled by the government, those forbidden by each individual viewer, those that are difficult or painful to see, and those that cannot be seen—that provoke blindness or a failure of comprehension—no matter how concertedly they might be looked at.

These are all fascinating topics, and they form part of the subject of another book, *The Object Stares Back*. In this context, I want to concentrate on two further problems that pertain specifically to schematized pictures of the body. The first concerns bodies and body parts that cannot be put

into images because they have no pictorial equivalents. In the history of medical illustration, skin diseases could not be adequately shown using the pictorial conventions of color lithography and engraving, and it required photography to give doctors a sense of what could be made into a picture. Before photography, even the most vigilant dermatological illustrations had a property I would call "glossing," in which the artist's eye, and the lithographic crayon, slid over the surface of the patient's body without stopping to record the outlandish textures of pathologies such as mercury poisoning, syphilis, or neurofibromatosis. In earlier medical illustration, skin is one of the places where unpicturable elements become centrally important. Asking about what is unpictured is a way of trying to understand what *is* represented, just as an artist tries to come to terms with a figure by drawing its outline. Often what is unrepresented is the crucial and proper *subject* of the pictured body, precisely because it cannot find adequate form. The elusive, repellent mottled disfigurations of the skin *are* the subject of dermatological illustration, even though earlier artists routinely failed to give them pictorial shape—either because they seemed excessive or inappropriate for the medium or the purpose of the illustration or because they seemed physically unrepresentable, without pictorial equivalents.

Beyond the unrepresentable is another issue that I think is even more elusive and little-studied, the *inconceivable as such*: the qualities, parts, textures, proportions, or motions that are absent from imagined bodies, and therefore fail even to present themselves as technical or conceptual lack in an image. As late-twentieth-century viewers of pictured bodies, it will not normally occur to us—as it would have to a Byzantine artisan, and as it will to a contemporary Byzantinist—that the nose is a radius whose length can provide a module for a face comprised of concentric circles, linking the skull, the hair, and even a halo to its unit length (see Figure 109). For most of us, the Byzantine nasal radius is inconceived—it is not part of our ways of imagining pictured bodies. We do not experience it as a lack, and when it is brought to our attention we experience it as a superfluity, a modification, or an *addition* to the represented body.

There are more intricate examples, and many of the analyses in this book have been generated by thoughts about how images of the body can be *lacking* in these two ways. One of the challenges for the history of represented bodies is to try to find ways of speaking about absences and ways of disentangling them, to search for signs and interpretive strategies that

might be able to construct the difference between unrepresentable and in-
conceivable forms, or else show where and how they collapse into the un-
differentiated category of forms that are not present. In any given picture,
the issue would be the relation between, on one hand, whatever is taken to
be properly *not* an attribute of the visualized body, so that it is excluded
from representation, finessed, glossed, or otherwise inadequately or par-
tially shown, and on the other hand, whatever can be described as a con-
ceptual absence, a gap *in the concept of the representable itself.* The former is
the unrepresentable; the latter, the inconceivable.[50]

Since schemata are denials of the body, it can help to consider what a
given image avoids and what its maker could not conceive. In the case of
this Gnostic magical plaque from Carthage (Figure 110), how might we
characterize what has been omitted or say where the limits of the repre-
sentable might lie? The inscription on the figure is a corrupted version of
a name for Osiris, and the figure itself is a crude version of a late Egyptian
convention for Osiris.[51] It is highly schematic—but exactly how does its
schematism work? Is it sufficient to invoke the category of the *gryllus* and
to think of the figure as a fusion of a man and a turtle or a snake? Under
what circumstances would it be enough to note the figure's bare outlines
and classify it as a "conceptual" image, opposing it to the equally large class
of "perceptual" images that respond more directly to visual phenomena?[52]
One of the virtues of concentrating on the unrepresentable and the in-
conceivable, instead of attempting to say what the figure *is*, is that it avoids
the assumption that a schema, or a *gryllus*, or a conceptual image, is some-
how a departure from a (Western) norm.

The Osiris figure lacks genitals, a mouth, nose, and ears. But it is rea-
sonable to assume that it is replete, lacking nothing that is pertinent to its
magical purpose. (Other Gnostic amulets have approximately the same
lacunae.) What is unrepresentable here might well include the details of
the god: there may have been no pictorial sign for the half-bestial and
half-human way that the trunk of the god articulates with its shoulders.
The ambiguity of those armpits and shoulders might itself be efficacious,
since it may have evoked the god's impossibility or his transcendence. The
magical attributes of the scorpion and the wheat may also be full and cor-
rect if they are partly ideographs; in that case, they would not be suscep-
tible to a more naturalistic rendering. I would suggest that the properties
that at first seem unrepresentable, or unrepresented—a fully articulated
gryllus, a naturalistic body—are actually *inconceivable.* In that respect, the

body is complete, and what is unrepresentable might lie elsewhere—for
example, in the inappropriateness of fleshing out the two symbolic attrib-
utes, or in the inadmissibility of a god whose shoulders are either a turtle's
or a man's.

From the universe of unruly schematic images, I choose one other, a
Syriac picture of King Solomon spearing a devil (Figure 111).[53] The man-
uscript from which this is taken, the *Little Book of Protection*, is a collection

FIGURE III

King Solomon spearing a
devil. Syriac. London, British
Museum, MS Orient.
No. 6673.

of charms and incantations for various purposes, and there are similar pic-
tures of the angel Gabriel spearing "the devil-woman of the Evil Eye," the
martyr Thaumasius spearing the "spirit of the daughter of the moon," and
so forth. In each image, the divine rider is more or less the same, with an
impassive, buglike face, and the horse generally has one great sagging eye
and two planks for jaws. But the demons and devils vary according to dif-
ferent rules. The circular face, flying hair, ratchet mouth, cyclopean eye,

and pincushion hands are common to several, but the pod-foot is unique to this devil. The evil figures seem schematic, and yet oddly sly or almost humorous—almost as if they were intentionally crude. The faces of the martyrs, prophets, angels, and knights were probably perceived as adequate representations; there was no need to make them into individuals or provide them with legible expressions. Given that particular lack of interest, it is also likely that some elements of the devils, dragons, wolves, lions, and mad dogs that are speared by the martyrs, prophets, angels, and knights would also have looked adequate—they would have been unremarkable, and sufficient for their task.

In the *Little Book of Protection*, holy figures are strongly schematic, and have little signifying power as pictures. Unholy bodies are different: each is unique, although they are all bristly and geometric like burrs (note the way the devil prods the horse's neck). A body in this case is a variable object: a schema of prickly horror, a positional marker (it must always be under the horse, which plummets on it from above), and a set of minimal attributes. It seems that what is unrepresentable in this case is pure horror, and the devil's quills and pod are inadequate reminders of what cannot be pictured. If this were modern art, then a critic might say that the artist lacked observational skills. But the structure of the images in the *Little Book of Protection* indicates that sort of unrepresentability should probably be assigned to the domain of the inconceivable. What cannot be represented is horror, and what cannot be conceived is the manner in which such a schema must fail to convey that horror.

Looking for unrepresentable and inconceivable elements is a strategy for coming to terms with what an image *does* show. It can help in understanding unusual bodies, like Humbaba's, Pazuzu's, Lamashtu's, and the Gorgon's.[54] Such unmeasured "anarchic" schemata omit a great deal—but then, so does any image of a body. In the Introduction, I said that this book could have been subtitled "A General Theory of Distortion," and I suppose it could equally well have been called something like "The Repression of the Body in Pictures." All representations of the body distort it by pressing it flat, and in doing so they extract its motion, its roundness, its textures, and its individuality. In other words, they hide the body, erasing some parts, censoring and repressing others. Inconceivability and unrepresentability are tools for characterizing the act of representation. They are most apparent when the images are already dry and schematic, but they apply universally, to any pictured body.

At the End of the Body

At the end of the body—at the far extreme of schematization, at the pitch of dryness and intellection—are representations that are no longer about the body, where the artists are really thinking about other matters. They are the least embodied, the most abstract, and therefore a fitting end to this book as a whole. A body might be almost entirely vanished into a symbol, as in the shrunken figures in Egyptian hieroglyphs, or it might suffer a metempsychosis, emerging as language—as in the word "body." As I argued at the beginning, abstract painting never gets far from the body, since it is too busy evoking bodily gestures and forms or denying them in the rigors of hard-edged geometry. To be more nearly free of the body, a form must have some other purpose, and I propose that language is the purpose that most forcefully evicts bodily meaning. When a body is used for a symbolic purpose, it can become, in a new way, invisible—it can enter the realm of things that are not seen, but are *read*. No door can be entirely closed on the figure; as I put it at the outset, every picture is a picture of the body. But there is a twilight where reading becomes more engrossing than seeing.

Traffic signs that flash a human icon for "walk" and a canceled icon for "don't walk" conjure, in the most fleeting, automatic, uncognized way, the reminder that a car can cancel a body as quickly as the red bar streaks across the icon. Those "don't walk" icons are gentle, abstracted images, but they manage to speak just a little about the destruction of the body. There are even fainter examples, in which the body is on the point of vanishing into the letter, such as Geoffrey Tory's Renaissance letter mysticism. To express his elaborate thoughts about the alphabet, Tory assigned each letter a symbolic function, linking the letters with the four Cardinal Virtues, the nine Muses, the seven Liberal Arts, and the three Charities.[55] For him, the vowels are the Cardinal Virtues: "A" for Justice, "E" for Fortitude, "I" for Prudence, and "O" for Temperance. At the same time, each letter is also personified, as if it were a little spirit. He draws them in nine-square grids that are themselves based on the nine Muses. In one plate, the letter "I" is imagined as a figure, a little *homo ad quadratum*, straitjacketed in its grid (Figure 112). It is a letter, but it is also a person, burdened by a huge weight of symbolic associations, compressed into an upright column, stretched until it conforms to the abstract grid.

FIGURE 112

Geoffrey Tory. The letter "I."
From Tory, *Champ fleury*
(Paris, 1529), book 2.

This is the end of the body, the place where the body fades and lan-
guage begins. Beyond it are only letters, whose "skins" come forward to
our eyes as only the faintest ghosts of bodily forms, but at the same time,
the trapped eyes and penis are insistent markers of the indelible presence
of the pictured body.

Reference Matter

Notes

Preface

1. The relevant texts are Jean-Paul Sartre, *Being and Nothingness*, trans. Hazel E. Barnes (New York: Washington Square Press, 1966); Maurice Merleau-Ponty, *The Visible and the Invisible*, trans. Alphonso Lingis (Evanston, Ill.: Northwestern University Press, 1968); Maurice Merleau-Ponty, *Phenomenology of Perception*, trans. Colin Smith (London: Routledge and Kegan Paul, 1962); Jacques Lacan, *The Four Fundamental Concepts of Psycho-Analysis*, trans. Alan Sheridan (New York: W. W. Norton, 1964), pp. 91–104; and Robert Vischer, *Das optische Formgefühl: Ein Beiträg Zur Aesthetik* (Leipzig: H. Credner, 1873), in *Drei Schriften zum ästhetischen Formproblem* (Halle, 1927), and *Empathy, Form, and Space: Problems in German Aesthetics 1873–1893*, trans. Harry Francis Mallgrave and Eleftherios Ikonomu (Santa Monica, Calif.: Getty Center for the History of Art and Humanities, 1994).

For Sartre, see also Hubert L. Dreyfus and Piotr Hoffman, "Sartre's Changed Conception of Consciousness: From Lucidity to Opacity," *The Philosophy of Jean-Paul Sartre*, ed. Paul Arthur Schilpp, The Library of Living Philosophers, vol. 16 (La Salle, Ill.: Open Court, 1981), pp. 229–45, especially p. 233. Marjorie O'Rourke Boyle's interesting *Senses of Touch: Human Dignity and Deformity from Michelangelo to Calvin* (Leiden: Brill, 1998), arrived too late to be of use.

2. Elaine Scarry, *The Body in Pain* (New York: Oxford University Press, 1985), p. 279. Scarry makes her comments in reference to "concussive experiences" of pain and torture, but as I will argue, her observations have force in regard to many bodily representations.

3. See Mark Johnson, *The Body in the Mind: The Bodily Basis of Meaning, Imagination and Reason* (Chicago: University of Chicago Press, 1987), whose account I will not be following here because it is too general—and too ra-

tional—to be of much help in accounting for pictures. Johnson's work is related to Spinoza and to Stoicism, and his approach also has unacknowledged affinities with existentialism; see Alphonso Lingis, *Libido: The French Existentialist Theories* (Bloomington: Indiana University Press, 1985), pp. 50–51. Gilles Deleuze, *Spinoza, Practical Philosophy*, trans. Robert Hurley (San Francisco: City Lights, 1988). There is related material in Drew Leder, *The Absent Body* (Chicago: University of Chicago Press, 1990); Jane Gallop, *Thinking Through the Body* (New York: Columbia University Press, 1988); Naomi Goldenberg, *Returning Words to Flesh: Feminism, Psycho-analysis, and the Resurrection of the Body* (Boston: Beacon Press, 1990); and George Lakoff, *Women, Fire, and Dangerous Things: What Categories Reveal about the Mind* (Chicago: University of Chicago Press, 1987).

4. Among these, I will not be explicitly addressing gender studies or feminist approaches. In order to undertake to read the depicted body as the site of gender construction or as evidence of the ways in which sexual and social roles have been presented, it is necessary to imagine pictures of the body as a kind of evidence of what might have been obtained in the world, and such readings are only made possible by partial oblivion to deeper philosophic questions regarding the nature of pictured bodies. In the large literature, see Lisa Tickner, "The Body Politic: Female Sexuality and Women Artists Since 1970," *Art History* 1 (1978): 236–47; E. Ann Kaplan, "Is the Gaze Female?" in *Powers of Desire: The Politics of Sexuality*, ed. Ann Snitow, Christine Stansell, and Sharon Thompson (New York: Monthly Review Press, 1983), pp. 309–27; A. Tüne, *Körper, Liebe, Sprache: Über weibliche Kunst, Erotik darzustellen* (Berlin: Elefanten Press, 1982); and *The Female Body, Figures, Styles, Speculations*, ed. Laurence Goldstein (Ann Arbor: University of Michigan Press, 1991). A good introduction to recent literature is Arthur Frank, "Bringing Bodies Back In: A Decade Review [of the 1980s]," *Theory, Culture, and Society* 7 (1990): 131–62.

5. Philostratus, *Imagines*, trans. Arthur Fairbanks (Cambridge, Mass.: Harvard University Press, 1960), I.4, p. 19.

6. In most illustrated versions of Philostratus, more conventional alignments of beholder and beheld forbid the possibility of blood flowing beyond the frame, and the blood spurts into a pool or drips down Menoeceus's body—in which case, he becomes a figure for Christ. See for example Philostratus, *Les Images*, trans. Blaise de Vigenère (Paris: Chez la veufue Abel l'Angelier . . . et la vuefue M. Guillemot . . . , 1614), reprinted in the series *The Renaissance and the Gods*, ed. Stephen Orgel (New York: Garland, 1976), p. 24.

7. The quotation is from Jean Starobinski, "A Short History of Bodily Sensation," trans. Sarah Matthews, in *Fragments for a History of the Human Body*, ed. Michel Feher, 3 vols. (Cambridge, Mass.: Zone Books, MIT Press, 1989), vol. 2, p. 369.

8. Krauss's book *The Optical Unconscious* (Cambridge, Mass.: MIT Press, 1993) can be read as an account of somatic involvements in the crucial moments of modernism. For Michael Fried, see especially *Courbet's Realism* (Chi-

cago: University of Chicago Press, 1990). Steinberg's engagement with questions of the body is especially eloquent not in the book on Christ's sexuality, which has a specific interpretive purpose, but in the meditations on Picasso's *Les Demoiselles d'Avignon*; see the reprint, "The Philosophical Brothel," *October* 44 (1988): 8–74, with a preface on somatic criticism by Rosalind Krauss. For Didi-Huberman, see *Devant l'image: question posée aux fins d'une histoire de l'art* (Paris: Minuit, 1990). Among Barbara Stafford's books that deal with corporeality, *Body Criticism: Imagining the Unseen in Enlightenment Art and Machine* (Cambridge, Mass.: MIT Press, 1991) is only the most explicit; see also the body metaphors in *Voyage into Substance: Art, Science, Nature, and the Illustrated Travel Account, 1760–1840* (Cambridge, Mass.: MIT Press, 1984).

9. *Fragments for a History of the Human Body*. Feher suggests that the genealogy of the "ethical and aesthetic conceptions of the psychosomatic link" that I have been adumbrating in this preface are to be found in Plotinus. See Eric Alliez and Michel Feher, "Reflections of a Soul," ibid., vol. 2, pp. 46–84. The same criticism of conceptual disarray could be applied to the large exhibition *L'âme au corps: arts et sciences 1793–1993*, ed. Jean Clair (Paris: Réunion des Musées Nationaux, 1994).

Introduction

1. Modified from B. Conrad, *Famous Last Words* (Garden City, N.Y.: Doubleday, 1961), p. 171.

2. Portions of this book are distilled in Chap. 4 of Elkins, *The Object Stares Back: On The Nature of Seeing* (New York: Harcourt Brace, 1997). The approach there is less historically specific and more geared to the phenomenology of sight in general. I think that bodies are both the primary objects of seeing and the principal conditions for the possibility of seeing; *The Object Stares Back* puts those possibilities to work in a general account of vision and blindness.

3. Lucretius Carus, *De rerum natura*, IV.28–96.

4. *Circonscrizione* in the Italian; see Alberti, *Della pittura e della statua* (Milan: Classici Italiani, 1804), p. 45.

5. *Lucretius, The Way Things Are, The* De Rerum Natura *of Titus Lucretius Carus*, trans. Rolfe Humphries (Bloomington: Indiana University Press, 1968), p. 120. Humphries also renders "films," as do the editors of Lucretius, *De rerum natura*, ed. William Ellery Leonard and Stanley Barney Smith (Madison: University of Wisconsin Press, 1942), p. 526 n. 31. See further Karl Konrad Friedrich Wilhelm Lachmann, *In T. Lucretii Cari De Rerum Natura libros commentarius* (New York: Garland, 1979 [originally Berlin, 1855]), and note *effugias* for *effigies*, p. 215 n. 42. For a general introduction to the passage, see John Masson, *Lucretius, Epicurean and Poet* (New York: E. P. Dutton, 1907), Chap. 11.

6. Diskin Clay, *Lucretius and Epicurus* (Ithaca, N.Y.: Cornell University Press, 1983), p. 119.

7. Sigmund Freud, *Instincts and Their Vicissitudes*, in *Standard Edition*, ed.

James Strachey (London: Hogarth Press, 1962), vol. 14, pp. 122–23. See further Jean Laplanche and J.-B. Pontalis, *The Language of Psycho-analysis*, trans. Donald Nicholson-Smith (London: Hogarth Press, 1973). In a talk at Johns Hopkins University (April 1994), Laplanche emphasized that his book is not intended as a dictionary but as a way of raising questions about the Freudian corpus.

8. Martin C. Dillon, "Merleau-Ponty and the Reversibility Thesis," in *Merleau-Ponty, Critical Essays*, ed. Henry Pietersma (Washington, D.C.: Center for Advanced Research in Phenomenology, 1989), p. 86, quoting Merleau-Ponty, *The Visible and the Invisible*, p. 136; Eliot Deutsch, "The Concept of the Body," in *Phenomenology East and West, Essays in Honor of J. N. Mohanty*, ed. Frank Kirkland and D. P. Chattopadhyaya (Dordrecht: Kluwer, 1993), pp. 93–110.

9. See Thomas Minner, "Portraits of a Relationship: Alberto Giacometti and Isaku Yanaihara," M.A. thesis, School of the Art Institute of Chicago, 1990, unpublished. Among published sources, see Isaku Yanaihara, "Pages de journal," *Derriere le miroir* 127 (May 1961): 18–25; and James Lord, *Giacometti, A Biography* (New York: Farrar Straus Giroux, 1985). Yanaihara's name is pronounced with the accent on the ante-penultimate syllable.

10. Yanaihara, "Pages," 21. Compare the parallel studies of bodies and space in Helmut Oehlers, *Figur und Raum in den Werken von Max Ernst, René Magritte, Salvador Dalí und Paul Delvaux zwischen 1925 und 1938*. Europäische Hochschulschriften, Reihe XXVIII, Kunstgeschichte (Frankfurt am Main: Peter Lang, 1986), vol. 54.

11. Elkins, *The Object Stares Back*, pp. 186–93, 210–15.

12. First and second seeing have affinities with the psychoanalytic concept of "anaclisis," the misplaced desire for the pleasure associated with an original instinct of self-preservation, but there is an important difference, because in the anaclitic model desire seeks something that is irretrievably lost (that is, the original scenario, in which the instinct for self-preservation created the first pleasure), whereas in this model the sight of the body must be considered as the aim (in the Freudian sense) of the desire. See Jean Laplanche, *Life and Death in Psychoanalysis*, trans. Jeffrey Mehlman (Baltimore: Johns Hopkins University Press, 1976). "Nomadic" is intended as an echo of Gilles Deleuze's concept; see for example Deleuze, "Nomad Thought," in *The New Nietzsche: Contemporary Styles of Interpretation*, ed. David Allison (New York: Dell, 1977), pp. 142–49.

13. L. Kubie, "Body Symbolization and the Development of Language," *Psychoanalytic Quarterly* 3 (1934): 433.

14. Scarry, *The Body in Pain*, p. 282.

15. D. H. Lawrence, *Lawrence on Hardy and Painting*, ed. J. V. Davies (London: Heinemann Educational, 1973), p. 146; and Meyer Schapiro, "The Apples of Cézanne," in *Modern Art: 19th and 20th Centuries* (London: Chatto and Windus, 1978), pp. 2 ff.

16. Stephen Bann, *The True Vine, On Visual Representation and the Western Tradition* (Cambridge, Eng.: Cambridge University Press, 1989), p. 91.

17. See *The Merleau-Ponty Reader: Philosophy and Painting*, ed. Galen A. Johnson (Evanston, Ill.: Northwestern University Press, 1993).

18. For examples of Cézanne's attention to the centers of pictures, see Elkins, "The Failed and the Inadvertent: The Theory of the Unconscious in the History of Art" *International Journal of Psycho-Analysis* 75, part 1 (1994): 119–32.

19. Jean Lemayrie, *Balthus*, 2d ed. (New York: Skira, 1982); Stanislas Klossowski de Rola, *Balthus* (New York: Abrams, 1996). I do not doubt that Stanislas is correct in what he says about his father's idea of women (basically, that they represent unattainable perfection) or about his artistic project (that it is, and has increasingly become, hermetic). But the history of art has rarely been comprised of artists' interpretations of their own work, especially when the works go so strongly against prevailing interpretive customs. For additional material on Balthus, see Milton Gendel, "H. M. The King of Cats," interview, *Art News* 61, no. 2 (April 1962): 36–38; Alice Rewald, "Interview with Balthus," *Gazette de Lausanne* (December 8, 1962); Michel Legris, "Si Rome n'est plus Rome," *Le Monde* (January 11, 1967), and "Entretien avec Balthus," *Le Monde* (January 12, 1967). The account I am developing here is parallel to *Die weibliche und die männliche Linie: Das imaginäre Geschlecht der modernen Kunst von Klimt bis Mondrian*, ed. Susanne Deicher (Berlin: Dietrich Reimer, 1993). Stanislas Klossowski de Rola's take on his father's project is also given in Bob Colacello, "Beauty and Balthus," *Vanity Fair* (December 1997): 300–16, 322–24, especially 312.

20. John Hay, "The Body Invisible in Chinese Art?" in *Body, Subject, and Power in China*, ed. Angela Zito and Tani Barlow (Chicago: University of Chicago Press, 1994), pp. 42–77, especially p. 68.

21. Hay says only that the rock is "the classical image of the Chinese tradition," parallel to "the Apollo or the Venus" (ibid., p. 68).

22. Pierre Klossowski, *La rassemblance* (Paris: Ryôan-ji, 1984), p. 83, discussed in Mario Perniola, "Between Clothing and Nudity," trans. Roger Friedman, in *Fragments for a History of the Human Body*, vol. 2, pp. 236–65, especially p. 252. See further Stanislas Klossowski de Rola, "Balthus Beyond Realism," *Art News* 55, no. 8 (1956): 26–31.

23. Krauss, *The Optical Unconscious*, pp. 282, 284.

24. Michael Fried, *Three American Painters* (Cambridge, Mass.: Fogg Art Museum, 1965), pp. 10–19. The theme is pursued from another perspective in Elkins, *On Pictures and the Words That Fail Them* (Cambridge, Eng.: Cambridge University Press, 1998).

25. Robert Rosenblum, *Modern Painting and the Northern Romantic Tradition, Friedrich to Rothko* (New York: Harper, 1975), p. 203.

26. In this respect, the concept of anamorphosis need not be confined to viewing positions that are literally skew. Lacan's theory implies as much; for discussion and further literature, see Elkins, *Poetics of Perspective* (Ithaca, N.Y.: Cornell University Press, 1994), pp. 248–52.

27. Krauss, *The Optical Unconscious*, p. 308.

28. Scopophilia is explored in Martin Jay, *Downcast Eyes: The Denigration of Vision in Twentieth-Century French Thought* (Cambridge, Mass.: MIT Press, 1993); it was coined by Freud, *Three Essays on Sexuality*, in *Standard Edition*, ed. James Strachey (London: Hogarth Press, 1962), vol. 17, p. 169. Most of the remaining terms are from Drew Leder, *The Absent Body*. The ecstatic body has been invoked most recently by Gertrud Sandquist, describing Andres Serrano's photographs. See "Body of Ecstasy," in *Andres Serrano* (Oslo: Galleri Riis, 1991).

29. Claude Gandelman, *Reading Pictures, Viewing Texts* (Bloomington: Indiana University Press, 1991), p. 74. Unfortunately, Gandelman ties this to a programmatic interpretation of the map of cortical motor functions, which he says implies a "homunculus" in the brain; recent research has distorted the homunculus beyond recognition and extended "humunculi" to other sense organs in other animals. Although it appeared too late to be included here, the argument about representation and distortion is also explored in Julia Kristeva, *Visions capitales* (Paris: Réunion des Musées Nationaux, 1998), pp. 45–56, 152, especially in relation to religion.

30. Erwin Panofsky, "Die Perspektive als 'Symbolische Form,'" *Vorträge der Bibliothek Warburg* 4 (1927): 258–330.

31. In Quintilian and classical rhetoric, "figure of speech" and "trope" were disjunct, while "figure of thought" coincided with some uses of "trope." See *Princeton Encyclopedia of Poetics*, ed. Alex Preminger (Princeton, N.J.: Princeton University Press, 1974), *s.v.* "Trope" and "Figure." Rosalind Krauss and Yve-Alain Bois, in *Formless: A User's Guide* (New York: Zone Books, 1997), develop a theory of representation that is logically disjunct from this one. Partly following Georges Bataille, and further developing his concept of the *informe* (the formless), they propose that the formless should not be "measured against resemblance or unlikeness at any price": that is, it should not be a separate "operation," "in itself . . . unbearable to reason." They oppose their position to George Didi-Huberman, whom they say has "neatly mapped" the *informe* "onto the idea of deformation" (*Formless*, pp. 79–80). In a footnote (ibid., pp. 268–69 n. 3) they continue the argument with Didi-Huberman's *La Rassemblance informe ou le gai savoir visuel selon Georges Bataille* (Paris: Macula, 1995), saying that Didi-Huberman almost subscribes to a position that would separate the formless from deformation, but then recants. I take all this as central to the project of this book, and I note that what I am doing here *is* a kind of mapping of the formless onto deformation. I do so while also acknowledging that Krauss's and Bois's is the strongest and clearest theory of deformation; but for purposes of this book, it would not be prudent to buy philosophic consistency at the price of tethering my account to a tendentious re-reading (and updating!) of a surrealist text. This book might have been logically stronger, but historically weaker, if I had unthreaded the moments where something like the *informe* is at work from those other moments—the majority, in visual art—where deformation is the master trope of resemblence.

32. This is taken up in Elkins, *The Object Stares Back*, and in a different

way, in the final chapter of Mieke Bal, *Reading "Rembrandt": Beyond the Word-Image Opposition* (Cambridge, Eng.: Cambridge University Press, 1991).

33. For that reason, I will not be considering images that have to do explicitly with the *theme* of pain, but rather images whose sight causes pain (or some allied, but less intense, reaction). For a feminist account of images *about* pain, see Paula Cooey, *Religious Imagination and the Body: A Feminist Analysis* (New York: Oxford University Press, 1994), on Frida Kahlo.

34. For proprioception, see Oliver Sacks, *The Man Who Mistook His Wife for a Hat* (New York: Summit, 1985). For cenesthesia and *tactus intimus* (the latter comes from Cicero's translation of Aristippus), see Jean Starobinski, "A Short History of Bodily Sensation," trans. Sarah Matthews, in *Fragments for a History of the Human Body*, vol. 2, pp. 350–70, especially p. 353.

35. Pierre-Louis Moreau de Maupertuis, *The Earthly Venus*, trans. Simone Brangier Boas, with an introduction by George Boas (New York: Johnson Reprint Corp., 1966), pp. 49–50. Maupertuis is discussed in Barbara Stafford, *Body Criticism: Imaging the Unseen in Enlightenment Art and Medicine* (Cambridge, Mass.: MIT Press, 1991), p. 315; see also Elkins, review in *The Art Bulletin* 74, no. 3 (1992): 517–20.

36. David Hume, *A Treatise of Human Nature*, ed. Lewis Amherst Selby-Bigge (Oxford: Clarendon Press, 1967), pp. 276, 287, 319. This is discussed also in Stafford, *Body Criticism*, p. 188.

37. Vischer, *Das optische Formgefühl*, Vischer's doctrine, which is still insufficiently studied, posits *Einfühlung* as one of a series of concepts that describe the relation between felt reality and the mind.

38. C. E. Gauss, "Empathy," *Dictionary of the History of Ideas*, ed. P. P. Wiener (New York, 1973), vol. II, p. 86.

39. Theodor Lipps, *Raumästhetik und geometrisch-optische Täuschungen* (Leipzig: L. Voss, *Psychologie des Schönen und der Kunst*, 1897); and Lipps, *Ästhetik: Psychologie des Schönen und der Kunst*, 2 vols. (Hamburg and Leipzig: Voss, 1903–6). Lipps's text and his categories seem to me to be confused, and I will not be following them here. He posits three levels of empathy: one in which the viewer reacts viscerally to an object (feeling expansive upon entering a large hall, swaying like a tree), a second in which objects elicit intellectual reactions (as when I analyze the hall, and place it in a specific historical period), and a third in which humans elicit specific readings (as in physiognomy and the languages of gesture). See C. E. Gauss, "Empathy," p. 86.

40. In this respect, Picasso's drawing participates in the modernist equation between pictures and puzzles; see Elkins, *Why Are Our Pictures Puzzles? On the Modern Origins of Pictorial Complexity* (New York: Routledge, 1999).

41. Ovid, *Metamorphoses*, trans. Rolfe Humphries (Bloomington: Indiana University Press, 1975), p. 19.

42. Joseph Wood Krutch, "The Colloid and the Crystal," *The Best Nature Writing of Joseph Wood Krutch* (New York: William Morrow, 1969), pp. 309–20. I thank Paul Hinchcliffe for this reference.

43. For Socrates as a virus, see Gregory Vlastos, *Socrates, Ironist and Moral Philosopher* (Ithaca, N.Y.: Cornell University Press, 1991), p. 107.

44. A related classification (into twelve categories) is proposed in William Ewing, *The Body: Photographs of the Human Form* (San Francisco: Chronicle Books, 1994), p. 31, and a less similar taxonomy is used in *L'âme au corps: arts et sciences 1793–1993*, exh. cat., ed. Jean Clair (Paris: Réunion des Musées Nationaux, 1993). The latter distinguishes "le théâtre d'anatomie," "l'homme machine," "l'homme électrique," "le temps de la phrénologie," "évolution et symétrie," "l'homme prosthétique," and "la drogue, les émotions, le rêve."

Chapter 1: Membranes

1. William Carlos Williams, "The Desert Music," in *Pictures from Brueghel and Other Poems by William Carlos Williams* (New York: New Directions Books, 1967), pp. 119–20.

2. It would be possible to extend this parallel to the properties of language, where "oppositional" structures articulate lexemes and other units of meaning. But I am resisting that here in favor of the *visual* parallels between marks and membranes. The oppositionality of language—or rather, the articulations of those oppositions—are abstract conditions of intelligibility instead of visible forms. For the lexicon of marks and *contorni*, see Elkins, "Marks, Traces, *Traits*, Contours, *Orli*, and *Splendores*: Nonsemiotic Elements in Pictures," *Critical Inquiry* 21 (1995): 822–60, expanded in *On Pictures and the Words that Fail Them*, pp. 3–46.

3. Sigmund Freud, *Beyond the Pleasure Principle*, in *Standard Edition*, ed. James Strachey (London: Hogarth Press, 1962), vol. 18, pp. 40–61. Freud is concerned with "germ-cells" (*Keimzeller*) as the originary constituents of life and the remnants of the desire to merge and simplify. For the German term, see *Freud, Gesammelte Werke*, ed. Anna Freud (London: Imago, 1940), vol. 13, p. 63.

4. Gilles Deleuze and Félix Guattari, *A Thousand Plateaus*, trans. Brian Massumi (Minneapolis: University of Minnesota Press, 1987); and see Deleuze and Guattari, *The Anti-Oedipus, Capitalism and Schizophrenia*, trans. Robert Hurley et al. (Minneapolis: University of Minnesota Press, 1983), pp. 9–16.

5. Gilles Deleuze, *Francis Bacon: Logique de la sensation*, 2d ed. (Paris: Editions de la Difference, 1981); and compare the disembodied account in Didier Anzieu, "Douleur et création chez Francis Bacon," in Anzieu and Michèle Monjauze, *Francis Bacon ou le portrait de l'homme désespécé* (Paris: Archimbaud, 1993).

6. *Antoine Wiertz*, ed. Jacques Damase (Brussels: Sonia, 1974); and see Hubert Colleye, *Antoine Weirtz* (Brussels: Renaissance du Livre, 1957).

7. H. G. Macpherson, *Agates* (London: British Museum, 1989), pp. 15–16.

8. *Dr. Albert Haller's Physiology . . . Compiled for the Use of the University of Gottingen*, 2 vols. (London: W. Innys and J. Richardson, 1754), vol. 2, pp. 2, 4.

9. Jean Starobinski, "The Inside and the Outside," *Hudson Review* 28

(1975): 333–51; Angela Zito, "Silk and Skin: Significant Boundaries," in *Body, Subject, and Power in China*, ed. Angela Zito and Tani Barlow (Chicago: University of Chicago Press, 1994), pp. 103–30, especially pp. 113–19.

10. Jean Starobinski, *A History of Medicine*. The New Illustrated Library of Science and Medicine (New York: Hawthorn, 1964), vol. 12.

11. Starobinski, "The Inside and the Outside," p. 343.

12. *Forrest Bess*, exh. cat., with an essay by Meyer Schapiro (New York: Betty Parsons, 1962); *Forrest Bess*, ed. Barbara Haskell, exh. cat. (New York: Whitney Museum of American Art, 1981); John Money and Michael De Priest, "Three Cases of Genital Self-Surgery and Their Relationship to Transsexualism," *Journal of Sex Research* 12, no. 4 (1976): 283–94, especially "case 1," pp. 284–87. Aside from Bess's theories about alchemical immortality, the immediate object of the incision was "to allow a 'host penis' to gain access to the bulbous urethra [*bulbous urethrae*]," a swelling posterior to the penis, in order to effect a "urethral orgasm," p. 284.

13. This couplet is also quoted in two relevant texts: Claude Gandelman, *Reading Pictures, Viewing Texts* (Bloomington: Indiana University Press, 1991), p. 115; and Jonathan Sawday, "The Fate of Marsyas: Dissecting the Renaissance Body," in *Renaissance Bodies: The Human Figure in English Culture, c. 1540–1660*, ed. Lucy Gent and Nigel Llewellyn (London: Reaktion, 1990), p. 111. Translation mine.

14. Anonymous, "A Case of Self-Castration," *British Medical Journal* 2 (1949): 59; for further references, S. E. Cleveland, "Three Cases of Self-Castration," *Journal of Mental and Nervous Diseases* 123 (1956): 386–91.

15. Pierre Boulez, *Pli selon pli, Nr. 2 improvisation I sur Mallarmé, "le vierge, le vivace et le bel aujourd'hui* (London: Universal, 1977).

16. Joseph Nechvatel, "Bio-technology in the Gallery," *Intelligent Agent* 1 (March 1997): 149, 152. For the fragmented body, see Sigrid Schade, "Der Mythos des 'Ganzen Körpers,' Das fragmentarische in der Kunst des 20. Jahrhunderts als Dekonstruktion bürgerlicher Totalitätskonzepte," in *Frauen, Bilder, Männer, Mythen, Kunsthistorische Beiträge*, ed. Isebill Barta et al. (Berlin: Dietrich Reimer, 1987), pp. 239–60.

17. See, for example, *Corporal Politics, Louise Bourgeois, Robert Gober, Lilla LoCurto and William Outcault, Annette Messager, Rona Pondick, Kiki Smith, David Wojnarowicz*, with essays by Donald Hall et al. (Boston: Beacon Press, 1992).

18. James Joyce, *Finnegans Wake* (London: Faber and Faber, 1966 [1939]), pp. 185–86.

19. For a theory of tattoos, see Didier Anzieu, *The Skin Ego*, trans. Chris Turner (New Haven, Conn.: Yale University Press, 1989). Dark Japanese tattoos are illustrated in Dietrich von Engelhardt, *Das Bild auf der menschlichen Haut* (Munich: Heinz Moos, 1972); Donald Richie, *The Japanese Tattoo* (New York: Weatherhilol, 1980); and Michel Thévoz, *The Painted Body: The Illusions of Reality* (New York: Rizzoli, 1984). I thank Kelly Dennis and Anna Friedman for information about tattoos.

20. For an account of the connections between the soul and the marked skin, see Stafford, *Body Criticism*, pp. 315–18.

21. Morris Jastrow, *Hepatoscopy and Astrology in Babylon and Assyria* (Philadelphia, 1909), reprinted from *The Proceedings of the American Philosophical Society* 47, no. 190 (1908): 651 ff. For original texts, see Jastrow, *Religion Babyloniens und Assyriens* (Giessen: A. Topelman, 1905–12), pts. 10–14; and Jastrow, "The Signs and Names for the Liver in Babylonian," *Zeitschrift für Assyriologie* 20: 105–29. Liver divination was also practiced in Greece, among the Etruscans, and in Rome: see further Raymond Bloch, *Divination dans l'antiquité* (Paris: Presses Universitaires de France, 1984), pp. 49–60.

22. Alfred Boissier, *Mantique Babylonienne et mantique Hittite* (Paris: Librairie Orientaliste Paul Geuthner, 1935), p. 15.

23. For the skin diseases, Leviticus 13:29–37 and 40–44. Leprosy is briefly discussed in 13:38–39. The translation follows *The New English Bible* (New York: Oxford University Press, 1970 [1961]).

24. *The Mishnah*, trans. H. Danby (Oxford: Oxford University Press, 1977 [1938]), Neg. 2.1, p. 678, translation modified.

25. *Mishnah*, Neg. 2.4, 14.9, pp. 678, 696.

26. Smallpox is discussed in Stafford, *Body Criticism*, p. 295.

27. See R. J. Friedman et al., "Malignant Melanoma in the 1990's: The Continued Importance of Early Detection and the Role of Physician Examination and Self-Examination of the Skin," *Ca—A Cancer Journal for Clinicians* 41, no. 4 (July–August 1991): 201 ff.

28. For the close match between normative beauty and deviation, see L. Hartmann, *"Capriccio"—Bild und Begriff* (Nuremberg: [s.n.], 1973).

29. G. Tilles, *La Naissance de la dermatologie (1776–1880)* (Paris: R. Dacosta, 1989); and G. Tilles and D. Wallach, "Histoire de la nosologie et dermatologie," *Annales de Dermatologie et de Vénéréologie* 116 (1989): 9–26.

30. Stafford, *Body Criticism*, pp. 23, 408–13, 433. See Albrecht von Haller, *Dissertation on the Sensible and Irritable Parts of Animals*, trans. M. Tissot (London: printed for J. Nourse, 1755), pp. iv–vi; and Robert Whytt, *Physiological Essays Containing an Inquiry into the Causes Which Promote the Circulation of Fluids in the Very Small Vessels of Animals* (Edinburgh: Hamilton, Balfour, and Neill, 1755), pp. 189–90. For a more recent example of related thinking, see L. Brocq, "La diminution de la résistance de la peau," *Annales de Dermatologie et de Syphiligraphie* ser. 5, vol. 5 (1914–15): 529–40.

31. "Longinus," *On Sublimity*, quoting Plato, *Timaeus*, in *Ancient Literary Criticism: The Principal Texts in New Translations*, ed. D. A. Russell and M. Winterbottom (Oxford: Clarendon, 1972), p. 491. See also the epigraph to Chapter 5, this volume.

32. David G. Karel, "The Teaching of Drawing at the French Royal Academy," Ph.D. dissertation, University of Chicago, 1977, unpublished.

33. Robert Whytt, *Essais physiologiques, contenant . . . II. Des observations sur la Sensibilité & sur l'Irritabilité des parties du corps animal* (Paris: Estienne, 1759),

especially pp. 134–38; and see Albrecht von Haller, *Dissertatio inauguralis medica sistens experimenta circa motum cerebri, cerebelli, durae matris et venarum in vivis animalibus instituta* (Göttingen: Schulz, 1753); and Jean Starobinski, "A Short History of Bodily Sensation," *Psychological Medicine* 20 (1990): 23–33, originally "Breve storia della coscienza del corpo," *Intersezioni* 1 (1981): 27–43.

34. S. H. Zaidens, "The Skin: Psychodynamic and Psychopathological Concepts," *Journal of Nervous and Mental Diseases* 113 (1951): 388–94, especially pp. 390 ff.

35. Ibid., p. 391. For a photograph of trichotillomania, see Ch. Féré, "Le Prurit et la trichotillomanie," *Nouvelle Iconographie de la Salpêtrière* 12 (1899): 312–16.

36. J. W. Wilson and H. E. Miller, "Delusions of Parasitosis," *Archives of Dermatology* 54 (1946): 48–49; and G. M. MacKee, "Neurotic Excoriations," *Archives of Dermatology* 1 (1920): 256–57.

37. Julia Kristeva, *Powers of Horror: An Essay on Abjection*, trans. Leon S. Roudiez (New York: Columbia University Press, 1982), especially pp. 92, 101–2.

38. Annette Michelson, "Heterology and the Critique of Instrumental Reason," *October* 36 (1986): 115.

39. For Witkin, see, for example, "Divine Revolt," *Aperture* 100 (1985): 34–41; "Theater of the Forbidden," interview conducted by A. D. Coleman and with panelists Witkin and Duane Michals, *Photo/Design* (January–February 1989): 68 ff. I thank Jeff Chiedo for these references.

40. Pieter Camper, *The Works of the Late Professor Camper: On the Connexion Between the Science of Anatomy and the Arts of Drawing, Painting, Statuary . . .* , ed. T. Coogan (London: J. Hearne, 1821).

41. George Henry Fox, *Photographic Illustrations of Skin Diseases*, 2d ed. (London: E. B. Trent, 1879); Fox, *Photographic Illustrations of Cutaneous Syphilis* (New York: E. B. Trent, 1881). An early journal relevant here is the *Annales de Dermatologie et de Syphiligraphie* (from 1869; continued under other titles).

42. Marie-Jean-Pierre Flourens, "Anatomie générale de la peau et des membranes muqueuses," *Archives de Musée d'Histoire Naturelle* 3 (Paris, 1843). Pl. 24 is reproduced in Pietro Corsi et al., *La Fabrique de la pensée* (Milan: Electa, 1990), 119, cat. no. II, p. 51.

43. See, for example, W. A. D. Anderson, *Synopsis of Pathology* (St. Louis: C. V. Mosby, 1946), p. 212; Friedrich von Recklinghausen, *Ueber die multiplen Fibrome der Haut* (Berlin: A. Hirschwald, 1882).

44. Martin C. Dillon, "Merleau-Ponty and the Reversibility Thesis," in *Merleau-Ponty, Critical Essays*, pp. 80–85.

45. Ashley Montagu, *Touching: The Human Significance of Skin*, 2d ed. (New York: Harper and Row, 1978), reviewed by J. Richie in *Parents Centres Bulletin* 52 (1952): 22.

46. Avrum Stroll, *Surfaces* (Minneapolis: University of Minnesota Press, 1988); and Felice Frankel and George Whitesides, *On the Surface of Things: Im-*

ages of the Extraordinary in Science (San Francisco: Chronicle Books, 1997). The latter is discussed (from a scientific point of view) in Elkins, *Domain of Images* (Ithaca, N.Y.: Cornell University Press, 1999).

47. Cartari, *Imagini delli dei de gl'antichi, Nachdruck der Ausgabe Venedig 1647*, introduction by Walter Koschatzky (Graz: Akademische Druck, 1963), vol. 1, pp. 58–59. Other editions have a different way of visualizing the figure's covering. In some, she looks male (see Cartari, *Neu-eröffneten Götzen-Tempel* [Frankfurt: Ludwig Bourgeat, 1692], pl. 15 and pp. 61–62), and in others she has a thin skinlike wrap down to her waist and then a thicker one like a shawl (Cartari, *Imagines deorum* [Leiden: Stephan Michael, 1581], p. 71; also Cartari, *Le imagini de gli dei de gli antichi* [Venice: Ecengelista Deuchino, 1625], p. 74).

48. For the parergon in this sense, see Jacques Derrida, *The Truth in Painting*, trans. Geoff Bennington (Chicago: University of Chicago Press, 1989). It should be noted that "parergon" was used in art criticism before Derrida or Kant; it denotes a nonessential figure used to ornament a landscape.

49. Kennedy Fraser, "Master of the Flesh," *Vogue* (November 1993): 288–92, 350–56.

50. For associated examples, see Howard Damon, *The Structural Lesions of the Skin* (Philadelphia: Lippincott, 1869).

51. Lindow Man is preserved in the British Museum (no. P.1984 10-2.1). For the topographic map, see Don Brothwell, *The Bog Man and the Archaeology of People* (Cambridge, Mass.: Harvard University Press, 1987), p. 47, Fig. 33. It is interesting to compare the effect when there is no scientific purpose: see Andrew Williams's *Lateral Colour Map of a Full-Term Primapara Produced by Light* (1977), reproduced in Gill Saunders, *The Nude: A New Perspective* (London: Herbert, 1989), p. 134.

52. Carl Darling Buck, *A Dictionary of Selected Synonyms in the Principal Indo-European Languages: A Contribution to the History of Ideas* (Chicago: University of Chicago Press, 1949), section 4.12, pp. 200–1. I have been unable to verify *cneas*; *craiceann* is modern Irish for "skin."

53. Leon Golub, quoted in Michael Newman, "Interview with Leon Golub," in *Leon Golub, Mercenaries and Interrogations* (London: Institute of Contemporary Arts, 1982), p. 5; and see Gerald Marzorati, *A Painter of Darkness: Leon Golub and Our Times* (New York: Penguin, 1990), pp. 83–85; and Gerald Marzorati, "Leon Golub's Mean Streets," *Art News* (February 1985): 74–87, especially p. 83 (on the surface's "vulnerability") and p. 85. I thank Stephanie Skestos for these references.

54. For conservation and technical details, see *Il Tondo Doni di Michelangelo e il suo restauro*, Gli Uffizi, Studi e Ricerche, no. 2 (Florence: Centro Di, 1985).

55. Hermann Rorschach, *Psychodiagnostics*, trans. Paul Lemkau et al. (Bern: Hans Huber, 1942); and see the computer compendium by Carol Bedell Thomas et al., *An Index of Rorschach Responses* (Baltimore: Johns Hopkins University Press, 1964).

especially pp. 134–38; and see Albrecht von Haller, *Dissertatio inauguralis medica sistens experimenta circa motum cerebri, cerebelli, durae matris et venarum in vivis animalibus instituta* (Göttingen: Schulz, 1753); and Jean Starobinski, "A Short History of Bodily Sensation," *Psychological Medicine* 20 (1990): 23–33, originally "Breve storia della coscienza del corpo," *Intersezioni* 1 (1981): 27–43.

34. S. H. Zaidens, "The Skin: Psychodynamic and Psychopathological Concepts," *Journal of Nervous and Mental Diseases* 113 (1951): 388–94, especially pp. 390 ff.

35. Ibid., p. 391. For a photograph of trichotillomania, see Ch. Féré, "Le Prurit et la trichotillomanie," *Nouvelle Iconographie de la Salpêtrière* 12 (1899): 312–16.

36. J. W. Wilson and H. E. Miller, "Delusions of Parasitosis," *Archives of Dermatology* 54 (1946): 48–49; and G. M. MacKee, "Neurotic Excoriations," *Archives of Dermatology* 1 (1920): 256–57.

37. Julia Kristeva, *Powers of Horror: An Essay on Abjection*, trans. Leon S. Roudiez (New York: Columbia University Press, 1982), especially pp. 92, 101–2.

38. Annette Michelson, "Heterology and the Critique of Instrumental Reason," *October* 36 (1986): 115.

39. For Witkin, see, for example, "Divine Revolt," *Aperture* 100 (1985): 34–41; "Theater of the Forbidden," interview conducted by A. D. Coleman and with panelists Witkin and Duane Michals, *Photo/Design* (January–February 1989): 68 ff. I thank Jeff Chiedo for these references.

40. Pieter Camper, *The Works of the Late Professor Camper: On the Connexion Between the Science of Anatomy and the Arts of Drawing, Painting, Statuary . . .* , ed. T. Coogan (London: J. Hearne, 1821).

41. George Henry Fox, *Photographic Illustrations of Skin Diseases*, 2d ed. (London: E. B. Trent, 1879); Fox, *Photographic Illustrations of Cutaneous Syphilis* (New York: E. B. Trent, 1881). An early journal relevant here is the *Annales de Dermatologie et de Syphiligraphie* (from 1869; continued under other titles).

42. Marie-Jean-Pierre Flourens, "Anatomie générale de la peau et des membranes muqueuses," *Archives de Musée d'Histoire Naturelle* 3 (Paris, 1843). Pl. 24 is reproduced in Pietro Corsi et al., *La Fabrique de la pensée* (Milan: Electa, 1990), 119, cat. no. II, p. 51.

43. See, for example, W. A. D. Anderson, *Synopsis of Pathology* (St. Louis: C. V. Mosby, 1946), p. 212; Friedrich von Recklinghausen, *Ueber die multiplen Fibrome der Haut* (Berlin: A. Hirschwald, 1882).

44. Martin C. Dillon, "Merleau-Ponty and the Reversibility Thesis," in *Merleau-Ponty, Critical Essays*, pp. 80–85.

45. Ashley Montagu, *Touching: The Human Significance of Skin*, 2d ed. (New York: Harper and Row, 1978), reviewed by J. Richie in *Parents Centres Bulletin* 52 (1952): 22.

46. Avrum Stroll, *Surfaces* (Minneapolis: University of Minnesota Press, 1988); and Felice Frankel and George Whitesides, *On the Surface of Things: Im-*

ages of the Extraordinary in Science (San Francisco: Chronicle Books, 1997). The latter is discussed (from a scientific point of view) in Elkins, *Domain of Images* (Ithaca, N.Y.: Cornell University Press, 1999).

47. Cartari, *Imagini delli dei de gl'antichi, Nachdruck der Ausgabe Venedig 1647*, introduction by Walter Koschatzky (Graz: Akademische Druck, 1963), vol. 1, pp. 58–59. Other editions have a different way of visualizing the figure's covering. In some, she looks male (see Cartari, *Neu-eröffneten Götzen-Tempel* [Frankfurt: Ludwig Bourgeat, 1692], pl. 15 and pp. 61–62), and in others she has a thin skinlike wrap down to her waist and then a thicker one like a shawl (Cartari, *Imagines deorum* [Leiden: Stephan Michael, 1581], p. 71; also Cartari, *Le imagini de gli dei de gli antichi* [Venice: Ecengelista Deuchino, 1625], p. 74).

48. For the parergon in this sense, see Jacques Derrida, *The Truth in Painting*, trans. Geoff Bennington (Chicago: University of Chicago Press, 1989). It should be noted that "parergon" was used in art criticism before Derrida or Kant; it denotes a nonessential figure used to ornament a landscape.

49. Kennedy Fraser, "Master of the Flesh," *Vogue* (November 1993): 288–92, 350–56.

50. For associated examples, see Howard Damon, *The Structural Lesions of the Skin* (Philadelphia: Lippincott, 1869).

51. Lindow Man is preserved in the British Museum (no. P.1984 10-2.1). For the topographic map, see Don Brothwell, *The Bog Man and the Archaeology of People* (Cambridge, Mass.: Harvard University Press, 1987), p. 47, Fig. 33. It is interesting to compare the effect when there is no scientific purpose: see Andrew Williams's *Lateral Colour Map of a Full-Term Primapara Produced by Light* (1977), reproduced in Gill Saunders, *The Nude: A New Perspective* (London: Herbert, 1989), p. 134.

52. Carl Darling Buck, *A Dictionary of Selected Synonyms in the Principal Indo-European Languages: A Contribution to the History of Ideas* (Chicago: University of Chicago Press, 1949), section 4.12, pp. 200–1. I have been unable to verify *cneas*; *craiceann* is modern Irish for "skin."

53. Leon Golub, quoted in Michael Newman, "Interview with Leon Golub," in *Leon Golub, Mercenaries and Interrogations* (London: Institute of Contemporary Arts, 1982), p. 5; and see Gerald Marzorati, *A Painter of Darkness: Leon Golub and Our Times* (New York: Penguin, 1990), pp. 83–85; and Gerald Marzorati, "Leon Golub's Mean Streets," *Art News* (February 1985): 74–87, especially p. 83 (on the surface's "vulnerability") and p. 85. I thank Stephanie Skestos for these references.

54. For conservation and technical details, see *Il Tondo Doni di Michelangelo e il suo restauro*, Gli Uffizi, Studi e Ricerche, no. 2 (Florence: Centro Di, 1985).

55. Hermann Rorschach, *Psychodiagnostics*, trans. Paul Lemkau et al. (Bern: Hans Huber, 1942); and see the computer compendium by Carol Bedell Thomas et al., *An Index of Rorschach Responses* (Baltimore: Johns Hopkins University Press, 1964).

56. See Leatrice Mendelsohn, "L'Allegorio d'Londra del Bronzino e la retorica di carnevale," in *Kunst des Cinquecento in der Toskana*, ed. Monika Cämmerer, Kunsthistorisches Instituts in Florenz, Italienische Forschungen, vol. 17 (Munich: Bruckmann, 1992), pp. 152–67.

57. These are not unusual characteristics of Pontormo's late work. Other drawings depict figures with even more radically stunted appendages, and some with missing limbs. They are also not entirely a function of the degree of finish of this particular drawing, since the *disegni finiti* for Eve have similarly atrophied thighs. A *primo pensiero* for the *Resurrection*, Cox-Rearick cat. 377, contains a figure with such radically shriveled legs that it takes on the appearance of an animal (lower center of the sheet). Ends of limbs are often simplified or missing in the marginal sketches in the diary. See Janet Cox-Rearick, *The Drawings of Pontormo*, 2 vols. (Cambridge, Mass.: Harvard University Press, 1964), cat. 358; and compare *Pontormo Drawings*, ed. Salvatore S. Nigro (New York: Harry N. Abrams, 1991).

58. This drawing owes a great deal to Michelangelo's *Last Judgment* and probably also his *Venus and Cupid* cartoon, which was entrusted to Pontormo. See further Larry Feinberg, "Florentine Draftsmanship under the First Medici Grand Dukes," in *From Studio to Studiolo* (Seattle: University of Washington Press, 1991), p. 13.

59. Compare for example Frederick Hartt, *Michelangelo Drawings* (New York, n.d.), Hartt cat. 379, bottom; and J. Cox-Rearick, *Drawings of Pontormo*, cat. 295.

60. For Grünewald's drawing, see Lottlise Behling, *Die Handzeichnungen . . . Grünewalds* (Weimar: H. Böhlaus, 1955); and Eberhard Ruhmer, *Grünewald Drawings, Complete Edition* (London: Phaidon, 1970).

61. The remainder of the drawing is held in the Staatliche Kunstsammlung, Dresden, and discussed in Elkins, *The Object Stares Back*, pp. 138–39, Fig. 31.

62. See Eva-Maria Schön's analytic *Tuschzeichnungen*, in *Körper-Belichtungen/Body Exposures*, ed. Katharina Sykora (Zürich: Lars Müller, 1993), p. 31; and for Yves Trémorin, see William Ewing, *The Body: Photographs of the Human Form* (San Francisco: Chronicle Books, 1994).

Chapter 2: Psychomachia

1. Katherine Melvina Huntsinger Blackford and Arthur Newcomb, *The Job, the Man, the Boss* (Garden City, N.Y.: Doubleday, Page, 1914), quoted in William Armand Lessa, *Landmarks in the Study of Human Types* (New York: Brooklyn College Press, 1942), p. 141.

2. This table is adapted from Lessa, *Landmarks*, table I, pp. iv–vi. Semiotics in art history is reviewed in Elkins, *On Pictures and the Words that Fail Them*.

3. The principal source is Girolamo Cardano, *Metoscopia* (Paris: T. Jolly, 1658 [1558]); see also Giovan Battista Della Porta, *Metoposcopia*, ed. Giovanni

Aquilecchia (Naples: Istituto Suor Orsola Benincasa, 1990); Ciro Spontone, *La metoposcopia* (Venice: Presso G. Imberti, 1651); Philip Phinella, *De metoposcopia* (Antwerp, 1648). For plates, see Kurt Seligman, *The Mirror of Magic* (New York: Pantheon, 1948), Figs. 176–95; a plate from a seventeenth-century manuscript on "mesoposcopy" is reproduced in Patrizia Magli, "The Face and the Soul," trans. Ughetta Lubin, in *Fragments for a History of the Human Body*, vol. 2, p. 112. For keiromancy, see John Rothmanne, *Keiromantia: Or the Art of Divining by the Lines and Signatures Engraven in the Hand of Man, by the Hand of Nature* (London: printed for Nathaniel Brooke, 1652).

4. Moshe Barash, *Giotto and the Language of Gesture* (New York: Cambridge University Press, 1987); Michael Baxandall, *Painting and Experience in Fifteenth-Century Italy* (London: Oxford University Press, 1974); and *Die Beredsamkeit der Liebes, Zur Körpersprache in der Kunst*, ed. Ilsebill Barta Fliedl and Christoph Giessmar, *Veröffentlichung der Albertina*, no. 31 (Salzburg: Residenz Verlag, 1992).

5. See the wonderful analysis of fingerprints in *The Science of Fingerprints: Classification and Uses*, printed for the U.S. Department of Justice, Federal Bureau of Investigation (Washington, D.C.: U.S. Government Printing Office, 1984), which includes instructions for taking fingerprints from dead and decaying hands. Palm prints are mentioned last; see pp. 207–11. The book is summarized in Elkins, *How to Use Your Eyes* (New York: Routledge, forthcoming).

6. Hippocrates, *The Genuine Works of Hippocrates*, trans. Francis Adams (London: Sydenham Society, 1849); Rudolph E. Siegel, *Galen on Psychology, Psychopathology, and Function and Diseases of the Nervous System* (Basel: Karger, 1973); and *Galen on the Passions and Errors of the Soul*, trans. Paul W. Harkins (Columbus: Ohio State University Press, 1963); Avicenna, *A Treatise on the Canon of Medicine of Avicenna*, trans. O. Cameron Gruner (London: Luzac, 1930); Daniel Sennert, *The Institutions, or Fundamentals of the Whole Art*, trans. N. D. B. P. (London: Lodowick Boyd, 1656); Lazaro Rivière, *Opera medica universa. Editio novissima; cui praeter Jacobi Grandii* (Geneva: De Tournes, 1737); T. Laycock, "Clinical Lectures on the Physiognomic Diagnosis of Disease," *Medical Times and Gazette* 1 (1862): 1–3, 51–54, 101–3, 151–54, 185, 205–8, 287–89, 341–44, 449–51, 499–502, 551–54, 635–37.

7. Antonius Polemo (c. A.D. 88–145), *Physiognomics*, in *Scriptores Physiognomici Graeci et Latini*, ed. Richard Förster (Leipzig: B. G. Teubner, 1893); Adamantius (fourth century A.D.), *Physiognomics*, in ibid.; Giovan Battista Della Porta, *De humana physiognomonia libri III* (Vici Aequensis, 1586); Cesare Lombroso, *L'Uomo deliquente* (Torino: Fratelli Bocca, 1896–97); Bénédict Auguste Morel, *Traité des dégénérescences physiques, intellectuelles et morales de l'espèce humaine* (Paris: J. B. Baillière, 1857).

8. Franz Joseph Gall, *Anatomie und Physiologie du système nerveux en général, et du cerveau en particulier* (Paris: F. Schoell, 1810–19); Johann Gaspar Spurzheim, *Phrenology*, 3d American ed. (Boston: Marsh, Capeu, and Lyon, 1834); George Combe, *Phrenology Applied to Painting and Sculpture* (London: Simpkin,

Marshall, 1855); Orson Squire and Lorenzo Niles Fowler, *Phrenology Proved, Illustrated, and Applied* (New York: Fowler and Wells, 1836).

9. Pierre Jean Georges Cabanis, *Rapports du physique et du moral de l'homme*, 2 vols. (Paris: Crapart, Caille et Ravier, 1802); F. T. De Troisvèvre, *Division naturelle des tempéraments, tirée de la functionomie* (Paris, 1821); Léon Rostan, *Traité élémentaire de diagnostic* (Brussels: H. Dumont, 1832); A. Chaillou, "Considérations générales sur quatre types morphologiques humains," *Bulletin et Mém. Société d'Anthropologie de Paris* ser. 6, vol. 1 (1910): 141–50; A. Chaillou and L. Macauliffe, "Le type musculaire," *Bulletin et Mém. Société d'Anthropologie de Paris* ser. 6, vol. 1 (1910): 201–24.

10. Adriaan van de Spiegel, *De humani corporis fabrica* (Venice: Evangelistam Deuchinum, 1627); Sir Frederick Treves, *The Anatomy of the Intestinal Canal and Peritoneum in Man* (London: H. K. Lewis, 1885); Carl Huter, *Menschenkenntnis, durch Körper-, Lebens-, Seelen- und Gesichts- Ausdruckskunde* (Nuremberg: Kupfer, 1957), written 1904–6; W. W. Graves, "The Clinical Recognition of the Scapohoid Type of Scapula and Some of Its Correlations," *Journal of the American Medical Association* 55 (July 2, 1910): 2–17; Graves, "The Age-Incidence Principle of Investigation in Evaluating the Biological Significance of Inherited Variations in the Problems of Human Constitution," *American Journal of Psychiatry* 93 (1937): 1109–17; Friedrich Wilhelm Beneke, *Die anatomischen Grundlagen der Constutionsanomalieen des Menschen* (Marburg: Elwert, 1878); Beneke, *Altersdisposition* (Marburg: N. G. Elwert, 1879); Beneke, *Constitution und constitutionelles Krankheitsein des Menschen* (Marburg: Elwert, 1881); R. B. Bean, "Morbidity and Morphology," *Bulletin of Johns Hopkins Hospital* 23 (1912): 363–70; Bean, "Two European Types," *American Journal of Anatomy* 31 (1923): 359–72; Bean, "Three Anatomic Types of Africa," *American Journal of Anatomy* 33 (1924): 105–18; Bean, "Types of the Three Great Races of Man," *American Journal of Anatomy* 37 (1926): 237–71; and also *Quarterly Review of Biology* 1 (1926): 360–92; L. T. Swaim, "Thirty-Nine Cases as Regards Intestinal Length and Nutrition," *Boston Medical and S. Journal* 167 (1912): 249–52.

11. P. Näcke, "Die sogen 'äusseren' Degenerationszeichen bei der progressiven Paralye der Männer, nebst einigen diese Krankheit betreffenden Punkton," *Zeitschrift für die gesamte Neurologie und Psychiatrie* 55 (1899): 557–693; Julius Bauer, *Die konstitutionelle Disposition zu inneren Krankheiten* (Berlin: Springer, 1917); Ernst Kretschmer, *Körperbau und Charakter* (Berlin: J. Springer, 1926 [1921]), trans. W. J. H. Sprott as *Physique and Character* (London: K. Paul, Trench, Trubner, 1925). For citations of Sheldon, see Chap. 4, nn. 31, 32, 35, this volume.

12. Georg Christoph Lichtenberg, *Über Physiognomik, wider die Physiognomen* (Waldshut-Tiengen: Aerni, 1996), William Armand Lessa, "An Appraisal of Constitutional Typologies," M.A. thesis, University of Chicago, n.d., unpublished; W. B. Tucker and W. A. Lessa, "Man: A Constitutional Investigation," *Quarterly Review of Biology* 15 (1940): 265–89, 411–55; R. Burger-

Villingen and Walter Nöthling, *Das Geheimnis der Menschenform, Lehrbuch der Menschenkenntnis auf Grund der Anlagenfeststellung* (Wuppertal: Barger-Verlag, 1958). For Lichtenberg as the first to insist that "all members were energetic and 'spoke,'" see Stafford, *Body Criticism*, p. 126.

13. Deleuze and Guattari, *A Thousand Plateaus*; and Deleuze and Guattari, *The Anti-Oedipus*, trans. Robert Hurley et al. (Minneapolis: University of Minnesota Press, 1983). For the concept of the face in China, see Angela Zito, "Silk and Skin," pp. 119–20. The concept of the face in general is explored in Elkins, *The Object Stares Back*, Chap. 5.

14. Hans Dieter Junker, "Picassos Kunsthändlerporträts von 1910," in *"Was sind wir Menschen doch! . . . " Menschen im Bild. Analysen, Hermann Hinkel zum 60. Geburtstag*, ed. Dietrich Grünewald (Weimar: Verlag und Datenbank für Geisteswissenschaften, 1995), pp. 41–50.

15. Rudolf Wittkower, *Gian Lorenzo Bernini*, 3d ed. (Oxford: Oxford University Press, 1981), p. 7.

16. See Moshe Barash, "The Tragic Face: The Classical Mask of the Tragic Hero, and Expression of Character and Emotion in Renaissance Art," and "'Pathos Formulae': Some Reflections on the Structure of a Concept," *Imago Hominis, Studies in the Language of Art*, Bibliotheca Artibus et Historiae (Vienna: IRSA, 1991), pp. 59–77 and 119–27, respectively.

17. Simon Richter, *Laocöon's Body and the Aesthetics of Pain: Winckelmann, Lessing, Herder, Moritz, Goethe* (Detroit, Mich.: Wayne State University Press, 1992).

18. Johann Caspar Lavater, *Essays on Physiognomy*, ed. Thomas Holloway, trans. Henry Hunter (London: John Murray, 1792). *The Faces of Physiognomy: Interdisciplinary Approaches to Johann Caspar Lavater*, ed. Ellis Shookman (Columbia, S.C.: Camden House, 1983); Flavio Caroli, *Storia della Fisiognomica: Arte e psicologia da Leonardo a Freud* (Milan: Arnoldo Mondadori, 1995); and Norbert Borrmann, *Kunst und Physiognomik: Menschendeutung und Menschendarstellung im Abendland* (Cologne: DuMont, 1994), are helpful studies. For the history of reception, see John Graham, *Lavater's Essays on Physiognomy, A Study in the History of Ideas*, European University Studies, ser. 18, Comparative Literature, vol. 18 (Berne: Peter Lang, 1979).

19. Lavater, *Essays on Physiognomy*, vol. 2, p. 126. The hippopotamus comes in for an even harsher attack in the unabridged original: "Die entsetzliche gleichfortgehende Breite der Stirn und Nase—oder vielmehr der Nasenlöcher und des Mauls—welch ein Ausdruck von dummwilder Unerbittlichkeit—und dann die Unregelmäßigkeit in der Positur und Figur der Zähne—welch eigentlicher Charakter, teuflischer doch planloser, sich selbst zerstörender Bosheit!" Lavater, *Physiognomische Fragmente* (Leipzig: Weidmanns Erben und Reich, 1777), vol. 3, p. 76.

20. Lavater, quoted by Lessa, *Landmarks in the Science of Human Types*, p. 6.

21. On caricature, see E. H. Gombrich, *Caricature* (Harmondsworth, Middlesex, Eng.: Penguin Books, 1941); Devin Burnell, "Art and Ambiguity: The

Aesthetics of Caricature Considered in Relation to Nineteenth Century Ro-
manticism and to the Work of Daumier," Ph.D. dissertation, University of
Chicago, 1976, unpublished; and Maren Gröning, "Groteske Kopfe," in *Die
Beredsamkeit des Leibes: Zur Körpersprache in der Kunst*, ed. Ilsebill Barta Fliedl
and Christoph Geissmar, *Veröffentlichung der Albertina*, no. 31 (Salzburg: Resi-
denz Verlag, 1992), pp. 100–112.

22. L. A. Vaught, *Vaught's Practical Character Reader*, rev. ed., with a preface
by Emily Vaught (Chicago: Vaught-Rocind, 1902), pp. 171–72.

23. Honoré-Gabriel-Victor de Riquetti, Comte de Mirabeau, *Lettre du
comte de Mirabeau à M . . . sur M. M. Cagliostro et Lavater* (Berlin, 1786),
quoted in J. Baltrusaitis, *Aberrations, An Essay on the Legend of Forms*, trans.
Richard Miller (Cambridge, Mass.: MIT Press, 1989), p. 49.

24. This is argued, partly following E. H. Gombrich, in Elkins, "Style,"
The Dictionary of Art (New York: Grove Dictionaries, 1996).

25. Stafford, "'Peculiar Marks': Lavater and the Countenance of Blem-
ished Thought," *Art Journal* 46 (1987): 185–92.

26. For Lavater on noses, see Eleonora Louis, "Der beredte Leib, bilder aus
der Sammlung Lavater," in *Die Beredsamkeit des Leibes*, pp. 113–55, especially
p. 134.

27. R. Burger-Villingen and Walter Nöthling, *Das Geheimnis der Men-
schenform, Lehrbuch der Menschenkenntnis auf Grund der Anlagenfeststellung* (Wup-
pertal: Barger-Verlag, 1958), pp. 272–73. See also Harold M. Holden, *Noses*
(Cleveland and New York: World Publishing Company, 1950).

28. Pierre Klossowski, *La Rassemblance* (Paris: Ryôan-ji, 1984).

29. Lavater, *Essays on Physiognomy*, vol. 2, p. 85.

30. Ibid., vol. 1, p. 184. For the connection between this problem and signs
"incapable of being misunderstood," see Stafford, *Body Criticism*, pp. 92–93.

31. See, for example, Philippe Sorel, "Le phrénologie et l'art," in *L'âme au
corps: arts et sciences 1793–1993*, exh. cat., ed. Jean Clair (Paris: Réunion des
Musées Nationaux, 1993), pp. 266–79.

32. Georg Christoph Lichtenberg, *Über Physiognomik, wider die Physiognomen*.

33. Philipp Lersch, *Gesicht und Seele, Grundlinien einer mimischen Diagnos-
tik*, 3d ed. (Munich: E. Reinhardt, 1951 [1932]).

34. See also H. Lamy, "Note sur les contractions «synergiques paradoxales»
observées à la suite de la paralysie faciale périphérique," *Nouvelle Iconographie
de la Salpêtrière* 18 (1905): 424–25.

35. L. J. Friedman, "Occulta Cordis," *Romance Philology* 11 (1957–58):
103–19; C. Guillén, p. 306. "Psychophysical" comes from L. Spitzer, "Le vers
834 du Roland," *Romania* 68 (1944–45): 471–77.

36. Claudio Guillén, "On the Concept and Metaphor of Perspective," in
Literature as System, Essays Toward the Theory of Literary History (Princeton, N.J.:
Princeton University Press, 1971), pp. 306–7.

37. Two principal sources are John Pope-Hennessey, *The Study and Criti-
cism of Italian Sculpture* (New York: Metropolitan Museum of Art, 1980); and

David Summers, "Contrapposto: Style and Meaning in Renaissance Art," *The Art Bulletin* 59 (1977): 336–61.

38. Sidra Stich, *Yves Klein*, exh. cat. (Cologne: Ludwig Museum, 1995), especially "Anthropometries," pp. 171–91; for Johns's "Studies for Skin" (1962) see *Jasper Johns: A Retrospective*, ed. Kirk Varnedoe, with an essay by Roberta Bernstein (New York: Museum of Modern Art, 1996), pp. 23–24, pl. 91; I thank Roberta Bernstein for bringing Johns's impressions to my attention.

39. For the Mandylion and related images, see Hans Belting, *Likeness and Presence: A History of the Image before the Era of Art*, trans. Edmund Jephcott (Chicago: University of Chicago Press, 1994), pp. 208–24. Recent artists who have made body prints include Günter Brus and Doug Prince. For Prince, see William Ewing, *The Body: Photographs of the Human Form* (San Francisco: Chronicle Books, 1994), pp. 370–71; and for Brus in relation to Klein and others, see Silvia Eiblmayr, *Die Frau als Bild: Der weibliche Körper in der Kunst des 20. Jahrhunderts* (Frankfurt am Main: Reimer, 1993), especially "Von der symbolischen Bildzerstörung bis zur aktionistischen Inszenierung des Körpers als Bild: Masson, Fontana, Wiener Aktionismus (Brus)", pp. 97–105. Body impressions are also discussed in *Frauen Körper Kunst*, exh. cat., Frankfurt am Main, Hochschule für Musik und Darstellende Kunst, ed. Martina Peter-Bolaender (Kassel: Furore, 1994).

40. Leon Battista Alberti, *De pictura*, ed. Cecil Grayson (Bari: Laterza, 1980).

41. D. Summers, "Contrapposto," p. 341.

42. Giovanni Paolo Lomazzo, *Idea del tempio nella pittura* (Milan: Paolo Gottardo Pontio, 1590).

43. "Flexus ille et, ut sic dixerim, motus . . . ," Quintilian, *Institutio oratoria* II.xiii.9, translation quoted from *The Institutio oratoria of Quintilian*, trans. H. W. Butler (London: William Heinemann, 1963), p. 293.

44. Lomazzo, *Trattato dell'Arte della Pittura* (Milan, 1584), pp. 22–24.

45. K. Birch-Hirschfeld, *Die Lehre von der Malerei in Cinquecento* (Rome, 1912), pp. 36–43, and John Shearman, *Mannerism* (Baltimore, 1967), pp. 81–91, both cited in David Summers, "Maniera and Movement: The Figura Serpentinata," *Art Quarterly* 35 (1972): 269–71; and for the passage in Lomazzo, see ibid., pp. 271–72.

46. Lomazzo, *L'Idea*, book VI, Chap. 4.

47. The term is attributed to Michelangelo, and Lomazzo may have gotten it via Marco Pino, who was in Rome in the late 1540s, "precisely the years when Michelangelo was most concerned with writing a treatise on human anatomy and movement." See D. Summers, "Contrapposto," p. 284.

48. In Elkins, *On Pictures and the Words That Fail Them*, this sequence is analyzed from a different point of view, one that would ultimately undermine the iconographic reading I assay here. In that book, the point of the analysis is that in these drawings, iconographic and narrative readings—that is, the usual readings—fail in an exemplary way, because the marks refuse to sort themselves out into discrete meaningful stages. But just as *On Pictures and the Words*

That Fail Them is not intended as a purely antisemiotic or antinarrative polemic, so the sequence of permissible crucified figures I sketch here would have underlain Michelangelo's project, even when he was least concerned with identifiable poses and most enmeshed in the project of envisioning sacrifice.

49. *Francis Bacon Interviewed by David Sylvester* (New York: Pantheon, 1975), p. 14.

50. Ilaria Bignamini and Martin Postle, *The Artist's Model, Its Role in British Art from Lely to Etty* (Nottingham: University Art Gallery, 1991), cat. 91, pp. 96–97 (the quotation is on p. 97); and see Julius Bryant, "Thomas Banks's Anatomical Crucifixion," *Apollo* 133 (June 1991): 409–11.

51. See Gertrud Schiller, *Iconography of Christian Art*, trans. Janet Seligman (London: Lund Humphries, 1972), vol. 2, cat. 321–34, and Moshe Barash, "The Frontal Icon: A Genre in Christian Art," *Imago Hominis, Studies in the Language of Art*, Bibliotheca Artibus et Historiae (Vienna: IRSA, 1991), pp. 20–35. Further sources include Engelbert Kirschbaum, *Lexikon der christlichen Ikonographie* (Rome: Herder, 1994), vol. 2, pp. 606b–642b; Karl Künstle, *Ikonographie der christlichen Kunst* (Freiburg im Breisgau: Herder, 1928), vol. 1, pp. 446–76; Margit Lisner, *Holzkruzifixe in Florenz und in der Toskanea von der Zeit um 1390 bis zum frühen Cinquecento* (Munich: Bruckmann, 1970); Louis Réau, *Iconographie de l'art chrétien* (Paris: Press Universitaires de France, 1955–59), vol. 2, pp. 475–503; Paul Thoby, *Le Crucifix des origines au Concile de Trente, Étude iconographique*, 2 vols. (Nantes: Bellanger, 1959–61).

52. Schiller, cat. 338.

53. Ibid., cat. 442, 443.

54. Ibid., cat. 413.

55. Ibid., cat. 337, 341–43, 447, 455.

56. Ibid., cat. 502.

57. See Mantegna's *Crucifixion* (1457–59) in the Louvre, and for a Northern example Tilman Riemenschneider's *Crucifixion* (1510–13) in Rothenburg.

58. Schiller, *Iconography*, cat. 503; and see also the analyses of similar positions in Evelyn Sandberg Vavala, *La croce dipinta italiana* (Verona: Casa Editrice Apollo, 1929).

59. For the C-arc, see also Tolnay 418, second state. It was copied in an especially detailed ivory; see M. Auclais, *Images du Christ* (Paris, n.d.), p. 108. For other examples, see also the initial outlines—the first states—of Tolnay 418 and 416r, as well as T415, T417, and T419.

60. Moshe Barash, "Character and Physiognomy: Bocchi on Donatello's *St. George*, A Renaissance Text on Expression in Art," in *Imago Hominis, Studies in the Language of Art*, Bibliotheca Artibus et Historiae (Vienna: IRSA, 1991), pp. 36–46.

61. Leo Steinberg, *The Sexuality of Christ in Renaissance Art and in Modern Oblivion* (New York: Pantheon, 1989); David Summers, "Maniera and Movement."

62. Richard Broxton Onians, *The Origins of European Thought about the Body, the Mind, the Soul, the World, Time, and Fate* (Cambridge, Eng.: Cambridge University Press, 1988 [1951]), pp. 426 ff.

63. *Iliad* XVI, p. 502 f.

64. Onians, *Origins of European Thought*, p. 427.

65. For eighteenth-century texts on bandages, see Johann Gottlob Bern-stein, *Systematische Darstellung des chirurgischen Verbandes, sowohl älterer als neuerer Zeiten*, 2 vols. (Jena: Akademischen Buchhandlung, 1798); Joseph Marie Achille Goffres, *Précis iconographique de bandages, pansements et appareils* (Paris: Baillière, 1866); and Jean Baptiste Jacques Thillaye, *Traité des bandages et appareils*, 3d ed. (Paris: Crochard, 1815). A good modern history is William Bishop, *A History of Surgical Dressings* (Chesterfield, Eng.: Robinson, 1959).

66. See the attack in F. Moser, *Der Okkultismus, Täuschungen und Tatsachen*, 2 vols. (Munich, 1935), vol. 2, pp. 832 ff; and the defense in Everard Feilding, *Sittings with Eusapia Palladino and Other Studies* (New Hyde, N.Y.: University Books, 1963); also Hereward Carrington, *Eusapia Palladino and Her Phenomena* (New York: B. W. Dodge & Co., 1909).

67. This is from Paolo Pino, quoted in D. Summers, "Contrapposto," p. 278. See "Paolo Pino's *Dialogo di Pittura*," trans. Mary Pardo, Ph.D. dissertation, University of Pittsburg, 1984 (Ann Arbor, Mich.: U.M.I. Dissertation Services, 1994).

68. See Titian's *Last Supper* in the Escorial, illustrated in Harold Wethey, *The Paintings of Titian*, vol. 1, *The Religious Paintings* (London: Phaidon, 1969), pl. 117, and compare 229.

69. For postures in Neolithic graves, see L. V. Grinsell, *Barrow, Pyramid, and Tomb, Ancient Burial Customs in Egypt, the Mediterranean and the British Isles* (London: Thames and Hudson, 1975), pp. 17–23. For asanas, see Gavin Flood, *Body and Cosmology in Kashmir Saivism* (San Francisco: Mellen Research University Press, 1993). Classical Indian dance postures are classified in the *Viṣṇudharmottara Purāṇa*, ed. Priyabala Shah (Baroda: Oriental Institute, 1958).

70. For (human) fetal positions, see Karen Newman, *Fetal Positions: Individualism, Science, Visuality* (Stanford: Stanford University Press, 1996).

71. The best discussions of surrealist distortions are in Rosalind Krauss, *L'Amour Fou: Photography and Surrealism*, with an essay by Dawn Ades (Washington, D.C.: Corcoran Gallery of Art, 1985). I illustrate the "boneless body" from a comic book to show how surrealist strategies diffused into popular culture, losing their sexual edge while they gained in topological freedom. (I take it the two have an inverse relationship: sexual readings are most clearly articulated when the represented body remains close to its possible shapes.)

Chapter 3: Cut Flesh

1. Ovid, *Metamorphoses* 6: 385–90, trans. Rolfe Humphries (Bloomington: Indiana University Press, 1973), p. 141, line breaks omitted.

2. The authorized version renders the verse as "my skin is broken." *The New English Bible* renders "My body is infested with worms, / and scabs cover my skin," and adds, in a footnote, "it is cracked and discharging." See *New En-*

glish Bible (New York: Oxford University Press and Cambridge University Press, 1970), Job 7:5 n.

3. Francisco Gómez de Quevedo y Villegas, *The Works of . . . Quevedo* (Edinburgh: Mundell and Son, 1798), vol. 1, p. 35, quoted in Elizabeth du Gué Trapier, *Valdés Leal, [The] Baroque Concept of Death and Suffering in His Paintings* (New York: Hispanic Society of America, 1956), p. 31, translation modified.

4. For the Philippine practice, see Jeffrey Mishlove, *The Roots of Consciousness* (New York: Random House, 1975), pp. 150–51 and pl. 9.

5. *Beowulf* 1122. *Bengeat* is usually translated as "wound door," "wound gate," or "wound offering." See, for example, *Beowulf, An Anglo-Saxon Poem*, with a glossary by M. Heyne, ed. James Harrison (Boston: Ginn, Heath, and Company, 1883), *s.v. ben-geat*. But see *Beowulf, A Dual-Language Edition*, trans. Howell D. Chickering Jr. (New York: Anchor, 1977), p. 113: "Their heads melted, / their gashes spread open, the blood shot out / of the body's feud-bites."

6. See Reginald Campbell Thompson, *The Devils and Evil Spirits of Babylonia* (New York: AMS Press, 1976 [1904]).

7. Graham Webster, "Labyrinths and Mazes," in *In Search of Cult*, ed. Martin Carver (Woodbridge, Suffolk: Boydell Press, 1993), p. 23, citing D. Kilmer, "Sumerian and Akkadian Names for Design and Geometric Shapes," in *Investigating Artistic Environments in the Ancient Near East*, ed. A. C. Gunter (Washington, D.C.: Smithsonian Institution, 1900), p. 84 and Fig. 1.

8. See *The Epic of Gilgamesh*, trans. Maureen Gallery Kovaks (Stanford: Stanford University Press, 1985), Tablet V, p. 42.

9. See W. G. Lambert, "Gilgamesh in Literature and Art: The Second and First Millennia," in Ann Farkas et al., eds., *Monsters and Demons in the Ancient and Medieval Worlds* (Mainz: P. von Zabern, 1987), pp. 37–52; and Dominique Collon, *First Impressions* (Chicago: University of Chicago Press, 1988), pp. 178 ff.

10. Mary Miller and Karl Taube, *The Gods and Symbols of Ancient Mexico and the Maya* (London: Thames and Hudson, 1993), p. 188.

11. For Picasso's drawings, see Christian Zervos, *Pablo Picasso*, vol. 8 (1932–37) (Paris: Cahiers d'art, 1957), nos. 49 and 50. Picasso also made more curvilinear paintings of the crucifixion: see ibid., vol. 7 (1926–32) (Paris: Cahiers d'art, 1955), nos. 287, 315, and 316, painted in 1930–31.

12. Freud, "Medusa's Head," *Standard Edition*, ed. James Strachey (London: Hogarth Press, 1962), vol. 18, pp. 273–74. In "Infantile Genital Organization," ibid., vol. 19, p. 144, Freud credits the idea to Ferenczi.

13. Early plastic surgery texts are relevant here; see, for example, Joseph Constantine Carpue, *An Account of Two Successful Operations for Restoring a Lost Nose* (London: Longman, Hurst, Rees, Orme, and Brown, 1816); and Carl Ferdinand von Graefe, *Rhinoplastik* (Berlin: Realschulbuchhandlung, 1818). For a modern work, see *The Healing of Surgical Wounds, State of the Art in the Ninth Decade of the Twentieth Century*, ed. Robert S. Sparkman (Dallas: Baylor University Medical Center, 1985). For the connection between airtight closure and theories of disease transmission, see Stafford, *Body Criticism*, pp. 161–62.

14. Ephraim Chambers, *Cyclopaedia: Or an Universal Dictionary of Arts and Sciences* (London: J. and J. Knapton et al., 1728), vol. 2, *v.* "suture." See also Stafford, *Body Criticism*, p. 161.

15. Tomás Ó Criomhthain, *The Islandman*, trans. Robin Flower (Oxford: Oxford University Press, 1951), pp. 74–79.

16. Carl Buck, *A Dictionary of Selected Synonyms in the Principal Indo-European Languages* (Chicago: University of Chicago Press, 1949), p. 202.

17. Ruth Padel, *In and Out of the Mind: Greek Images of the Tragic Self* (Princeton: Princeton University Press, 1993), reviewed by Jasper Griffin in *The New York Review of Books* (June 24, 1993): 45. (The quotation is Griffin's.)

18. Albrecht von Haller, *First Lines of Physiology*, trans. William Cullen (Edinburgh: Charles Elliott, 1786), vol. 1, pp. 9–14.

19. Haller, *First Lines of Physiology*, pp. 14–15, translation modified. The original Latin is from Haller, *Primae lineae physiologiae* (Edinburgh: G. Drummond, 1768), pp. 5–6. For a discussion of Haller's style, see Bianca Cetti Marinoni, "La Prosa Scientifica," in *Ricerche Halleriane*, ed. Bianca Cetti Marinoni et al. (Milan: n.p., 1984).

20. This parallel is developed at length in Elkins, *What Painting Is* (New York: Routledge, 1999).

21. For this portrait and its immediate context, see Johann Winkler and Katherine Erling, *Oskar Kokoschka: Die Gemälde 1906–1929* (Salzburg: Galerie Welz, 1995), cat. 44.

22. For *écorchés*, see Edith Hoffman, *Kokoschka: Life and Work* (London: Faber and Faber, 1947), pp. 37–38.

23. Henry I. Schvey, "Mit dem Auge des Dramatikers: Das Visuelle Drama bei Oskar Kokoschka," in *Oskar Kokoschka, Symposion*, ed. Erika Patka (Vienna: Residenz Verlag, 1986), pp. 100–13, especially pp. 111–12.

24. Stafford, *Body Criticism*, pp. 58–70.

25. Ovid, *Metamorphoses* 5:437–60. For the identification of the gecko, see Carl Gotthold Lenz, *Erklärende Anmerkungen zu Ovids Metamorphosen*, vol. 1. From the series *Erklärende Anmerkungen zu der Encyclopädie der lateinischen Classiker*, vol. 3, pt. 1. (Braunschweig: Schul-Buchhandlung, 1792), p. 349: "Der *Stellio* . . . ist eine kleine Eidesche, man glaubt, *Lacerta gecko L.*"

26. For Ingres's "obsession," see Robert Rosenblum, *Jean-Auguste-Dominique Ingres* (New York: Abrams, 1967). For other sources of "waxy painted figures," see Stafford, *Body Criticism*, p. 78. For Sweerts, see Rolf Klutzen, *Michael Sweerts: Brussels 1618–Goa 1664*, trans. Diane Webb (Doornspijk: Davaco, 1996).

27. For Sally Mann, see, for example, *Still Time: Sally Mann* (New York: Aperture, 1994); for Kiki Smith, see her work with David Wojnarowicz, especially *Untitled* (1982–91), reproduced in Nicholas Mirzoeff, *Bodyscape: Art, Modernity, and the Ideal Figure* (New York: Routledge, 1995); for Serrano, see *Andres Serrano: Works, 1983–1993*, ed. Patrick Murphy, with essays by Wendy Steiner and others (Philadelphia: Institute of Contemporary Art, 1994); and

Andres Serrano: Body and Soul, ed. Brian Wallis, with essays by bell hooks and others (New York: Takarajima, 1995).

28. Sylvester, *Francis Bacon Interviewed*, p. 46. Willem de Kooning's nudes could also be discussed in this context, especially those that are manifestly liquid and without secure boundaries. See, for example, Janet Hobhouse, *The Bride Stripped Bare: The Artist and the Female Nude in the Twentieth Century* (New York: Weidenfeld and Nicolson, 1988), pp. 236–60.

29. See Dado's *Caneliphage Papou* and Paul Rebeyrolle's *L'Homme à la Jambe Brisée*, in Marc le Bot, *Images du Corps*, exh. cat. (Aix-en-Provence: Présence Contemporaine, 1986), pp. 114–15. Le Bot calls this kind of body "le corps-monstre."

30. On *alla prima* painting, see Max Doerner, *Malmaterial und seine Werwendung im Bilde* (1921), translated as *The Materials of the Artist* (London: Granada, 1973–77). For a recent appreciation of Doerner, see Thierry De Duve, *Pictorial Nominalism: On Marcel Duchamp's Passage from Painting to the Readymade*, trans. Dana Polen and the author, *Theory and History of Literature*, vol. 51. (Minneapolis: University of Minnesota Press, 1991), pp. 175–85. De Duve is interested in parallels between Duchamp's readymades and the tradition of painting, and the parallel I am drawing here between Bacon and Titian is not without affinities to Duchamp's lingering interest in paint, palettes, tubes, and the rudiments of painting. De Duve has rethought these ideas in *Kant After Duchamp* (Cambridge, Mass.: MIT Press, 1996).

31. Erwin Panofsky, *Tomb Sculpture* (New York: Abrams, 1992). For Hans Baldung, see Robert Koch, *Hans Baldung Grien, Eve, the Serpent, and Death* [bilingual French and English], *Masterpieces in the National Gallery of Canada*, no. 2 (Ottawa: National Gallery of Canada, 1974).

32. Duncan Theobald Kinkead, *Valdés Leal, His Life and Work* (New York: Garland, 1978).

33. Raimund van Marle, *Iconographie de l'art profane* (La Haye, 1932), vol. 2, pp. 383–84, quoted in Elizabeth du Gué Trapier, *Valdés Leal, Spanish Baroque Painter* (New York: Hispanic Society of America, 1960), p. 57.

34. In Elizabeth du Gué Trapier's opinion, "Had the directors of the charity hospital wished to hasten the end of their impoverished clients they could not have chosen more effective subjects as decorations for the new church than the hieroglyphs." *Valdés Leal* (1956), p. 34.

35. Norman Bryson, *Looking at the Overlooked, Four Essays on Still Life Painting* (Cambridge, Mass.: Harvard University Press, 1990), pp. 96–135, reads some of these images as one end of a spectrum from ascetic inhibition to chaotic excess, and in this context I would note that bodily metaphors function most strongly as signifiers of excess.

36. Other, rival, interpretations of perspective are given in Elkins, *Poetics of Perspective* (Ithaca, N.Y.: Cornell University Press, 1994), Chap. 1.

37. Robert Burton, *The Anatomy of Melancholy, What It Is. With all the*

Kindes, Causes, Symptomes, Prognosticks, and Severall Cures of It. In Three Maine Partitions with their Severall Sections, Members, and Subsections. Philosophically, Medicinally, Historically, Opened and Cut Up. By Democritus Junior (Oxford: John Lichfield and James Short for Henry Cripps, 1621).

38. Ephraim Chambers, *Cyclopaedia: Or an Universal Dictionary of Arts and Sciences*, 2d ed. (London: printed for D. Midwinter [and 16 others], 1738), p. 209, and René-Jacques Croissant de Garengeot, *A Treatise of Chirurgical Operations*, trans. Mr. St. André (London: printed for Thomas Woodward, 1723), p. 2; both cited in Stafford, *Body Criticism*, p. 485 nn. 6, 7.

39. Hugo Friedrich, *Montaigne*, 2d ed. (Bern and Munich: Francke, 1967), pp. 305–36.

40. *Magnetic Resonance Imaging: A Reference Guide and Atlas* (Philadelphia: J. B. Lippincott, 1986); Navin C. Nanda, *Atlas of Color Doppler Echocardiography* (Philadelphia: Lea and Febiger, 1989); Howard Sochurek, *Medicine's New Vision* (Easton, Penn.: Mack Publishing Company, 1988).

41. Eric J. Cassell, *The Nature of Suffering and the Goals of Medicine* (New York and Oxford: Oxford University Press, 1991), pp. 195 ff.

42. For further examples, see Elkins, "Art History and the Criticism of Computer-Generated Images," *Leonardo* 27, no. 4 (1994): 335–42 and color-plate. For a good recent summary of medical imaging, see Robert P. Crease et al., "Biomedicine in the Age of Imaging," *Science* 261 (July 30, 1993): 554–61.

43. Nancy Siriasi, "Vesalius and Human Diversity in 'De humani corporis fabrica,'" *Journal of the Warburg and Courtauld Institutes* 57 (1994): 60–88. See further Katherine Rowe, "'God's Handy Worke': Divine Complicity and the Anatomist's Touch," in *The Body in Parts: Fantasies of Corporeality in Early Modern Europe*, ed. David Hillman and Carla Mazzio (New York: Routledge, 1997), pp. 285–312. especially p. 300.

44. William Hogarth, *The Analysis of Beauty* (New York: Garland, 1975), a reprint of the first edition (London: J. Reeves, 1753).

45. See Elkins, "Two Conceptions of the Human Form: Bernard Siegfried Albinus and Andreas Vesalius," *Artibus et historiae* 14 (1986): 91–106; Hendrik Punt, *Bernard Siegfried Albinus (1697–1770) On "Human Nature": Anatomical and Physiological Ideas in Eighteenth-Century Leiden* (Amsterdam: B. M. Israel, 1983); Tim Huisman, "Squares and Diotpers: The Drawing System of a Famous Anatomical Atlas," *Tractrix* 4 (1992): 1–11; and Barbara Stafford, "Depth Studies: Illustrated Anatomies from Vesalius to Vicq d'Azyr," *Caduceus* 8, no. 2 (1992): 39–47.

46. See, for example, Peter Murray Jones, *Medieval Medical Miniatures* (Austin: University of Texas Press, 1984), Figs. 27 and 51.

47. Charles Estienne, *La dissection des parties du corps humain divisee en trois livres* (Paris: Simon de Colines, 1546); Jean-Claude Margolin, *Science, humanisme et société: Le cas de Charles Estienne* (Paris: Klincksieck, 1993).

48. "Questa figura, mostra il sito de gl'Intestini, & la reticella spiegata, & volta verso dietro, & tirata co denti." Giovanni Valverde, *Anatomia del corpo hu-*

mano (Rome: Antonio Salamanca and Antonio Lafreri, 1560), book III, p. 93. See further Jonathan Sawday, *The Body Emblazoned: Dissection and the Human Body in Renaissance Culture* (New York: Routledge, 1995).

49. The "dead body in a room problem" also leads into the history of funerary installations; the subject is explored in Elkins, *Things and Their Places: The Concept of Installation from Prehistoric Tombs to Contemporary Art*, in progress.

50. For *écorchés* in general, see L. Price Amerson, "The Problem of the Ecorché: A Catalogue Raisonné of Models and Statuettes from the Sixteenth Century and Later Periods," Ph.D. dissertation, Pennsylvania State University, 1975, unpublished; Zofia Ameisenowa, *The Problem of the Écorché and the Three Anatomical Models in the Jagellonian Library*, trans. Andrzej Potocki (Wroclaw: Zaklad Narodowy im. Ossolinskich, 1963); also Elkins, "Two Conceptions of the Human Form"; and the history in Henry Meige, "Une Révolution anatomique," *Nouvelle Iconographie de la Salpêtrière* 20 (1907): 174–83 (which concerns an *écorché* made by the French art anatomist Paul Richer).

51. Pliny, *Historia naturalis* 35:6 and 153; the *Madonna* was said to have miraculous powers, according to Lanza et al., *Cere Anatomiche*, p. 18. On wax models in general, see E. J. Pyke, *A Biographical Dictionary of Wax Modellers* (Oxford: Clarendon Press, 1973). A supplement was published in London in 1981.

52. See J. Adhémar, "Les Musées de cire en France. Curtius, le 'banquet royal,' les têtes coupées," *Gazette des Beaux-Arts* 92, no. 2 (1978): 206–7; M. Lemire, *Les Modèles anatomiques en cire colorée du XVIIIe siècle et du XIXe siècle* (Paris: Musée National d'Histoire Naturelle, Laboratoire d'Anatomie Comparée, 1987); Peter Klerner Knoefel, "Florentine Anatomical Models in Wax and Wood," *Medicine nei Secoli* 15 (1978): 329–40; Benedetto Lanza et al., *Le Cere Anatomiche della Specola* (Florence: Arnaud, 1979) (there is also a second volume on the pathological anatomies); and Michel Lemire, "Fortunes et infortunes de l'anatomie et des préparations anatomiques, naturelles et artificielles," in *L'âme au corps: arts et sciences 1793–1993*, exh. cat., ed. Jean Clair (Paris: Réunion des Musées Nationaux, 1993), pp. 70–101.

53. For the dermatologic models, see Stafford, *Body Criticism*, pp. 281–83; Gérard Tilles and Daniel Wallach, *Le Musée des moulages de l'hôpital Saint-Louis* (Paris: Doin, 1996); Georges Solente, "Le Musée de l'Hôpital Saint-Louis," *American Journal of Dermatology* 5 (October 1983): 483–89, especially p. 486 for the identification of the medium; and Ernest Besnier, Alfred Fournier, et al., *A Pictorial Atlas of Skin Diseases and Syphilitic Afflictions in Photo-Lithochromes from Models in the Museum of the Saint Louis Hospital, Paris, with Explanatory Woodcuts and Text* (London: Rebman, 1904); and Ernest Besnier, *La Pratique dermatologique*, 4 vols. (Paris: Masson, 1904), with color reproductions after the casts, keyed to numbers in the collection. Fournier was an authority on syphilis; see his *Les Chancres extra-génitaux* (Paris: Rueff, 1897). A color photograph of the model shown in Figure 47 is in Tilles and Wallach, *Le Musée*, p. 67.

54. Ruysch's dissections served as the models for Füssli's illustrations to Jean-Jacques Scheuchzer's monumental *Physique sacrée*. See Stafford, *Body*

Criticism, p. 240; and Johann Jacob Scheuchzer, *Physique sacrée, ou histoire naturelle de la Bible*, 8 vols. (Amsterdam: Chez P. Schenk et al., 1732–37). For Ruysch, see T. H. Lunsingh Scheurleer, "Early Dutch Cabinets of Curiosities," in Oliver Impey and Arthur MacGregor, eds., *The Origins of Museums: The Cabinet of Curiosities in Sixteenth- and Seventeenth-Century Europe* (Oxford: Clarendon Press, 1985), pp. 119–20.

55. These models are kept in the Musée Fragonard, in the École Vétérinaire d'Alfort in Paris. There are similar preparations in the Musée d'Anatomie Delmas-Orfila-Rouviere; a file on several dozen Parisian collections is kept at the Musée de l'Hôpital Saint-Louis.

56. Church crypts open to the public include the Cimitero dei Cappuccini in Rome and the Momias de Guanajuato in Guanajuato, Mexico.

57. Govert (or Govard, or Gothfried, or Godefroid) Bidloo (1649–1713), *Anatomia humani corporis* (Amsterdam: Joannis à Someren et al., 1685).

58. Lairesse's originals are in the Bibliothèque de l'ancien faculté de médécine de Paris. See Paule Dumaître, *Le Curieuse destinée des planches anatomiques de Gérard de Lairesse, peintre en Hollande* (Amsterdam: Rodopi, 1987); David Williams, "Nicholas Bidloo and His Unknown Drawings," *Janus* 63 (1976): 195–206.

59. A point first made by Ludwig Choulant, *Geschichte und Bibliographie des anatomischen Abbildung* (Leipzig: Weigel, 1955), p. 35.

60. Mario Perniola, "Between Clothing and Nudity," trans. Roger Friedman, in *Fragments for a History of the Human Body*, vol. 2, pp. 236–65, especially p. 258.

61. The *Icones anatomicae* have a difficult publishing history. Later installments appeared in 1745, 1747, 1749, 1752, 1753, 1754, and 1756, and Haller collected them all in 1756. This plate is from Albrecht von Haller, "Icones uteri humani," in *Icones anatomicae* (Göttingen: Abram Vandenhoeck, 1761), Fig. 2. A later impression, with a softer, more three-dimensional effect, appears in Haller, *Iconum anatomicarum quibus aliquae partes corporis humani, fasciculus I* (Göttingen: Abram Vandenhoeck, 1781), n.p.

62. For the history of depictions of the female reproductive tract, see Thomas Laqueur, "Amor Veneris, vel Dulcedo Appeletur," *Fragments for a History of the Human Body*, vol. 3, pp. 90–131.

63. Two plates from Charles Nicolas Jenty, *Demonstratio uteri praegnantis mulieris cum foetu ad partum maturi* (Nuremberg: [s.n.], 1761) are reproduced in Elkins, *The Object Stares Back*, Figs. 35a and b. (The English edition is Jenty, *The Demonstration of a Pregnant Uterus* [London, 1757]). Figure 8 in this book is also from Jenty, *Demonstratio uteri*. Among many related texts, see the engravings by Robert Strange for William Hunter, *Anatomia uteri humani gravidi* (Birmingham: [s.n.], 1774); and William Smellie, *A Sett of Anatomical Tables, With Explanations, And an Abridgement, of the Practice of Midwifery* (London: n.p., 1754). Jenty's illustrator Rymsdyk (or Riemsdyck) is discussed in John Thornton and Carole Reeves, *Medical Book Illustration* (Cambridge, Mass.: Oleander, 1983).

64. Albinus, "An Account of the Work," fol. c recto, cols. a, b. For sources, see Elkins, "Two Conceptions of the Human Form."

65. Samuel Thomas von Sömmering's equally precise *Tabula sceleti femini* (Frankfurt: Varrentrap and Wenner, 1796) lacks Albinus's kind of key plates; it is discussed in Londa Schiebinger, "Skeletons in the Closet: The First Illustrations of the Female Skeleton in Eighteenth-Century Anatomy," in Catherine Gallagher and Thomas Laqueur, *The Making of the Modern Body* (Berkeley and Los Angeles: University of California Press, 1987), pp. 42–82.

66. See also Sömmering, *Abbildungen des menschlichen Hoerorganes* (Frankfurt am Main: Varrentrap und Wenner, 1806).

67. For comparative material, see Susan Stewart, *On Longing: Narratives of the Miniature, the Gigantic, the Souvenir, the Collection* (Durham, N.C.: Duke University Press, 1993).

68. A further example is the clammy, steel-blue, three-dimensional sonogram of a fetus in situ, in *Science* 262 (November 19, 1993): 1207.

69. For Lepier (1900–74), see John Thornton and Carole Reeves, *Medical Book Illustration*, p. 119.

70. Early examples that have become important to later generations include Hans Bellmer and Barnett Newman. For Bellmer, see Hal Foster, *Compulsive Beauty* (Cambridge, Mass.: MIT Press, 1993).

Chapter 4: By Looking Alone

1. *Charcot the Clinician, The Tuesday Lessons. Excerpts from Nine Case Presentations on General Neurology at the Salpêtrière Hospital in 1887–88,* ed. Christopher G. Goetz (New York: Raven, 1987), p. 107.

2. Jan Dequeker, quoted in the *Wall Street Journal*, September 13, 1988, p. 34. For more reliable information about Botticelli, see Charles Dempsey's excellent article in *The Dictionary of Art* (New York: Grove Dictionaries, 1996).

3. Heinrich Wölfflin, *Kunstgeschichtliche Grundbegriffe, Das Problem der Stilentwicklung in der neueren Kunst* (Munich: F. Brückmann, 1915), p. 2.

4. For Simonetta Vespucci, see E. H. Gombrich, "Botticelli's Mythologies," in *Symbolic Images: Studies in the Art of the Renaissance* (London: Phaidon, 1972), pp. 31–81.

5. I also mean the word "thereness" to have echoes of Aristotle's "thisness," which denotes "a particular of some kind," with stress on the declaration of uniqueness within the frame of a larger category. See Mary Louise Gill, *Aristotle on Substance, The Paradox of Unity* (Princeton, N.J.: Princeton University Press, 1989), pp. 31–34, especially p. 34.

6. Martin Heidegger, *Discourse on Thinking* (New York: Harper and Row, 1966), p. 66.

7. Heidegger's descriptions are discussed from this point of view in Jacques Derrida, *The Truth in Painting*, trans. Geoff Bennington (Chicago: University of Chicago Press, 1987), Chap. 4.

8. Georges Didi-Huberman, *Invention de l'hysterie, Charcot et l'iconographie*

photographique de la Salpêtrière (Paris: Macula, 1982); and see Jacqueline Car-roy, "L'hystérique, l'artiste et le savant," in *L'âme au corps: arts et sciences 1793–1993*, exh. cat., ed. Jean Clair (Paris: Réunion des Musées Nationaux, 1993), pp. 446–57.

9. Lorraine Daston and Peter Galison, "The Image of Objectivity," *Representations* 40 (1992): 81–128.

10. For hysteria in gender construction, see, for example, the work of Mary Kelly. There is a large literature on hysteria from the eighteenth century onward that tends to be ignored by contemporary feminist inquiries; see, for example, the wonderful descriptions in Robert Whytt [Whyte], *Observations on the Nature, Causes, and Cure of Those Disorders Which Have Been Commonly Called Nervous, Hypochondriac, or Hysteric*, 2d ed. (Edinburgh: T. Becket, 1765).

11. Another example is reproduced in Elkins, *The Object Stares Back*, Fig. 17. See also Charcot, *Iconographie photographique de la Salpêtrière*.

12. Gottfried Ewald, *Neurologie und Psychiatrie* (Munich: Urban und Schwarzenberg, 1954), pp. 294 ff.

13. See, for example, J. Séglas, "Démence précoce et catatonie," *Nouvelle Iconographie de la Salpêtrière* 15 (1902): 330 ff.

14. See, for example, Paul Marie Louis Pierre Richer, *Études cliniques sur l'hystéro-épilepsie* (Paris: Delahoye and Lecrosnier, 1881); and Richer, *L'art et la médecine* (Paris: Gaultier, Magnier, 1902).

15. Jean-Martin Charcot, *L'hystérie* (Toulouse: Privat, 1971).

16. H. Lang, "Note sur les contractions «synergiques paradoxales» ob-servées a la suite de la paralysie faciale périphérique," *Nouvelle Iconographie de la Salpêtrière* 18 (1905): 424–25; J. S. Estèves, "Contracture faciale bilatérale hytérique," ibid. 5 (1892): 38–42; and Ch. Féré and H. Lamy, "Des contrac-tures spontanées et provoquées de la langue chez les hystero-épileptique," ibid. 11 (1899): 203 ff.

17. Henri Meige, "Le Juif-errant a la Salpêtrière, étude sur certains néuro-pathes voyageurs," *Nouvelle Iconographie de la Salpêtrière* 6 (1893): 191–204, 277–91, 333–58.

18. Ian Hacking, *The Taming of Chance* (New York: Cambridge University Press, 1991), reviewed by M. Schrabas, *Science* 251 (March 15, 1991): 1373, with further references; and Stephen Stigler, *The History of Statistics: The Measurement of Uncertainty before 1900* (Cambridge, Mass.: Harvard University Press, 1986).

19. Georges Canguilhem, *On the Normal and the Pathological*, trans. Caro-lyn R. Fawcett and ed. Robert S. Cohen (Dordrecht: D. Reidel, 1978).

20. Stafford, *Body Criticism*, pp. 85, 107. See also Martin Cureau de La Chambre, *L'Art de connoistre les hommes* (Amsterdam: Chez Jacques le jeune, 1660).

21. Kai Kaus, "The Purchase of Slaves," in *An Anthology of Islamic Litera-ture*, ed. James Kritzeck (New York: Penguin, 1964), p. 160; and compare the "enlightened" description in Frederick W. Farrar, "Aptitudes of Races," *Trans-actions of the Ethnological Society of London* n.s. 5 (1867): 115–26.

64. Albinus, "An Account of the Work," fol. c recto, cols. a, b. For sources, see Elkins, "Two Conceptions of the Human Form."

65. Samuel Thomas von Sömmering's equally precise *Tabula sceleti femini* (Frankfurt: Varrentrap and Wenner, 1796) lacks Albinus's kind of key plates; it is discussed in Londa Schiebinger, "Skeletons in the Closet: The First Illustrations of the Female Skeleton in Eighteenth-Century Anatomy," in Catherine Gallagher and Thomas Laqueur, *The Making of the Modern Body* (Berkeley and Los Angeles: University of California Press, 1987), pp. 42–82.

66. See also Sömmering, *Abbildungen des menschlichen Hoerorganes* (Frankfurt am Main: Varrentrap und Wenner, 1806).

67. For comparative material, see Susan Stewart, *On Longing: Narratives of the Miniature, the Gigantic, the Souvenir, the Collection* (Durham, N.C.: Duke University Press, 1993).

68. A further example is the clammy, steel-blue, three-dimensional sonogram of a fetus in situ, in *Science* 262 (November 19, 1993): 1207.

69. For Lepier (1900–74), see John Thornton and Carole Reeves, *Medical Book Illustration*, p. 119.

70. Early examples that have become important to later generations include Hans Bellmer and Barnett Newman. For Bellmer, see Hal Foster, *Compulsive Beauty* (Cambridge, Mass.: MIT Press, 1993).

Chapter 4: By Looking Alone

1. *Charcot the Clinician, The Tuesday Lessons. Excerpts from Nine Case Presentations on General Neurology at the Salpêtrière Hospital in 1887–88*, ed. Christopher G. Goetz (New York: Raven, 1987), p. 107.

2. Jan Dequeker, quoted in the *Wall Street Journal*, September 13, 1988, p. 34. For more reliable information about Botticelli, see Charles Dempsey's excellent article in *The Dictionary of Art* (New York: Grove Dictionaries, 1996).

3. Heinrich Wölfflin, *Kunstgeschichtliche Grundbegriffe, Das Problem der Stilentwicklung in der neueren Kunst* (Munich: F. Brückmann, 1915), p. 2.

4. For Simonetta Vespucci, see E. H. Gombrich, "Botticelli's Mythologies," in *Symbolic Images: Studies in the Art of the Renaissance* (London: Phaidon, 1972), pp. 31–81.

5. I also mean the word "thereness" to have echoes of Aristotle's "thisness," which denotes "a particular of some kind," with stress on the declaration of uniqueness within the frame of a larger category. See Mary Louise Gill, *Aristotle on Substance, The Paradox of Unity* (Princeton, N.J.: Princeton University Press, 1989), pp. 31–34, especially p. 34.

6. Martin Heidegger, *Discourse on Thinking* (New York: Harper and Row, 1966), p. 66.

7. Heidegger's descriptions are discussed from this point of view in Jacques Derrida, *The Truth in Painting*, trans. Geoff Bennington (Chicago: University of Chicago Press, 1987), Chap. 4.

8. Georges Didi-Huberman, *Invention de l'hysterie, Charcot et l'iconographie*

photographique de la Salpêtrière (Paris: Macula, 1982); and see Jacqueline Carroy, "L'hystérique, l'artiste et le savant," in *L'âme au corps: arts et sciences 1793–1993*, exh. cat., ed. Jean Clair (Paris: Réunion des Musées Nationaux, 1993), pp. 446–57.

9. Lorraine Daston and Peter Galison, "The Image of Objectivity," *Representations* 40 (1992): 81–128.

10. For hysteria in gender construction, see, for example, the work of Mary Kelly. There is a large literature on hysteria from the eighteenth century onward that tends to be ignored by contemporary feminist inquiries; see, for example, the wonderful descriptions in Robert Whytt [Whyte], *Observations on the Nature, Causes, and Cure of Those Disorders Which Have Been Commonly Called Nervous, Hypochondriac, or Hysteric*, 2d ed. (Edinburgh: T. Becket, 1765).

11. Another example is reproduced in Elkins, *The Object Stares Back*, Fig. 17. See also Charcot, *Iconographie photographique de la Salpêtrière.*

12. Gottfried Ewald, *Neurologie und Psychiatrie* (Munich: Urban und Schwarzenberg, 1954), pp. 294 ff.

13. See, for example, J. Séglas, "Démence précoce et catatonie," *Nouvelle Iconographie de la Salpêtrière* 15 (1902): 330 ff.

14. See, for example, Paul Marie Louis Pierre Richer, *Études cliniques sur l'hystéro-épilepsie* (Paris: Delahoye and Lecrosnier, 1881); and Richer, *L'art et la médecine* (Paris: Gaultier, Magnier, 1902).

15. Jean-Martin Charcot, *L'hystérie* (Toulouse: Privat, 1971).

16. H. Lang, "Note sur les contractions «synergiques paradoxales» observées a la suite de la paralysie faciale périphérique," *Nouvelle Iconographie de la Salpêtrière* 18 (1905): 424–25; J. S. Estèves, "Contracture faciale bilatérale hytérique," ibid. 5 (1892): 38–42; and Ch. Féré and H. Lamy, "Des contractures spontanées et provoquées de la langue chez les hystero-épileptique," ibid. 11 (1899): 203 ff.

17. Henri Meige, "Le Juif-errant a la Salpêtrière, étude sur certains néuropathes voyageurs," *Nouvelle Iconographie de la Salpêtrière* 6 (1893): 191–204, 277–91, 333–58.

18. Ian Hacking, *The Taming of Chance* (New York: Cambridge University Press, 1991), reviewed by M. Schrabas, *Science* 251 (March 15, 1991): 1373, with further references; and Stephen Stigler, *The History of Statistics: The Measurement of Uncertainty before 1900* (Cambridge, Mass.: Harvard University Press, 1986).

19. Georges Canguilhem, *On the Normal and the Pathological*, trans. Carolyn R. Fawcett and ed. Robert S. Cohen (Dordrecht: D. Reidel, 1978).

20. Stafford, *Body Criticism*, pp. 85, 107. See also Martin Cureau de La Chambre, *L'Art de connoistre les hommes* (Amsterdam: Chez Jacques le jeune, 1660).

21. Kai Kaus, "The Purchase of Slaves," in *An Anthology of Islamic Literature*, ed. James Kritzeck (New York: Penguin, 1964), p. 160; and compare the "enlightened" description in Frederick W. Farrar, "Aptitudes of Races," *Transactions of the Ethnological Society of London* n.s. 5 (1867): 115–26.

22. On beauty in this context, see Abigail Solomon-Godeau, "Written on the Body," in *Visible Light: Photography and Classification in Art, Science, and Technology*, exh. cat., ed. Chrissie Iles and Russell Roberts (Oxford: Museum of Modern Art, 1997), pp. 69–81.

23. These properties are from Giovanni Battista della Porta, *De humana physiognomia* (Naples: Apud Iosephum Carchium, 1586), p. 58, quoted by Patrizia Magli, "The Face and the Soul," in *Fragments for a History of the Human Body*, vol. 2, p. 100.

24. In the West, the two basic sources are della Porta, *De humana physiognomia*, and Charles de Brun, *Conférence sur l'expression générale et particulière des passions* (1698), English edition, *The Conference of Monsieur Le Brun* (London: printed for John Smith, Edward Cooper, and David Mortier, 1701). A recent Western example is C. R. Stockard, *The Physical Basis of Personality* (New York: W. W. Norton, 1931); a plate comparing people to dogs is reproduced in Harold M. Holden, *Noses* (Cleveland: World Publishing Company, 1950). A recent non-Western example is Man-Hui Kim, *Minsok Torok* [Collection of Korean Folklore Pictures] (Seoul: Songmisa, 1977).

25. Paulus Lentulus, *Historia admiranda de prodigiosa Apolloniae Schreierae, virginis in agro Bernensi, inedia* (Bern, 1604), described in Petr Skrabanek, "Notes Towards the History of Anorexia Nervosa," *Janus* 70 (1983): 114–24. For an opposed viewpoint (that medieval and modern anorexia nervosa are related), see Rudolph Bell, *Holy Anorexia* (Chicago: University of Chicago Press, 1985). See also Hillel Schwartz, "The Three-Body Problem and the End of the World," in *Fragments for a History of the Human Body*, vol. 2, pp. 406–65; Schwartz, *Never Satisfied: A Cultural History of Diets, Fantasies and Fat* (New York: Free Press, 1986); and Noelle Caskey, "Interpreting Anorexia Nervosa," in *The Female Body in Western Culture: Contemporary Perspectives*, ed. Susan Suleiman (Cambridge, Mass.: Harvard University Press, 1986), pp. 175–89.

26. Jacques Lacan, *The Seminar of Jacques Lacan*, Book II, *The Ego in Freud's Theory and in the Technique of Psychoanalysis 1954–1955*, ed. J.-A. Miller (New York: Cambridge University Press, 1991), p. 50.

27. Mikkel Borch-Jakobsen, *Lacan, The Absolute Master* (Stanford: Stanford University Press, 1991), chapter on "The Statue Man."

28. For historically specific thoughts on the different effects of reflections in actual paintings, see Michael Fried, *Manet's Modernism* (Chicago: University of Chicago Press, 1996).

29. See also Martin Jay, *Downcast Eyes* (Cambridge, Mass.: MIT Press, 1994). However, I agree with many of the reservations expressed in the review by W. J. T. Mitchell, *Artforum*, XXXII, no. 5 (1994): 9; and see the somewhat inconclusive catalogue in Peter Benson, "Freud and The Visual," *Representations* 45 (1994): 101–16.

30. The last is argued in E. H. Gombrich, *The Sense of Order: A Study in the Psychology of Decorative Art* (Ithaca, N.Y.: Cornell University Press, 1984).

31. Sheldon was also interested in mental ability, and to that extent he was

a physiognomist (see Table 3); see William Herbert Sheldon, "Social Traits and Morphological Types," *Personnel Journal* 6, no. 1 (1927); "Ability and Facial Measurements," ibid. 6, no. 2 (1927); "Morphological Types and Mental Ability," *Journal of Personnel Research* 5 (1927): 447–51.

32. The quotation is from Sheldon, *The Varieties of Human Physique: An Introduction to Constitutional Psychology* (New York: Harper and Brothers, 1940), caption to Fig. 93. See Sheldon, *Atlas of Men: A Guide for Somatotyping the Adult Male at all Ages* (New York: Harper and Brothers, 1954).

33. Sheldon, *Atlas of Men*, p. 5.

34. For triangle graphs, see further Elkins, *Domain of Images* (Ithaca, N.Y.: Cornell University Press, forthcoming), Chap. 13.

35. Sheldon, *The Varieties of Temperament* (New York: Harper and Brothers, 1942).

36. Ibid., p. 14. Sheldon adds: "Instead of the terms gynandromorphy, gynandry and gynandrophreny some writers would use androgynomorphy, androgyny and androgynophreny. These latter terms put the man ahead of the woman, which may be advantageous, but they are also a syllable longer which is disadvantageous."

37. Sheldon, *Atlas of Men*, p. 14.

38. The useful term "gynaikocentric" (centered on women; an opposite to androcentric) comes from Andrew Stewart, *Art, Desire, and the Body in Ancient Greece* (Cambridge, Eng.: Cambridge University Press, 1997), p. 173.

39. In the vast literature, one of the most analytically reflective texts is Whitney Davis, "Gender," in *Critical Terms for Art History*, ed. Robert Nelson and Richard Shiff (Chicago: University of Chicago Press, 1996), pp. 220–36; and see Davis, "Erotic Revision in Thomas Eakins's Narratives of Male Nudity," *Art History* 17, no. 3 (1994): 301–41; in comparison with Michael Hatt, "The Male Body in Another Frame: Thomas Eakins' *The Swimming Hole* as a Homoerotic Image," *Journal of Philosophy and the Visual Arts* (1993): 8–21; and Michael Hatt, "Muscles, Morals, Mind: The Male Body in Thomas Eakins's *Salutat*," in *The Body Imaged: The Human Form and Visual Culture Since the Renaissance*, ed. Kathleen Adler and Marcia Pointon (New York: Cambridge University Press, 1993), pp. 57–69, 194–95. I thank Kym Pinder for the references to Eakins.

40. Margaret Mead et al., *Science and the Concept of Race* (New York: Columbia University Press, 1968), pp. 6, 103. See further Ashley Montagu, "Antidote to Barbarism," *Saturday Review of Literature* 33 (August 19, 1950): 8–9 and 38–40; Montagu, *The Idea of Race* (Lincoln: University of Nebraska Press, 1965); *Race: Individual and Collective Behavior*, ed. Edgar Tristram Thomson and Everett Cherrington Hughes (Glencoe, Ill.: Free Press, 1958); and the breathless denials of race in Samuel A. Barnett, *The Human Species: A Biology of Man* (Harmondsworth, Middlesex, Eng.: Penguin, 1961).

41. Immanuel Kant, *Von den verschiedenen Racen der Menschen* (1775), translation modified from E. Count, *This Is Race: An Anthology Selected from the*

International Literature on the Races of Man (New York: Schuman, 1950). See also Monika Firla, *Untersuchungen zum Verhältnis von Anthropologie und Moralphilosophie bei Kant* (Frankfurt am Main: Lang, 1981).

42. Charles Darwin, *Descent of Man, and Selection in Relation to Sex* (London: J. Murray, 1871), vol. 1, p. 306.

43. See the description of an insane man with *hypertrichosis partialis* in M. Bartels, "Ueber abnormale Behaarung beim Menschen," *Zeitschrift fur Ethnologie* 11 (1879): 145–94; also *The Hirsute Female*, ed. Robert Greenblatt (Springfield, Ill.: Thomas, 1963).

44. N. von Miklacho-Maklay, "Anthropologische Notizen, gesammelt auf einer Reise in West-Mikronesien und Nord-Melanesien im Jahre 1876," *Verhandelungen der Berliner Gesellschaft für Anthropologie, Ethnologie, und Urgeschichte* 10 (1878): 99–119, especially p. 118. The reference to the penis is on p. 114.

45. Hermann Heinrich Ploss, *Das Weib in der Natur- und Völkerkunde*, ed. Max Bartels, 4th ed. (Leipzig: Th. Grieben's Verlag, 1895), Fig. 101; and see Paula Weidegger, *History's Mistress: A New Interpretation of a Nineteenth-Century Ethnographic Classic* (New York: Viking Penguin, 1983), pp. 16–17.

46. The book is in the collection of the medical library at Stanford University. It contains three unrelated texts, including one by Albinus (see Figures 44, 51, and 52) and a description of the tanning procedure. See Walter Blumenthal, *Bookmen's Bedlam: An Olio of Literary Oddities* (New Brunswick, N.J.: Rutgers University Press, 1955), pp. 77–78, 178.

47. Hans Friedenthal, *Beiträge zur Naturgeschichte des Menschen, Sonderformen der menschlichen Leibesbildung* (Jena: Gustav Fischer, 1910), Part V, text to pl. 46: ". . . eine bis kindskopfgroße Schwelling und Auftreibung."

48. A. Edwards and R. E. L. Masters, *The Cradle of Erotica, a Study of Afro-Asian Sexual Expression and an Analysis of Erotic Freedom in Social Relationships* (New York: Julian Press, 1963), especially pp. 39–72.

49. Burger-Villingen and Nöthling, *Das Geheimnis der Menschenform*, pp. 480–81.

50. Ibid., p. 385.

51. Francis Graham Crookshank, *The Mongol in Our Midst: A Study of Man and His Three Faces* (London: Kegan Paul, French, Trubner, 1925). See further Crookshank, "Mongols," *Universal Medical Record* 2 (1913): 12–29, 417, 418; "A Note on Mongolism," *Proceedings of the Royal Society of Medicine* 6 (1912–13): 124–26; "A Case of Mongolism," *Proceedings of the Royal Society of Medicine* 6 (1912–13): 133–36; "Handprints of Mental Defectives," *Lancet* 1 (1921): 274, with R. L. Langon-Down's response to the "Buddha posture" (he suggests it is caused by abnormal flexibility of the joints); Crookshank, *Individual Psychology, Medicine, and the Bases of Science* (London: C. W. Daniel, 1932); and his *Flatulence and Shock* (London: Lewis, 1912).

52. Crookshank, *Mongol in Our Midst*, p. 46. See also L. Trepsat, "Un cas de démence précoce catatonique, avec pseudo-oedème compliqué de purpura,"

Nouvelle Iconographie de la Salpêtrière 17 (1904): 195; and for a contemporaneous source on the history of psychosis, see A. von Gebauchten, *Les malades nerveuses* (Louvain, 1920). The basic texts on dementia praecox include Eugen Bleuler, *Dementia praecox, oder Gruppe der Schizophrenien* (Leipzig: F. Deuticke, 1911); and see J. Hoenig, "The Concept of Schizophrenia: Kreapelin-Bleuler-Schneider," *British Journal of Psychiatry* 142 (1983): 547–56.

53. Crookshank, *Mongol in Our Midst*, pp. 65–66, 56, 61, respectively.

54. Ibid., pp. 49 and 46, respectively. See R. H. Steen, "A Characteristic Attitude Assumed by Many Cases of Dementia Praecox," *Journal of Mental Science* (1916): 179, comparing three Egyptian statues to a photograph of dementia praecox patients.

55. Crookshank, *Mongol in Our Midst*, pp. 51–55.

56. For diagrams of the hand, see J. Kollmann, "Die Rassenanatomie der Hand und die Persistenz der Rassenmerkmale," *Archiv für Anthroplogie* 28 (1907): 91 ff. For brain contours, see, for example, R. Zampa, "Vergleichende anthropologische Ethnographie von Apulien," *Zeitschrift für Ethnologie* 18 (1886): 201 ff. Fingerprints are discussed from a genetic and racial standpoint in Harold Cummins and Charles Midlo, *Finger Prints, Palms, and Soles: An Introduction to Dermatographics* (Philadelphia: Blakiston, 1943), pp. 251–68 (the most "primitive" races have the least developed patterns); and see *Studien über die Fingerleistenmuster der Japaner*, ed. Keizi Koike (Tokyo: Japanische Gesellschaft zur Förderung der wissenschaftlichten Forschungen, 1960).

57. On bluish back hairs, see E. Baetz, "Menschen-Rassen Ost-Asiens mit specieller Rücksicht auf Japan," *Zeitschrift für Ethnologie* 33 (1901): 166–90, especially p. 188. For studies of pubic hair, see G. Fritsch, "Buschmannhaar im Gegenzatz zu gestapelten Spirallocken," *Zeitschrift für Ethnologie* 48 (1916): 1 ff.; and F. Seiner, "Beobachtungen und Messungen an Buschleuten," *Zeitschrift für Ethnologie* 44 (1912): 274 ff.

58. Reginald Ruggles Gates, *The Inheritance of Hairy Ear Rims* (Edinburgh: Mankind Quarterly, 1961).

59. From *Fortune-Telling Through the Identification of the Body* [in Chinese] (Kowloon: Kurhwa, n.d.), p. 71.

60. For ethnographic photography in the context of bodily fragmentation, see Nicholas Mirzoeff, *Bodyscape: Art, Modernity, and the Ideal Figure* (New York: Routledge, 1995), pp. 135–61.

61. Georg Schweinfurth, "Das Volk der Monbuttu in Central-Afrika," *Zeitschrift für Ethnologie* 5 (1873): 1 n. 27, 310.

62. See, for example, Matthew Baillie, *A Series of Engravings, Accompanied by Explanations, Which Are Intended to Illustrate the Morbid Anatomy of Some of the Important Parts of the Human Body*, 2d ed. (London: W. Bulmer, 1812); Sir Robert Carswell, *Pathological Anatomy, Illustrations of the Elementary Forms of Disease* (London: printed for the author, 1838); and above all, the soft lithographs in J. Cruveilhier, *Anatomie pathologique du corps humain, ou descriptions, avec figures lithographiées et colorées, des diverses altérations morbides*, 2 vols. (Paris:

J.-B. Baillière et Fils, 1856–42). The standard source for the history of pathological anatomy is Edgar Goldschmid, *Entwicklung und Bibliographie der pathologisch-anatomischen Abbildung* (Leipzig: Hiersemann, 1925).

63. Among the first uses of the microscope in comparative and pathological anatomy is Hermann Lebert, *Traité d'anatomie pathologique generale et speciale, ou description et iconographie pathologique des alterations morbides tant liquides que solides*, 4 vols. (Paris: J.-B. Baillière et Fils, 1857–61). The liver is illustrated in pl. 40.

64. The dissolution of gross anatomy in cross sections, details, and histological thin sections is the subject of Elkins, "Two Conceptions of the Human Form."

65. Studies of bodily fragmentation in modern art include Linda Nochlin, *The Body in Pieces: The Fragment as a Metaphor of Modernity* (London: Thames and Hudson, 1994); and *Le corps en morceaux*, exh. cat., ed. Roberto Ostinelli (Paris: Réunion des Musées Nationaux, 1990), which is principally on Auguste Rodin.

66. W. R. H. Koops, *Petrus Camper (1722–1789). Onderzoeker van nature*, exh. cat. (Groningen: Universiteits Museum, 1979).

67. See Pieter Camper, *Over het natuurlijk verschil der wezenstrekken in menschen* (Utrecht: B. Wild and J. Altheer, 1791). The first treatise that discusses the facial angle is Camper, *Dissertation physique: Sur les différences réelles que présentent les traits du visage chez les hommes*, op. posth. (Utrecht: B. Wild and J. Altheer, 1791).

68. Pieter Camper, *Naturgeschichte des Orang-Utang und Einiger andern Affenarten, des Africanischen Rashorns, und des Rennthiers*, ed. J. F. M. Herbell (Düsseldorf: J. C. Dänzer, 1791). See also Cal Nissle, "Beiträge zur Kenntniss der sogenannten anthropomorphen Affen," *Zeitschrift für Ethnologie* 5 (1873): 50–53; O. Hermes, "Anthropomorphen Affen der Merliner Aquarium," *Zeitschrift für Ethnologie* 8 (1876): 88–94; and A. Primrose, *The Anatomy of the Orang-Ourang*, University of Toronto Studies: Anatomical Series no. 1 (Toronto, 1900).

69. Camper, "The Natural Difference of Features in Persons . . . ," in *The Works of the Late Professor Camper*, trans. T. Cogan (London: printed for C. Dilly, 1794), p. 62. See further Miriam Meijer, "The Anthropology of Petrus Camper (1722–1789)," Ph.D. dissertation, University of California at Los Angeles, 1991, unpublished; and Claudio Pogliano, "Entre forme et fonction: une nouvelle science de l'homme," in *L'âme au corps: arts et sciences 1793–1993*, exh. cat., ed. Jean Clair (Paris: Réunion des Musées Nationaux, 1993), pp. 238–65.

70. For another introduction, see Stephen Jay Gould, "Petrus Camper's Facial Angle," *Natural History* 96, no. 7 (1987): 12–18. Facial angles were frequently measured after Camper; J. Séglas, "De l'examen morphologique chez les aliénés et les idiots," *Nouvelle Iconographie de la Salpêtrière* 4 (1891): 274 ff.; p. 277, Fig. 57, illustrates a mechanism for measuring the facial angle.

71. See Edward Philip Stibbe, *An Introduction to Physical Anthropology* (London: E. Arnold, 1930), pp. 162 ff.; Carmelo Midulla, *Antropologia fisica*

(Cremona and Rome: Cremonese, 1940), pp. 75 ff.; Juan Comas, *Manual of Physical Anthropology* (Springfield, Ill.: Thomas, 1960), pp. 411 ff. (Comas was a physical anthropologist who wrote widely on cranial forms in Mesoamerica and Mexico); and Aleš Hrdliška, *The Forehead* (Washington, D.C., 1935).

72. For Schiller, see R. Neuhaus, "Schillers Schädel," *Zeitschrift für Ethnologie* 45 (1913): 973 ff.; and Carl Gustav Carus, *Atlas der Cranioscopie* (Leipzig: Weichardt, 1843), vol. 1, pl. 1; for Kant, see C. Kupffer and F. Bessel-Hagen, "Der Schädel Immanuel Kants," *Archiv für Anthropologie* 13 (1881); for Bach, see W. His, "Anatomische Forschungen über Johann Sebastian Bachs Gebeine und Antlitz, nebst Bemerkungen über dessen Bilder," *Abhandlungen der Königliche Sächsischen Gesellschaft der Wissenschaften zu Leipzig* 22 (1896): 379–420. See also Karl Pearson, *The Skull and Portraits of Henry Stewart, Lord Darnley, and Their Bearing on the Tragedy of Mary, Queen of Scots* (London: Cambridge University Press, 1928).

73. W. Krause, "Schädel von Leibniz," *Zeitschrift für Ethnologie* 34 (1902): 471–82.

74. To approximate the facial angle on a living subject, position the head so that the external auditory meatus (earhole) is on a horizontal line with the base of the nose. Then measure the angle between the philtrum above the upper lip and the superciliary arch (the ridge above the eyes). Camper's method for determining the facial angle is as follows: (1) Draw *AB*, a horizontal line through the base of the nose *N* and the external meatus *C*. (2) Note this follows the *os jugale Q*. (3) Draw *EF* perpendicular, through the meatus. (4) Draw *RN* perpendicular, through the point of contact of the teeth. (5) Draw *GN* along the forehead (sometimes it also coincides with the nasal bone *D* and the chin). (6) This line *GN* is the *linea facialis*, and the angle it makes with the vertical is the "facial angle."

75. Measurements are in centimeters. Sculptors' calipers (available in artists' supply stores) are a handy way to make accurate measurements. Length is measured from the glabella to the inion. The glabella is the ridge just above the eyes. Alternatively, the ophyron is used: the point in the center of the narrowest portion of the forehead. The inion is the point farthest from the glabella, either (a) the external occipital protuberance, the change of curvature at the base of the skull in back, or (b) the interparietal part of the occipital bone.

76. The greatest width is generally between the two parietal eminences, which are swellings about one-half of the way back on the skull. They are best seen from above.

77. The auricular height is measured from the external auditory meatus (earhole) to the top of the skull, normal (perpendicular) to the Frankfort plane, which is the plane including both ears and the bases of the orbits.

78. See A. Lee, "Reconstruction of the Internal Capacity of a Skull from External Measurements," *Philosophical Transactions of the Royal Society, London*, 196A (1901): 225–64; K. Pearson and A. G. Davin, "On the Biometric Constants of the Human Skull," *Biometrika* 16 (1924): 328–63.

79. This table does not reflect any single research program, since it is intended to illustrate the coercive quality of statistically indefensible measurements. The central rows, naming human races, are taken verbatim from Wilfrid Dyson Hambly, "Cranial Capacities, A Study in Methods," *Fieldiana, Anthropology* 36, no. 3 (1947): 25–75, especially pp. 61 and 63. Hambly says that the data "give an accurate summary of all we know of the racial differences" (ibid., p. 61). See also Hambly, *Cranial Capacities* (Chicago: Field Museum of Chicago, 1947).

For other formulae for cranial capacity, see the references in Spencer Rogers, *The Human Skull: Its Mechanics, Measurements, and Variations* (Springfield, Ill.: Charles C. Thomas, 1984), pp. 54–55; M. L. Tildesley, "A Critical Survey of Techniques for the Measurement of Cranial Capacity," *Journal of the Royal Anthropological Institute* 83, no. 2 (1953): 182–93; and Stephen Jay Gould, *The Mismeasure of Man* (New York: W. W. Norton, 1971). Further sources include Gerrit Pieter Frets, *The Cephalic Index and Its Heredity* (The Hague: M. Nijhoff, 1925); Rene Herrera Fritot, *Nueva tecnica para calcular la capacidad craneana* (Havana: Departamento de Antropologia, Academia de Ciencias, 1965); Herrera Fritot, *Craneotrigonometria* (Havana: Departamento de Antropologia, Academia de Ciencias, 1965); and the references in n. 68 above. For literature with pertinent images, see O. Berkham, "Zwei Fälle von Skaphokephalien," *Archiv für Anthropologie* 54 (1907): 8; A. Frey, "Drei mikrocephalische Geschwister," *Archiv für Anthropologie* 54 (1907): 33; John Shaw Billings, *On Composite Photography as Applied to Craniology* (Washington, D.C.: Government Printing Office, 1886); and Fritz Falkenburger, "Diagraphisches Untersuchungen an normalen und deformierten Rassenschädeln," *Archiv für Anthropologie* 40 (1913): 81–96.

80. Carl Heinrich Stratz den Haag, "Das Problem der Rasseneinteilung der Menschen," *Archiv für Anthropologie* I (1904): 189–200.

81. Carl Heinrich Stratz den Haag, *Die Körper des Kindes*, 2d ed. (Stuttgart: Enke, 1904); *Die Rassenschönheit dexs Weibes* (Stuttgart: Enke, 1904); *Körperformen in Kunst und Leben der Japaner* (Stuttgart: Ferdinand Enke, 1904).

82. Stratz was preceded in this by several authors; see especially the frontispiece of Ernst Haeckel, *Natürliche Schöpfungsgeschichte*, 1st ed. (Berlin: Georg Reiner, 1868), which shows an Asian and a negro as the representatives of the most primitive strains. (The frontispiece was not printed in the later editions of the text.) Slightly later English-language sources are R. B. Bean, "Two European Types," *American Journal of Anatomy* 31 (1923): 359–72; Bean, "Three Anatomic Types of Africa," ibid. 33 (1924): 105–18; and Bean, "Types of the Three Great Races of Man," ibid., 37 (1926): 237–71.

83. Stratz, *Naturgeschichte des Menschen, Grundriss der somatischen Anthropologie* (Stuttgart: Ferdinand Enke, 1904). Another in the series is discussed in Elkins, *The Object Stares Back*, pp. 214–15, Fig. 56.

84. Peter De Bolla, *The Discourse of the Sublime, Readings in History, Aesthetics, and the Subject* (London: Blackwell, 1989), p. 219.

85. Stratz, *Naturgeschichte des Menschen, Grundriss der somatischen Anthropologie* (Stuttgart: Ferdinand Enke, 1904), pp. 257–84.

86. E. Bassani and L. Tedeschi, "The Image of the Hottentot in the 17th and 18th Centuries," *Journal of the History of Collections* 2, no. 2 (1990): 157–86; Sander Gilman, "Black Bodies, White Bodies: Toward an Iconography of Female Sexuality in Late Nineteenth-Century Art, Medicine, and Literature," *Critical Inquiry* 12 (1985): 204–42; Anne Fausto-Sterling, *Gender, Race, and Nation: The Comparative Anatomy of "Hottentot" Women in Europe, 1815–1817* (Bloomington: Indiana University Press, 1995); Linda Merians, "What They Are, Who We Are: Representations of the 'Hottentot' in 18th-century Britain," *Eighteenth-Century Life* 17, no. 3 (1993): 14–39.

87. And in opposition to other visual records, for example, those of Alberto Maria de Agostini, *I miei viaggi nella Terra del Fuoco* (Torino: Cartografia Flli de Agostini, 1923); and de Agostini, *Trent'anni nella Terra del Fuoco* (Torino: Società Editrice Internazionale, 1955): de Agostini clothed the natives before he photographed them.

88. Stratz, *Die Schönheit des weiblichen Körpers, den Müttern, Ärzten und Künstlern gewidmet* (Stuttgart: Ferdinand Enke, 1913).

89. *Treasury of Human Inheritance*, ed. Karl Pearson, 4 vols. (Cambridge, Eng.: Cambridge University Press, 1912–48), vol. 1, pl. E.

90. Catharine MacKinnon, *Only Words* (Cambridge, Mass.: Harvard University Press, 1993); and Andrea Dworkin, *Pornography and Civil Rights: A New Day for Women's Equality* (Minneapolis, Minn.: Organizing Against Pornography, 1988). It can be argued that absence of images in Susanne Kappeler's *The Pornography of Representation* (Minneapolis: University of Minnesota Press, 1986) makes it easier for her to draw increasingly exact parallels between a photograph of a lynching and pornography, and between pornography and representation in general. For analyses that pay more attention to individual images (but still without reproducing any), see Linda Williams, *Hard Core: Power, Pleasure, and the "Frenzy of the Visible"* (Berkeley and Los Angeles: University of California Press, 1989); and Laura Kipnis, *Ecstasy Unlimited: On Sex, Capital, Gender, and Aesthetics* (Minneapolis: University of Minnesota Press, 1993), pp. 219–42. I thank Kelly Dennis for drawing my attention to Kappeler, Williams, and Kipnis.

91. Thomas McEvilley, "Who Told Thee That Thou Was't Naked?" *Artforum* 25 (February 1987): 102–8. See also Lynn Avery Hunt, *The Invention of Pornography: Obscenity and the Origins of Modernity, 1500–1800* (Cambridge, Mass.: MIT Press, 1996); Walter Kendrick, *The Secret Museum: Pornography in Modern Culture* (Berkeley and Los Angeles: University of California Press, 1996); and the related argument in Susan Sontag, "The Pornographic Imagination [1967]," in *Styles of Radical Will* (New York: Farrar Straus Giroux, 1969), pp. 35–73. Michael Kimmel, "Introduction: Guilty Pleasures—Pornography in Men's Lives," in *Men Confront Pornography* (New York: Meridian, 1990), pp. 1–22, makes a statistical and social case for pornography's importance.

92. Thomas McEvilley, "Who Told Thee That Thou Was't Naked?" p. 105.

93. Kelly Dennis, "The Face of God: Representation as the Pornography of Modernity," Ph.D. dissertation, University of California at Los Angeles, 1994, unpublished, p. 189.

94. McEvilley, "Who Told Thee That Thou Was't Naked?" p. 106.

95. *I modi, The Sixteen Pleasures: An Erotic Album of the Italian Renaissance,* ed. Lynne Lawner (Evanston, Ill.: Northwestern University Press, 1988); and Pietro Aretino, *Sonetti sopra i 16 modi,* ed. Giovanni Aquilecchia (Rome: Salerno, 1992). The book is deliberately classicizing, although it is quite different from real ancient prototypes; see, for example, *Pornography in Greece and Rome,* ed. Amy Richlin (New York: Oxford University Press, 1992).

96. The most prominent exceptions are late-nineteenth- and early-twentieth-century photographs that mimic academic art traditions. Robert Mapplethorpe is the most prominent example; some of his poses go back to Hippolyte Flandrin, and virtually none of his work refers to the period between the decline of art academies and the rise of postmodernism. Dennis, "The Face of God," pp. 190–93, provides a list of nineteenth-century French photographic societies. See further *The Body Exposed: Views of the Body, 150 Years of the Nude in Photography,* ed. Michael Köhler (Zürich: Stemmle, 1995), especially Chap. 16.

97. McEvilley, "Who Told Thee That Thou Was't Naked?" p. 105.

98. Andrea Dworkin, *Pornography: Men Possessing Women* (New York: E. P. Dutton, 1989); and Michel Foucault, *The History of Sexuality,* trans. Robert Hurley (New York: Pantheon, 1980).

99. C. G. Gordon, "Eden, and Its Two Sacramental Trees: Autograph Dissertation on the Supposed Site of the Garden of Eden, with Two Autograph Sketch-Maps in Colour" (MS, February 26, 1882, advertised for sale in Alan G. Thomas, bookseller, cat. 53, pp. 11–12; 300 King's Road, London SW3 5UJ); see further Fred Plaut, "General Gordon's Paradise," *Analytische Psychologie* 12, no. 3 (1981): 197–226; and "General Gordon's Map of Paradise," *Encounter* (June-July 1982): 20–32.

100. In this connection, see Susanne Kappeler, *The Pornography of Representation* (Minneapolis, 1986), and Susan Sontag, "The Pornographic Imagination," in *A Susan Sontag Reader,* ed. Elizabeth Hardwick (New York: Farrar Straus Giroux, 1982), pp. 205–34.

101. *The Invention of Pornography, Obscenity and the Origins of Modernity, 1500–1800,* ed. Lynn Hunt (New York: Zone Books, 1993).

102. For comparative material on constructions of gender in pictures, see especially Aline Roussel, *Porneia: On Desire and the Body in Antiquity,* trans. Felicia Pheasant (New York: Basil Blackwell, 1988); and Danielle Jacquard and Claude Thomasset, *Sexualité er savoir médical au Moyen Age* (Paris: Presses Universitaires de France, 1985).

103. For Fragonard, see Mary Sheriff, *Fragonard: Art and Eroticism* (Chicago: University of Chicago Press, 1990). On the question of the status of

erotic art, see Robert Benayoun, *Érotique du Surréalisme*, Bibliothèque Internationale d'Érotologie, no. 5 (Paris: Pauvert, 1965); and Volker Kähmen, *Erotic Art Today*, trans. Peter Newmark (Greenwich, Conn.: New York Graphic Society, 1972). The standard source for earlier work is Eduard Fuchs, *Geschichte der erotischen Kunst*, 8 vols. (Munich: Albert Langen, 1908–23). Recent collections include Bradley Smith, *Erotic Art of the Masters: The Eighteenth, Nineteenth, and Twentieth Centuries* (New York: The Erotic Art Book Society, n.d. [c. 1975]); and Eberhard and Phyllis Kronhausen, *The Complete Book of Erotic Art*, 2 vols. (New York: Bell, 1978).

104. See also *Primitive Erotic Art*, ed. Philip Rawson (New York: G. P. Putnam's Sons, 1973).

105. On Salle, see especially S. Liebmann, "Harlequinade for an Empty Room: On David Salle," *Artforum* 25 (February 1987): 94 ff.; and also Peter Schjeldahl, "Absent-Minded Female Nude on Bed," *Artforum* 20 (December 1981): 49.

106. For Millet's pornographic drawings, see Salvador Dalí, *The Tragic Myth of Millet's Angelus, Paranoiac-Critical Interpretation*, trans. Eleanor Morse (St. Petersburg, Fla.: Salvador Dalí Museum, 1986), pp. 140–41. See further Paul Gerhard, *Pornography in Fine Art from Ancient Times up to the Present* (Los Angeles: Elysium, 1969).

107. Volker Kahmen, *Erotic Art Today*, trans. Peter Newmark (Greenwich, Conn.: New York Graphic Society, 1972), Fig. 113.

Chapter 5: Analogic Seeing

1. "Longinus," quoting Plato, *Timaeus*, in *Ancient Literary Criticism*, p. 491, translation modified.

2. Ovid, *Metamorphoses* 14:56–60, trans. Rolfe Humphries (Bloomington: Indiana University Press, 1973), p. 340, line breaks omitted.

3. The theory of emblemata is discussed in Elkins, *Domain of Images*, Chap. 12.

4. Arthur Charles Fox-Davies, *A Complete Guide to Heraldry* (New York: Bonanza Books, 1978).

5. See *Pablo Picasso, A Retrospective*, ed. William Rubin (New York: Museum of Modern Art, 1980), *Woman-Flower* (May 5, 1946), p. 394; and *Bust of a Woman with Self-Portrait* (February 1929), p. 272.

6. Sigmund Freud, "A Mythological Parallel to a Visual Obsession," *Standard Edition*, ed. James Strachey (London: Hogarth Press, 1986), vol. 14, pp. 337–38; Claude Gandelman, *Reading Pictures, Viewing Texts* (Bloomington: Indiana University Press, 1991), pp. 94–110.

7. Analogic difficulties are the driving interest of Bernard Heuvelmans, *On the Track of Unknown Animals*, trans. from the French by Richard Garnett, with 120 drawings by Monique Watteau, and an introduction by Gerald Durrell (New York: Hill and Wang, 1959).

8. *Cézanne, The Late Work*, ed. William Rubin (New York: Museum of Modern Art, 1977). I thank Margaret MacNamidhe for conversations on "passage" and other terms.

9. See, for example, Pierre Daix, *Picasso, The Blue and Rose Periods: A Catalogue Raisonné of the Paintings, 1900–1906*, trans. Phoebe Pool (Greenwich, Conn.: New York Graphic Society, 1967).

10. Leo Steinberg, "The Algerian Women and Picasso at Large," *Other Criteria* (Oxford: Oxford University Press, 1972), pp. 159–60.

11. This analysis is continued in Elkins, "Piero, Picasso: The Aesthetics of Discontinuity," in *Streams into Sand: Links between Renaissance and Modern Painting* (New York: Gordon and Breach, forthcoming).

12. Armand Landrin, *Les Monstres marins* (Paris: Hachette, 1867).

13. Ambroise Paré, "De monstris et prodigis," in *Opera chirurgica Ambrosii Paraei* (Frankfurt am Main: Peter Fischer, 1594), book 24, pp. 717–63, ill. on p. 619. The monster's appearance varies in different editions of Paré's book. It also occurs without the cross and the "Y"—for example, in *Les Oeuvres de M. Ambroise Paré* (Paris: Gabriel Buon, 1575), p. 813. For its history, see Ambroise Paré, *Des Monstres*, ed. Jean Céard (Geneva: Droz, 1971), pp. 155–57. Contemporaneous literature includes Julius Obsequens, *Obseqventis Prodigiorvm liber ab urbe condita ad Augustum Caesarem: cuius tantum extabat fragmentum, nunc demum historiarum beneficio*, per Conradum Lycostenem Rubeaquensem, integritati suae restitutus (Lugduni: Apud Ioan. Tornaesium et Guil. Gazeium, 1553); and Pierre Boaistuau, *Histoires prodigieuses* (Paris: Slotkine, 1996 [1561; 1550]).

14. Ambroise Paré, *Des Monstres et prodiges* (Paris, 1573), trans. Janis Pallister as *On Monsters and Marvels* (Chicago: University of Chicago Press, 1982), Fig. 86. On Paré, see Deboue [no initial], "Ambroise Paré," *Nouvelle Iconographie de la Salpêtrière* 18 (1905): 92 ff.

15. Ambroise Paré, *Des Monstres*, and V. Hamburger, "Monsters in Nature," *Ciba Symposia* 9 (1947): 666–83.

16. John Block Friedman, *The Monstrous Races in Medieval Art and Thought* (Cambridge, Mass.: Harvard University Press, 1981); W. Born, "Monsters in Art," *Ciba Symposia* 9 (1947): 684–96; and Zofia Ameisenowa, "Animal-Headed Gods: Evangelists, Saints, and Righteous Men," *Journal of the Warburg and Courtauld Institutes* 12 (1949): 21–45. The history of monsters is a fast-growing area of inquiry. See especially Harriet Ritro, *The Platypus and the Mermaid and Other Figments of the Classifying Imagination* (Cambridge, Mass.: Harvard University Press, 1997); *Frankenstein, Creation, and Monstrosity*, ed. Stephen Bann (London: Reakton, 1994); and Lorraine Daston and Katherine Park, *Wonders and the Order of Nature, 1150–1750* (Cambridge, Mass.: Zone Press, 1998).

17. For the *gryllos*, *gryphos*, or *aenigma*, see Antonio Francesco Gori, *Thesaurus Gemmarum Antiquarum Astriferarum* (Florence: Albizinia, 1750), vol. 2, p. 171. See also Richard Merz, *Die numinose Mischgestalt. Methodenkritische Untersuchungen zu tiermenschlichen Erscheinungen Altägyptens, der Eiszeit, und der*

Aranda in Australien, religionsgeschichtliche Vorsuche und Vorarbeiten. XXXVI, ed. W. Burkert and C. Colpe (Berlin: de Gruyter, 1978). For *grylli* in glyptics, see Stafford, *Body Criticism*, p. 269. The history of *grylli* should also include early efforts to imagine non-Western deities, as in the odd versions of Hindu gods in Phillips Baldaeus, *Beschrijving der oost-Indische Kusten Malabar en Choromaudel* (Amsterdam: Johannes Janssonius van Woesberge, 1672); Olfert Dapper, *Umbstaendliche und eigentliche Beschreibung von Asia* (Nuremberg: Johannes Hoffman, 1681); and Bernard Picart, *The Ceremonies and Ritual Customs of the Various Nations of the Known World* (London: Claude Du Bose, 1739).

18. Claude Duret, *Histoire admirable des plantes* (Paris: N. Bvon, 1605); and see John Priest, *The Garden of Eden, The Botanic Garden and the Re-Creation of Paradise* (New Haven, Conn.: Yale University Press, 1981), pp. 51–52 nn. 47–50.

19. Arthur O. Lovejoy, *The Great Chain of Being* (New York: Harper, 1986 [1936]).

20. Duncan G. N. Barker, "*Grylli, Verstand und Unsinn* in Classical Glyptics," M.A. thesis, Department of Art, University of Chicago, 1989, unpublished; and Stafford, *Body Criticism*, p. 211.

21. Katherine Park and Lorraine Daston, "Unnatural Conceptions: The Study of Monsters in Sixteenth- and Seventeenth-Century France and England," *Past and Present* 92 (1981): 20–54; Heinz Adolf Mode, *Fabulous Beasts and Demons* (London: Phaidon, 1975); Russell Charles Maulitz, *Morbid Appearances: The Anatomy of Pathology in the Early Nineteenth Century* (New York: Cambridge University Press, 1987); and Gilbert Lascault, *Le Monstre dans l'art occidental: Un problème esthétique* (Paris: Klincksieck 1973).

22. Descartes, *Discourse on Method and Meditations on First Philosophy*, trans. Donald A. Cress (Indianapolis: Hackett, 1980), p. 267.

23. Donna Haraway, "Manifesto for Cyborgs, Science, Technology, and Socialist Feminism," in *Feminism/Postmodernism*, ed. Linda J. Nicholson (New York: Routledge, 1990); *Inventing Women: Science, Technology, and Gender*, ed. Gill Kirkup and Laurie Smith Keller (Cambridge, Mass.: B. Blackwell, 1992); Lucie Schauer, "Vom Mythos zur Megamaschine: Zur Geschichte des künstlichen Menschen," in *Maschinenmenschen*, exh. cat., ed. Lucie Schauer (Berlin: Neuen Berliner Kunstvereins, 1989), pp. 7–20. The recent interest in machine-human hybrids is the outgrowth of the "machine aesthetic," a prominent aspect of modernism in the first decades of the century. See Myriam Wierschowski, *Studien zur Ikonographie der anthropomorphen Mechanik in der Kunst des 20. Jahrhunderts* (Mainz: Wissenschaftsverlag, 1994).

24. The connection between the eighteenth-century breakdown of the analogic Chain of Being and microscopy can also be followed in Bishop Berkeley's "argument from microscopes": blood appears solidly red, even though under the microscope it is part red cells and part clear fluid. But either one or both of these impressions must be wrong, and therefore color is a secondary quality, so that "the colors which we see [do not] exist in external

bodies." This approach was made famous in another form and for our century by Bertrand Russell's argument about the various "real" tables shown us by our eyes and by our microscopes. See Berkeley, *Three Dialogues Between Hylas and Philonous* (Indianapolis: Bobbs-Merrill, 1979), p. 20; and Russell, *The Problems of Philosophy* (London: Oxford University Press, 1975 [1948]), p. 10. David R. Hilbert, *Color and Color Perception* (Stanford, Calif.: Center for the Study of Language and Information, 1987), pp. 23 and 29, argues that "at heart, Berkeley's argument depends on a failure to take seriously the partial nature of perception"—a conclusion in line with my argument about analogy.

25. Elkins, *The Object Stares Back*, pp. 151–53; S. Conway Morris, "A New Metazoan from the Cambrian Burgess Shale, British Columbia," *Palaeontology* 20 (1977): 624; Rick Gore, "The Cambrian Period Explosion of Life," *National Geographic* 184, no. 4 (October 1993): 120–36, especially 126–27; Stephen Jay Gould, *Wonderful Life* (New York: W. W. Norton 1989).

26. Louis Joblot, *Descriptions et usages de plusieurs nouveaux microscopes. . . .* (Paris: Collombat, 1718), p. 55. For the connection between microscopy, sophistry, and fraud, see Stafford, *Body Criticism*, pp. 341–98, especially p. 362.

27. "Lächerlichen Sprünge und hüpfenden Verdrehungen und Wendungen"; see Martin Frobenius Ledermüller, *Nachleese seiner mikroskopischen Gemüths- und Augen-Ergötzung* (Nuremberg: C. de Launoy, 1760), p. 145, tab. LXXV. See also Ledermüller's *Mikroskopische Gemüths- und Augen-Ergötzung* (Nuremberg: C. de Launoy, 1760); and his *Physikalische Beobachtungen* (Nuremberg: G. P. Monath, 1756).

28. On Pasteur, see, for example, Bruno Latour, *The Pasteurization of France* (Cambridge, Mass.: Harvard University Press, 1988); and on Spallanzani, see Giulio Vassale, *Lazzaro Spallanzani e la generazione spontanea: discorso inaugurale letto nella R. Università di Modena* (Modena: Società tipografia modenese, 1899).

29. The idea was that animalcules need never die because they could divide themselves, willing all of their bodies to the next generation. Critics of this notion thought that sexual reproduction would eventually be necessary, so that the individual animalcules could die. (The psychology of this is immediately apparent: sex involves death, and the researchers wanted to be sure that microscopic animalcules had not found a better way.) Eventually, in the first decades of this century, Lorande Loss Woodruff conducted exhaustive experiments to prove that *Paramecium* sp. could regenerate indefinitely without needing to resort to sexual reproduction. A single individual, therefore, is effectively "immortal": it splits part of itself, which goes on living until it is ready to split—there is no dissolution, no "death," and no need to find another organism to perpetuate life. See Woodruff, "A Summary of the Results of Certain Physiological Studies on a Pedigreed Race of Paramecium," *Biochemical Bulletin* I (1912): 396 ff. For a review of sexual reproduction and an excellent bibliography, see David Henry Wenrich, "Sex in Protozoa: A Comparative Review," in D. H. Wenrich et al., *Sex in Microorganisms* (Washington, D.C.: American Association for the Advancement of Science, 1954), pp. 134–65.

Freud was aware of the earlier literature and puzzled over it in "Beyond the Pleasure Principle," *Standard Edition*, ed. James Strachey (London: Hogarth Press, 1986), vol. 18, pp. 45 ff.

30. C. Wilson, "Visual Surface and Visual Symbol: The Microscope and the Occult in Early Modern Science," *Journal of the History of Ideas* 49 (1988): 85–108.

31. Until C. T. von Siebold, synonyms seem to multiply as quickly as the organisms themselves. "*Dierken*" is Leeuwenhoek's term. Henry Baker, *Of Microscopes* (London: R. and J. Dodsley, 1753), vol. 1, p. 68, calls them "Invisibles." For "protozoa," see Georg August Goldfuss, *Handbuch der Zoologie* (Nuremberg: J. L. Schrag, 1820 [1817]). For "protista," see Ernest Heinrich Philipp August Haeckel, *Generelle Morphologie* (Berlin: de Gruyter, 1988 [1866]). On "infusoria," see Ledermüller, *Nachleese*.

32. Described, for example, in Haeckel, *Das Protistenreich: Eine populäre Übersicht* (Leipzig: E. Günther, 1870).

33. Stafford, *Body Criticism*, p. 288.

34. Swift, "The Lady's Dressing Room," *The Poems of Jonathan Swift*, ed. Harold Williams (Oxford: Clarendon Press, 1958), vol. 2, p. 527. For a parallel example in twentieth-century literature, see Mary Marples, "Life on the Human Skin," *Scientific American* 220, no. 1 (1969): 108–15.

35. See also Ledermüller, *Mikroskopische Gemüths- und Augen-Ergötzung*, tab. XXVII, pp. 76 ff. (*Daphnia*, "Ein kleines Wasserinsekt der Dauphin genannt"); and see tab. VII, p. 15 ff. ("Die Schwarzer Wasserflöhe," which gathers little balls of water under its feet). The sea was a source for strange creatures; see François Valentijn, *Oud en Nieuw Oost-Indien*, 5 vols. (Dordrecht: J. van Braam, 1724–26), especially vol. 3; two plates of "fish" are reproduced in S. Peter Dance, *The Art of Natural History* (New York: Overlook Press, 1978), p. 48.

36. Ledermüller, *Nachleese seiner mikroskopischen Gemüths- und Augen-Ergötzung*, tab XXVI, p. 49.

37. The early history of *Holostycha* is exemplary because it "crawls" "like a millipede" but has no "legs" or "arms." See Leeuwenhoek, letter 26, in *The Collected Letters of Antoni van Leeuwenhoek* (Amsterdam: N.v. Swets en Zeitlinger, 1941), vol. 2, p. 69. (Vols. II, 1941, and IV, 1952, contain letters on protozoa.)

38. "Animalculum singularissimum" is from Otto Frederik Müller, *Animalcula infusoria, fluvia tilia et marina* . . . (Copenhagen and Leipzig: N. Möller, 1786), p. 10; Henry Baker's "Proteus" may have been *Lacrymaria olor* Müller. See Baker, *Of Microscopes*, vol. 1, pp. 260–66. Müller, *Animalcule*, calls Baker's organism *Trichoda proteus* (p. 179) and the amoeba proper *Proteus diffluens* and *Proteus tenax* (pp. 9–11).

39. August Johann Rösel von Rosenhof, *Der monatlich-herausgegebenen Insecten-Belüstigung*, 1741 [1741–55], pl. CI, pp. 622–24.

40. John Turberville Needham, *New Microscopical Discoveries* (London: printed for F. Needham, over-against Gray's Inn in Holborn, 1745), p. 265; pl.

X, no. xi, Figs. 3 and 4. See further S. A. Roe, "John Turberville Needham and the Generation of Living Organisms," *Isis* 74 (1983): 159–84.

41. *The Biology of the Naked Mole-Rat*, ed. Paul Sherman, Jennifer Jarvis, and Richard Alexander (Princeton, N.J.: Princeton University Press, 1991). The quotation is from the review by Gail Michener, *Science* 253 (August 16, 1991): 803–4.

42. Martin Hart, *Rats* (London: Allison and Busby, 1982), Chap. 4, especially pp. 81–84.

43. Scarry, *The Body in Pain*, p. 283.

44. Leeuwenhoek, *Letters*, letters of November 1677 (p. 277), March 18, 1678 (p. 325), May 31, 1678 (p. 357), and February 21, 1629 (p. 411). See also tables XVIII–XIX, p. 295 n. 31, p. 333 n. 9, p. 335 n. 12, and p. 363 n. 9; Grew, in *Philosophical Transactions of the Royal Society of London* 12 (1678): 1043; and Brian J. Ford, *Single Lens* (New York: Harper and Row, 1985), with a photograph of Leeuwenhoek's blood.

45. Leeuwenhoek, *Letters*, pp. 367, 333, 295, respectively. Leeuwenhoek's protest is in a letter of May 31, 1678, p. 365.

46. For illustrations of Hartsoeker's hallucinations, see, for example, R. C. Punnett, "Ovists and Animalculists," *The American Naturalist* 62 (1928): 481–507. There are exceptions to these fantasies. Ledermüller's *Physicalische Beobachtungen derer Saamenthiergens, durch die aller besten vergrößerungs-Gläser und bequemlichsten Microscope betrachtet; und mit einer unpartheyischen Untersuchung und Gegeneinanderhaltung derer Buffonischen und Leuwenhoeckischen Experimenten* (Nuremberg: G. P. Monath, 1756), especially pl. [3], Fig. XIII, shows internal structures in the spermatozoa (which he calls "Saamenthiergens" and "Moleculas," following Buffon); and the same author's *Mikroskopische Gemüths- und Augen-Ergötzung*, tab. XVII, p. 33.

47. Needham, *New Microsopical Discoveries*, p. 56. See further C. T. von Siebold, *Beiträge zur Naturgeschichte der Wirbellosen Thiere . . . Ueber Medusa, Cylops, Loligo, Gregaria und Xenos* (Danzig, 1839), tab. II.

48. Needham, *Philosophical Transactions of the Royal Society of London* 65 (1748): 615–66, §25.

49. Philipp Ludwig Status Müller, *Des Ritters Carl von Linné Vollständiges Natursystem* (Nuremberg: Gabriel Nicolaus Raspe, 1775), vol. VI, part 2, "Von der Corallen," pp. 917, 924, pl. 36, Figs. 4b–4d.

50. Linnaeus, *Systema naturae* (Stockholm: L. Salvius, 1767), vol. I, part III. In the second edition (1740), the genus *Microcosmus* is the last of the three orders (*Testacea*) of *Vermes*.

51. *Correspondence inédite entre Réaumur et Abraham Trembley*, ed. M. Trembley (Geneva: Georg, 1943), p. 15, quoted in Virginia P. Dawson, *Nature's Enigma: The Problem of the Polyp in the Letters of Bonnet, Trembley and Réaumur* (Philadelphia: American Philosophical Society, 1987), pp. 101–2, with a good bibliography of secondary sources and transcription of the letters. See also Baker, *An Attempt Towards a Natural History of the Polype: In a Letter to Martin*

Folkes, Esq, President of the Royal Society (London: R. Dodsley, 1743); Trembley, in *Philosophical Transactions of the Royal Society of London* 42 (1745): 474. Hand-colored illustrations can be found in Ledermüller, *Mikroskopische Gemüths- und Augen-Ergötzung*, tab. LXVII ("Die Armpolype"), tab. LXXI ("Die braunen Poypen mit langen Armen"), and tab. LXXVII ("Die Fortsetzung von Polypen"). Hydras in wax are preserved in the Museo della Specola in Florence; see Lanza et al., *Le cere anatomiche della Specola*, p. 239, Fig. ET 22.

52. Aram Vartanian, "Trembley's Polyp, La Mettrie, and Eighteenth-Century French Materialism," *Journal of the History of Ideas* 11 (1950): 159–86.

53. Heinrich August Wrisberg, *Observationum de animalculis infusoriis satura* (Göttingen: B. Vandenhoeck, 1765).

54. Ledermüller, *Nachleese seiner mikroskopischen Gemüths- und Augen-Ergötzung.*

55. J. Ellis, "Observations on a Particular Manner of Increase in the Animalcula of Vegetable Infusions," *Philosophical Transactions of the Royal Society of London* 59 (1719): 143.

56. Needham, *New Microscopical Discoveries*, [sec.] 10.

57. John Hill, *Essays in Natural History* (London: J. Whiston and B. White, 1752), p. 105. A clever discussion of such mysteries, including Jonathan Swift's poem about fleas (which have ever-smaller fleas on them) is in Augustus De Morgan, *A Budget of Paradoxes* (Chicago: Open Court, 1915), vol. 2, p. 191.

58. Linnaeus, *A General System of Nature* (London: Lackington, Allen, 1806), vol. IV, p. 724. See Müller, *Animalcula infusoria*, p. 917: "Es sey, dass es ihm als ein *Chaos* der Verwirrung Vorkomme, oder als ein Urstoff, woraus fernere Bildungen entstehen."

59. Edward Harrison, *Darkness at Night: A Riddle of the Universe* (Cambridge, Mass.: Harvard University Press, 1987). To Christian Gottfried Ehrenberg, protozoa had "surpassed" [überflügen] "all the limits of visible effects." *Verbreitung und Einfluss mikroskopischen Lebens in Süd- und Nord-Amerika* (Berlin: Königliche Akademie der Wissenschaften, 1843), p. 5.

60. Joblot, *Descriptions et usages de plusiers nouveaux microscopes* (Paris: Collombat, 1781), pl. 6, pp. 51–58. Joblot's book is the first independent monograph on infusoria; it continues a Continental emphasis on the animalcules that correspond to particular infusions (of hay, vinegar, mullet) and their particular smells. Smell and taste were important to protozoology from the outset; Leeuwenhoek's pepper infusions were designed in order to find out how the pepper odor and taste were preserved.

61. Baker, *Of Microscopes*, vol. 1, p. 261.

62. The plate is reproduced in Elkins, *The Object Stares Back*, p. 157, Fig. 39.

63. Baker, *Of Microscopes*, pp. 16, 24, 27, 31, 32, 41.

64. Hill, *Essays in Natural History*, pp. 103, 108–9.

65. Baker, *Of Microscopes*, p. 73. Leeuwenhoek, *Letters*, vol. II, p. 67.

X, no. xi, Figs. 3 and 4. See further S. A. Roe, "John Turberville Needham and the Generation of Living Organisms," *Isis* 74 (1983): 159–84.

41. *The Biology of the Naked Mole-Rat*, ed. Paul Sherman, Jennifer Jarvis, and Richard Alexander (Princeton, N.J.: Princeton University Press, 1991). The quotation is from the review by Gail Michener, *Science* 253 (August 16, 1991): 803–4.

42. Martin Hart, *Rats* (London: Allison and Busby, 1982), Chap. 4, especially pp. 81–84.

43. Scarry, *The Body in Pain*, p. 283.

44. Leeuwenhoek, *Letters*, letters of November 1677 (p. 277), March 18, 1678 (p. 325), May 31, 1678 (p. 357), and February 21, 1629 (p. 411). See also tables XVIII–XIX, p. 295 n. 31, p. 333 n. 9, p. 335 n. 12, and p. 363 n. 9; Grew, in *Philosophical Transactions of the Royal Society of London* 12 (1678): 1043; and Brian J. Ford, *Single Lens* (New York: Harper and Row, 1985), with a photograph of Leeuwenhoek's blood.

45. Leeuwenhoek, *Letters*, pp. 367, 333, 295, respectively. Leeuwenhoek's protest is in a letter of May 31, 1678, p. 365.

46. For illustrations of Hartsoeker's hallucinations, see, for example, R. C. Punnett, "Ovists and Animalculists," *The American Naturalist* 62 (1928): 481–507. There are exceptions to these fantasies. Ledermüller's *Physicalische Beobachtungen derer Saamenthiergens, durch die aller besten vergrößerungs-Gläser und bequemlichsten Microscope betrachtet; und mit einer unpartheyischen Untersuchung und Gegeneinanderhaltung derer Buffonischen und Leuwenhoeckischen Experimenten* (Nuremberg: G. P. Monath, 1756), especially pl. [3], Fig. XIII, shows internal structures in the spermatozoa (which he calls "Saamenthiergens" and "Moleculas," following Buffon); and the same author's *Mikroskopische Gemüths- und Augen-Ergötzung*, tab. XVII, p. 33.

47. Needham, *New Microsopical Discoveries*, p. 56. See further C. T. von Siebold, *Beiträge zur Naturgeschichte der Wirbellosen Thiere . . . Ueber Medusa, Cylops, Loligo, Gregaria und Xenos* (Danzig, 1839), tab. II.

48. Needham, *Philosophical Transactions of the Royal Society of London* 65 (1748): 615–66, §25.

49. Philipp Ludwig Status Müller, *Des Ritters Carl von Linné Vollständiges Natursystem* (Nuremberg: Gabriel Nicolaus Raspe, 1775), vol. VI, part 2, "Von der Corallen," pp. 917, 924, pl. 36, Figs. 4b–4d.

50. Linnaeus, *Systema naturae* (Stockholm: L. Salvius, 1767), vol. I, part III. In the second edition (1740), the genus *Microcosmus* is the last of the three orders (*Testacea*) of *Vermes*.

51. *Correspondence inédite entre Réaumur et Abraham Trembley*, ed. M. Trembley (Geneva: Georg, 1943), p. 15, quoted in Virginia P. Dawson, *Nature's Enigma: The Problem of the Polyp in the Letters of Bonnet, Trembley and Réaumur* (Philadelphia: American Philosophical Society, 1987), pp. 101–2, with a good bibliography of secondary sources and transcription of the letters. See also Baker, *An Attempt Towards a Natural History of the Polype: In a Letter to Martin*

Folkes, Esq, President of the Royal Society (London: R. Dodsley, 1743); Trembley, in *Philosophical Transactions of the Royal Society of London* 42 (1745): 474. Hand-colored illustrations can be found in Ledermüller, *Mikroskopische Gemüths- und Augen-Ergötzung*, tab. LXVII ("Die Armpolype"), tab. LXXI ("Die braunen Poypen mit langen Armen"), and tab. LXXVII ("Die Fortsetzung von Polypen"). Hydras in wax are preserved in the Museo della Specola in Florence; see Lanza et al., *Le cere anatomiche della Specola*, p. 239, Fig. ET 22.

52. Aram Vartanian, "Trembley's Polyp, La Mettrie, and Eighteenth-Century French Materialism," *Journal of the History of Ideas* 11 (1950): 159–86.

53. Heinrich August Wrisberg, *Observationum de animalculis infusoriis satura* (Göttingen: B. Vandenhoeck, 1765).

54. Ledermüller, *Nachleese seiner mikroskopischen Gemüths- und Augen-Ergötzung*.

55. J. Ellis, "Observations on a Particular Manner of Increase in the Animalcula of Vegetable Infusions," *Philosophical Transactions of the Royal Society of London* 59 (1719): 143.

56. Needham, *New Microscopical Discoveries*, [sec.] 10.

57. John Hill, *Essays in Natural History* (London: J. Whiston and B. White, 1752), p. 105. A clever discussion of such mysteries, including Jonathan Swift's poem about fleas (which have ever-smaller fleas on them) is in Augustus De Morgan, *A Budget of Paradoxes* (Chicago: Open Court, 1915), vol. 2, p. 191.

58. Linnaeus, *A General System of Nature* (London: Lackington, Allen, 1806), vol. IV, p. 724. See Müller, *Animalcula infusoria*, p. 917: "Es sey, dass es ihm als ein *Chaos* der Verwirrung Vorkomme, oder als ein Urstoff, woraus fernere Bildungen entstehen."

59. Edward Harrison, *Darkness at Night: A Riddle of the Universe* (Cambridge, Mass.: Harvard University Press, 1987). To Christian Gottfried Ehrenberg, protozoa had "surpassed" [überflügen] "all the limits of visible effects." *Verbreitung und Einfluss mikroskopischen Lebens in Süd- und Nord-Amerika* (Berlin: Königliche Akademie der Wissenschaften, 1843), p. 5.

60. Joblot, *Descriptions et usages de plusiers nouveaux microscopes* (Paris: Collombat, 1781), pl. 6, pp. 51–58. Joblot's book is the first independent monograph on infusoria; it continues a Continental emphasis on the animalcules that correspond to particular infusions (of hay, vinegar, mullet) and their particular smells. Smell and taste were important to protozoology from the outset; Leeuwenhoek's pepper infusions were designed in order to find out how the pepper odor and taste were preserved.

61. Baker, *Of Microscopes*, vol. 1, p. 261.

62. The plate is reproduced in Elkins, *The Object Stares Back*, p. 157, Fig. 39.

63. Baker, *Of Microscopes*, pp. 16, 24, 27, 31, 32, 41.

64. Hill, *Essays in Natural History*, pp. 103, 108–9.

65. Baker, *Of Microscopes*, p. 73. Leeuwenhoek, *Letters*, vol. II, p. 67.

Leeuwenhoek also found "globules," a "tail" with a "bollotge" at its end (the base of the stalk, in modern terms).

66. Hill, *Essays in Natural History*, p. 104.

67. Needham, "A Summary of Some Late Observations," p. 618.

68. The English renders *Infusionsthierchen als volkommene Organismen, Ein Blick in das tiefere organische Leben der Natur* (Leipzig: L. Voss, 1838). It is significant that Erhenberg also wrote a beautifully illustrated *Erläuterungstafeln zur vergleichenden Anatomie* (1855) with illustrations of "complete" prosected intestinal tracts.

69. Ehrenberg, *Erläuterungstafeln*, vol. IV, p. 5.

70. ". . . excessivement variable; elle est quelquefois multiple, quelquefois formée de grains irrégulièrement agrégés." Félix Dujardin, *Histoire naturelle des zoophytes, infusoires* (Paris: Roret, 1841).

71. Carl Theodor Ernst von Siebold and Hermann Stannius, *Lehrbuch der vergleichende Anatomie der wirbellosen Thiere* (1845), pp. 25–26. Trans. by W. I. Burnett as *Comparative Anatomy* (Boston: Gould and Lincoln, 1854). Siebold gave the first modern definition of "protozoa" as a group "without clear separation between organ systems"; he included polyps and medusae. In his taxonomy, Infusoria and Rhizopoda both constituted Protozoa.

72. Dujardin, *Histoire naturelle*, p. 111: "tout le reste est fourni par l'analogie."

73. See also Carl Gustav Carus, *Erläuterungstafeln zur vergleichenden Anatomie* (Leipzig: Barth, 1855); and see Ernst Haeckel, *Kunstformen der Natur* (Leipzig: Verlag des Bibliographischen Instituts, 1899–1904).

74. Siebold, *Beiträge zur Naturgeschichte der Wirbellosen Thiere*.

75. Karl G. Grell, *Protozoology* (Berlin: Springer, 1973 [1956]).

76. E. S. Barghoorn and S. A. Tyler, "Microorganisms from the Gunflint Chert," *Science* 147 (1965): 563–77; S. M. Siegel and C. Giumarro, "On the Culture of a Microorganism Similar to the Precambrian Microfossil *Kakabekia umbellata* Barghoorn in NH3-rich Atmospheres," *Proceedings of the National Academy of Sciences, U.S.A.* 55 (1966): 349–53; S. M. Siegel, K. Roberts, and O. Daly, "The Living Relative of the Microfossil *Kakabekia*," *Science* 156 (1967): 1231–34. The discovery was disseminated in Walter Varian Brown and Eldridge Melvin Bertke, *Textbook of Cytology* (St. Louis: C. V. Mosby, 1969).

77. "The helical organism forms, as it were, part of an imaginary helix extending in either direction beyond the limits of the body; at any moment part of the helix is realized . . . we might say that the green helical organism moves by growing." Lawrence Ernest Rowland Picken, "On a Green Helical Organism and Its Motion," *Proceedings of the Royal Society, London*, ser. B, no. 129 (1940): 89; Picken, *The Organization of Cells and Other Organisms* (Oxford: Clarendon Press, 1960), pp. 94–96.

78. Wilhelm Reich, *Die Bione zur Entstehung des vegetativen Lebens* (Oslo: Sexpol-Verlag, 1938), trans. Derek Jordan and Inge Jordan as *The Bion Experiments on the Origin of Life* (New York: Octagon, 1979), p. 143: "Pasteur's experiment thus does not disprove the theory of spontaneous generation but

merely discloses the effect of dust particles in the air." Pasteur, "Fermentations et générations dites spontanées," *Oeuvres* (Paris: Masson, 1922), vol. 2, appears in Reich's bibliography.

79. Reich, *The Bion Experiments*, p. 114.

80. Ibid., pp. 47, 48, 59, 79.

Chapter 6: Dry Schemata

1. Deleuze, *La logique de la sensation*, p. 67, my translation.

2. From "The Humanist," in Geoffrey Hill, *New and Collected Poems 1952–1992* (Boston: Houghton Mifflin, 1994), p. 57.

3. See, for example, the schemata in the eighth-century MS Lat. 14300 in the Bayerisches Staatsbibliothek, Munich, reproduced in Albert S. Lyons and R. Joseph Petrucelli, *Medicine: An Illustrated History* (New York: H. N. Abrams, 1978), Fig. 423. See also the Greek cross form in Claude Thomasset, "The Nature of Women," in *A History of Women in the West*, ed. Christiane Klapisch-Zuber (Cambridge, Mass.: Harvard University Press, 1992), vol. 2, pp. 42–69, especially p. 49, reproducing a chart in W. D. Sharpe, "Isidore of Seville: The Medical Writings," *Transactions of the American Philosophical Society* 44, no. 2 (1964): 24.

4. See further A. Pagel, "Religious Motives in the Medical Biology of the Seventeenth Century," *Bulletin of the History of Medicine* 3 (1935): 279.

5. Love melancholy is also known as *amoreus* and *knight melancholy*, and there are other kinds as well. Robert Burton, *Anatomy of Melancholy* (Kila, Mont.: Kessinger Reprints, 1991), pp. 108, 109, 112. For Burton's distortions of Galenic theory, see Thomas Canavan, "Madness and Enthusiasm in Burton's 'Anatomy of Melancholy' and Swift's 'Tale of a Tub.'" Ph.D. dissertation, Columbia University, 1970, unpublished; and Patricia Vicari, *The View from Minerva's Tower: Learning and Imagination in* The Anatomy of Melancholy (Toronto: University of Toronto Press, 1989).

6. Burton, *Anatomy of Melancholy*, p. 242.

7. Ibid., p. 243.

8. Fludd and Burton also share ideas about geography and its influence on temperament; see Anne Chapple, "Robert Burton's Geography of Melancholy," *Studies in English Literature, 1500–1900* 33, no. 1 (1993): 99–130.

9. The philosophy and history of schemata are discussed in Elkins, *The Domain of Images*, Chap. 13, "Schemata."

10. In this context, the late-nineteenth- and early-twentieth-century use of the pair "haptic" and "optic" can also be read as a particular reaction to the represented body, with haptic outlines corresponding to geometric schemata, and optical fields corresponding to flesh. See Margaret Olin, *Forms of Representation in Alois Riegl's Theory of Art* (University Park: Pennsylvania State University, 1992).

11. In the scene reproduced here, the newly alive Saw-Horse has toppled and lies bewildered in a ditch. "'How many sides have I?' asked the creature,

wonderingly. 'Several,' said Tip, briefly." Most of the creatures are in L. Frank Baum, *The Land of Oz* (New York: Rand McNally, n.d. [c. 1904]); the 3-Wheelers and TikTok are in *Ozman of Oz* (Chicago: Reilly and Lee, 1907). The quotation is from *The Land of Oz*, p. 47.

12. Stafford, *Body Criticism*, pp. 12–15; Nicole Loraux, "Therefore, Socrates Is Immortal," trans. Janet Lloyd, in *Fragments for a History of the Human Body*, vol. 2, pp. 12–45, especially pp. 35–36.

13. Stafford, *Body Criticism*, pp. 11, 148; Stafford, *Symbol and Myth: Humbert de Superville's Essay on Absolute Signs* (Cranbury, N.J.: University of Delaware Press, 1979), pp. 78–80; Elkins, "Clarification, Destruction, and Negation of Pictorial Space in the Age of Neoclassicism, 1750–1840," *Zeitschrift für Kunstgeschichte* 56, no. 4 (1990): 560 ff.

14. Tom Conley, *The Graphic Unconscious in Early Modern French Writing* (Cambridge, Eng.: Cambridge University Press, 1992).

15. Camille Paglia, *Sexual Personae* (New Haven, Conn.: Yale University Press, 1990), p. 18.

16. Sigmund Freud, "A Mythological Parallel to a Visual Obsession," in *Standard Edition*, ed. James Strachey (London: Hogarth Press, 1986), vol. 14, pp. 337–38; Claude Gandelman, *Reading Pictures*, pp. 94–110.

17. The same observations could be made of Julia Kristeva's concept of abjection. In *Powers of Horror: An Essay on Abjection*, trans. Leon Roudiez (New York: Columbia University Press, 1982), the abject can be horrible *to contemplate*, but it doesn't often cause a visceral, "painful" reaction.

18. Mikhail Mikhailovich Bakhtin, *Rabelais and His World*, trans. Hélène Iswolsky (Bloomington: Indiana University Press, 1984 [1968]), p. 317. In the recent literature, see, for example, Elizabeth Childs, "Big Trouble: Daumier, *Gargantua*, and the Censorship of Political Caricature," *The Art Journal* 51, no. 1 (1992): 30–37.

19. Johannes de Ketham [Petrus de Montagnana], *Fasciculus medicinae* (Venice: par Joannem et Gregorium de Gregoriis, 1491) was translated into Latin in 1495 and reprinted in 1500. See further Jacques Le Goff, "Head or Heart? The Political Use of Body Metaphors in the Middle Ages," in *Fragments for a History of the Human Body*, vol. 3, pp. 12–27, especially pp. 12 and 27; and P. M. Jones, *Medieval Medical Miniatures*, Fig. 29. There are other, more grotesque variations on this theme: see, for example, early *ars memorativa* texts such as Nicholas Simonis, *Ludus artificialis oblivionis gratia dei omniumque vitiorum fugativus virtutum ac scientiarium lucrativus memoriam tum arte medicinalibus salvans* (Leipzig: [s.n.], 1510); or anonymous, *Rationarium Evanglistarum* (Pforzheim: Thomas Anshelm, 1507).

20. Much of what follows is indebted to Erwin Panofsky's essay "The History of the Theory of Proportions as a Reflection of the History of Styles," in *Meaning in the Visual Arts* (Chicago: University of Chicago Press, 1982 [1955]), pp. 55–107.

21. D'Arcy Wentworth Thomson, *On Growth and Form*, 2 vols. (Cam-

bridge, Eng.: Cambridge University Press, 1968), vol. 2, pp. 1053–90, especially p. 1063.

22. H. A. Wilmer and R. E. Scammon, "A Comparison of the Topography and Composition of the Body at Birth and in the Adult by Some Newer Methods," abstract of a demonstration at the American Association of Anatomy, 55th National Session, *Anatomical Record* 73, suppl. (1939): 77.

23. "Morphometrics" is the contemporary scientific study of the rules of structural change. See *Proceedings of the Michigan Morphometrics Workshop*, ed. F. James Rohlf and Fred Bookstein (Ann Arbor: University of Michigan Museum of Zoology, 1990).

24. Gregory Vincent Leftwich, *Ancient Conceptions of the Body and the Canon of Polykleitos*, Ph.D. dissertation, Princeton University, 1987 (Ann Arbor, Mich.: UMI Dissertation Information Service, 1989).

25. For the Middle Ages, see M. Kurdzialek, "Der Mensch als Abbild des Kosmos," in Albert Zimmerman, ed., *Der Begriff der repräsentatio im Mittelalter: Stellvertretung, Symbol, Zeichen, Bild* (Berlin: de Gruyter, 1971), pp. 35–71; for the Renaissance, see Elkins, "The Case Against Surface Geometry," *Art History* 14, no. 2 (1991): 143–74.

26. Manfred Lurker, *Der Kreis als Symbol im Denken, Glauben und künstlerischen Gestalten der Menschheit* (Tübingen: Wunderlich, 1981), pp. 145–71.

27. Mario Merz, *Fibonacci 1202* (Turin: Sperone, 1972); Fibonacci, *Scritti di Leonardo Pisano . . . pubblicati da Baldassarre Boncompagni*, 2 vols. (Roma: Tipografia delle scienze matematiche e fisiche, 1857–62).

28. Miloutine Borissavlievitch, *The Golden Number and the Scientific Aesthetics of Architecture* (London: Alec Tiranti, 1958). The best general source is Hermann Graf, *Bibliographie zum Problem der Proportionen: Literatur über Proportionen, Mass und Zahl in Architektur, bildender Kunst und Natur*, Pfälzische Arbeiten zum Buch- und bibliothekswesen und zur Bibliographie, no. 3 (Speyer: Pfälzische Landesbibliothek, 1958), pt. 1, *Von 1800 bis zur Gegenwart.* (Part 2 was apparently never published.) For excellent arguments against the ostensible prevalence of the golden section, see Robert Palter, "*Black Athena*, Afro-Centrism, and the History of Science," *History of Science* 31 (1993): 227–87; and George Markowsky, "Misconceptions about the Golden Ratio," *College Mathematics Journal* 23, no. 1 (1992): 2–19.

29. Matila Costiescu Ghyka, *The Geometry of Art and Life* (New York: Sheed and Ward, 1962).

30. For Greece, see August Kalkmann, *Die Proportionen des Gesichts in der griechischen Kunst*, Berliner Winckelmannsprogram, no. 53 (Berlin: G. Reimer, 1893); for the history of Egyptophilia, see Martin Bernal, *Black Athena, The Afroasiatic Roots of Classical Civilization*, vol. 1, *The Fabrication of Ancient Greece 1785–1985* (New Brunswick, N.J.: Rutgers University Press, 1987). For individual examples of attempts to analyze Egyptian figures in harmonic terms, see André Fournier des Corats, *La Proportion Égyptienne et les rapports de divine*

harmonie (Paris: Véga, 1985 [1957]); and Heinrich Schäfer, *Von ägyptischer Kunst* (Leipzig: J. C. Hinrichs, 1919).

31. Kielland says that the Egyptians had only the fraction ²/₃, for which they had a special symbol, and fractions of the form ¹/n. Hence a segment divided into 7 had one-sevenths, each of which "is to be regarded rather as a *quality* than a *quantity*." What is left over is not ⁶/₇ but $1 - ¹/₇$. "In this way an intimate relation arose between the original whole and the part, between the part and the complementary fraction. These are the very qualities which are characteristic of the golden section division." Needless to say this does not prove the presence of the golden ratio in Egyptian art. Kielland, *Geometry in Egyptian Art* (London: A. Tiranti, 1955), pp. 10–11; and compare her *Geometry in Greek Art* (Oslo: Dreyer, 1984).

32. Loden Sherap Dagyab, *Tibetan Religious Art*, Asiatische Forschungen series (Wiesbaden: Harrassowitz, 1977), 2 vols.; Lama Gega, *Principles of Tibetan Art: Illustrations and Explanations of Buddhist Iconography and Iconometry According to the Karma Gardri School* (Darjeeling: Jamyang Singe, 1983); Janice A. and David Paul Jackson, *Tibetan Painting Methods and Materials* (Warminster, Eng.: Aris and Phillips, 1983); and the same authors' *Tibetan Thangka Painting* (Boulder, Colo.: Shambhala, 1984), which is a practical manual.

33. The decipherment of Egyptian proportions is largely due to Erik Iverson, *Canon and Proportions in Egyptian Art*, 2d ed., fully revised in collaboration with Yoshiaki Shibata (Warminster, Eng.: Aris and Phillips, 1975). An earlier text, that paved the way for Iverson, is C. Richard Lepsius, *Denkmäler aus Ägypten und Äthiopien*, 7 vols. (Geneva: Éditions de Belles-Lettres, 1972–73 [1849–1913]).

34. Plates 107 and 108 derive from R. Lepsius, *Denkmäler aus Ägypten und Äthiopien* (Geneva: Belles-Lettres, 1973 [1849–56]), vol. 3, pp. 78 ff., text vol. 3, p. 222, and vol. 4, Bl. 48a, text vol. 4, p. 58, respectively.

35. Andrew Stewart, *Art, Desire, and the Body in Ancient Greece* (Cambridge, Eng.: Cambridge University Press, 1997), pp. 45–46.

36. Galen, *De placitis Hippocratis et Platonis libri novem*, ed. Iwanus Mueller, vol. 1. *Prolegomena critica, textum Graecum, adnotationem criticam versionemque Latinam contiens* (Leipzig: B. G. Teubner, 1874). The text is usually known as *De Hippocratis et Platonis decretis*.

37. Measurements strongly suggest that Donatello's *Martelli David* (c. 1435) in Washington, D.C., and the slightly earlier bronze *David* in Florence were both made in accord with what Alberti proposed in *De statua*; yet it is significant that we cannot generally tell which Renaissance figures were made with grids, moduli, and scales. The two ways of conceiving the body apparently coexisted for a while in the fifteenth and early sixteenth centuries, with the grid serving as a check or aid to less quantitative ways of imagining the body.

38. See also Jürgen Fredel, "Ideale Maße und Proportionen, Der konstruierte Körper," in *Die Beredsamkeit der Liebes, Zur Körpersprache in der Kunst*, ed.

Ilsebill Barta Fliedl and Christoph Giessmar, *Veröffentlichung der Albertina*, no. 31 (Salzburg: Residenz Verlag, 1992), pp. 11–42.

39. The measurements are self-contradictory: points 1 and 2 contradict 4 and 5. The corruption of the text is inferred to be in 4 or 5.

40. Dionysus of Fourna (c. 1670–c. 1745), *Malerhandbuch des Malermönchs Dionysios vom Berge Athos*, ed. Godehard Schäfer (Munich: Slavisches Institut, 1960 [1855]).

41. Cennino Cennini, *Libro dell'Arte*, trans. Daniel Varney Thompson Jr. (New Haven, Conn.: Yale University Press, 1933), 48–49.

42. For this icon, see Kurt Weitzmann, Manolis Chatzidakis, and Svetozar Radojcic, *Icons* (New York: Alfred A. Knopf, 1982), cat. 143.

43. Panofsky, "History of the Theory of Proportions," pp. 81–83.

44. On Cimabue's proportions, see Luigi Salerno, "Proportion," *Encyclopedia of World Art* (New York: McGraw-Hill, 1959–87), vol. 11 (1966), pp. 715–42, especially p. 726. Ristoro d'Arezzo, *Della composizione del mondo* (1282) mentions "the learned designers" who divide the figure into ten heads.

45. Cennino Cennini, *Libro dell'arte, ed. cit.*, Chap. 70. The formulation he records was apparently widely used in the earlier Renaissance. It depends, Byzantine-fashion, on the face instead of the entire head. According to Cennini, the arms reach to the middle of the thighs, presumably meaning 1 face below the crotch and 1 face above the knees. Measurements like Cennini's, including the tripartite face on which they are based, appear to be used in Mantegna, and some works by Donatello. It has even been claimed that Michelangelo's *David* follows these proportions except for "an extra measure between the shoulder and the elbow." See Eugenio Battisti, "Proportion in the Human Figure," *Encyclopedia of World Art* (New York: McGraw-Hill, 1959–87), vol. 11 (1966), pp. 722–31, especially p. 727.

46. Albrecht Dürer, *Hierinn sind begriffen vier Bücher von menschlicher Proportion* (Nuremberg: J. Formschneyder, 1528). See also Dürer, *Underweysung der messung, mit dem Zirckel und Richtscheyt* (Nuremberg: [s.n.], 1525), facs. ed., ed. Alvin Jaegeli (Dietikon-Zürich: Stocker-Schmid, 1966), trans. Walter L. Strauss as *The Painter's Manual* (New York: Abaris, 1977).

47. I do not know of any attempts to use Dürer's system, either in classrooms or in the history of art. There are several reasons for this. Dürer made exceptionally accurate measurements—he must have used sharp silverpoints and calipers. (Today's compasses come blunted to protect students, making measurements like Dürer's impossible.) He does not make the process easier by giving fractions in forms such as "$1/13 + 2/27$." He used a scale of fractions to avoid having to find common denominators, but the scale he gives in the book is a woodcut version and is too coarse to be useful. The process of constructing a figure takes several hours, and even with all 91 points marked there is not enough information to complete a reasonable outline of the body without reference to Dürer's completed figures; most of the smaller forms (muscles, etc.) that appear in his illustrations are invented rather than measured.

48. McEvilley, "Who Told Thee That Thou Was't Naked?"

49. Leo Steinberg, *The Sexuality of Christ in Renaissance Art and in Modern Oblivion*, 2d ed. (Chicago: University of Chicago Press, 1996).

50. This analysis is continued in Elkins, *On Pictures and the Words That Fail Them*, Chap. 8, "The Unrepresentable, the Unpicturable, the Inconceivable, the Unseeable," outside the specific context of represented bodies. See also Jean-François Lyotard, *The Inhuman: Reflections on Time*, trans. Geoffrey Bennington and Rachel Bowlby (Stanford: Stanford University Press, 1991), Chap. 9.

51. Aug. Audollent, "Note sur une plaquette magique de Carthage," *Académie des Inscriptions et Belles-Lettres* [Paris], *Comptes rendus des séances de l'année 1930* (Paris: Auguste Picard, 1930), pp. 303–9, citing Richard Wünsch, *Sethianische Verfluchungstafeln aus Rom* (Leipzig: B. G. Teubner, 1898), pp. 83–84.

52. For "conceptual" images, see David Summers's work, most recently "Conditions and Conventions: On the Disanalogy of Art and Language," in *The Language of Art History*, ed. Salim Kemal and Ivan Gaskell (Cambridge, Eng.: Cambridge University Press, 1991), pp. 181–212.

53. Originally published in E. A. Wallis Budge, *Amulets and Superstitions* (London: Oxford University Press, 1930; reprinted New York: Dover, 1978), p. 276. See further *The Book of Protection*, trans. Hermann Gollancz (London: H. Frowde, 1912; reprinted Amsterdam: APA-Philo Press, 1976).

54. For the Gorgon, see especially Stewart, *Art, Desire, and the Body*, pp. 182–86, and the remarkable protoattic amphora from Eleusis, illustrated on p. 17, Figs. 7 and 8, and colorplate IIa.

55. Geoffrey Tory, *Champ fleury* (Paris: Geoffry Tory et Gilles de Gourmont, 1529).

Index

In this index an "f" after a number indicates a separate reference on the next page, and an "ff" indicates separate references on the next two pages. A continuous discussion over two or more pages is indicated by a span of page numbers, e.g., "57–59." *Passim* is used for a cluster of references in close but not consecutive sequence.

Abjection, 35, 53f, 226, 276, 333n17
Aborigines, 188ff, 193
Abstraction, 13–18, 182, 283
Acne, *see* Pimples
Acting, 82
Adam and Eve, 55
Aenigmae, 214f, 226. *See also Grylli*
Aertsen, Pieter, 126
African images of the afterlife, ix
Agate, 41
Alberti, Leon Battista, 1, 86, 88, 271f
Albinus, Bernard Siegfried, 129–34 *passim*, 141–45, 317n46
Albright, Ivan, 59, 117
Alice in Wonderland, 250
Allantoides, 1
Allergy, 35
Ammannati, Bartolomeo, 85
Amoeba, 223, 241ff
Anaclisis, 290n12
Analogic seeing, 30
Analogy, 22, 28, 30
Anamorphic positions, 16f
Anatomy, 22, 37f, 42, 65, 72, 127
Anatomy of Melancholy, 127, 247f
Androids, 216
Anorexia nervosa, 162–63
Anthropometries, 85
Anus, 44, 46, 206, 247, 251f
Arc en cercle, 157
Architecture, 6f, 43, 46, 118, 149, 209

Arcimboldo, Giuseppe, 216, 219
Aristotelian qualities, 245
Art history, viiif, 169
Arthritis, 153ff
Art Orienté Objet, 46
Asanas, 103
Asceticism, 12
Assyrian divination, 47f
Astrology, 254
Athos, Mount, 273
Azimuthal maps, 20
Aztecs, 110

Babylonian divination, 47f
Bach, Johann Sebastian, 186
Bacon, Francis, 25, 45, 73, 95, 98, 104, 112, 117, 120f, 199f
Bacteria, 232, 240f
Baker, Henry, 234f
Bakhtin, Mikhail, 31, 251–54
Baldung, Hans, 124, 126
Balthus (Balthasar Klossowski de Rola), 7–12, 17, 126
Bandages, 114
Bann, Stephen, 7
Barberini panels, Master of the, 88
Bataille, Georges, 277, 292n31
Baudelaire, Charles, 207
Baum, L. Frank, 248ff
Beauty, 21, 35, 74, 124, 160–64, 184, 186, 222, 270f

Beckmann, Max, 73, 91f, 104
Bellmer, Hans, 313n70
Belting, Hans, 304n39
Beowulf, 109
Berkeley, George, 326n24
Bernini, Gian Lorenzo, 74f, 139
Bernstein, Roberta, 304n38
Bess, Forrest, 42
Beyond the Pleasure Principle, 38
Bibémus quarry, 12
Bidloo, Govert, 137ff, 141
Bions, 241ff
Birth, 54ff
Birth defects, 213f
Birthmarks, 76
Blob, The, 112
Blondes, 70
Blood, 49, 54, 117, 120, 170
Bloodletting, 252ff
Body, *see under individual parts*
Body without organs, 38–41
Book of Kells, 47
Borch-Jakobsen, Mikkel, 164
Borometz, 214f
Bosch, Hieronymus, 219
Botticelli, Sandro, 29, 153ff, 201f
Boulez, Pierre, 44
Bourgeois, Louise, 46
Boyle, Margorie O'Rourke, 287n1
Boys, *see* Children
Brain, 38, 51, 146f, 170, 180, 186
Breasts, 171f, 190f
Bronchial tubes, 37
Bronzino, 62, 64
Brunelleschi, Filippo, 87f, 95
Brunettes, 70
Buck, Carl, 115
Buddha, 179
Burger-Villingen, R., 80, 174
Burgess Shale, 219
Burnell, Devin, 302n21
Burton, Robert, 127, 247f
Buttocks, 191
Byzantine proportions, 263, 272ff, 278

Calamary, 228f
Calmucks, 184
Calves, 38
Camper, Pieter, 55, 183–86, 220
Cancer, 50
Caroline Islands, 171
Carpals, 95
Carpue, Joseph Constantine, 95
Caravaggio, 74, 120, 169
Cardiovascular system, 43
Caricature, 74
Carpenter, John, 112, 218f

Cartari, Vicenzo, 39, 56
Cartesian coordinates, *see* Deformation grid; Metrology
Carthage, 279
Cartilage, 51, 116
Cassell, E. J., 128f
Castagno, Andrea del, 88f
Castration, 43, 52
Catherine C., 59
Caul, 1
Cell, simple protoplasmic, 38f, 41, 45
Cennini, Cennino, 273f
Centaur, 30, 215
Cézanne, Paul, 7f, 10–12
Chain of being, 215, 234
Chalcedony, 41
Chaos theory, 27
Charcot, Jean-Martin, 83, 152, 156f
Children, viii, 189, 221
Chimpanzee, 172, 177, 179f, 188
Chinese, 42, 179ff, 186, 191
Chinese gardens, 9
Chinese landscape painting, 9f
Chloroplasts, 221
Chrysippos, 270
Chrysler Building, 6f
Cicadas, 1
Cigoli, Ludovico Cardi da, 134
Cimabue, 95, 98, 274
Circonscrizione, 289n4
Circumscriptiones, 1
Clay, 47f
Clay, Diskin, 1
Cleanliness, 49f
Clitoris, 42, 139
Clothing, 43, 46, 115
Clouds, 2
Clownisme, 157
Cnead, 61
Coco de mer, 197
Coleridge, Samuel Taylor, 220
Colonna, Vittoria, 100
Columns, 90f
Comics, 105, 252, 306n71
"Conceptual" images, 279
Concetti, 26, 206
Condoms, 45
Conformal maps, 20
Connective tissue, 38
Contorno, 36
Contrapposto, 20, 28f, 72f, 85–106, 115, 132, 195f
Cowper, William, 222
Cranial capacity, 186ff
Cronenberg, David, 231
Crookshank, Francis Graham, 176–80, 202

Crucifixion, 69
Cubism, 30, 73f, 207–12, 217, 243. *See also* Picasso, Pablo
Cubit, 263–70 *passim*
Cupping, 252ff
Cureau de La Chambre, Martin, 161
Curiosity cabinets, 217
Cyborgs, 216
Cyclopes (birth defects, mythic creatures), 212
Cyclops (invertebrate animal), 237
Cysts, 221

Dactyloscopy (fingerprinting), 71
Dancing, 87f, 102
Dante Alighieri, 186
Daphne, 26
Darwin, Charles, 170
Daston, Lorraine, 156
David, Jacques-Louis, 250
David (Michelangelo's), 89
De Andrea, John, 136f
Death, 27, 119, 132, 145, 149
De Bolla, Peter, 190
Decay, 54
De Duve, Thierry, 309n30
Deformation, 21, 87, 292n31
Deformation grid, 254f
De Kooning, Willem, 128, 309n28
Deleuze, Gilles, 38–41, 44f, 244
Dementia praecox, 157, 177–80
Democritus, 252
Demons, Babylonian, 109
Dennis, Kelly, 194, 295n19, 322n90
Dequeker, Jan, 153ff, 201f
Dermatitis factitia, 52
Dermatoglyphics, 71
Dermatology, 28, 46–53 *passim*, 72, 278
Dermography, hysterical, 46, 157
Dermis, 42
Derrida, Jacques, 44, 127
Descartes, René, 215
De Staël, Madame de (Anne Louise Germaine Necker), 80
Diaresis, 127f
Didi-Huberman, Georges, ix, 156, 292n31
Disease, 49ff
Disegno, 65f
Disfiguration, 22
Disiejcta membra, 54
Disjunction, 21
Dissection, 21, 126f, 134, 142, 145
Dissolution, 21
Distances from a painting, viii, 16–17
Distension, 21
Distortion, 19–22, 194
Divination, 47f

Dogs, 51
Dolichocephaly, 190
Donatello, 89, 271
Dong Qichang, 10
Down's syndrome, 177, 179
Dragons, 215
Drang, 2
Dravidians, 189
Dujardin, Félix, 237f
Du Quesnoy, Fançois, 74
Dürer, Albrecht, 254, 255, 271, 274f
Dutch, 55, 186
Dyer, George, 39

Eakins, Thomas, 193
Ears, 42, 190
Écorché, 95, 118, 134, 137, 142
Ectomorphs, 165–69
Eczema, 52
Eden, 197
Egyptian art, 259, 263–71, 283
Ehrenberg, Christian Gottfried, 235–38, 243
Einfühlung, 24
Elsheimer, Adam, 118ff
Embryo, 43, 56, 172, 234
Empathy, 24, 252, 276, 293n39
Empedocles, 27
Endomorphs, 165–69
Epicanthic fold, 177
Epicurus, 1f
Epidermis, 42
Epilepsy, 157
"Episodic" seeing, 67
Equal-aread maps, 20
Ernst, Max, 215f, 219, 243, 250
Erotic art, 139, 198, 201
Eskimo, 177, 188f
Estienne, Charles, 132
Euglena, 237
Europeans, 170, 184, 188, 191ff
"Evil demon," 215
Excision, 127
Expressionism, German, 75, 91ff, 101
Ex-votos, 134
Eyes, 142, 144f, 237

Faces, 2–5, 65f, 73. *See also* Physiognomy
Facial angle, 184ff
Farting, 252, 317n51
Fascial sheets, 38, 139
Fat, superficial, 43
Feeling, *see* Meaning, opposed to feeling
Feet, 191
Feher, Michael, ix
Felt, 45
Feminism, 288n4

Ferenczi, Sándor, 112
Fern, 27
Fetus, 24, 53, 56, 116, 172
Fiber art, 45f, 115, 126
Fibonacci series, 259
Fibrous membranes, 38
Ficino, Marsilio, 101
Figura serpentinata, 90f, 101
Figure of speech, 22
Figure mark positions, 15–16
Fingerprinting, 71, 180, 318n56
Fingers, 119, 266, 271
Finnegans Wake, 46f
Flaying, 43
Flesh, 29, 100, 115–24
Flourens, Marie-Jean-Pierre, 55
Flower, 25
Flower, ice, 27
Fludd, Robert, 245–48, 251
Folding, 41–46 *passim. See also* Skin folds,
 Wrinkles
Follicular crypts, 42
Fractions, 335n31, 336n47
Fragments for a History of the Human Body,
 ix
Fragments of the body, 45f, 129, 180–88
 passim, 205
Fragonard, Honoré (anatomist), 136
Fragonard, Jean-Honoré (painter), 198
Francis Bacon: Logique de la sensation, 39
Freckles, 50
French Academy, 51
Freud, Lucian, 28, 57ff
Freud, Sigmund, ix, 31, 38, 41, 44, 54, 169,
 174, 230, 251
Friedenthal, Hans, 172ff, 180
Friedman, Anna, 295n19
Fried, Michael, ix
Frontal poses, 87, 93–100 *passim*, 104

Gabriel (the angel), 281
Galison, Peter, 156
Gandelman, Claude, 19f
Gas, 41
Gastrula, 42
Gates, Reginald Ruggles, 180
Gender, 153ff, 166–75, 216, 230, 288n4,
 316n39
Geometry, 28, 245–84 *passim. See also*
 Fractions; Perspective
Germans, 191ff
Germ plasm, 43
Gestures, 20, 71, 84, 160. *See also* Frontal
 poses
Ghiberti, Lorenzo, 87
Giacometti, Alberto, 2–5
Gilgamesh, 109f

Giorgione, 10
Giotto, 98, 274
Giovanni Bologna, 85
Girls, *see* Children
Giulio Romano, 196
Glue, 116
Gnosticism, 279f
Gober, Robert, 46
Goldberg, Rube, 230
Golden section, 259
Golub, Leon, 61
Gooseflesh, 52
Gordon, C. G., 197
Gorgon, 112, 282
"Gothic wave," 95
Grafting, 127
Gravity, sense of, 23
Greek art, 270, 272
Greek interests in surfaces, 48
Greenberg, Clement, 15
"Green helical organism," 240, 243
Grell, Karl G., 238ff
Greuze, Jean-Baptiste, 8
Grid, *see* Deformation grid; Metrology
Gross anatomy, *see* Anatomy
Grotesque, the, 31, 206, 251–54, 276
Ground mark positions, 16–17
Grünewald, Matthias, 28, 67ff, 90, 98
Grylli, 214–20, 226, 243, 279
Guattari, Félix, 38
Gunflint Chert formation, 240

Haeckel, Ernst, 238, 321n82
Hair, 172, 180ff
Haller, Albrecht von, 42, 116, 139
Hallucigenia, 219
Hamlet, 247
Haptic, 332n10
Haraway, Donna, 326n23
Harlequin worm, 220, 222
Hartsoeker, Nicolaas, 228, 235
Hay, John, 9
Heat, sense of, 23
Heidegger, Martin, 156
Heraclitus, 252
Heraldry, 205
Hermaphrodite, 43
Hesse, Eva, 38
Heterology, 54, 98. *See also* Fragments of
 the body
Heziré relief, 259
Hicceity, 156
Hill, Geoffrey, 244
Hill, John, 234f
Hinchcliffe, Paul, 293n42
Hippopotamus, 76
Histology, 182

Hodler, Ferdinand, 160
Hoehne, Karl-Heinz, 146
Homo ad circulum, 250, 258
Homo ad quadratum, 258, 283
Homo interior and *exterior*, 84
Homosexuality, 167, 169, 181, 196, 201
Homunculus, 292n29
Hooke, Robert, 227
"Hottentots," 191
Humbaba, 109–14 *passim*, 282
Hume, David, 24
Humoralism, 72, 165, 245–48
Huyghens, Christiaan, 227
Hydras, 222, 231ff, 235, 237
Hydrocephaly, 188
Hyperhydriosis (clammy skin), 52
Hyperopic positions, 16–17
Hypertrichosis, 171
Hysteria, 46, 156f, 175

Iliac spines, 42
Iliad, 101
Imagini de gli dei delli antichi, 56
Inconceivable, 31f, 64, 198, 278–84 *passim*
Infection, 49
Informe, 292n31
Ingres, Jean Auguste Dominique, 119
Inorganic, the, 27
Inside and outside, 42–46, 84f, 116, 118–24
 passim, 222, 231, 252
Intestines, 37
Invagination, 41
Irish, 61
Irritabilité, 51
Irruption, 41
Israelites, 47–50
Iverson, Erik, 263

Japanese, 5, 47, 177, 179f, 189, 191
Jargon, *see* Neologisms
Jews, 157, 160, 184
Job, 108
Joblot, Louis, 234f, 237
Johns, Jasper, 85
Johnson, Mark, vii
Journal of Sex Research, 43
Joyce, James, 46f
Judas, 81, 103
Julius II, 214
Junty, Charles Nicolas, 37, 312n63

Kakabekia, 240, 243
Kalf, Willem, 126
Kant, Immanuel, 57, 170, 186, 244
Keiromancy (palmistry), 71
Kelly, Mary, 314n10
Ketham, Johannes de, 252ff

Kidneys, 38
Kielland, Else Christie, 259, 263
Klein, Yves, 85
Klossowski de Rola, Balthasar (Balthus),
 7–13, 17
Klossowski de Rola, Pierre, 13, 81
Klossowski de Rola, Stanislas, 8
Koikoins, 189
Kokoschka, Oskar, 117f
Koons, Jeff, 199
Kouroi, 270
Krauss, Rosalind, ix, 13, 292n31
Kristeva, Julia, 53f, 226, 333n17
Krutch, Joseph Wood, 27

Labia, 42, 172, 191
Lacan, Jacques, vii, 37, 41, 54, 163f
Lairesse, Gerard de, 137, 141
Lamashtu, 282
Landscape painting, 9–12, 216
Lanugo, 177
Laocöon, 75
Larchant, 10
La Tour, Georges de, 118, 120
Lavater, Johann Caspar, 76–82, 106, 161
Lawrence, D. H., 7
Ledermüller, Martin Frobenius, 220, 234
Lee-Pearson formula, 186
Leeuwenhoek, Anthony van, 220, 227f,
 235, 237, 243
Leibniz, Gottfried Wilhelm, 186
Leiris, Michel, 121
Lemayrie, Jean, 8
Le Nain, Louis, 160
Leonardo da Vinci, 31, 179, 250, 275
Lepier, Erich, 148f
Lepinski Vir posture, 103
Leprosy, 49, 54
Lesions, 50
Leslie, Alfred, 160
Lessing, Gotthold Ephraim, 80
Leviticus, 47ff, 54
Lexeme, 79, 250
Liminal passages, 37
Lindow Man, 61
Linnaeus, Carolus, 234
Lipps, Theodor, 24
Lips, 37
Liquidity, 29
Liver, 47f, 247
Liver spots, 50
Livingstone, Joan, 149
Lockhart, Robert Douglas, 21, 255, 257
Logos, 27
Lomazzo, Giovanni Paolo, 90f
Longinus, 204
Louis XII, 214

Lovejoy, A. O., 215, 219
Lucina, 39, 56f
Lucretius (Titus Lucretius Carus), 1f
Lyotard, Jean-François, 79

McEvilley, Thomas, 194–97 passim, 277
MacKinnon, Catherine, 193
Macrocephaly, 188
Macular (spotted), 50
Magritte, René, 182
Mallarmé, Stéphane, 44
Mandylion, 85
Mann, Sally, 120
Mantegna, Andrea, 95
Maori, 47
Maps, 20
Mark, pictorial, 15, 36
Marsyas, 43, 108
Masaccio, 90, 98
Matisse, Henri, 209
Mead, Margaret, 169
Meaning, opposed to feeling, 22–27 passim,
 128, 252, 333n17
Meat, 39, 121
Mechanomorphs, 216, 247
Medical imaging, 128f, 145–48
Medusa, 112
Melancholy, 245–48
Membranae, 1
Membranes, 1f, 28, 36–69 passim, 116
Memento mori, 108
Mendeleyev, Dmitri Ivanovich, 165
Menoeceus, viii
Merleau-Ponty, Maurice, vii, 2, 7, 56
Mesomorphs, 165–69
Messager, Annette, 115
Metamorphoses, 26, 119, 204
Metamorphosis, x, 29ff, 155, 250.
Metaphor, 28, 30
Metoposcopy, 71, 73
Metrology, 31, 254–76 passim
Michelangelo, 28, 62–65 passim, 74, 89–101
 passim, 105
Michelson, Annette, 54
Microscopy, 219–43
Milia, 52
Millet, Jean François, 199
Minner, Thomas, 290n9
Mirabeau (Honoré Gabriel Riqueti), 78
Mirror stage, 163f
Mishnah, 49f, 54
Mitchell, W. J. T., 315n29
Mitochondria, 238f
Modernism and racism, 182f
Modi, I, 196
Moduli, 263, 268, 270, 273, 335n37
Mole-rat, 223f

Mongols, 176–80, 184, 188
Monsters, 76, 109ff, 160–64, 212–19, 215,
 223, 254, 325n16
Montaigne, Michel Eyquem de, 127
Moreau de Maupertuis, Pierre-Louis, 24
Morris, Robert, 38
Morris's Human Anatomy, 39
Morula, 42
Mucous membranes, 37, 44
Mucus, 34, 38
Muller, Philipp Ludwig Status, 230
Multicellular organisms, 42
Mummies, 146f
Münchhausen, Karl Fiedrich, Baron von,
 230
Musée de l'Hôpital Saint-Louis, Paris, 55,
 136
Myopic positions, 16–17

Narwhals, 213
Navel, see Umbilical fovea
Needham, John Turberville, 223, 228ff,
 234
Negroes, 170, 172, 177ff, 184ff, 189
Neill, John R., 249
Neologisms, 226, 228ff
Neoplatonism, 27, 101, 103, 250
Nervous system, 43, 51, 118
Neuralgia, 35
Neurology, 51
Newman, Barnett, 313n70
Niam-niam, 182
Nietzsche, Friedrich, 48
Nitzsch, Hermann, 109
Normalcy, 161f
Noses, 37, 49, 80, 184, 190, 222, 273, 278
Nöthling, Walter, 80, 174

Object Stares Back, The, 5, 277, 289n2
Objet petit a, 54
Obstetrics, 179
Occulta cordis, 84
Ó Criomhthain, Tomás, 115
October, viii
Oil, 45, 116, 222
Olin, Margaret, 332n10
Oncology, 50
Onians, Richard, 101
Optic, 332n10
Orangutans, 177, 179, 184, 188
Organic, the, 27, 30
Orifices, 38, 41f
Osiris, 279
Other, the, 5, 161f, 176, 180
Outside, see Inside and outside
Ovid, 26, 108, 204
Oz, 248ff

Pain, x, 22–27 *passim*, 39, 128, 145–49, 276f, 333n17
Painting, *see* Distances from a painting; Landscape painting; Mishnah; Still lifes
Palladino, Eusapia, 102
Palmistry, 71, 179f
Panofsky, Erwin, 20, 124, 254, 258, 272
Panspermism, 229f, 235, 240
Papuans, 189ff
Papular (pimply), 50
Paramecium sp., 327n29
Paré, Ambroise, 213
Parergon, 57
Passions, 78
Pasteur, Louis, 220, 240
Paulet, Jean-Jacques, 50
Pazuzu, 282
Pelt, 47
"Perceptual" images, 279
Penis, 31, 42f, 145, 171f, 197, 218, 252, 254, 277, 284, 295n12
Perniola, Mario, 139
Perspective, 1, 20, 127, 211
Phenomenology, viif
Philippine "psychic healing," 109
Philosophy, vii, 27, 45
Philostratus, viii
Phlegmatism, 245, 248
Photography, 139, 141, 188f, 190–93, 207, 278
Phrenology, 72f, 78, 82
Physiognomy, 20, 28f, 72–85, 100, 104ff, 195
Physiology, 72
Phytoflagellates, 221
Picasso, Olga, 206
Picasso, Pablo, 25f, 30, 73f, 98, 104, 112, 182, 206–12, 215, 243
Piloerector reflex (gooseflesh), 52
Pimples, 50, 52
Pino, Paolo, 102
Piranesi, Giovanni Battista, 118
Placenta, 53
Plastic surgery, 307n13
Plastids, 238
Plato, 27, 51, 204, 244
Pli, 44
Ploss, Hermann Heinrich, 171ff
Plotinus, ix, 289n9
Plumb line, 89f
Pneuma, 27
Pockets, 44
Poliziano, Angelo, 155
Pollock, Jackson, 13–18 *passim*
Polykleitos, 270
Polypes, *see* Hydras
Pongo, 184, 220

Pontormo, Jacopo da, 28, 64f, 255
Pornography, 29f, 160, 188–201, 277
Portraiture, 2–5, 73f, 79, 195, 207–12 *passim*
Poses, *see* Frontal poses; Gestures
Pregnancy, 55. *See also* Birth
Presence, 16f, 29f
Prognathism, 190
Proportion, 21, 31. *See also* Metrology
Proprioception, 23f
Prosection, 127f, 139
Prosthesis, 127f, 223
Proteus (amoeba), 223, 237
Proteus (god), 209
Protoplasm, 223, 234, 236, 240
Protozoa, 220–43 *passim. See also Euglena; Paramecium sp.*
Prudentius, 101
Psyche, 27
Psychoanalysis, 28, 45, 54, 276f
Psychomachia, 28, 101
Psychosomatic illnesses, 53
Pustules, 50
Pythagoras, 27

Qi, 9
Quelle, 2
Quevedo, 108
Quintillian, 91

Rabbit skin glue, 45
Racism, 29f, 160–61, 165–93
Radiolaria, 238
Raphael Sanzio, 17, 62, 196
Ratio, 27
Rat kings, 226
"Ravenna monster," 213
Rectum, 44
Reich, Wilhelm, 240–43
Rembrandt, 73, 95, 98
Renaissance, 62–69
Repetition compulsion, 69
Representation, theory of, 18–22, 194. *See also* Unrepresentable
Rhinoceros, 145
Rilke, Rainer Maria, xx
Rorschach, Hermann, 62
Rösel von Rosenhof, Johann, 223
Rosenblum, Robert, 15–16, 119
Rubens, Peter Paul, 95, 98
Ruysch, Frederick, 136f

Sacred, the, 54
Sadomasochism, 38, 196
St. Sebastian, 67ff
Saint-Victoire, Mont, 10
Salle, David, 199

Sarcode, 236
Sartre, Jean-Paul, vii
Satyrs, 213, 215
Scabs, 49
Scale, 15–16, 18, 31. *See also* Metrology
Scarry, Elaine, vii, 7, 226
Schapiro, Meyer, 7
Schematization, 22, 28
Schiller, Friedrich von, 186
Schizophrenia, *see* Dementia praecox
Schön, Eva-Maria, 69
Schreyer, Apollonia, 164
Schweinfurth, Georg, 182
Scopophilia, 19
Sculpture, 134–37 *passim*, 149
Scylla, 204
Scythian lamb, 214f
Sebastiano del Piombo, 101
Seborrheic keratoses, 50
Seeing, first and second, 5–12
Segal, George, 102
Sememe, 79
Semiology and semiotics, 51, 71f, 79, 104
Sensation, levels of, 39
Senses (other than sight), 23, 330n60
Sensibilité, 51
Serous membranes, 38
"Serpentinated figure," 90f
Serrano, Andres, 120, 292n28
Serum, 38
Sexism, 29
Seychelles, 197
Shakespeare, 247f
Shapeless, 34
Sheldon, William Herbert, 72, 165–69, 202
Shem "the Penman," 46f
Shen, 9
Shit, 6, 46, 54, 220, 251f
Siebold, Carl Theodor Ernst von, 237f
Sign language, international, 251, 283
Sirens, 212, 215
Skestos, Stephanie, 298n53
Skin, 1, 28, 35–69 *passim*, 172, 177, 182, 222, 284
Skin diseases, 48–51
Skin folds, 20f, 59, 67. *See also* Dermato-glyphics
Skrabanek, Petr, 162f
Smallpox, 50
Smith, Kiki, 46, 120
Snyders, Frans, 126
Socratic dialogues, 27
Solomon, King, 280
Somatotypology, 72, 165–69
Sömmerring, Samuel Thomas von, 145
Spallanzani, Lazzaro, 220
Specola, La, 134, 137

Sperm, 226–31, 234, 252
Spielbein, 88ff
Spinal cord, 43
Spinario, 88
Sprinkle, Annie, 85
Stafford, Barbara, ix, 50, 250, 293n35, 293n36, 296n20, 296n26, 296n30, 303n25, 307n13, 308n24, 310n38, 310n45, 311n53, 311n54, 314n20, 326n17, 326n20, 333n12, 333n13
Standbein, 88ff
Starobinski, Jean, 42
Statistics, 161, 170
Steatopygia, 191
Steinberg, Leo, ix, 101, 207–12, 277
Stewart, Andrew, 335n35
Stigma, 237
Still lifes, 8ff, 126, 137, 197
Stoicism, 1f
Stoss, Veit, 95
Straz den Haag, Carl Heinrich, 189–93, 202
Surface, *see* Skin; Membrane
Surfaces, 56
Surrealism, 30, 243. *See also under individual artists*
Sutherland, Graham, 95, 98, 112, 121
Sutures, 114f
Sweerts, Michael, 118, 120
Swift, Jonathan, 222
Sylvester, David, 121
Syphilis, 51
Syphilophobia, 52
Syriac art, 280ff
Syrinx, 26

Tabula rasa, 82
Tactus intimus, 23
Tattooing, 47, 117
Telos, 100f
Tendons, 51
Teratologies, *see* Birth defects
Testicles, 43, 247, 254
Thaumasius, 281
Thereness, 156–60, 201, 276, 313n5
Thing, The, 112, 121, 218
Thompson, D'Arcy, 254
Thousand Plateaus, 38f
Tibetan art, 263
Tibetan medical manuals, ix
Tierra del Fuegans, 191
Tin Woodman, 250
Titian, 121, 124
Tolnay, Charles de, 97
Tongue, 42, 235
Topology, 44, 59
Torquere, 21

Tory, Geoffrey, 283
Touch, sense of, 23, 56
Transcendence, 26
Translucence, 118–24
Trémorin, Yves, 69
Trope, 22
Trophoedema, 192f

Ugliness, 74
Umbilical cord, 214f
Umbilical fovea (navel), 42, 172
Uncanny, the, 54
Unicorns, 213
Unrepresentable, 31f, 278–84 *passim*
Urethra, 43

Vagina, 37, 42f, 45, 139, 172, 197. *See also*
 invagination
Valdés Leal, Juan de, 124ff
Valverde, Giovanni, 132
Van Gogh, Vincent, 199
Vanitas symbols, 124
Van Rymsdyk, Jan, 139
Vasari, Giorgio, 31
Vaseline, 45
Vauxcelles, Louis, 209
Velázquez, Diego, 29
Venn diagrams, 19
Venus de Medici, 172
Venus's necklaces, 71
Verrucose (wartlike), 50, 59
Vesalius, Andreas, 129–34 *passim*
Vespucci, Simonetta, 153ff, 201f
Villard de Honnecourt, 95, 98
Virus, 27
Vischer, Robert, vii, 24
Visibilization, 19
Visual culture, 19
Visual desperation, 30, 219–43 *passim*

Vitruvius, 272f
Vlastos, Gregory, 294n43
Voyeurism, 190f, 193–202

Wales, 240
Walker, Mary, 174
Wandelaer, Jan de, 129, 141–45 *passim*
Warts, 50, 76, 148, 177
Watteau, Antoine, 29, 160, 169, 193, 202
Wax, 45, 58, 134–37, 222
Wedda, 189
Werewolves, 247
West, Benjamin, 95, 184
Wheel, 225f, 234
Whytt, Robert, 51
Wiertz, Antoine, 39
Williams, William Carlos, 34, 56
Witkin, Joel-Peter, 54
Witte, Emanuel de, 184
Wittgenstein, Ludwig, 73, 127
Wittkower, Rudolf, 74
Wölfflin, Heinrich, 62, 153
Womb, ix, 34, 56, 228, 231
"Wound door," 109
"Wound-Men," 132
Wrinkles, 20f, 35, 59
Wrisberg, Heinrich August, 232f
Writing, 46f
Wyvern, 215

Xipe Totec, 110

Yamnaya posture, 103
Yanaihara, Isaku, 2–5, 290n9
Yoga, 103f

Zaidens, S. H., 52
Zito, Angela, 42
Zodiac man, 252ff

Library of Congress Cataloging-in-Publication Data

Elkins, James
 Pictures of the body : pain and metamorphosis /
James Elkins.
 p. cm.
 Includes bibliographical references and index.
 ISBN 0-8047-3023-7 (cloth : alk. paper). —
ISBN 0-8047-3024-5 (pbk. : alk paper)
 1. Human figure in art. 2. Metamorphosis in art.
3. Art—Philosophy. I. Title.
N7625.5E45 1999
704.9'42—dc21 99-27632

∞ This book is printed on acid-free, archival quality paper.

Original printing 1999

Last figure below indicates the year of this printing:
08 07 06 05 04 03 02 01 00 99

Designed by Janet Wood
Typeset by James P. Brommer in 10.5/15 Bembo